Digital Wedding Photography: Capturing Beautiful Memories

Second Edition

Glen Johnson

WILEY

Wiley Publishing, Inc.

Digital Wedding Photography: Capturing Beautiful Memories, Second Edition

Published by
Wiley Publishing, Inc.
10475 Crosspoint Boulevard
Indianapolis, IN 46256
www.wiley.com

Copyright © 2011 by Wiley Publishing, Inc., Indianapolis, Indiana

Published by Wiley Publishing, Inc., Indianapolis, Indiana

Published simultaneously in Canada

ISBN: 978-0-470-65175-9

Manufactured in the United States of America

10 9 8 7 6 5 4 3 2 1

For general information on our other products and services or to obtain technical support, please contact our Customer Care Department within the U.S. at (877) 762-2974, outside the U.S. at (317) 572-3993 or fax (317) 572-4002.

Library of Congress Control Number: 2011928393

WILEY

About the Author

Glen Johnson, an acclaimed wedding photographer whose client list spans the globe, has shot more than 50 weddings outside the United States. His website, www.aperturephotographics. com, is filled with inspirational images and wedding stories as well as a lot of information for both photographers and brides.

Glen is a founding member of Best of Wedding Photography. This invitation-only group is the premier association for the world's top wedding photographers. Glen regularly provides input in the direction for the group as well as serves on the review board to choose which photographers are invited for membership.

Acknowledgments

Thanks to my mom for being my constant cheerleader in everything I do, and thanks to my father for encouraging me in photography and for sending me to my first photo seminar, and especially for letting me steal every camera he ever owned.

Credits

Acquisitions Editor
Aaron Black

Project Editor
Katharine Dvorak

Technical Editor
Haje Jan Kamps

Copy Editor
Lauren Kennedy

Editorial Director
Robyn Siesky

Business Manager
Amy Knies

Senior Marketing Manager
Sandy Smith

Vice President and Executive Group Publisher
Richard Swadley

Vice President and Executive Publisher
Barry Pruett

Project Coordinator
Patrick Redmond

Graphics and Production Specialists
Andrea Hornberger
Jennifer Mayberry

Proofreader
Cynthia Fields

Indexing
Estalita Slivoskey

Preface

I was shooting a wedding in the Bahamas where the bride and groom purchased a "package" wedding from a large resort. The package came with a minister, a videographer, and all of the other essentials except the photographer (me), which the couple arranged separately because they wanted more than what the typical hotel photographer provides. On the day of the wedding, I did my usual photojournalistic thing until just before the ceremony when the videographer arrived. This man stepped up with a loud voice and took over the reins of that whole wedding. From then on, he and the minister ran the show completely, telling the bride and groom where to stand, when to move, where to put each hand, how to hold the pen, and even when to smile at the camera — much to my dismay. They were arranging shots for me (which I didn't ask for) and then saying, "There you go, Mr. Photographer! That's how we do it here in the Bahamas!"

When the first dance started, the videographer was occupied at the bar but he quickly came charging back with a drink in his hand and a napkin flying in the air behind him. He was waving his hands and motioning across his throat at the DJ to cut the music. The DJ was ignoring him so he finally just yelled, "Stop!" which of course everyone did. Then he walked out onto the dance floor and carefully placed the groom on one side, and the bride on the other, and then he grabbed his camera and motioned for the DJ to start the music again.

Only a few weeks before this scene, I witnessed another bride in the Bahamas almost subjected to the same treatment. However, she stopped all of that nonsense right in the beginning. She told the minister and videographer how she wanted the events to go, and if they didn't want to do it her way, they could just pack up! At first, the minister didn't want to comply, but when she told her father to ask him to leave, he changed his mind. She then proceeded to have a very quiet ceremony that went exactly her way, with no interruptions.

Those two very different experiences made me think about how those of us in the wedding business go about our business. Sometimes videographers, ministers, and we photographers forget to honor the sacredness of the wedding. We all see so many weddings that we forget this is the first and perhaps only time the bride and groom will ever experience it. Our familiarity makes us good at what we do, but it also wears away our perception of the sacredness of the event. Before long, each wedding is simply another day at work, and we are eventually tempted to herd our clients through the paces.

Thankfully, a change is swirling in the air around the wedding photography industry. The move toward photojournalism brings with it a change toward relinquishing control — a change toward allowing the bride and groom to express their individuality, creating their own ceremony within the bounds of whatever religion they choose without us "professionals" trying to force them into our perception of what a wedding should be.

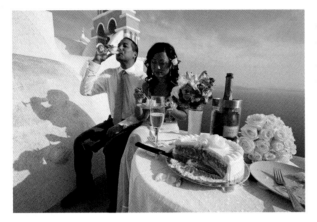

If you enjoy photography and you want to develop those skills into a marketable business, there are many options in the photography world. This book will help you decide if wedding photography is the right path for you.

Is This Book for You?

This book is not a beginning photography book. You will find very little information here on f-stops, apertures, or how to operate your camera. If you need to learn beginning photography, this book is *not* the place to start, and I would add that taking on a paid wedding at such a beginning stage could be considered a criminal act. If you already feel fairly comfortable with the basics of photography, and you want to learn how to apply those skills to shooting weddings, then this is the book for you.

If you're looking for a book full of perfectly exposed inspirational images — this is not it. This is a textbook about the basics of wedding photography. Of course I'll try to squeeze in a favorite shot or two when I can, but if you want to see my own best images, check out my website where I have them on display. Many of the images in these pages were chosen from my files because they illustrate what *not* to do. As such, they are often pulled directly out of the trash, where they belong. I'm a big believer in the idea that your mistakes are your greatest teachers, and this book is full of them.

Anyone interested in learning wedding photography, and particularly how to do it with digital equipment, will find *this book* useful. Seasoned photographers looking to branch out into shooting weddings will also find it useful, although of course they won't have as much to gain as a complete beginner to the wedding photography business.

After reading through the chapters in this book, you should have enough information to feel comfortable signing on as a second photographer with a more established wedding photographer. If you can't find a mentor like that, the knowledge in this book provides insight about the thoughts, attitude, camera techniques, and business practices to give you a good solid starting point from which you can comfortably take on (preferably free of charge) those first few small weddings on your own.

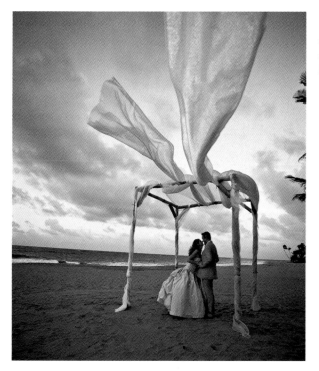

Being tuned into the things in your environment is key to finding and using the beautiful elements each wedding location has to offer.

What Does This Book Cover?

In this book I take an in-depth look at the challenging and rewarding world of digital wedding photography. Whether you are an aspiring amateur or a professional looking to add weddings into your business, I provide valuable insights and information to assist you on your way to becoming a digital wedding photographer.

Part I: Understanding Digital Wedding Photography

This book is organized into three parts with 19 chapters. Part I is a general overview of styles, equipment, daily workflow, and some specifics about composing good images.

In Chapter 1 I provide a general overview of the business of wedding photography.

We must remember that the bride and groom hire us to create a beautiful record of their wedding — not to create the wedding itself. We must also remember that the purpose of a wedding is to publicly announce the couple's agreement to be bound together as a family for the rest of their lives, and contrary to what some photographers seem to believe, a wedding is *not* a photo shoot.

In writing this book, my wish is that a new generation of photographers will continue the current trend of working in a more discreet fashion through the ceremony while still enjoying unhindered creativity in the more quiet moments of the wedding day.

In Chapter 2 I provide an overview of the different styles of wedding photography and how the style is determined by your personality type and the sort of images you prefer to shoot. If you're just starting out, this chapter may give you some direction in developing your own style.

Wedding photographers have a set of unique and very specific equipment needs, as you'll discover in Chapter 3. Many equipment choices you make are simply a matter of personal preference, while others are dictated almost completely by the specific requirements of the job at hand. No matter how serious your business aspirations are, this chapter can give you a long list of qualities to look for as you shop for that perfect camera system.

In Chapter 4 I discuss the various ways to set up your camera and how all the settings are used in a wedding photography context.

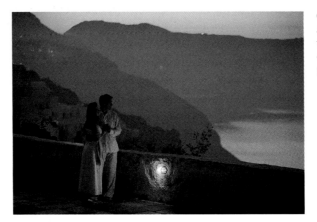

Creating beautiful images requires an advanced knowledge of how to use your camera and the specific ways to set it up for wedding photography.

Part II: Wedding Photography Techniques and Concepts

In Part II I go into depth about the thought process and techniques used to shoot a wedding. Topics range from camera setup to where to stand at any particular moment during the ceremony.

In Chapter 5 I discuss how the rules of good composition are simply guidelines that help to set you on your way toward creating great art. These guidelines are valuable to all artists, but the beginner stands to gain the most from learning and adhering to them. As you master the basics, you develop a *feel* for when you can bend or break the rules and still create images that work.

In Chapter 6 I cover information on how to develop a comfortable relationship with people while shooting in the dressing rooms. Anyone getting started in wedding photography needs to know how to approach the dressing rooms so that your clients will trust you to capture

great images while still respecting everyone's need for privacy. Other topics range from what sort of equipment is needed, what settings to use, dressing room etiquette, how to arrange the room, and how to create detail shots that capture the feeling of the day.

In Chapter 7 I discuss general concepts and specific techniques that can help you deal with changing outdoor light conditions, from the bright sun of a mid-day ceremony to the complete darkness you may encounter with a late evening event.

Shooting indoor weddings requires some specialized equipment as well as a lot of knowledge about how an indoor ceremony works. In Chapter 8 I cover everything from how to put out the candles, how to set up your lights, how to avoid reflections, and how to select a good background for family groups. Reflections are discussed in detail because they are a constant threat to your indoor images and you need to know why they happen and how to avoid them if you want to shoot indoors. The dark scenes you often encounter shooting indoors present a unique set of challenges, forcing you to make decisions about whether to set your ISO high and go for the natural light look or to use artificial light and lose the natural qualities of the scene. Your personal shooting style dictates which type of images you choose to create.

The ceremony can easily be considered the pinnacle of every wedding day. In Chapter 9 I provide an in-depth look at this important time in the wedding day. Months of preparation lead up to this one moment and yet when it actually happens, it seems to go by so fast that I often find myself standing there thinking, "Is that it? Is that all of it?" Thankfully, most weddings follow a predictable sequence of events that seldom varies within the United States. This predictability enables an experienced wedding photographer to stand in exactly the right spot at exactly the right time to catch the most important events. In this chapter I share some insights and the thought processes that go into every movement that a professional photographer makes during those few fleeting moments of the ceremony.

In Chapter 10 I provide information on equipment to use as well as tips on capturing candids by learning how to see them coming. A good candid image captures a spontaneous natural moment. Candids frequently tell a story, but more important, they simply capture people living their lives. The images are not contrived or posed. Candids catch rare and fleeting moments of reality — often achieving a "snapshot" look by trading perfect photographic technique for speed.

In Chapter 11 I describe a few of the techniques and thought processes that go into creating a type of image that contains such elusive qualities that no words can fully describe what it is or how it should look. For thousands of years, artists have been trying to capture or create images that portray romance. Photographers, painters, and sculptors alike all struggle with the same question, "What does romance look like?" For that matter, what is romance? Like beauty, romance is an elusive trait that only the eyes of the beholder can judge. Every person knows it when he or she sees it, yet no two viewers see it in the same place.

In Chapter 12 I talk about shooting at the reception. During the hours that follow the ceremony, you will have few responsibilities and only a couple of "must have" shots to capture. There are shots of the food, the first dance, the cake cutting, and the garter and bouquet toss. The last portion of this chapter introduces some advanced flash techniques that are so much fun to experiment with that you may find yourself staying at the reception far into the night.

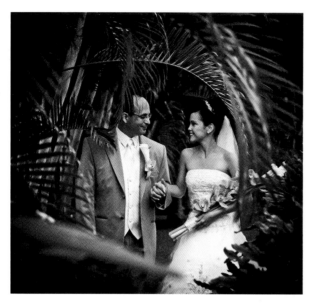

After the ceremony there is often time to walk around the grounds and shoot some creative images with just the couple.

Part III: The Business of Digital Wedding Photography

The last section of the book looks at the most important and least glamorous side of wedding photography — running a business. Topics in Part III include how to create your own workspace, what types of equipment you need, and what sort of products you might offer to your clients.

In Chapter 13 I offer a brief overview of the workplace options and office equipment you need to create a full-featured digital wedding business capable of handling all aspects of image processing and client contacts. The space needed may be as small and unassuming as a spare bedroom or as large as a full-featured studio, without having any effect on the style or the quality of the final product. In this chapter I look at the physical space where a wedding photographer works on a day-to-day basis, as well as the many different types of equipment and software needed to run a successful photography business.

In Chapter 14 I cover the topic of digital workflow. I break down the whole process into the major parts and then analyze the various jobs you must perform in this rewarding yet tedious part of a digital photographer's day. Each photographer must develop an organized system that allows work to flow from one task to the next as each job progresses from beginning to end. Tasks include downloading and editing the previous weekend's images, backing them up on the computer, editing out the bad ones, and finally delivering the images to the client. The workflow information you gain in this chapter can help you to streamline your business so that it functions as efficiently as possible.

In Chapter 15 you'll find an overview of the techniques used to manipulate images in Adobe Photoshop and Lightroom. These two programs dominate the wedding photography business today and mastering their use will be one of your greatest challenges as a wedding photographer.

In Chapter 16 I look at the various ways you can deliver finished products to your clients. Current options include online print sales, albums, DVD data discs, DVD slide shows, and more. The digital age is teeming with products that you can offer to your wedding clients. The choices are so numerous that the job of narrowing down to the best offerings is a difficult and time-consuming task.

Breaking into the wedding photography business may seem like a daunting task to the beginner. In Chapter 17 I discuss the major options for finding jobs and provide tips on who to talk to about finding jobs. In this chapter I also discuss how to conduct client interviews. After all, finding a client is not the same as getting one to sign a contract. Knowing where to meet and what to talk about in client interviews is vital to your ability to get the signature on that contract.

In Chapter 18 I discuss the topic of web sites. Your website is the single most important part of the advertising puzzle. If you don't have one, you don't exist. And if you have one, but you don't know how to set it up for basic search engine optimization (SEO), then for all practical purposes, your website still doesn't exist. Your website has to be attractive, and your clients have to be able to find it.

In Chapter 19 I take a look into the special requirements and rewards of destination weddings. Topics include options for marketing yourself to these clients, pricing the job, choosing the right equipment for travel, and getting there and back in one piece.

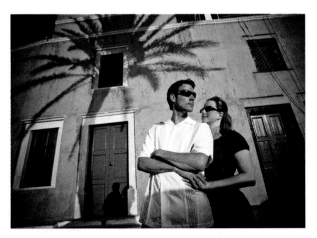

Dramatic couple shots are always challenging and fun to create. If you shoot destination weddings, the challenge is multiplied by the fact that every wedding takes place in a completely new location.

Contacting the Author

You can contact Glen Johnson by e-mail at aperture1@hotmail.com or grj@aperturephoto graphics.com. For more information about the author and his upcoming projects, visit his website at www.aperturephotographics.com.

Contents at a Glance

Contents

PART I: Understanding Digital Wedding Photography 1

PART II: Wedding Photography Techniques and Concepts 73

Chapter 5: Composing Your Art . 75

Chapter 6: Finding Beauty and Emotion in the Dressing Room 89

PART III: The Business of Digital Wedding Photography 223

Chapter 13: Creating Your Own Workspace.......................225

Understanding Digital Wedding Photography

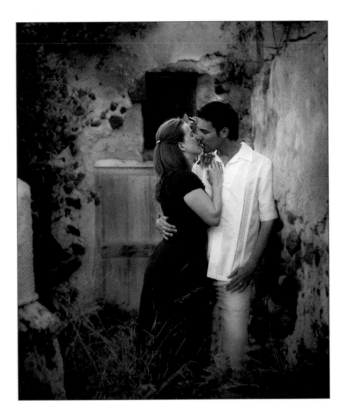

1

The World of Wedding Photography

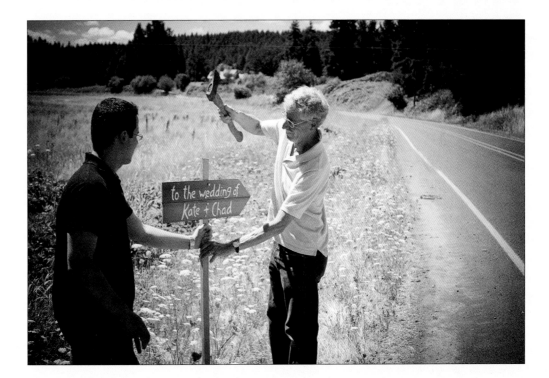

Wedding photography varies from other types of photography in that you must move from place to place throughout the day, constantly searching for tiny important details to record, and constantly trying to catch your clients in the act of doing something interesting. You'll be expected to create beautiful images at times when they may not appear to exist. The pressure to create art on demand (whether you're in the mood or not) can feel quite overwhelming — especially if the people or the settings don't inspire you. And the pressure mounts even higher when you have to set up and compose twenty group shots with a hundred thirsty people who have only you standing between them and the bar. However, all the external pressures are nothing compared to that internal nagging fear that you have to get it right. Unlike other types of photography, with wedding photography you don't get a second chance to do it over.

Capturing Weddings

Telling the story of an entire wedding day with still images is not something that can be distilled into a simple formula that you can repeat over and over. No two weddings are alike, and even if you go back to the same location over and over again, every day has different light and every wedding has different people and different customs. You can't just sit down the night before to plan your workday or make a list of the images you want to create. You have to be ready and able to handle all sorts of conditions quickly and without help from other people (see Figure 1-1). Your equipment must be reliable and self-contained, and you must have backups of the most critical pieces of equipment, such as the camera body and the flash. Further, everything you use must be fairly portable so that you can easily move it from one location to another during the day without causing much fuss.

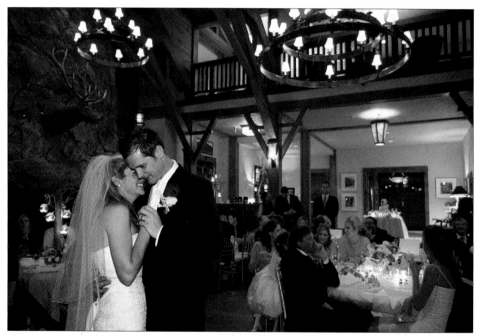

Figure 1-1: This first dance took place in a very dark indoor location. You can make it look well lit if you know how to mix your flash to get the foreground, while adjusting your ISO and shutter speed to get just enough of the background.

If you are considering diving into the world of wedding photography as a career, or even as a part time job, you will soon learn that this job is not just about creating a few artistic images

on the wedding day. Much more important, wedding photography is a performance art. Those who do it well glide through the day with grace and confidence as they anticipate and capture hundreds of tiny moments of the day. Each picture becomes a fleeting glimpse of everyday events preserved in a way that brings out a hidden beauty that was simply not accessible to the average person until it was captured and then revealed through that particular photographer's vision. And each image is far from a random event captured in a haphazard manner. Each image says something important about the day (see Figure 1-2). And each image is crafted very purposefully; sometimes with the goal of including all the essential pieces of the story; sometimes eliminating all but a single detail; sometimes capturing the light in a specific way; sometimes playing with a shadow; sometimes showing motion; sometimes capturing an emotion. Later, when the best images are viewed together as a slide show or in an album, the collection captures and distills the emotion and the story of the day down to the absolute essentials.

The art of wedding photography is in seeing beauty in everyday life.

Figure 1-2: These items are examples of things you might find in the bride's dressing room, but they were not arranged like this. I gathered them up and placed them here. Teaching you to see opportunities like this and then capture them with your camera is the goal of this book.

A Challenging and Rewarding Profession

The world of digital wedding photography can be both challenging and rewarding. You set your own hours during the week and then work on the weekend at what is probably the grandest party a couple will host in their entire lives. You get to be a "fly-on-the-wall" for one of the most important and emotional days of a new couple's life, inconspicuously following every move the bride and groom make from the time they arrive in the morning until they leave at night. If you become good at it, couples won't hesitate to pay you large sums of money and fly you around the globe for your services.

As glamorous as the job may sometimes sound, in reality, the digital wedding photographer spends long hours sitting in front of a computer, editing images, building a website, working on album pages, answering e-mail messages, burning discs, and much more. The actual wedding shoot is only a small fraction of the job.

A common industry adage about photography is, "You can be the greatest photographer in the world and still starve; or you can be a mediocre photographer and make millions if you're good at running a business."

I've had young people ask me what sort of college classes they should take to prepare them for a career in photography. My advice is to take classes in this priority:

Business management

Advertising

Website development

Computer technology

Art

Photography

Yes, photography appears last on the list. This is because without a strong basis in the other skills, your photographic abilities are useless.

Using the Tools of the Trade

The tools of the trade are few. As businesses go, wedding photography requires a relatively small cash outlay to get the few pieces of high-quality equipment necessary for the job. Learning how to use the equipment is the real challenge, because, fortunately for photographers, having the best camera in the world won't make you a good wedding photographer, and having the fanciest computer won't get your color correction right, nor will it build beautiful albums. Many excellent wedding photographers use old, beat-up cameras with far fewer settings and capabilities than the high-end cameras many wedding guests will have slung around

their necks. However, as you probably already know, cameras don't take pictures — photographers do! A good wedding photographer can take better shots with a point-and-shoot camera than the ones most people can take with a top-of-the-line digital camera.

What camera should you use?

The specific tools each photographer uses have nothing to do with whether or not the person can be a good photographer or run a successful wedding photography business, but they will play a major role in the styles of images you create. As shown in Figure 1-3, the important part is how skilled the photographer is at seeing a beautiful moment and capturing it in an artistic manner. For example, when you admire a painting by Picasso or Rembrandt, you don't ask what brand of brush they used. The tools they used are as irrelevant as the choice between a Nikon and a Canon. The artistic vision of the person and the technical expertise necessary to capture that vision are what make the real magic of photography. It doesn't matter if the person used an old beat-up camera body, or a funky lens, or an expensive lens; all that matters is that the equipment produces the image qualities the photographer is trying for.

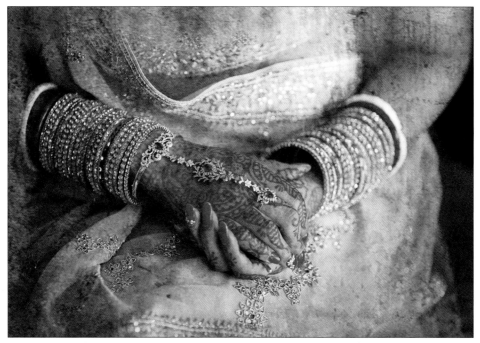

Figure 1-3: While the tools used to capture an image like this are important — they must be of the highest quality — the vision of the person holding the tools is the most important part of the creation.

With that said, I will add that the difference between a low-priced "consumer" camera compared to the speed and added functionality of the "pro" cameras is *huge*. In the right hands, the professional-level cameras and lenses will contribute a tremendous amount to the type and quality of images you can capture, as well as the ease with which you can make them.

Personality goes a long way

One of the most valuable tools you can have as a wedding photographer is the right kind of personality. You don't have to be the life of the party, but you should have a friendly, outgoing personality that puts people at ease almost immediately. If you don't like people, or if you are impatient or easily frustrated by people who are always late and generally can't seem to get it together, then this job isn't a good match for you. But if you function well under pressure (a lot of pressure), and if you're flexible enough that you can go with the flow when the bride is late, or it rains all day, then this job might be a good fit.

Training your mind

Last but not least, the most valuable tool you need as a wedding photographer is knowledge. You need to develop your skills and understanding of photography to the point that taking a picture is no more difficult than walking across the room. Eventually, you will be able to create the vision of what each picture should look like before preparing to take the shot. When you see an activity taking place — or better yet, about to take place — you'll envision the image and know which lens to grab, how to set the camera settings, and what angle to shoot from to tell the story. And you'll put it all together in the span of about 10 seconds or less.

With practice, you will become in tune with the types of locations that make good portrait backgrounds, such as the one shown in Figure 1-4. Eventually you'll find yourself noticing places with good light or great angles, even when you're not at a wedding. You'll find yourself thinking things like, "These converging lines look so cool, I could put the bride right there and shoot it from down low with about a 20mm lens." Or, "That long line of trees would be so nice with the bride looking around the trunk of the fourth tree. I could shoot it with my 200mm at f/2.8 to throw all the other trees into a blur." Once you get to the point of thinking like that, things will come together quite easily on the wedding day.

Getting experience

A trained eye can only be gained through experience. Practice on your friends and family and anyone else who might be willing. Kids and pets make great subjects because it's so darn hard to control them that you'll soon give up and just start capturing whatever it is that they want to do — hey, that's just how a wedding works! Ask a caterer or florist to help you find couples who don't have the budget to hire a professional photographer, then approach the couple and

offer to volunteer your services for free. It's actually much better for you to work for free when you start out because once there are contracts and money involved, you have a legal responsibility to perform and will be held accountable if the couple is not happy with your results.

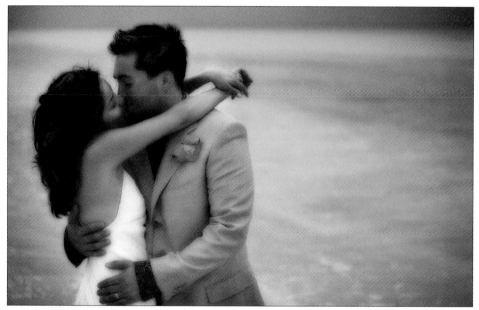

Figure 1-4: Finding the right light and posing a romantic scene takes a lot of practice. When you've done it well, it looks as if it happened naturally, without any forethought. Soft focus effects like this can be added later in Adobe Photoshop to further complete the effect you envisioned when the scene was happening.

With this book, you can read all about how to make great images, but no amount of reading can substitute for the experience you get working at a real wedding. I highly recommend that you seek out wedding professionals in your area and ask them if you can assist or shoot as a second photographer to gain experience and confidence before you take on your first paid wedding. In the beginning, you should expect little or no pay for the education you get while working with established wedding photographers. Consider it the cheapest college course you ever bought and learn everything you possibly can. In fact, I'd go so far as to tell the photographer you don't want money; you're willing to work for free just so you can pick his or her brain at every possible moment throughout the day.

As your skills progress, you should start getting paid, but don't expect to make much money at first. The point of working as a second photographer is to gain all the experience you possibly can. When you reach the point where your first mentor has little left to offer, take your portfolio and seek another mentor. Eventually you will have to shoot a wedding on your own to understand the full impact of the job, but I don't recommend that you do this until you've shot at least ten weddings (unless you're already an accomplished photographer in some other field).

Other valuable sources of education include seminars at big photography conventions like the annual Wedding and Portrait Photographers International (WPPI) convention in Las Vegas, or your state branch of Professional Photographers of America (PPA). Of course, there are also many photography schools where you can take classes to develop your photography and your business skills. Some classes may be as close as your nearest community college, while other classes are at schools like the Brooks Institute, which specializes in teaching just photography. Another good educational tool is, of course, the Internet. You can learn all sorts of techniques on YouTube or with a Google search. You can also check out the website, Best of Wedding Photography (www.bestofweddingphotography.com), to peruse the websites of the cream of the crop of current wedding professionals throughout the world.

Recording Life's Milestone with Pictures

In almost every human life, there are at least four major milestones: birth, marriage, birth of the first child, and death. A wedding photographer has the privilege of being a witness and a historian on one of those four big days.

If you've ever looked through old albums of pictures from your childhood, you may realize that the memories you have of your childhood are actually somehow tied to the pictures. For example, you probably have many pictures where you can't remember anything else that happened during that day or even the month it was taken, but because you've looked at that picture many times over the years, the events immediately surrounding it are burned into your memory. While I can't explain how it works, I do believe that photographs help us store memories in a way that makes them last for the rest of our lives. Seeing that photo every few years reinforces that memory and embeds it in a way that causes it to remain present.

The first time a bride looks through her wedding pictures, there is a very high likelihood she will be moved to tears. If you've done a bad job, they will be tears of deep sorrow. If you've done a good job, they will be tears of joy — the same sort of tears she may have cried when the groom said his vows and when her father made a toast to their happiness. These are memories, such as those shown in Figure 1-5, that you've frozen in time for her. Other types of photography are important to our clients too, but nothing will be as emotionally charged and profoundly important as their wedding photographs.

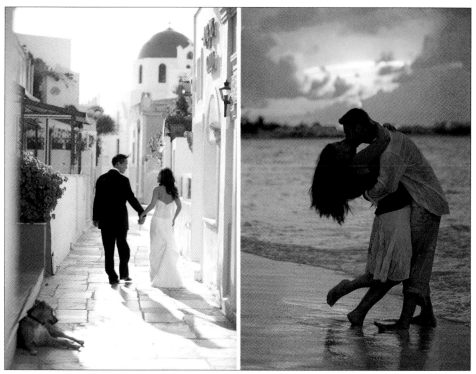

Figure 1-5: Allowing the couple to create their own pose takes very little coaching but it requires a lot of ability on your part to realize when they've got something good and press the shutter before it disappears.

Breaking Into the Business

What is it that attracts so many to the lure of wedding photography? Having been the paid photographer at hundreds of weddings, I still find myself amazed at the number of people who recognize the best angle, and stand up in front of me and my camera to try their hand at getting a good shot of the bride and groom. They are all interested in wedding photography on some level. Few have professional aspirations, but many will come up to me repeatedly throughout the day and ask questions because they are genuinely interested in the wedding photography business. You can see the gleam in their eyes as they think to themselves, "I could do that!" Their eyes sparkle even more when they find out how much it pays. When they hear that I've shot weddings in Mexico, Jamaica, and the Virgin Islands, and that my next few weddings are in Aruba, Greece, and Hong Kong, their eyes become wide and their jaws drop in disbelief. After all, wasn't it only just a few years ago that "real" photographers didn't shoot weddings? It simply wasn't cool.

Even today, remnants of those feelings persist among older photographers, but the younger crowd is embracing the new world of wedding photography like never before. With the likes of photographers Joe Buissink, Mike Colon, and Denis Reggie not only shooting celebrity weddings, but also showing up on TV shows as celebrities themselves, the world of wedding photography has taken a decided turn in popularity. It's becoming downright stylish!

Of course, reading this book won't make you a celebrity wedding photographer, or get you a bunch of calls for destination weddings, but it will give you the information you need to start down the path in that direction. Who knows where that path may take you? Even if you don't want to shoot celebrities or jet off to exotic locales, shooting weddings right in your own neighborhood is a great way to make a comfortable living while doing something that is fun, creative, and extremely enjoyable. And never underestimate the power of determination. After all, every established wedding photographer out there today — no matter how famous — started off at the beginning, right where you are standing today.

Summary

The world of wedding photography is an exciting and challenging place to be. If you are an aspiring professional photographer or simply an amateur who wants to learn more about digital wedding photography, you'll find the business surprisingly easy to enter. After you've built a small portfolio, either by working with an established photographer or shooting a few weddings for free, I'm sure you'll find no shortage of eager clients who are more than willing to try you out. It may take several years to work your way up the ladder into the higher price bracket, but if and when you do, you may find clients willing to pay extraordinary fees to reserve your services.

The job definitely has its challenges. You have to learn to control your equipment in any sort of lighting conditions imaginable, with a lot of hectic activity going on around you, and with a lot of people watching and waiting on you. And, unfortunately, you'll end up spending far more time running the business than shooting pictures.

Not only can you make a comfortable living, but also you get to work at something you can truly enjoy, while performing a service that is extremely important to your clients. Many of them will tell you that your pictures are one of the most important things happening on the wedding day, second only to the act of getting married. This is a day they will remember for the rest of their lives and they want those memories to be formed by an artist. When clients hire you, they are entrusting you to create images that will shape their memories and become part of their family history.

2 Developing Your Own Style

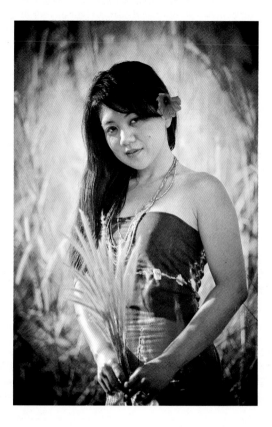

Your "style" of photography is a combination of the way you act while shooting the pictures and the type of pictures you create. Wedding photographers generally fall into one of three styles; however, it is possible for one photographer to shoot in more than one style and even to switch styles throughout the wedding day. In this chapter I take an in-depth look at the three main stylistic approaches to wedding photography: Traditional, Photojournalistic, and Portrait Journalism. I discuss the different photographic techniques used in each style, how the images differ, and what the clients want; and I include a few tips

to help you decide which style is right for you. But first, I begin the chapter with a discussion about various methods for pricing wedding photography. Although the topic may appear to be misplaced, it is vital to understanding the different styles of wedding photography.

Two Business Models

Key to developing your own wedding photography style is understanding the various methods of pricing wedding photography. The price structure you choose is what motivates you to shoot certain types of images and to work in different styles throughout the day. For example, are you shooting to generate print sales, or are you shooting to provide a personal service for the bride and groom? Your answer may be determined by your personality, or by a conscious effort to adopt a certain business model.

Essentially there are two financial models for a wedding photography business. I call them the "Aftermarket Sales" business model and the "Creative Fee" business model. The one you choose determines your motivation for taking pictures, which in turn determines the type of images you create for your clients.

The Aftermarket Sales business model

A longstanding tradition in the wedding photography business, the Aftermarket Sales business model relies on a low initial fee to attract customers, with a heavy push on aftermarket sales of items such as prints, albums, frames, video slide shows, and digital image files, which serve to bring in the real profit. The typical wedding package includes the service of taking the pictures only. Afterward, clients must purchase any prints, albums, or other items for an additional fee. In general, photographers using this business model keep the negatives or digital files; otherwise, the client could make her own prints. Occasionally, these photographers sell the digital files, but they often charge a hefty price for them to compensate for the loss in print sales.

Clients know they're purchasing the wedding photography service, but many neglect to consider the fact that after the wedding is over, they will have nothing physical to show for the money they've spent, unless they spend a substantial additional amount. These clients are initially happy because they've gotten such a bargain on their photographer, and their thought is that they'll just buy a few prints after the wedding. But when they go to place an order and discover that the few prints they want will cost another $1,000, they start to grumble. With this model, it is not unusual for clients to be surprised at the high cost of the additional prints and then end up spending more on these aftermarket items than what they originally spent on the photography fee.

Photographers who use this model are not out to cheat anyone; they just know that human nature makes us all suckers for a low price; and with all the competition photographers face, any little thing one can do to lower the price or give the appearance of having a low price, helps to draw in more business. This method can be highly effective if there are many other photographers in your area in the same price bracket and you don't have anything in particular that differentiates you from the crowd.

When shooting in a traditional style with the Aftermarket Sales business model in mind, photographers are looking for images that the couple may want to purchase to frame or put into albums (see Figure 2-1). Such traditional-style prints include and are often limited to shots of the bride and groom, their families, and group shots of the wedding party. Of course, the couple may also purchase many loose prints in smaller sizes to give as gifts to family and friends, but with this limited number of purchases in mind, it doesn't take much experience for a photographer to get a feel for the types of images clients want to buy and then shoot only those — thus limiting the types of images a couple receives to the types of images a photographer believes they may actually want to pay for.

In combination with these factors is the fact that you, the photographer, will quickly develop a feel for how much you think each client can afford to spend. If you know the client has an unlimited budget, then the quantity and variety of the images may be unlimited. However, many clients are attracted to the Aftermarket Sales business model because they are working with a limited budget. If you know this, then there is little motivation for you to create anything that you know they can't afford to buy.

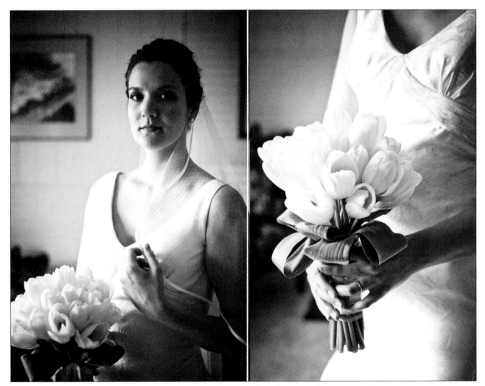

Figure 2-1: Traditional-style images are not found; the photographer creates them.

The Creative Fee business model

With the Creative Fee business model, photographers charge the full amount of the entire sale up front. The client pays for the photographer's service, and the photographer typically delivers images on a set of DVDs or a small USB drive that the clients can keep and print in any quantity they like as long as it is for personal, noncommercial use. The "creative fee" pays for the photographer's talent, overhead, business expenses, and everything else that the photographer needs to make in order to stay in business and make the desired profit. Because the finished product is frequently a full-resolution set of images, when the photographer delivers the image set to the client, it may be accompanied by a good-bye handshake or hug. After that day, the photographer and client may never speak again unless the client orders an album or custom prints, and these items may also be purchased from other photographers or graphic designers if the client chooses to do so.

The Creative Fee price structure influences what sort of images each photographer creates. For example, if you are paid a low price up front and the only remaining income is generated from print sales, then there is no motivation to take a shot unless you think it might generate print sales (see Figure 2-2). You may take a few extra shots just to be nice, but you are not required or motivated to put any effort into anything unless you think it will sell.

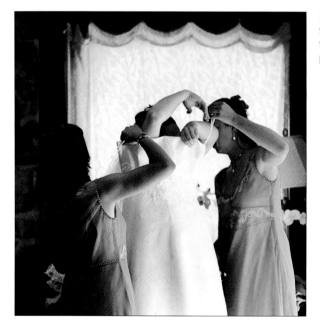

Figure 2-2: Cute moments like this are of little value to a photographer who is concerned with print sales.

On the other hand, if the photographer is paid up front to provide a photographic service for the day, then he does not think about print sales. Instead, he thinks about shooting anything the bride and groom might find even slightly interesting and want to preserve in their memories of the day. You become the bride and groom's personal photographer — shooting anything they ask for, and anything that you find interesting, in an effort to create a complete story of the day. Instead of wondering what the bride and groom will buy, your driving motivation is to capture what you think the bride and groom will want to remember. This motivation factor is the essence of what separates the Traditional style from the Journalistic and Portrait Journalism styles. I would not have shot the image in Figure 2-2 if I had been concerned with print sales, but it makes an excellent contribution to the story of the wedding day.

Follow the money

The vast majority of photographers who follow the Creative Fee business model operate a one-man-show sort of business, with no studio and no staff. If they have to do everything themselves, it doesn't take them long to realize that they can make much more money taking pictures than they can from printing a bunch of 4×6s for Grandma. The Creative Fee model allows these solo photographers to concentrate on shooting weddings, which is what they do best, and what makes them the most money.

Photographers who follow the Aftermarket Sales business model tend to have a much bigger operation. Having a large studio space and a staff between 1 and 20 people is not unusual, because these types of businesses rarely specialize in weddings. These photographers are usually shooting something every day of the week. They might do weddings on the weekend and then portraits, school photos, and commercial work throughout the week. The staff handles all the non-photographic work, leaving the photographer to concentrate on the photography.

With total sales often reaching a third higher (per wedding), the Aftermarket Sales business model may appear to gross a lot more money than the Creative Fee business model. However, even though the gross income potential is high for the Aftermarket Sales model, many more costs are involved, such as studio rent, staff salaries, an accountant to track staff and tax information, and large invoices from suppliers of prints and frames and other supplies. The studio photographer may be supporting a whole community of staff, so when all costs are averaged, the net income from a single wedding is probably very close, if not equal, between an Aftermarket Sales, studio photographer and a Creative Fee, individual photographer (comparing photographers of similar skill levels and geographic area).

Three Styles of Wedding Photography

There are three main stylistic approaches to wedding photography: Traditional, Photojournalistic, and Portrait Journalism. Each style has benefits and drawbacks that mesh with different personality styles, resulting in an almost automatic attraction for one style or another by each photographer.

Traditional style

As the term implies, the Traditional style of wedding photography is the oldest (and perhaps still the most common) style of wedding photography practiced today, especially if you look at the entire world market. The images created by photographers using this style can be summed up into one word — posed. They are carefully arranged to bring out the absolute best in the client. Often there is little effort made at creating images that capture reality. In fact, it could be said that these photographers don't capture images — they create them.

Like the example shown in Figure 2-3, Traditional-style images usually consist of exquisite portraits of the wedding participants and a few of the major events of the wedding day (which are often staged either before or after the actual event so that they can be captured perfectly without the inconvenience of interference from the actual wedding). In many countries, due to a combination of low budget and tradition, the studio portrait is the only photographic record of the wedding. If there is any storytelling to be done at all, the job is left to the videographer.

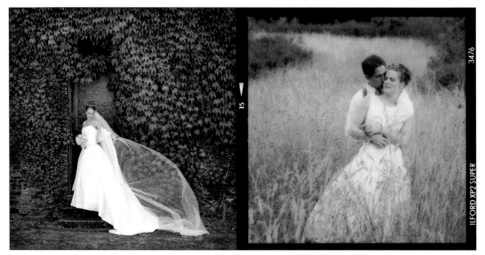

Figure 2-3: These two Traditional-style images were shot with a square format Hasselblad film camera, which is far larger and slower than today's digital cameras.

Equipment

The Traditional style is so deeply ingrained in most cultures that (worldwide) it remains by far the most popular style of wedding photography. This style evolved in the early days of photography when professional cameras were large and bulky; the 4×5 Speed Graphic was the camera of choice for many years. As black-and-white film eventually gave way to color, smaller, lighter cameras such as the Hasselblad with its 6×6-centimeter negative, and the Mamiya with its 6×7-centimeter negative, gained popularity. Although not small or light by today's standards,

these cameras reigned supreme throughout the film era, and many film camera users still produce wonderful work with them. The size and weight of these cameras doesn't exactly encourage fast shooting. In fact, they encourage a slow, methodical approach best suited to the photo studio and the meticulously posed group shots that are still associated with the Traditional style of wedding photography. Many of these photographers still use film, although by now, even the most diehard film fanatics are slowly converting to digital.

Personality

Another aspect typical of the Traditional style is that the photographer is often very active and vocal about guiding the event. This can be an advantage if the couple didn't hire a wedding coordinator. The photographer can organize and move people involved in the formal shots, as well as frequently ask the couple and guests to stop what they are doing and smile at the camera for a shot. This interaction is most noticeable during the reception, as the cake cutting and first dance are often interrupted by the photographer asking the couple to "look this way and smile."

Although intrusive, this process of stopping people for a smile or to pose a certain way is so embedded in the tradition of the style that it is seen as completely acceptable. The tradition is so strong that sometimes the wedding officiant or the DJ may stop the couple from what they are doing and tell them to smile at the photographer without even checking to see if the photographer wants this. If you don't want this sort of "help" you may want to catch these people in a quiet moment and let them know that you prefer to catch real smiles.

Services and items offered

Traditional-style photographers typically offer a package that consists of a few hours of coverage, which includes all of the ceremony and the first hour or two of the reception. The initial payment for the photography is generally on the low side compared with other styles because the photographer makes much of his income from the aftermarket sale of prints and albums after the wedding is over.

At some time after the wedding day, the newlyweds meet with the photographer to view a set of the proofs. (For more on proof prints, see Chapter 16.) At that time, the couple can place orders for wall portraits, prints for the album, and prints to give as gifts. A professional salesperson on the photographer's staff often conducts the proof-viewing session. This person is well trained at guiding the presentation for the ultimate emotional impact and then capitalizing on that emotion for high sales. The work of keeping track of these sales, filling print orders, framing prints, and constructing albums practically demands that the Traditional photographer have a staff of at least one other person. If the studio does very much volume at all, these jobs are far too demanding for a single photographer to keep up with and still hope to have any time left for taking pictures or having a life outside the office.

The wedding day

On the wedding day, the photography session often starts with a half-hour of setup time, during which the photographer and assistant set up two or more studio lights with umbrellas. This is in preparation for the "formals" or formal family group shots. If the altar area is

acceptable, it is used as the background; if not, a large studio backdrop may be set up or an alternate location may be chosen if it provides a superior backdrop. At large weddings, two or more of these sets (each with a photographer and assistant) may be set up to work at the same time. Eventually the family and wedding party file in for group pictures. For big weddings, this portion of the shoot often requires two hours or more to get the many different combinations of the bride and groom with the wedding party and all the relatives and attendants. Each shot is meticulously arranged to very exacting standards. Frequently by the end, the bride and groom complain of sore facial muscles from so much sustained smiling, and it is common for guests to complain about how long the photographer took (even though it may have been the bride who insisted on the large shot list).

Typically during this session, the photographer does not allow any guests to shoot images with their own cameras. This is because the photographer makes money from print sales; if a guest takes a picture of the same groups, that guest obviously won't need to purchase a print. In fact, that one camera-happy guest may later pass out his own prints to all the guests for free, further eroding the photographer's potential income. This is occasionally a point of serious contention with guests trying to sneak in a shot and the photographer or assistant acting as police officer to stop them from doing so. The only way to deal with this situation without causing a lot of stress is to limit the number of guests who are present in the photo sessions and make a general announcement when the photo session begins, requesting that no pictures be taken by the family or guests. If someone refuses to comply, it is debatable whether you will lose more in print sales by letting him take his shots or by causing an angry scene in the middle of the wedding. If you manage to anger the bride and her family, you stand to lose a lot more than the price of a few prints.

After the formals session, the photographer typically captures images of all the big moments, such as the ceremony, the kiss, the couple leaving the altar, the couple entering the reception, the first dance, the father/daughter dance, the cake cutting, the garter toss, and the bouquet toss.

After the wedding

After the couple returns from the honeymoon, the studio schedules a viewing and ordering session as mentioned earlier. The final proof set the couple views may only include a few shots from each of the main wedding events because the photographer may have "weeded out" those prints she feels the clients won't purchase. The typical Traditional-style shooter may only take a few hundred images. These images are printed in 4×5 or 4×6 and the bride is allowed to borrow this proof set (often with a large deposit as insurance that it will be returned) for viewing purposes only and only for a limited time. From this selection, the couple and their families may purchase single prints and select images to include in albums.

Photojournalistic style

The completely unobtrusive presence of the photographer is the key feature that distinguishes the Photojournalistic style of wedding photography. Other elements common to this style

include the use of the Creative Fee business model, large numbers of mostly black-and-white images, and a strong storytelling quality that truly captures the feeling of the day. The true photojournalist does not rearrange anything or ask anyone to do anything, such as smile, pose, or move to a better location for pictures. Images are captured without any disturbance from the photographer and they do not undergo any major changes in Adobe Photoshop aside from minimal sharpening and conversion to black and white. Some photojournalistic purists flat-out refuse to do any sort of posed photo shoot at all. Being that strict may seem like a certain recipe for disaster, but a growing number of brides prefer this approach. It allows the couple and guests to enjoy the wedding day with very little intrusion from the photographer.

History and current trends

The Photojournalistic style of wedding photography evolved as a lucrative weekend opportunity for working photojournalists who were hired by newspapers during the week. By shooting with the same cameras, in the same basic style they were trained to shoot for the newspapers, and with the same ethic of unobtrusiveness, they soon won a place all their own in the wedding photography world. The images photojournalists capture are often described as "real" and "honest" representations of the day. They simply shoot what is actually happening — nothing is made up for the pictures. But the word "simple" should not lead you to believe that this style is photographically simple. In fact, I would say that this is easily the most difficult style to do well at a wedding because you can't control anything. You have to actually capture it in action, which is extremely challenging.

Many of the best Photojournalistic-style photographers are in such high demand that they eventually leave their newspaper jobs to focus on wedding photography full time. New photographers are adopting the Photojournalistic style at a fast pace. Some simply have a quiet, observant personality that fits well with the style; others appreciate the hands-off approach to wedding photography.

Brides are seeking out Photojournalistic-style photographers in record numbers. It is no accident that the sudden growth of this style coincides with the equally sudden growth of digital photography. Digital cameras perfectly match the speed, quality, and low expense per shot the Photojournalistic style thrives on, and this combination of style and camera is very quickly changing the face of wedding photography.

Personality

The subtle mannerisms of photographers using the Photojournalistic style contrast sharply with the intrusive mannerisms of the Traditional-style photographer. Rather than stopping the first dance and asking the couple for a smile, the photojournalist is faced with the far more difficult task of catching the couple in the act of really smiling. Pulling this off takes a lot more patience and a certain amount of luck. Without the ability to control and arrange matters, Photojournalistic-style wedding photographers must be tuned in to the people and events so that they can predict when the elements of a good photograph are about to come together. This sense of intuition and timing is far more difficult to achieve than simply asking someone to stand still and smile for the camera.

Informal formals

Little time, if any, is spent on group photos with the Photojournalistic style. However, a small number of group shots are usually still included because they are so ingrained in wedding tradition that it is almost impossible to bypass them. The difference lies in the level of formality. Photojournalistic group photos are generally taken quickly, as loose gatherings of friends and family with a scenic background (see Figure 2-4). The number of groupings may be limited to 15 to 20, and all of these shots are frequently taken in less than half an hour.

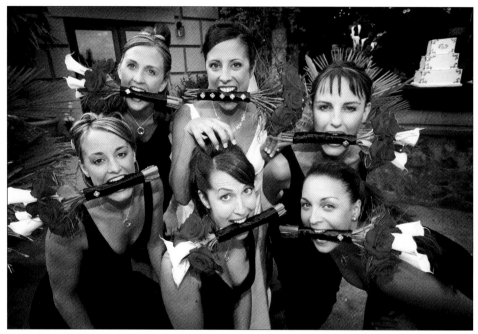

Figure 2-4: In the Photojournalistic style, group shots are generally low key and quite a bit less formal than in the Traditional style.

During the group photo session, the Photojournalistic-style photographer can ignore the amateurs when they snap away right over her shoulder. There is no motivation to clash with these folks because with the Creative Fee business model, the photographer has already been paid in full. However, if there are more than one or two amateur photographers, it is in the wedding photographer's best interest to tell them that they need to stay close behind so that the people in the shot are all looking in the same direction. The photographer should also make it clear that she won't wait for each amateur photographer to snap a shot; the amateurs need to take their shots at the same time so that the whole process moves quickly from one grouping to the next.

The wedding day

The Photojournalistic photographer typically starts shooting in the dressing rooms and continues late into the evening, capturing images of all the big moments as well as the smaller details. Anything that catches the photographer's interest is captured along with anything that the photographer feels may be even mildly important to the bride and groom. As you can see in Figure 2-5, catching every event is important: every smile, every tear, nothing is too small and everything is fair game because the photographer is being paid to tell the whole story of the day. Of course, the goal is to tell the story in a way that is quite a lot more than simple documentary. Beautiful, unstaged images are the trademark of this style. How many images does it take to tell the whole story? The actual number of images depends largely on the wedding, but typically, the range is from 1,000 to 2,500 images per photographer, per day.

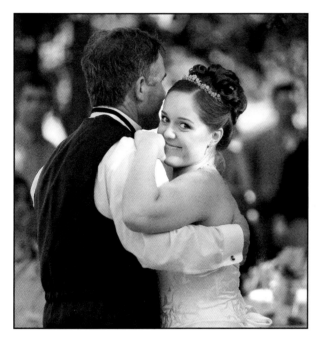

Figure 2-5: Instead of simply asking people to smile for the camera, Photojournalistic photographers must catch them in the act.

After the wedding

Within a few weeks after the wedding, the typical Photojournalistic-style photographer presents the bride and groom with a set of DVDs or a USB drive that contains high-resolution digital images. If the couple is interested in getting an album or custom prints, they may purchase those items at additional cost. Because the couple has the disc with all digital images, they typically choose to produce small prints for family and friends on their own but then come back to the photographer for high-quality albums and larger prints to frame. Figures 2-6, 2-7, 2-8, and 2-9 are representative of the types of images a Photojournalist might capture.

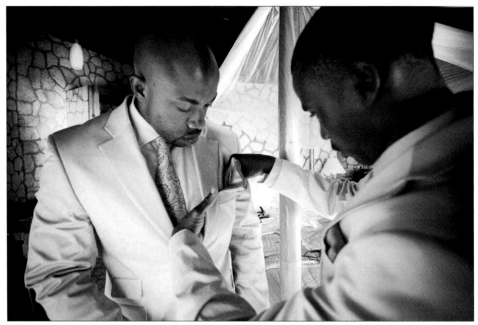

Figure 2-6: Fun images such as this contribute to the story, but they won't sell many prints.

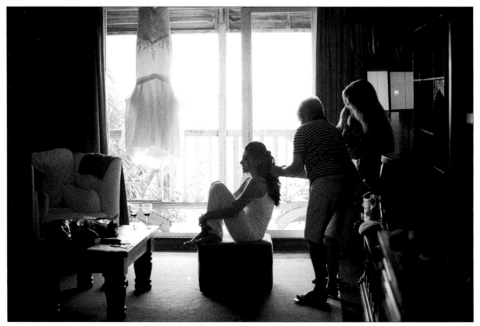

Figure 2-7: A shot like this helps tell the story of what was going on in the dressing room.

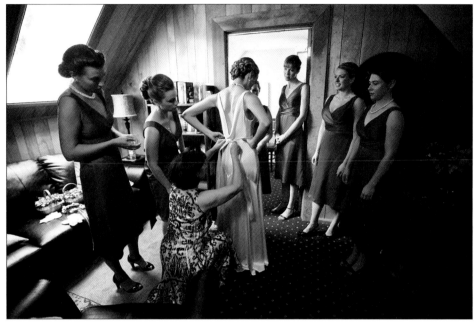

Figure 2-8: The most important shot in the dressing room is when the bridesmaids or family members help the bride into her dress.

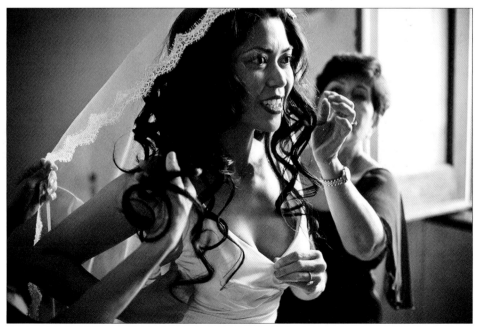

Figure 2-9: Little details like these women helping the bride with her hair and veil are very typical of the Photojournalistic style.

Portrait Journalism style

The term *portrait journalism* seems to imply a blend of Traditional and Photojournalistic styles. However, as you can see from Figure 2-10, photographers using this style tend to produce results that look more like a collision between fine art and high fashion — in a wedding dress. In reality, the Portrait Journalism style produces portrait images that range from traditional to ultramodern to fine art and anything in between. With Portrait Journalism, you are not bound by the constraints of being totally non-intrusive like a true Photojournalist-style photographer. You can shoot in a Photojournalistic style when things are happening, but then when there's a break in the action, you can pose the bride in a beautiful location for a portrait. This lack of constraint on posing combined with the Creative Fee business model, which pays you to shoot whatever you want, releases your creative potential in a way that never existed before.

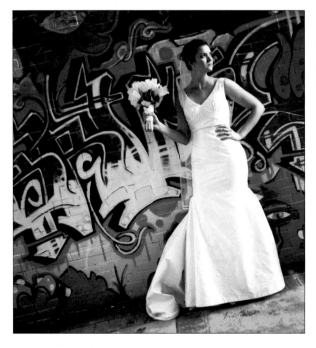

Figure 2-10: In the Portrait Journalism style, portrait images often lean toward fine art and fashion styles. Images are frequently manipulated in Photoshop to create artistic effects.

Distinguishing any difference between images shot by a Traditional-style or a Portrait Journalism-style photographer can be difficult. Both styles allow the photographer to organize, pose, and manipulate the scene to any degree desired, and both styles create beautiful portraits. The portrait journalist may be a bit more likely to use digital manipulation to enhance the image, but otherwise the techniques used are the same.

The differences between the two styles are found in things that you won't see in pictures. The Portrait Journalism-style photographer only poses live subjects when it can be done without interfering with the natural progression of the wedding day. Any time there are events

happening, such as the ceremony, reception, dancing, and cake cutting, the photographer shoots in an unobtrusive, photojournalistic style. Moreover, like the Photojournalist-style photographer, the Portrait Journalism-style photographer shoots with the goal of telling the whole story of the day. The portrait journalist will be there to capture events in the dressing rooms and throughout the entire day, whereas the Traditional-style photographer typically works on a more limited portion of the entire event. For example, a beautiful window-lit portrait of a bridesmaid shot in the dressing room would not exist if a Traditional style of photography was requested, as the photographer simply would not have been present during that portion of the day.

Current trends

Many of the most highly sought-after and highly paid photographers in the business today use the Portrait Journalism blend of styles to create exciting images for the biggest stars and celebrities around the globe. Although they often command prices in excess of $10,000 per wedding, they seem to have no shortage of clients who think their services are well worth the rates they charge.

The celebrity excitement is boosting the popularity of the Portrait Journalism style among average "real world" clients, and this growing client base boosts the attraction to new photographers. Most young photographers coming into the field today are adopting the Portrait Journalism style, and if that trend continues, it will soon outpace the Traditional style as the most common in the industry.

The wedding day

What does the Portrait Journalism style look like in action on the wedding day? A portrait journalist approaches the wedding day very much as a photojournalist would. The first photos are typically shot in the dressing rooms where the coverage is mostly in a journalistic style, with some arranging of details and compositions, and a few posed portraits. A group photo session that uses the same quick, low-key approach used in the Photojournalistic style takes place before (and sometimes after) the ceremony. The ceremony is covered in a purely Photojournalistic style with no interference from the photographer. The reception is mostly Photojournalistic as well, but any small group shots that the couple wants are accommodated.

At some point in the evening, the photographer and the couple may sneak off for a portrait shoot that gives this style its name. The photographer scouts out the best locations in advance so that the session flows quickly from one prime spot to the next and the couple is back to the reception before anyone even notices they were gone. In some cases it may be possible to do this photo session before or after the wedding day — thus avoiding the need to disrupt the wedding day while gaining much more time and freedom for the photo shoot.

Equipment

A portrait journalist uses a combination of Traditional-style and Photojournalistic-style equipment. Typically, the portrait journalist uses digital cameras, but art lenses and elaborate flash setups are not out of the question. Most photographers of this style tend to prefer natural light as a first choice, but they don't hesitate to use flash and other light sources when it adds to the image. Figures 2-11, 2-12, and 2-13 are examples of natural light images taken in the Portrait Journalism style.

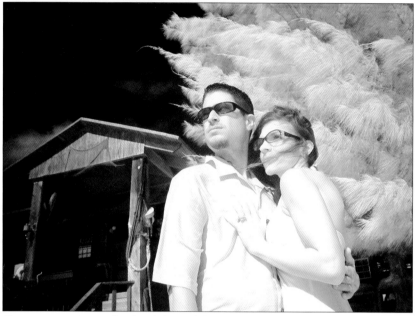

Figure 2-11: I pre-visualized and directed this infrared image to get the couple into a dramatic pose that flows with the direction of the tree in the background.

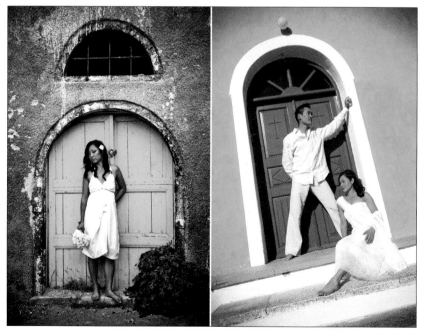

Figure 2-12: This pair of images from Finikia, Greece, was created while the couple and I wandered around the town for several hours on the day after the wedding.

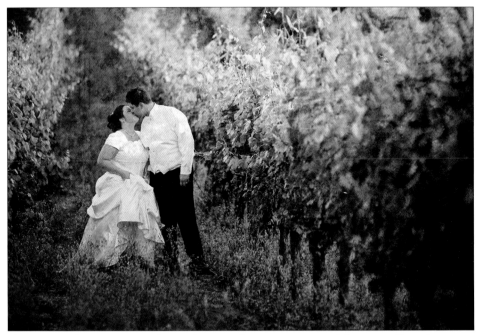

Figure 2-13: The Portrait Journalism style sets no limitations on your ability to use Photoshop to transform and enhance images that might otherwise seem plain.

Finding a Style That Works for You

If you're a newcomer to the wedding photography world, you may wonder where you fit in and what style you should use. You may be lucky or determined enough to be employed by an experienced photographer who acts as your mentor. If so, the style you learn from this person will certainly influence your own direction, even if only to teach you what you don't want to do. I highly recommend working with other photographers because this is by far the fastest way to learn the business and get some hands-on experience.

What is the best style? There is no best style! But on the other hand, there is a best style for you.

Does it matter which style you choose? Absolutely! In fact, I would say that for every photographer, there is only one best style — the right one for you depends on your personality. Are you the shy, introspective type who likes to hang on the sidelines and take it all in? If so, the Photojournalistic style is for you. Portrait Journalism requires a similar, yet a bit more outgoing, personality along with the desire for more creative control. The Traditional style calls to the photographer who has a slow, methodical approach to life — one who likes to be in complete control of the situation. As you work your way through the first few weddings, you can't help but find a style that fits you.

The only mistake you can make is to try to do it all. Never tell your clients you can shoot in any style they want. This is a certain recipe for mediocrity. Instead, pick a style and stick with it. It won't take long before you become known for what you do. Not all clients will like that style and some of them will pass you by. Don't worry. You don't have to catch every single fish in the sea. Just do what you love. As you get more experience, clients will find you because they love what you love to do. Figure 2-14 shows a type of image that I personally love to create. After shooting images like this one for a couple of years, I now have brides who come in asking if I can do something like this for them.

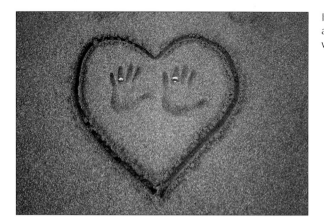

Figure 2-14: Do what you love, and clients who love what you do will find you.

Giving Clients What They Want

One thing I learned in my transition from the Traditional to Portrait Journalism style (which didn't exist when I first started) is that clients have a predictable priority list. First, if they are forced to purchase prints by the photographer, they will almost invariably purchase the family group shots first. Then, depending on their budget, they may also purchase a simple portrait of the two of them together, then small groupings of friends, then overall shots of the event, and finally artsy shots. Even clients with the most limited of budgets invariably come back around the holidays to purchase a couple of 8×10s of the big family group. This says a lot about what clients need to fill their gift-giving obligations during the holidays, but does it say anything about what they want for themselves? As the photographer, it is your obligation to decide how you want to record the memories for your couples. What will they want to look at 30 years from now when they show their grandchildren what happened on their wedding day?

As I began incorporating more and more artsy images into my work, I realized that these images are what draw the clients in and attract them to my work in the first place, but oddly enough, these are the last ones they purchase if they have a tight budget. It's clear that the family rules! If a young couple's house were to catch on fire, it's the family photos they grab as they run out the door, not the artsy shot of the bouquet or the bride's shoes laying on the floor. If I were to attempt to apply any logic to the situation, it would seem clear that all of my couples should have hired a photographer who specialized in the Traditional style because these folks can certainly make better family group shots than I can.

Lucky for me, this logic isn't the leading factor when a couple decides who they will hire to shoot the wedding. Of course, the family portraits are important — even critical — but even in the Traditional style, they are not what gets you the job. In fact, all the standard shots, such as the family groups, the cake cutting, the first kiss, the first dance, and the bouquet toss, may make up the very core of wedding photography, but they are not what the couple looks at when choosing a photographer. I would go so far as to say that you could easily get clients to hire you without showing them a single shot from that core list.

Couples make hiring decisions based on a million little personality factors that make them unique individuals, such as their personal taste, budget, level of interest in art, how well they like you as a person, how professional they believe you are, and so on. None of these factors is based on logic. What couples really seem to be looking for most is uniqueness in you as a photographer because, like the image shown in Figure 2-15 and others throughout this chapter, they want you to create something unique and unusual at their own wedding.

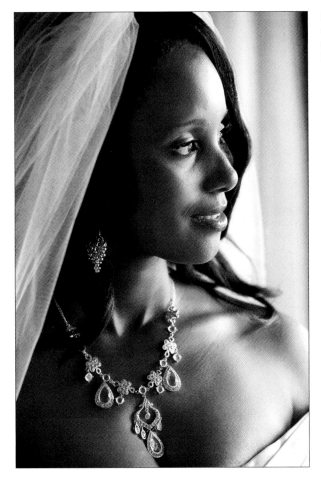

Figure 2-15: A beautiful and emotional portrait such as this is something that all brides hope for in their package.

Couples know they are only one wedding out of the millions that take place every year, and perhaps this is why each couple wants to stand out. They don't want their pictures to look like everyone else's. Right now, as you read this, there are thousands of brides sitting at their computers studying websites in search of something different. The shooting style you choose is irrelevant because there will always be someone out there who likes your style. What matters most is that you grab them emotionally. They want to see a story on your website that brings tears to their eyes.

Summary

Whether you are new to the wedding photography business or have been in it for many years, you must consider how your price structure influences the way you shoot. You have to decide if you want to shoot for print sales, or if you want to shoot for the bride. Once you decide, your personality will eventually determine the style of work you do. Outgoing people who like to be in control may prefer the Traditional style, while quieter, more introverted types may gravitate toward the Portrait Journalism or pure Photojournalistic styles. The style you choose won't affect your success because there will always be plenty of brides who like each style. The important thing is that you pick the style that is right for you.

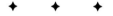

3

The Right Equipment for the Job

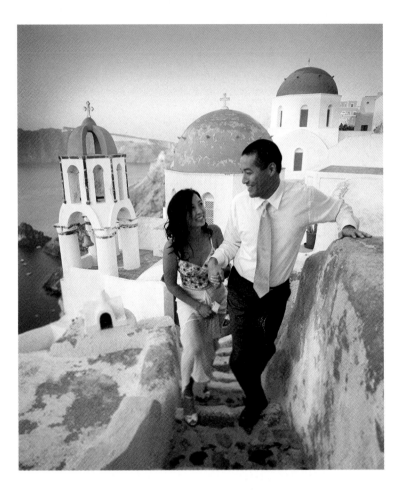

Wedding photographers have unique and specific equipment needs. Many equipment choices are simply a matter of personal preference, while others are dictated almost completely by the specific requirements of the job at hand. Your shooting style greatly affects what goes in your own gearbox. For example, Traditional-style wedding photographers

typically carry a lot more lighting gear than Photojournalistic-style shooters, and destination wedding photographers may carry only the absolute essentials.

No matter how serious your business aspirations may be, in this chapter I prepare you for making major equipment choices and handling challenges all wedding photographers face. Included is information about the demands of the job, because it is these demands that dictate the best choices in equipment. I purposefully avoid listing specific equipment makes and models because the technology changes so rapidly. Instead, I provide a list of qualities to look for that will meet the demands of the job. So whether you're just starting out, or you're more experienced but not yet completely satisfied with the tools in your gearbox, this chapter provides the information you need as you shop for that perfect camera system.

Choosing a Camera of Your Own

Several companies are constantly jockeying for the lead position in the wedding camera market. Nikon and Canon are the main players that target professional wedding photographers but many very fine cameras from other companies are also available. In the beginning of the digital revolution, camera technology changed so fast that the smaller companies couldn't hope to keep up. Now that the evolution of digital cameras is slowing a bit, the smaller companies are entering the market with some really competitive camera systems.

Choosing a digital wedding camera is somewhat a personal decision. As such, it isn't possible for anyone to say whether this or that brand is best for you. Digital camera technology is still fairly new, so even if I were to point out which camera I think is the perfect wedding camera, there would certainly be something better on the market by the time you read this book. Instead, I can provide a list of qualities that, when combined, create the perfect digital wedding camera. These qualities will remain the same for years to come and they have no bearing on which brand of camera you choose. If you find yourself in the market for a new camera, using these qualities as a checklist might help you quickly narrow your selection to one or two camera models per company.

Lightweight

On the average wedding day, you may find yourself holding the camera up to your face anywhere from four to twelve hours. That's a lot of strain on the muscles in your wrists, back, shoulders, and neck — all of which work together to hold the camera up. If you happen to be small, the camera's weight will be a greater consideration for you, and it might even disqualify some of the top cameras as these tend to be built to withstand heavy abuse, which makes them the heaviest of all.

Interchangeable lenses

Fixed-lens cameras have only one advantage: They don't get dust on the imaging chip because the lens and body are built into a single unit that can't be exposed to the air. This isn't a huge issue when you compare it to the quality advantages of using interchangeable lenses. There's an old saying: You can do many things poorly or one thing really well. Lenses are definitely subject to this rule. If you hope to get one zoom lens that covers everything from 10mm to 300mm, you're going to be sadly disappointed. Fixed-lens cameras run into this problem. For serious wedding work, you should only consider cameras that have interchangeable lenses.

Fast focus

Focus speed is critical to the wedding photographer. Your camera needs to have options for either a single spot or a wide pattern of focus points. The focus should also have the option of changing from a single focus action with each touch of the shutter button, to continual focusing with the shutter button held down halfway. Each of these features is useful at different times during an average wedding day. Most professional-level cameras have multiple ways that you can activate the autofocus mechanism, including buttons on the lens as well as on the back of the camera body. Many sports and wedding photographers prefer to activate the focus with the thumb button on the back of the camera body. This completely separates the act of focusing from the act of releasing the shutter because a separate button is used for each.

Fast motor drive

In wedding photography, you may not need to shoot quick bursts of images very often, but when you do, you'll want a motor drive speed of at least three frames per second. Most modern digital cameras function at least this fast. Some models on the low end of the price scale suffer considerably in this category. Some cameras may shoot images so fast that you'll find yourself spending far too much time editing out the duplicates until you learn to use the motor drive sparingly.

Good color

A good wedding camera should produce rich, true colors under most lighting conditions, and for the vast majority of locations, you should get very acceptable color using only the auto white balance setting. The white balance controls should be easy to understand and easy to access; you should not have to scroll through different options in the menu. The camera absolutely must provide the capability to shoot in RAW file format, and some sort of software to manipulate the RAW files for better color management should be included with the camera.

High ISO range

Wedding photography is full of moments that challenge cameras. At times you will be shooting a white dress next to a black tuxedo in full sunlight; at other times you will be shooting a gathering of friends making a toast at night with only the light of a few candles. Shooting at night requires fast lenses with wide apertures, but even more important, it requires a camera that is capable of making acceptable images at ISO (International Standardization Organization) settings of 1600 and higher. This is perhaps one of the most demanding criteria on this entire list. If you read reviews and make test shots of your own as you shop for a camera (both of which you should do), you'll find only a handful of cameras that are capable of accomplishing this feat.

No perceptible shutter lag

When you press the shutter button on your camera, it should go off! Any delay can cause you to miss the magic moment and that simply won't do if you are to call yourself a professional photographer. This is perhaps the single most important reason to buy high-end cameras. The more expensive models will consistently outperform cheaper models in this area.

Pay Attention to Focus Speed

You are partially responsible for focusing speed and if you don't do your part, you can make things more difficult than necessary for your camera. For example, if you try to focus on a smooth white wall or the center of a piece of smooth fabric, the camera simply can't do anything. The focus point needs some texture to lock onto before the camera can work. You must place the focus point on an area with some detail that the camera's automatic focusing system can recognize. Using multiple focus points instead of just one can help solve this problem in many situations, but if you're dealing with a lens that produces very shallow depth of field, you'll have to be extremely specific about where you allow your camera to focus.

Long battery life

How do batteries always seem to know when you are about as far away from your camera bag as you could possibly get before they die? Ideally, your camera should not require battery changes during an entire wedding, and this is entirely possible with current technology. If your camera comes with a small battery, consider purchasing a battery pack that attaches to the bottom of the camera and doubles as a grip. These grips often include an additional shutter release button that enables you to shoot vertical images without having to raise your elbow up in the air. To the beginner, this may seem like a small detail, but when you start shooting ten hour days, keeping your elbow down conserves a lot of energy.

Availability of a powerful TTL flash system

A good camera is designed to take advantage of one or more flash units that are specifically designed to work with that camera. The flash unit should have easy +/– exposure compensation controls that allow you to adjust the ratio of flash to ambient light. A good flash also has a little white reflector card that pulls up to deflect a small amount of light directly forward when you're bouncing the flash off the ceiling. An added bonus is to have a slave transmitter and receiver built into the flash unit that still allows Through-the-Lens (TTL) metering while the flash is away from the camera. (For more detail about slaves and specific techniques for using multiple flashes refer to the chapters in Part 2.)

LCD screen

The liquid crystal display (LCD) preview screen should be large and bright, with vivid colors that nearly match what you see on a color-calibrated monitor. Image scrolling speed must allow you to do a speedy review of the images on your memory card. There should be a zoom feature that enables you to zoom in on a portion of the LCD image to check for sharpness at 100 percent. While zoomed in, you should also be able to scroll around to see any part of the image you want.

When viewing the LCD screen, you should always be aware of the fact that it is not a 100 percent accurate preview of the image, especially when viewed under bright outdoor conditions. Get to know the limitations of your screen, and as discussed later in this book, learn how to read the histogram when shooting outdoors. And don't make the mistake of running up the

screen brightness to view your images when you're out in the sun because you'll forget you did that and for the rest of the day you'll be shooting images that are really too dark because your screen is set so bright.

Vertical shutter-release button

The vertical shutter-release button enables you to maintain the same relaxed hand/arm position when shooting either vertical or horizontal pictures. If your camera doesn't have this feature, check to see if the manufacturer offers an add-on battery pack. This addition often incorporates a vertical grip and a second shutter-release button.

Short power-on time

When you flip on the power button, how long does it take before you can shoot the first shot? More than one second is too long, especially if you shoot in a Photojournalistic style. A good wedding camera also has an automatic power-off feature, which shuts down the camera after a few minutes of inactivity. This same feature should wake the camera when you touch the shutter button, enabling you to leave the camera on throughout the whole wedding without worrying about draining the batteries.

Choosing Your Lenses

The lenses you choose are an extremely important part of your photographic arsenal. The glass they contain is the only thing that modifies the light as it travels through the camera to eventually strike the sensor and become an image. This is one area where you do not want to conserve money. Instead, purchase lenses that are the absolute best you can afford and then some. In fact, I would go so far as to say that having a collection of at least three really high-quality lenses is the absolute top purchasing priority when you first start out. You may be forced to settle for less in the beginning, but if you're serious about making wedding photography into a business, you absolutely must own three good lenses: one wide, one medium range, and one telephoto.

Lenses obviously determine the critical quality of sharpness, but as you'll soon discover through the examples and text in this book, your lenses also determine many other qualities about the way an image appears. Each lens has a set of unique qualities and characteristics that it imparts to an image. All lenses control aspects such as sharpness, color, and contrast, as well as the amount and type of Bokeh. *Bokeh* (pronounced Boke-uh) is the blur, or the quality of the blur, that is created in the out-of-focus portions of an image.

The f/2.8 lenses that many pros think of as standard equipment often have huge glass elements that result in added weight and add an extra $1,000 to the price tag. Is it worth it? Absolutely! Do you have to have f/2.8 lenses in order to shoot weddings? No. Most amateurs and new professionals cannot afford the expense of purchasing a full set of top-quality lenses all at once, so they may opt to start out with variable aperture lenses to cut down on start-up costs.

As your business grows, you should quickly upgrade to the better and more expensive lenses because there are many circumstances where wide aperture lenses and cameras capable of

shooting at ISO 3200 are going to be the only way to get the shot. Cheap cameras and lenses are simply not capable of performing in low light situations.

Because it's not vital to own wide aperture lenses, I've left out any references to the aperture size in the following discussion about which lenses are best for wedding photography. It should be noted, however, that the wide aperture professional lenses are definitely the best choice. Of course, they won't make you a good photographer, but they can add a lot to the quality and the "look" of your images, as well as enable you to capture images in low-light situations that would otherwise be impossible with a cheaper lens (unless you turn on the flash and forego the beautiful effects you can get with just natural light). Figure 3-1 is an example of the natural low-light effect you can achieve with a wide aperture lens and no flash.

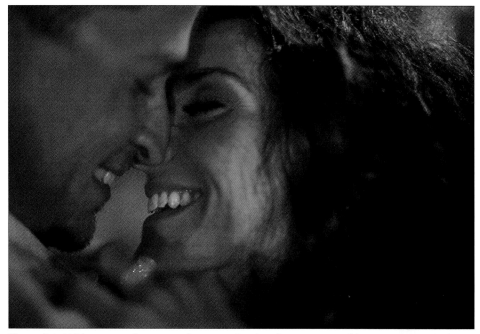

Figure 3-1: Wide aperture lenses may be expensive, but there are some things you just can't do without them — like this shot taken in the light of a single street lamp with an aperture of f/1.4 at 3200 ISO.

The list of lenses that are absolutely essential for wedding photography is surprisingly short. There are really only three or four must-have lenses. The short list of workhorse lenses that every wedding photographer absolutely must have includes:

 ✦ A wide (17-35mm) zoom

 ✦ A medium (24-105mm) zoom

 ✦ A telephoto (70-200mm) zoom

Much of the unique flavor that each wedding photographer imparts to an image is derived from that photographer's choice of lenses. Some photographers seem particularly comfortable getting in close for a wide-angle view, while others like to stay on the sidelines with a long telephoto. An experienced professional photographer can form a mental image of what he wants a picture to look like and then grab the right lens to make it actually come out that way.

General Lens Information

Fixed and variable apertures

Many of the more expensive lenses are capable of holding the same aperture settings while you zoom the lens in and out. Most of the cheaper zoom lenses change the aperture setting as you zoom. This means that as the lens is zoomed to its wide-angle setting, the aperture will be something like f/3.5, and then as you zoom out to the telephoto setting, the aperture changes to something like f/4.5 or f/5.6. Being able to hold the aperture at a fixed position as you zoom in or out usually adds an extra $1,000 to the price of a lens, but the benefits far outweigh the price.

Image stabilization

Image stabilization describes the effect achieved by placing a set of small motors inside the lens and attaching it to a moveable glass element in the middle of the lens. The motor is connected to sensors that detect small vibrations from normal camera shake. The motor is then engaged to shift the internal lens element in the opposite direction of the vibration so that it cancels out the motion. The result is that the image stays in the same position in the back of the camera even though the outside of the camera is shaking slightly. Image stabilization enables wedding photographers to catch low-light images that would be practically impossible without this feature.

Extra-low dispersion glass

In recent years many lenses have come out using a new type of glass called *extra-low dispersion glass*. This glass is called extra-low dispersion because it corrects chromatic aberrations, or optical color defects, that are caused when different light wavelengths do not converge at the same point after passing through optical glass. This new type of glass corrects this problem so that all wavelengths converge at the same point, creating large improvements in color and sharpness when compared to the older lenses. Nikon's "ED" line of lenses use this glass as do the "II" line by Canon.

Rubber gasket seals

One of the most valuable differences between the "pro" lenses and the consumer versions is the addition of rubber seals that keep out moisture, dust, and other contaminants. These gasket seals enable you to continue shooting right through a rainstorm, in a dust storm, and so on. As long as the camera is also a pro model (with its own seals) you should have little to worry about. For a wedding photographer, this comes in extremely handy on days when the bride and groom decide to continue on despite the presence of a little rain shower. You can't exactly say, "Sorry, but I have to go in now." If you have a professional-level camera and professional-level lenses, you'll be fine. If not, you might enlist someone to protect you and your kit by holding an umbrella for you, or try draping a towel or cotton napkin over your camera and lens to absorb some of the water.

One of the biggest mistakes most beginners make is using the wrong lens for the moment. While a professional may intentionally grab a wide-angle lens for a portrait and get stunning results, amateurs may grab the same lens without any clue as to why they did or for what purpose the lens is normally used. In the preceding sidebar, "General Lens Information," I explain the basic uses for each type of lens and provide some examples of the various visual effects each lens creates. Bear in mind that when I refer to a specific lens for specific types of photos, these suggestions are only meant as general guidelines for beginners.

Wide-angle zoom lens

Wide-angle zoom lenses are primarily used for documentary work, or "telling stories" as it is frequently called in the wedding world. As you can see in Figure 3-2, these lenses have a wide angle of view that captures a large amount of the scene. Wide-angle lenses can occasionally be useful for environmental portraits when you want to include a lot of the background (see Figure 3-3).

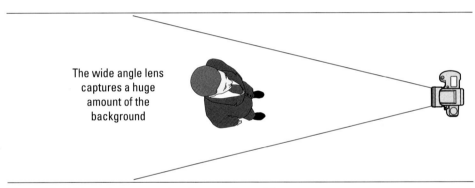

The wide angle lens captures a huge amount of the background

Figure 3-2: Wide-angle lenses capture large portions of the scene.

With a wide-angle lens, you must be particularly careful of the distance to your subject because this lens is perhaps most famous for its capability to make closer things look large while diminishing the size of things that are a little farther away. This effect can be particularly noticeable in a close-up of a person's face, where it makes the nose seem far larger than it should be. If you stand at normal height and shoot toward another person, you often find yourself tilting the lens downward to get the feet of your subject and to cut down on wasted space above the head. When you do this with a very wide-angle lens, it tends to make people have large heads and tiny feet. This distortion of size is most noticeable when the lens is set to the most wide angle part of the zoom range. The effect is also more pronounced at the edges of the lens than in the middle. The wide-angle lens is a great lens for wedding photography but it must be used with caution to avoid these distortion effects.

Portraits

In general, wide-angle lenses get a much larger depth of field than telephoto lenses. This feature makes them great for environmental portraits where you want the subjects in the foreground and the background to be sharply focused at the same time. This lens also includes a

huge amount of the background, so if you have a sweeping landscape and you want to make that landscape a prominent aspect of your portrait, grab your wide-angle lens.

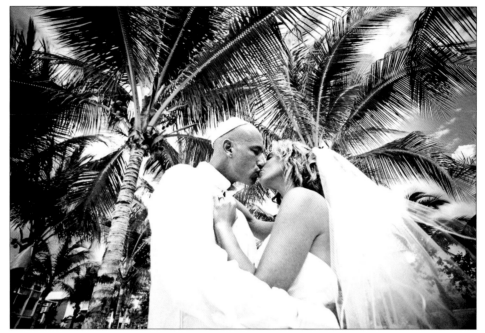

Figure 3-3: Environmental portraits can work great with this lens in places where you want to include a lot of the background.

Dressing room shots

The wide-angle zoom lens is the first thing I grab when heading into the dressing rooms. These places are often extremely cramped quarters and I frequently find myself standing in the shower stall or on top of a toilet just to keep from being trampled by bridesmaids jockeying for the mirror. The wide-angle zoom lens has the wonderful capability to capture practically everything in the room except the photographer. This lens is a wonderful storyteller, as shown in Figure 3-4.

Dancing shots

Another use for the wide-angle lens is to capture dancing shots at the end of the reception. This is quite possibly my favorite part of the entire wedding day. I love the challenge of getting in close enough to the dancers to fill the frame, while trying to anticipate what they will do next. The action is fast paced, and there is no second chance to catch something. The music is usually too loud to communicate with your subjects so you are on your own to anticipate where the action will be. Figure 3-5 shows an example of the close nature of dance floor action. Watch for the wildest dancers as these people will consistently provide your best bet for dramatic images.

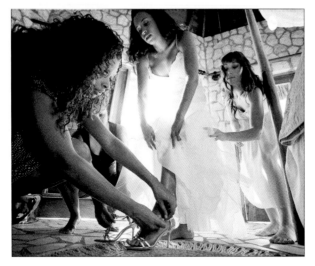

Figure 3-4: The wide-angle zoom lens is great for shooting in tight places such as dressing rooms.

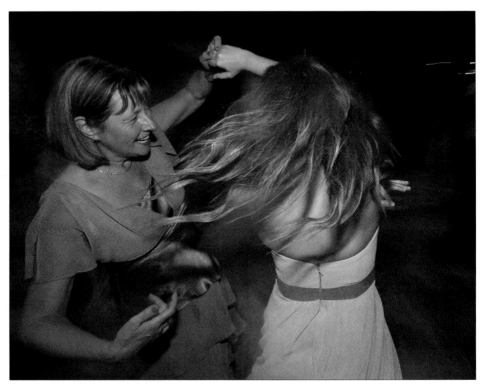

Figure 3-5: Getting in close with a wide-angle lens is your best bet for catching action on the dance floor.

Group shots

Group shots work well with the wide-angle zoom lens for a number of reasons. First, you can cover a very wide angle of view, which gets many people in the shot. Second, a wide angle puts you closer to the people in your groups. This is especially useful if you're using on-camera flash to add some fill light. This may not seem important on a cloudy day when there isn't much light out and your flash won't have to work very hard to match the low level of light. However, on a bright sunny day it's a completely different story.

Most single-lens reflex (SLR) cameras can only work with a flash if the shutter speed is 1/250 second or slower. On a bright sunny day, you may have to set your ISO to 100 and your aperture to f/11 just to get your shutter speed down this slow. This set of circumstances creates a big challenge for a small flash unit. Most of these units can put out enough light for f/11 or even f/16, but if the group is 15 to 20 feet away, you'll get a dramatic drain on your batteries. Using a wide-angle lens as was done to create the image shown in Figure 3-6 puts you close enough to minimize the battery drain. If you don't have quite so much sun to deal with, you should try to back up as much as possible so that you can use the least wide angle setting you can manage for any particular group size. This will keep the distortion effects down to the bare minimum.

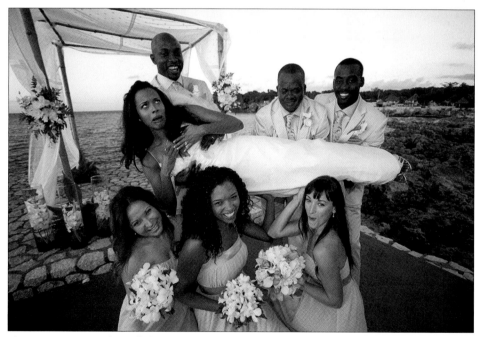

Figure 3-6: Use a wide-angle lens when you need to get in close for your group shots.

Medium zoom lens

If you're just starting out and want to know which lens to purchase first, go with a medium zoom lens in the 24-105mm range. Later you can upgrade to the higher quality 28-70mm f/2.8 lens. When I purchased my first digital camera system, a 24-105mm lens was the only

decent lens I owned and I shot quite a few weddings without ever taking it off. You can easily use this one lens to shoot entire weddings. However, it excels only in its capability to produce generic images. This lens won't impart much flair or artistic feeling to your images, but it will provide a zoom range that covers a little bit of everything. It works okay in the dressing rooms, although it won't be ideal in a small dressing room. Even today, I keep this lens around because I think it is perhaps the absolute best lens for small- to medium-sized family group pictures. As shown in Figure 3-7, the medium telephoto lens also works well for portraits if you zoom out to the 100-135mm end of the zoom range. This lens is a real workhorse that consistently delivers good quality images in the widest possible variety of circumstances.

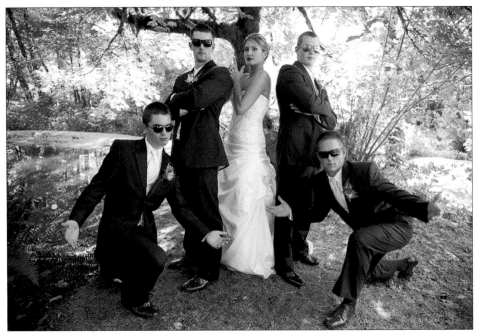

Figure 3-7: The medium zoom lens has the most useful zoom range for wedding photograph3y.

The drawback to using this lens for everything you encounter throughout the wedding day is that, although it does a lot, it doesn't do anything very well. You can get much better results with a lens that specializes in the effect you desire. For example, the medium zoom lens can do a decent wide-angle effect, but a true wide-angle lens gets a much more dramatic effect. A medium zoom lens can do a decent telephoto shot, but a real telephoto lens will do far better.

Telephoto zoom lens

By far the heaviest lens in my camera box is the 70-200mm f/2.8 zoom lens with an image stabilizer. This lens is so valuable to me that I absolutely have to carry it despite the weight and added expense. I use it during the ceremony, the romantic portraits, and even in the dressing rooms when I want to zoom in close to catch some small detail of what the bride is doing.

Many telephoto lenses on the market don't have the wide f/2.8 aperture or the image stabilizer, so you can save a lot of weight and money if you choose to do without these features, but such a compromise is definitely not worth it over the long term. If you must buy a cheaper telephoto lens to start out, immediately start saving your pennies until you can manage to scrape together enough cash for the f/2.8 image stabilizer lens — you will almost immediately fall in love with it. After the first wedding, you'll wonder how you ever worked without it.

Low-light shooting

The large f/2.8 aperture and the image stabilizer combine to make the 70-200mm telephoto zoom great for shooting in the low-light conditions of late evening. When I schedule an evening portrait session with the bride and groom, I rely heavily on this lens to allow me to shoot right through sunset and on practically into the dark. Photographers refer to this time as the "magic hour." With a 70-200mm f/2.8 telephoto zoom, you can leave the tripod and shoot handheld at speeds as slow as 1/40 second. As you can see in Figure 3-8, this combination of wide aperture and stabilizer enables me to continue shooting much farther into the evening than I could before. What a dream come true for wedding photographers!

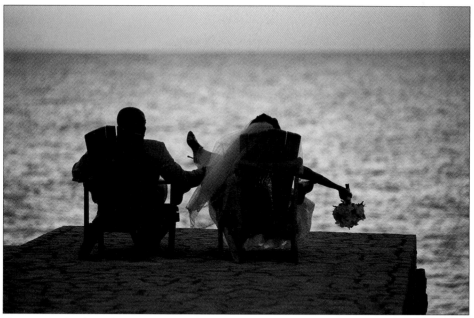

Figure 3-8: Thanks to the image stabilizer and the wide f/2.8 aperture, the 70-200mm telephoto zoom works great even in low light.

Shallow depth-of-field

Another use for the 70-200mm telephoto zoom lens is to create shallow depth-of-field effects. At wide apertures, the zone of sharpness is so small that it draws the viewer's attention to the subject by isolating it as the only sharply focused point in the image. This effect is often used for portraits. Figure 3-9 illustrates how the 70-200mm telephoto zoom lens can isolate your

subject and separate it from the background by imparting a beautiful blur (Bokeh) to everything that falls outside the narrow zone of focus. The blurriness of the foreground and background accentuate the sharpness of the subject, making it appear as if it were somehow raised out of the blurry surroundings.

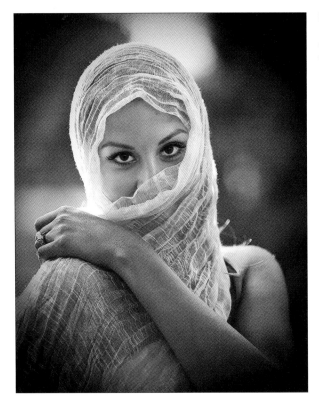

Figure 3-9: The telephoto lens is great at removing distracting elements in the background and creating a beautiful Bokeh.

Figure 3-10 demonstrates another interesting and useful characteristic of the telephoto lens, which has to do with the way a telephoto lens captures a very small portion of the background behind your subject. This can be a great advantage when you realize that you only have to find a very small beautiful section of your location to use as the background behind your portraits. Many of my favorite portrait backgrounds had trash cans and other distracting elements only a few feet away from the couple. I easily avoided them because this lens captures such a narrow angle behind the subjects.

Candid shots

You can't beat the 70-200mm telephoto zoom lens for catching long-range candid shots of people interacting with each other, as shown in Figure 3-11. You can stand 30 to 40 feet away and still catch views that look as if you were right there in the conversation. The magic here comes from the fact that you're so far away that people don't even know you're watching them. They often comment afterwards that they didn't even know the photographer was around. That's

the point! If they knew the photographer was around, they probably wouldn't have acted so naturally. Even with portraits where your subjects are fully aware of your presence, the telephoto lens still gets you so far away from your subjects that they feel more comfortable than if you were standing right next to them with your camera pointed in their faces.

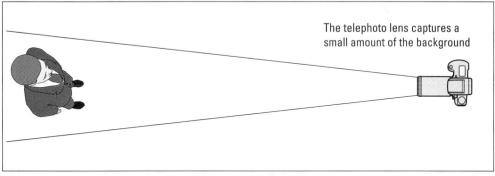

The telephoto lens captures a small amount of the background

Figure 3-10: A telephoto lens has a very narrow angle of view, which enables you to capture only a very small portion of the background in your image.

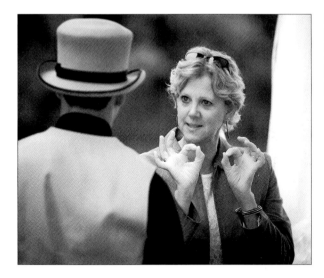

Figure 3-11: The 70-200mm telephoto lens is perfect for capturing candid shoots of people because you can stay far enough away that your subjects are unaware of your presence.

Compression of subject and background

As you can see in Figure 3-12, telephoto lenses make distant and nearby objects appear much closer together than they really are. This effect is not commonly used at weddings, but it actually comes in handy quite often. For example, a bride may request to be photographed in front of an outdoor location that is sentimental to the couple. Accomplishing this is easy if the object is close by, but what if it's far away? Try putting the bride and groom about 40 yards away

from your position but between you and the object you want for the background. Shoot at a small aperture of f/8 (or smaller) to get some depth of field and you will be amazed at how close together your foreground and background appear to be.

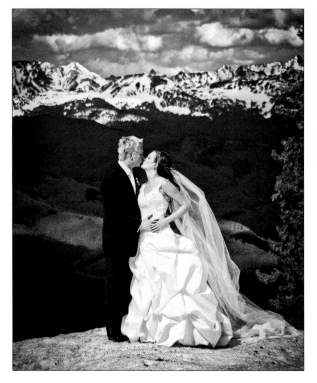

Figure 3-12: The telephoto lens has the ability to compress the distance between foreground and background, making objects look closer together than they really are. This image was shot with a 70-200mm zoom lens using ISO 200 and f/13 at 1/750 second. To maximize this effect, I moved myself back as far as necessary to frame the shot using the 200mm zoom setting.

Using Art Cameras and Lenses

The use of lenses in this category is definitely not a requirement. These are additions to your arsenal that will add flair and a much more artistic feeling than the standard lenses. I usually carry two secret weapons in the pockets of my vest. One is a 50mm f/1.4, and the other is a Lensbaby lens (www.lensbaby.com). Both fall into a category that I call *art lenses*.

Super-wide aperture lenses: 50mm f/1.4

The super-wide aperture lens excels at creating the extreme shallow depth-of-field effects and has the added benefit of being by far the cheapest of all the super-wide aperture lenses. For example, the 50mm f/1.4 costs roughly $350 while the 50mm f/1.2 costs $1,500. With either of these lenses, the extremely soft background it produces serves to emphasize the subject. The effect works great for portraits. However, such a shallow depth of field can be difficult to use. If you want your subject's eyes to be in focus, you have to be extremely careful to focus on

the eye and then shoot quickly before your body sways forward or backward enough to ruin the shot. On a reasonably close portrait like the one shown in Figure 3-13, you may have less than an inch of depth of field, which makes it almost impossible to get both eyes in focus at the same time. Many shots are ruined with this lens because of missed focus. However, when you do get it right, the results are well worth the effort.

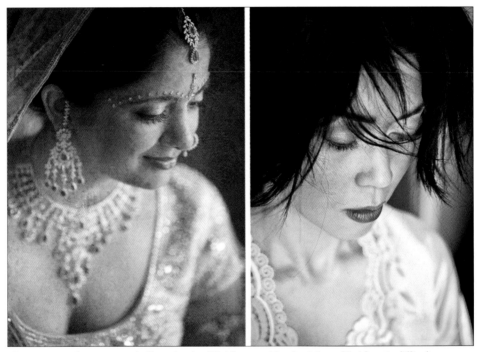

Figure 3-13: The extreme shallow depth of field created by the 50mm f/1.4 lens is difficult to use for portraits but well worth the effort.

The 50mm lens has another use as well. During the reception, I often use it to take natural light shots even though the available light may be nothing more than a couple of candles, as shown in Figure 3-14. Of course, you must set your ISO to 1600 or 3200 but the grain is still quite acceptable if you give your subjects enough exposure (assuming you've purchased a professional-level camera). Shutter speeds are still slow so you must catch people who are not moving around too much in order for this to work. When it does work, surprisingly beautiful candid shots can be created at a time when your clients were expecting only flash images.

The image shown in Figure 3-15, captured at a reception in the Bahamas, was one of ten images I shot while this brother and sister were singing to the reception music. Had I flashed them in the face ten times in a row, you can bet I would not have continued getting such natural expressions all the way through that series of shots. The 50mm f/1.4 enabled me to capture this action with only a hint of natural light.

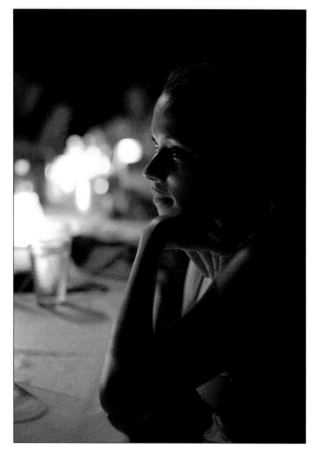

Figure 3-14: The 50mm f/1.4 is the perfect lens for shooting in very low-light situations.

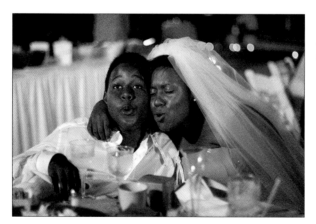

Figure 3-15: Few lenses can pull off a low-light action shot like this. The 50mm f/1.4 is one of the best, and it is also the most reasonably priced.

There are many other lenses in the same category as this lens. Several sport even wider apertures, and all of them produce even more pronounced versions of the effects mentioned for the 50mm f/1.4.

Lensbaby

Lensbaby lenses by Lensbaby, Inc., create an adjustable blurry/dreamy sort of look around the edges with a clear center. The aperture rings that fit inside the Lensbaby are interchangeable so you can adjust the size of the clear area in the middle of the image and the amount of blurriness around the edges. For example, the wider apertures create a very small "sweet spot" of clear image in the center and then a dramatic blur grading out from that central area. The smaller apertures create a much larger sweet spot and much less blur toward the edges. The effect is very similar to the blurry, vignette edges seen in images shot with the old Holga or Diana film cameras, but without all the hassle and unpredictability of shooting film. The newest Lensbaby lens, the Composer, is much easier to adjust and focus than previous versions. The Lensbaby really shines when you want to add a little bit of dreaminess to an image.

Protective Filters for Your Lenses

I don't recommend using a digital camera with any sort of special effects filters simply because you can almost always achieve the same effects in either Adobe Photoshop or Lightroom. However, I would never dream of using a lens without a filter attached. I'm referring to the ultraviolet (UV) type that filters out UV light, but more important, it protects the large glass element on the front of your lens from scratches and chemical contact that could easily ruin the glass or the fragile coatings on the surface.

Think of these filters as a disposable protective bumper for your lens. The only reason for having one on a lens is to protect it when you drop it or bump it on the corner of a table as you're walking by. However, you don't want to get the cheapest filter on the market because the lens and that little filter are the only two things in the path of the light as it travels from the outside world into your camera. You have to ask yourself, what is the point of purchasing an expensive lens if you put a cheap filter on the front of it?

Choose filters that are constructed from a grade of glass that is at least as good as the lens itself. If you have pro-level lenses, seek out the absolute highest quality glass filters from B+W or Heliopan, which can be purchased at www.amazon.com or www.bhphotovideo.com. They may cost more than $100 apiece, but I consider this a bargain compared to the thought of throwing away a $1,600 lens because I bumped it into something and scratched the front lens element. I have personally replaced several of these filters after smashing them into one thing or another. In every case, the lens survived without a scratch.

Infrared camera conversions

One of the coolest things you can do with an old camera body is send it in to have it converted to record infrared light only. This process removes the normal glass filter that covers the imaging chip and replaces it with a black filter that only transmits light in the infrared wavelength portion of the light spectrum. When you use the camera, everything works as usual but the images come out looking quite different. You can't actually see the effect of infrared light until you shoot an image and check it on the LCD screen, but after a few minutes of playing around, you'll find that it works at its peak in bright sunlight. Yes, that's right. You now have pretty much the *only* type of camera that prefers to work in bright sun. Figures 3-16 and 3-17 (as well as Figure 2-11 from Chapter 2) are examples of infrared images shot with a converted Canon 20D. You can find many individuals and companies that will convert your own camera by typing "infrared conversion" into the Google search engine. Look for the companies that offer many filter options because each filter transmits a different wavelength of light and the resulting images will all look quite different.

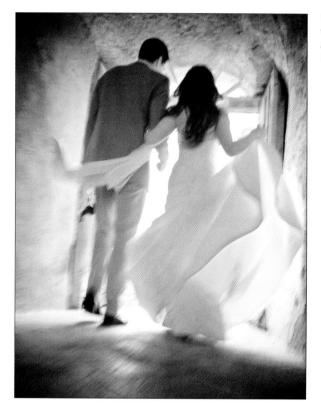

Figure 3-16: I shot this image while walking behind the bride and groom with the camera held low to the ground.

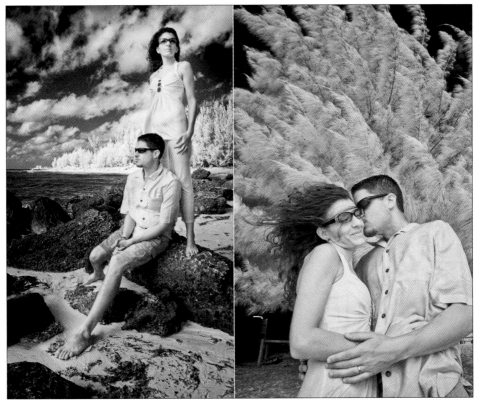

Figure 3-17: When you shoot in bright sun, most plants will take on a white glow because they reflect infrared light. The sky also turns very dark, which creates a dramatic backdrop for clouds and trees.

Deciding What Flash to Use

No matter what style of photography you choose, you will undoubtedly find yourself shooting wedding images in places that require additional light. The type of lighting gear you carry is determined to a certain extent by the style of images you shoot. Traditional-style wedding photographers typically shoot more posed, indoor images that require elaborate flash setups. Many of these photographers are also commercial or portrait photographers and they simply carry a small set of studio gear to use at the wedding. Photojournalistic-style photographers tend to shoot fewer posed groups and most of them carry nothing more than a set of small on-camera type flashes.

While it is possible to use larger studio flashes that sit on top of a stand and require a large power source, for the purposes of this book, I stick to a discussion of on-camera type flashes. Not only are these little flashes plenty powerful for the vast majority of wedding uses, but also they are relatively cheap and extremely portable. Also, I would go so far as to say that with a little creativity, you can do anything with a couple of little flashes that you could do with a bigger flash — and more. In fact, there is a whole new generation of studio photographers and commercial photographers who use these little flashes for everything they do. With all that in mind, there seems to be absolutely no reason why we wedding photographers should ever carry anything else.

All major camera manufacturers produce excellent flash units that are plenty powerful for wedding photography. You'll need at least two units to start with (one for backup) and then if you get more elaborate in your lighting setups, you may need several more. Many photographers use multiple light setups to light big spaces at the reception, and this is the most common use for multiple flash units. (How to use flash is covered in much more depth in Chapters 7, 8, and 12.)

Selecting the Right Bag to Carry Your Gear

One of the things I've learned from traveling to shoot destination weddings is how to lighten my load. I've got my camera case whittled down to the bare minimum. Every item in that case is selected based on a balance between weight, quality, and usefulness. However, even before I began traveling on airplanes with my camera gear, I was always traveling somewhere with it. By their very nature, weddings always take place away from your office/studio; they rarely happen in the same place, and always require that you move your gear around several times during the day. For example, you generally start the day in the dressing rooms, then move everything to the ceremony, and then move again to the reception location. Frequently, these places are miles apart from each other. You also occasionally find yourself being sent to the wrong location, and suddenly you have to grab everything up and jog with it. Because of this, I developed my own personal philosophy that I wasn't going to carry any more than what I could pick up and move in one load. If I need more gear, I hire an assistant and then we only bring what the two of us can carry in one load. To this day I still operate on that same principle and I highly recommend it to newcomers.

If you're wondering how I manage to carry backup gear in that load, the answer is — I don't. I bring a complete set of backup gear but it stays in the car unless some part of my primary set fails.

No matter how light or heavy your load may be, you will definitely need some sort of bag, box, or case to carry your camera gear. A good camera bag makes it possible for you to move your gear around comfortably and quickly. The type of carry method you choose should be dictated, to some degree, by the type of work you do. For example, a backpack is the ultimate choice if you frequently travel over rough ground. However, if you are mostly in cities with decent paved streets and sidewalks, a rolling bag is a far better choice.

I discourage you from purchasing bags that hang from one shoulder by a single strap. If you do end up spending much time in this business, your bag will be heavy and you'll carry that bag around *a lot*. If you put all that weight on one shoulder, you may end up with frequent backaches.

The photo backpack

My favorite bag to hold my camera gear is a Tamrac backpack (www.tamrac.com). With your gear in a backpack, you can get everything on your back and still manage to shoot with your camera as you walk. You also have your hands free to carry lighter items, such as a tripod or a lighting kit. The backpack is easily the fastest and most comfortable way to carry your gear if you do a lot of moving over rough terrain. However, a full pack can weigh in at 40 pounds if you pack two camera bodies and many lenses, so this should not be the first choice for smaller people or those with back problems.

The rolling box

No matter how large or small you may be, if you know you'll be moving long distances on paved ground, a rolling box is by far the most comfortable means of transporting your gear. You can find many excellent rolling cases at Porter Case (www.portercase.com). If you need waterproof and bombproof protection, Pelican cases (www.pelican.com) are a good option. You can get these cases in all shapes and sizes to fit your needs. If you travel rarely or just around your hometown, then one of the lighter weight cases like the Porter cases will do.

My personal favorite, shown in Figure 3-18, is the Pelican 1510. The 1510 is designed around the exact dimensions allowed by the airlines for carry-on luggage. Several companies sell cases such as this but the Pelican offers extreme durability, a waterproof seal around the lid, and a Gore-Tex valve to equalize the pressure when going up and down in airplanes. These boxes are designed to take a real beating while protecting your gear.

Figure 3-18: Rolling camera boxes, such as this Pelican case, can provide protection in even the harshest of conditions. Mine has sat out in the sand through many, many beach weddings like this one in Tahiti.

The Bomb!

The combination of tough and waterproof was very comforting when I tossed my Pelican case full of gear out over the water and into the hands of the captain of a little water taxi (small boat) near Cabo San Lucas, Mexico. The bridal couple and I took a short ride out to Lovers Beach where we were to do a two-hour portrait session. As we approached the beach, the captain refused to go all the way in because the waves were pounding on the sand. We had to jump out of the boat into waist-deep surf and wade ashore through the pounding waves, while carrying all our gear and clothing for the shoot. Then we went on to spend the next couple of hours photographing in the sand, which is only slightly less deadly than salt water if you get it on your camera. This type of shoot is something I would never have even considered without my Pelican case.

Another time, while boarding a very small jet on my way to a wedding, I placed my camera box on the gate check cart along with all the other carry-on bags and then boarded the plane and took a seat. Almost immediately it started to rain and quickly turned into a total deluge, coming down so hard you could barely see from the plane to the cart where all our belongings sat getting soaked. Several passengers jumped up and began complaining loudly about laptops and important papers and leather satchels that were getting ruined. The captain called for bag handlers while the stewardess refused to let any of us get out and fix the problem ourselves. My seatmate leaned over with a very distraught expression and said, "That's my laptop getting soaked there in the blue bag." I said, "That's my black box over there with about $15,000 of camera gear inside." He looked at me and said, "You're not worried?" I said, "Nope! Not at all."

I recently read an article where the author claimed the weight of a Pelican case makes it inappropriate for traveling photographers and he went on to promote different soft cases as being highly preferable. My Pelican case has logged more than 300 airplane flights while traveling to over 50 destination weddings outside the continental United States, it's bounced around in the trunk of countless third-world taxis, rolled over miles of cobblestone streets, been dragged through miles of sand on various beaches, sat out in the rain, endured hours of bone-jarring rides in small boats, and been used as a stool, a chair, and a pillow. Yes, it weighs 12 pounds empty, but don't let anyone tell you that any soft bag can protect your gear through all that abuse.

The photo vest

Whether you decide to carry your gear to the wedding in a backpack or box, once you get there, you still need a way to carry all your stuff around while you're there. The photo vest is absolutely perfect for this. A vest is a bit like a wearable camera bag. It fits comfortably over your shoulders and holds lenses, filters, a flash, memory cards, extra batteries, snacks, water, a hat, and any other small items you may need. A vest keeps all the important stuff right there in easy reach. I like the black Domke vest because it has more than enough pockets, the construction is top quality, and the dark color feels a bit more discreet than lighter colors — it doesn't seem to call attention to the fact that there's a photographer wandering around.

Using a Tripod

While it is true that you can shoot weddings without a tripod, I believe very firmly that every wedding photographer must have a decent tripod. It doesn't have to be the newest, lightest,

$1,000 carbon fiber job on the market, but you do need something, and you do need to know when to bring it out and when to put it away.

In a typical wedding, there may be only a couple of times when you really need a tripod, and many weddings won't need one at all. So what exactly is it that makes a "tripod moment"? There are two very different times when you should bring the tripod out. One is the obvious setting where you want to use a very slow shutter speed, either because it's dark or because you also want to use an extremely small aperture to maximize the depth of field. Once you get down into the slower shutter speeds, your images will undoubtedly benefit from the stability a good tripod provides. Often this benefit won't even be noticeable on the LCD screen, but when you get back to the computer and zoom in on the details, you will always be able to see a difference between handheld images and those shot from a tripod. This is also true for lenses with an internal image stabilizer, except the shutter speeds can be about two stops slower than otherwise before you start to need the tripod.

The other time when a tripod will be invaluable is for family groups — especially big groups. Not only will you see small benefits in sharpness, but also even more important, a tripod enables you to carefully frame your shots and freeze the camera in that position. Once you get the framing set, you can leave the camera there and walk around to adjust clothing, remove junk on the ground, rearrange people, and so on. When you get back behind the camera, you can hold your face up just above the camera and your finger on the shutter release as you engage with your group by talking or telling a joke to get a smile. This type of interaction is much more comfortable for your clients than looking at a faceless photographer who has her head hidden behind the camera. Also, having your head up enables you to see all the little imperfections in the picture before you press the shutter. I frequently find myself walking around the camera three or four times to get the group just right. This same use of the tripod holds true for romantic portrait images with the bride and groom — especially in the very late evening when the light is low and you might need to have your camera supported during a long exposure.

The Importance of Backup Gear

The very first time you shoot a wedding for pay, you absolutely must have at the very least a bare minimum of backup gear to use in case something breaks. In the beginning, this set may consist of a few items that you borrow or rent just for the day. But as your business grows, you will certainly need to double up on a few items of gear. One of the best ways to do this is to create a completely separate set of gear for the primary and secondary photographers. Eventually, each of these sets will have at least two camera bodies and two flash units.

Tripod Etiquette ━━━━━━━━━━━━━━

No discussion about tripods should go without some mention of the fact that it is plain bad manners to leave your tripod standing alone during the wedding while you wander off and do other things for long periods of time. When you're not using it, fold the legs and lay it down so the other photographers and videographers, and of course the wedding guests, don't have to look at it and trip over it all day.

I saw the image shown in Figure 3-19 on my LCD screen one evening while shooting in Jamaica. When I took the lens off to see what was going on in there, the mirror fell out on the table. I just grabbed my other camera body and kept on shooting. To give Canon cameras the credit they deserve, this 5D shot 50 destination weddings and countless others in the United States before finally falling apart. Now it's got a new shutter assembly and I expect to get that much more work out of it in the future.

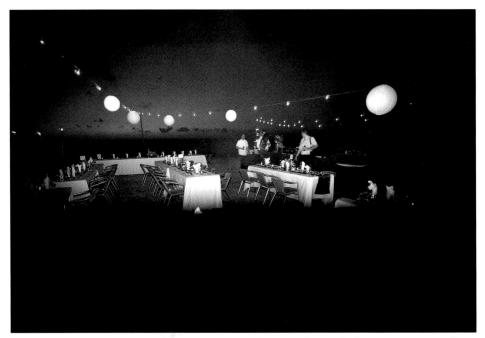

Figure 3-19: Having a set of backup gear is essential because almost all of your equipment will eventually fail, and when it does, you have to be able to grab a replacement and keep right on shooting without missing a beat.

Summary

As businesses go, wedding photography actually has a very small list of required equipment. Knowing what to look for and why each piece is important can be very helpful as you search for the perfect gear. If you're just starting out, you may have to make some compromises by purchasing a few items that are functional although not the best quality. Then as your business grows, you can sell off the cheaper items and purchase top-of-the-line gear one item at a time. When you're ready to go shopping, I've included a comprehensive list of my favorite gear, along with links to purchase the items, on my website at www.aperturephotographics.com.

4

Camera Settings and Digital Exposure

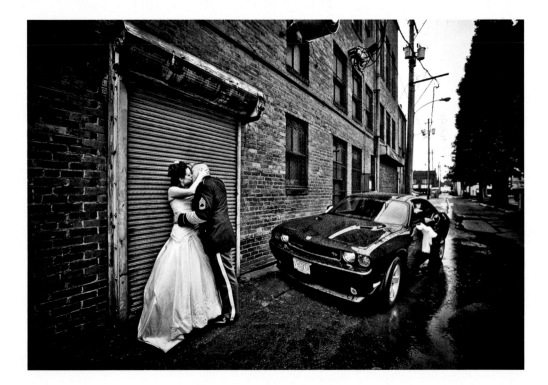

Every digital camera has a menu that you can access through the LCD screen. You may have several different menus with hundreds of options that you can control. These options change the way your camera functions. Some options change the way the camera functions on the outside, such as how it focuses or how it behaves with your flash; other options control the way the software functions inside the camera; still other options may change the file type, whether or not each image is sharpened, or whether the images are in color or black-and-white. Many of the available choices are simply a matter of personal preference and most are not permanent if you shoot in RAW format. However, some of the changes you can make have a big effect on the end result. The purpose of this chapter is to help you become familiar with these settings so that you can make the appropriate adjustments for each type of job you do with your camera.

Camera Settings

Digital cameras have certain basic settings that are necessary for the camera to function, and all digital cameras will have these options no matter what the make or model. The purpose of these settings, and a description of how they are used by the average wedding photographer, is the topic of the following section.

Color space

The term *color space* is used to describe a particular set of colors. Different electronic devices (cameras, monitors, printers) use different color spaces, and each color space has a slightly different set of colors in it. In fact, each and every one of those devices interprets colors in a completely unique way — just as you and I see colors slightly differently.

There are many different color spaces but the two you encounter most often in digital photography are sRGB (standard red, green, blue) and Adobe RGB. The Adobe RGB color space contains the most color tones, but most printers and computer monitors can only use the sRGB color space. The standard practice among most photographers is to shoot and process all images in Adobe RGB and then output the images to sRGB for printing, or to some other color space depending on the type of project you may be doing.

In your camera menu settings, you should find a place where you can choose between Adobe RGB and sRGB. If you shoot in RAW format, the color space setting on your camera will not matter because you can always change the color space before you output a file from RAW to JPEG. If you shoot in JPEG format, choosing the right color space is important because it becomes locked into the image.

File format

In your camera Setup menu, there is a place to choose the file type and the amount of compression. The available options vary among different cameras, but for digital wedding photography there are essentially only two practical file formats: RAW and JPEG. Each file type has its strengths and weaknesses, and there is a place for both in your wedding workflow, but I strongly recommend that you set this option to RAW in your camera Setup menu and never change it.

Sharpening

All digital cameras have menu options for adjusting the amount of sharpening. The setting you choose depends on what you want to do with the images. If you plan to give your clients JPEG images as a finished product, you will definitely want to do a small amount of sharpening, but this is performed in Adobe Photoshop Lightroom, not in your camera. For wedding photography, the sharpening option should be set to zero so the camera does not apply any sharpening at all.

Exposure Modes

All modern digital cameras are equipped with several shooting modes that adjust how much control you want the camera to have with exposure settings for each shot. On one end of the scale, you have manual mode where you must personally set the aperture and shutter speed for the right exposure. On the other end you have program mode, or automatic mode, where the camera decides the best setting for each shot — all you do is push the button.

Each shooting mode is useful in different situations and there will be times during the wedding day when each of the different modes is most appropriate. Knowing when to choose one mode over the others demands that you understand the strengths and weaknesses of each one. In the following sections I discus each mode and offer examples of when you might choose to use each one during a typical wedding day.

Aperture priority mode

Aperture priority mode is perhaps the most useful exposure mode for general daytime shooting. With this mode, you pick the aperture and the camera chooses the shutter speed. Choosing the aperture yourself gives you the ability to pick the amount of depth of field needed in each scene. The only drawback to the aperture priority mode is that the camera sets slower shutter speeds as the scene gets darker in the late evening. If you fail to pay attention at this time of day, you will eventually start getting unacceptable amounts of blur. This mode works fantastically in the daytime; you just have to remember to raise your ISO and/or switch to a different mode as the light gets low.

Shutter priority mode

In shutter priority mode, you choose the shutter speed and the camera will automatically set the proper aperture to achieve a good exposure. This lessens your chance of having the camera set shutter speeds that are too slow to use, such as when you're shooting late in the evening. Another time to use this mode is when you want a slow shutter speed to create a certain amount of blur for a visual effect such as panning. You may also want to use shutter priority mode when you want a fast shutter speed that will freeze action. Sports photographers use this mode a lot, but there will be very few times that you need to be concerned with stopping action at a wedding.

Program mode

Program mode puts the camera in charge of determining both the aperture and the shutter speed. Like most professional photographers, I rarely use this mode simply because it would allow the camera to make all exposure decisions, yet it would give no real benefits over aperture or shutter priority modes. If you're going to call yourself a professional photographer, you should be able to understand the effects of your aperture and shutter speed settings enough to know which one you need to control for different effects.

Manual mode

Manual mode puts you in complete control. At a wedding, manual mode is only useful when you know you'll be shooting many shots in the same place and in the same lighting conditions. Manual mode lets you find the correct exposure and stick with it. I often use this mode for shooting portraits and I *always* use it for group photos. If you were to use one of the automatic settings for a group shot, the camera would change the exposure every time you recompose the scene because different things will be in the center of the metering area each time. With manual mode, you don't have to worry about the camera making exposure changes.

Manual mode is extremely useful for shooting at night with a flash because you are able to dial in just the right combination of ISO and shutter speed to get a pleasant amount of ambient light in the background without causing too much ghosting around the subject. As long as the light stays consistent, your camera settings can stay the same.

Metering for Proper Exposures

Your camera is an incredibly complex and accurate light-metering machine — but it has one big shortcoming — it can't think! Thinking is your job. Once you understand how your camera sees the world, you can learn to take a meter reading (using your camera) and then override that reading as necessary before you ever even shoot your first shot. Once you understand the process of how your camera sees things, you can make a fairly accurate prediction as to when it will make correct or incorrect exposures and you can dial in a change to counteract the mistakes that you know it will make. Being able to do this helps you capture a much higher percentage of fleeting moments and expressions that pass by so quickly on the wedding day. For example, if you notice the bride walking toward a beautiful doorway with bright light streaming in from outside, you can simply point the camera and shoot — in which case you'll get a great exposure for the bright outdoor light and nothing on the inside. However, if you know that your meter will set itself for the bright outside light — which it will — you can use the thumbwheel to quickly dial in an exposure compensation of +2 before you take that first shot. This gives you some detail on the shadowed (indoor) side of the image while creating a glowing white wash from the bright light outdoors. You would have missed this shot if you relied on the camera's meter, and you certainly can't catch quick moments like this by looking at the LCD and then trying it again.

Digital cameras have a tendency to breed lazy photographers who think they don't need to understand metering because they can look on the LCD screen and make corrections for the second shot. The bad news is that many of the best moments happen far too quickly for you to shoot test shots. You have to hone your ability to predict what your meter will do in many different situations so that you know when to override the meter and by how much.

The two concepts you must grasp as you learn your camera's meter are: (1) the camera is always trying to average things out no matter what you put in front of it, and (2) the camera has absolutely no idea what you're putting in front of it. Of course, averaging out the exposure works great if you actually do have a scene with average tones in the central area. The camera simply reads the average tones and sets the exposure perfectly every time. However, the camera has no idea whether or not the scene before it is average or not, and very few scenes are perfectly average, so if you put a groom and all his groomsmen with their black tuxedos in the

center, and the camera makes everything appear average — but it's not average — suddenly you've got gray tuxedos and the groom will almost certainly *not* appreciate the change.

"Average" in camera language translates into tuxedos and white dresses that look medium gray. With this concept in mind, if you meter on a black tuxedo, you can set your camera to a –1 exposure compensation, which underexposes just enough to make the blacks appear black like they really are, and suddenly you've got black tuxedos again. With a white dress, you dial in a +1.5 and the dress appears white again just like it is in real life.

Okay, now comes the really confusing part. Oddly enough, you can actually improve your images by allowing your camera to make black things go gray. As discussed in the following section on digital exposure, a slight overexposure is actually helpful because of the nature of digital cameras. So while it is true that using a –1 exposure for black subjects will bring them back to "normal," it will actually improve your images if you skip this step — allowing the image to be overexposed a bit in capture. Then you can lower the exposure back to a normal in Lightroom. (This concept will make more sense by the time you reach the end of this chapter.)

The same process happens in reverse when you have a white object like a bride's dress dominating the center of the image. The camera sees the white, assumes it should be average, and creates a gray wedding dress. You (being the brains of this operation) have to dial in a +1.5 exposure compensation to make the white cloth appear white again. This time you *don't* want to skip this step and correct the image later in Lightroom because the camera will underexpose the image, and underexposure is never good. A little overexposure is good; underexposure is always bad. So the rule is: for white things, add +1.5 to the exposure, for black things, you can either subtract 1 stop from the exposure or do nothing, and either way you'll be fine.

It's important to remember that a camera can't think. It's great at only one job and that is to expose for an average scene and make it look average. You are responsible for supplying the intelligence and the artistic vision needed to consistently create properly exposed images. Get to know the limitations of your meter and you start to appreciate how wonderfully predictable it is. It will consistently give you a baseline exposure that is incredibly accurate. You just have to know how to do your part by correcting that exposure to make bright things appear bright and dark things appear dark.

Methods of Exposure Compensation

Many times while shooting with a digital camera, you will look at the LCD preview screen and realize that you disagree with how the camera's meter is reading the scene. To correct the exposure you need to make some sort of compensation using one of the following methods.

Exposure lock button

All professional and most consumer SLR-type cameras have a button (usually operated by the right thumb) that enables you to lock the exposure and then recompose before shooting. This is sometimes the fastest way of accomplishing the exposure compensation discussed in the previous section. Using the example of the bride walking toward the brightly lit doorway, this time you would simply turn the camera toward another area of the room (without the bright light) and press the exposure lock button. Then you recompose on the doorway and release the shutter.

The advantage to this method is that it is fast. However, it only locks the exposure once; after the picture is taken, everything goes back to normal. If you want to make a second shot the same way, you have to repeat the process. For me, I find this single use mode to be extremely valuable because if I switch to some other method that keeps the exposure locked, I will invariably walk away from that location and forget to change everything back — resulting in ruined photos until I look at the LCD and notice that I forgot to change the settings back to normal.

+/– dial adjustment

Your camera has a dial that changes your exposure to create either overexposure or underexposure while still allowing you to use the various automatic modes. You can continue using modes like aperture priority, shutter priority, or program, but the exposure compensation is added or subtracted from this setting. For example, if you shoot into the sun you might dial in a +1 exposure compensation to bring out some shadow detail while letting the highlights overexpose a little. The camera still functions in an automated mode like aperture priority but your +1 compensation is added to each shot. This is the preferred method of exposure compensation if you are shooting in the same type of light condition for some time.

A drawback to this method is that you will invariably forget that you moved the dial, and when you continue to shoot this way in a different sort of light, you may end up ruining a number of images before you notice the problem. If you have a bad memory as I do, you may want to rely on the exposure lock button whenever possible because it automatically switches back to normal after each shot.

Manual mode

As mentioned earlier, manual mode is an excellent way to make exposure compensations. With this mode, the camera's meter still tells you what it calculates as the correct exposure, but you can purposefully dial in whatever exposure you want without worrying about the camera changing the settings on you. The disadvantage to using this mode is that it is very slow, and weddings are not slow. The action at a wedding happens way too fast for you to shoot on manual mode all day long.

Digital Exposures

To get the most out of your digital camera, you must understand how to place your exposures on the histogram. If you do it wrong, you will either lose the detail in your highlights, or create unnecessary grain (digital noise) in your shadows.

Before you can begin using the histogram, you must first understand what a histogram is and how it works. As you can see in Figure 4-1, a histogram is basically a bar graph that shows where the brightness values are in an image. Although the graph may appear to be a perfectly smooth curve, it's actually made up of many tiny vertical bars, much like the teeth of a comb, and each one represents a single level of brightness. The histogram for a JPEG file is a bar graph made up of 256 bars, while the histogram for a RAW file represents 4,096 bars.

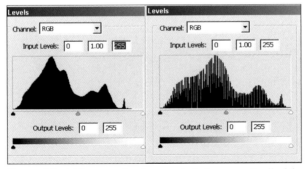

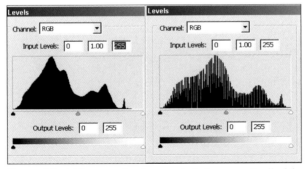

Figure 4-1: A histogram is a bar graph that represents all of the different tones of brightness in the image. I manipulated the histogram on the right to pull the bars apart so you can see them better.

When you look at the histogram as a bar graph, all of the white or light-toned objects in the image are represented by the bars on the right side of the graph, while the darker tones are represented by the bars on the left of the graph. Each bar represents a level of brightness; the higher the bar, the more pixels there are in the image that share the same level of brightness. As you can see in Figure 4-2, if there are a lot of darker tones in the image, the histogram rises up on the left side; if there are a lot of average tones, the histogram rises in the middle; and if there are a lot of lighter tones, the histogram rises up on the right side.

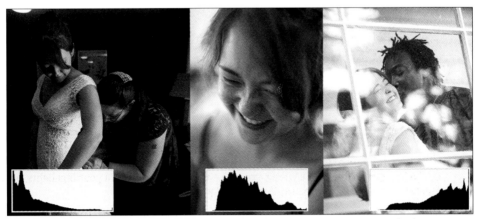

Figure 4-2: The histogram on the left represents an image with a lot of dark tones; the histogram in the middle represents an image with average tones; and the histogram on the right represents an image with a lot of light tones.

Underexposure

In the previous edition of this book, I recommended shooting images that were slightly under-exposed and I cautioned against overexposing any image. This would seem like common sense because it makes the image on the LCD screen *appear* much closer to what you're seeing in real life. However, this is the opposite of what you should be doing if you want to get the best final result, because digital image files take better to being darkened than to being brightened, as the latter brings out any digital noise in the shadows.

My advice now is to avoid underexposure. Instead, push your digital exposure to the right side of the histogram (by overexposing) as far as you can without losing highlight detail; later when you rework the image on your computer, you can easily darken the image with the "Exposure" control and you'll end up with better color and less digital noise in the shadows. Digital noise appears in the areas where the sensor doesn't get enough light to know what to do, so it makes something up. If you give it some extra light to work with (by overexposing slightly), it doesn't have to imagine what might have been there — it creates true colors with very little digital noise.

Figure 4-3 is an image that should have been flashed but for some reason, the flash didn't go off. It should have been deleted but I pulled it out to illustrate this point. On the left side, you can see how dark the original was, and on the right side, you can see how extremely prominent the digital noise became when I tried to brighten the image up.

In Figure 4-4, you see an image that I shot a few seconds later and this time the flash did go off. This image got plenty of light, resulting in far less digital noise. As you can see, the histogram shows a much more normal hump in the midtone area. I zoomed in on a small portion of the original image file for Figures 4-3 and 4-4, but the magnification is identical in both examples. Both images were shot at ISO 1250, but as you can see, the amount of digital noise is drasti-cally different between them.

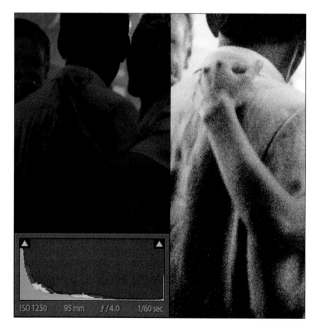

Figure 4-3: Underexposed im-ages suffer from excessive grain effects (digital noise) when you try to brighten them up in the computer to make them look normal.

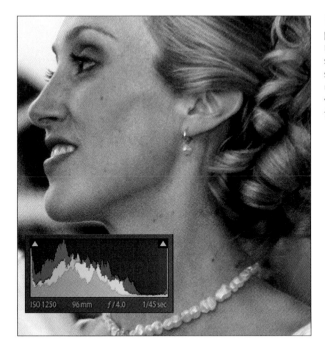

Figure 4-4: When an image gets plenty of light, the level of digital noise is low even at high ISO settings. This image was shot only seconds after the example in Figure 4-3 except this time the flash went off and provided ample light for a proper exposure.

Overexposure

Slightly overexposing an image and then darkening it in the computer will actually *lessen* the amount of digital noise and improve the final image. However, too much overexposure creates problems that will definitely ruin an image.

A correctly exposed image will have a histogram that barely touches the bottom right corner of the histogram. When you see a histogram with data that starts to stack up higher and higher on the right side, you know the image will have places where there is absolutely no detail in the highlights. As I mentioned before, this can be fine in small amounts, but as the histogram goes higher and higher on the right side, as it does in Figure 4-5, your image will start to contain large areas of pure white. Many things in the world appear to our eyes as if they are pure white, but in reality, they always contain tons of tiny details that are not quite pure white. These details give texture to the white thing. You might say, "The bride wore a pure-white dress," but if you manage to make it truly pure white in a digital photo, she won't like it.

When I captured the image shown in Figure 4-5, I exited a dark limo into bright sunlight and forgot to turn off my flash, which caused the first few shots to be extremely overexposed. On the right side of Figure 4-5 you can see what happened when I attempted to use Lightroom to correct the mistake. I lowered the brightness and exposure sliders all the way to the bottom and still there is not a scrap of detail in the bride's dress. That dress truly is pure white and no amount of digital processing can ever put texture back in that dress.

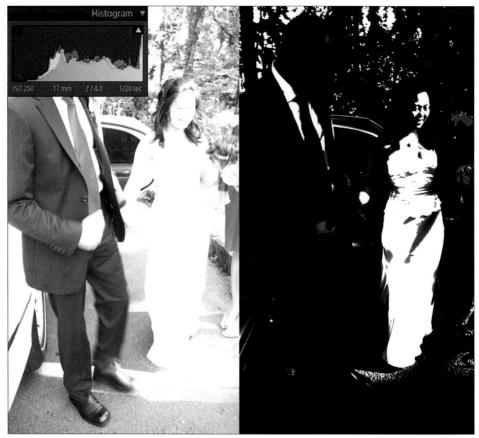

Figure 4-5: When you see a histogram that climbs this far up on the right (highlight) side, you can easily guess that it won't be good, and you won't be able to save it later in the computer either.

What is the best exposure?

Okay, now you know that underexposure creates digital noise that looks really awful, and overexposure creates patches of pure white that also look really awful. So the best exposure should be in the middle, right? Well, not exactly. The imaging sensor in your camera records the vast majority of its information on the right side of the histogram — toward overexposure. That doesn't mean you should drastically overexpose everything, but it does mean that if you push your exposures as far to the right as you can without causing the histogram to start climbing up that right side, you'll get the absolute maximum out of your imaging sensor. The end result will look a bit bright at first, but it won't have blown-out highlights and when you get everything imported into Lightroom, you can easily pull the exposure down a bit and have an image with beautiful color, detail in the highlights, and very little digital noise in the shadows.

RAW Versus JPEG

In the previous version of this book, I was much more neutral about whether a beginning wedding photographer should shoot RAW or JPEG files. At that time, it was indeed practical to shoot JPEG in many circumstances. However, as technology marches on and computers get faster, software gets better and cheaper, hard drives get bigger and cheaper, and memory cards get bigger and cheaper — before you know it all those reasons to shoot in the JPEG file format are gone.

In the current and future world of wedding photography, there is absolutely no reason to shoot a wedding professionally with a camera that is set to produce only JPEG files. Today the software used to process RAW files is so fast and easy to use that it actually makes your work-flow far quicker, easier, and cheaper (considering the price of Adobe Photoshop) than what it would be if you shot JPEG files and then edited even just 20 or 30 images from the day's shoot in Photoshop. The level of color correction you can achieve in 10 seconds (and often less) with Lightroom exceeds what most beginning photographers can do in 5 minutes with Photoshop. And this becomes more evident when you either buy Lightroom presets, or learn the simple process of making your own. With presets, you can apply all sorts of different special effects with the click of a single button. (You can find a selection of my favorite Lightroom presets on my website at www.aperturephotographics.com/presets.)

Image differences

The fact that the JPEG file format has 256 tones of brightness and the RAW file format has 4,096 tones is important. When you make anything more than minor changes in a JPEG file, the bars of the histogram pull apart, leaving gaps. The larger the gaps are, the more the image starts to show bands of color instead of smooth gradations from one tone to the next. A RAW file has 16 times as many bars to start with, so you can make huge changes to brightness and color balance without causing any noticeable gaps in the histogram.

The camera settings you choose for each shot influence the way your images look, and if you shoot in JPEG format, the following qualities become permanent attributes of the file:

- ✦ Noise reduction
- ✦ Sharpness
- ✦ Color saturation
- ✦ Color space
- ✦ White Balance
- ✦ Quality of JPEG compression

If you accidently use a camera setting that is inappropriate for the particular purpose of that image, you're stuck with it. And if you shoot a JPEG image with a setting that is appropriate at the time but you later decide you want to do something different with that image, you're stuck. With RAW files, you can change all these settings over and over again in the computer without ever permanently affecting the actual image data.

Minimizing digital noise

The only image qualities you cannot edit in a RAW file are those the camera settings create, such as shutter speed, aperture, and the ISO setting. The ISO setting is permanent, and one of the side effects of the ISO setting is digital noise. Digital noise is the grainy looking texture that appears mostly in the shadows. In general, high ISO settings result in greater digital noise throughout the image, but this noise is especially noticeable in underexposed shadow areas. If your camera is set to render files to JPEG format, this digital noise will be much more difficult to remove, especially if you've used any settings for sharpening or JPEG compression, both of which drastically increase the appearance of digital noise.

Some software programs, such as Noise Ninja by PictureCode (www.picturecode.com) and Neat Image by ABSoft (www.neatimage.com), do a decent job of removing digital noise even on JPEG files. However, these programs can't match the noise removal capabilities of programs that work directly with the RAW file data, such as Lightroom and Adobe Camera Raw. However, like Adobe Camera Raw and Lightroom, Noise Ninja and Neat Image work quite a bit better when they're used on unrendered RAW file data rather than images that have already been rendered out to any other file format. If minimizing digital noise is the slightest concern for you, you should be shooting RAW files.

Manual conversion advantages

In the case of a sunny day, one of the biggest concerns with using the JPEG file type is that it cannot possibly contain all of the tones your camera can produce. The JPEG file type is an 8-bit (2^8) file, which means that it can contain only 256 tones of brightness. The original RAW data captured by most medium- and high-quality digital cameras is a 12-bit (2^{12}) file type that can contain 4,096 tones of brightness. That means a JPEG file can only contain one-sixteenth of the total data your camera can produce.

When you shoot JPEG images on a bright sunny day, the software in your camera must attempt to get as much data as possible compressed into the tiny space available with a JPEG file. To do this, the software may often need to compress the information by raising the contrast until both ends of the histogram fit into the limited amount of space. This isn't a problem on an overcast day because there are no super bright spots and no dark shadows, but on a sunny day, bright spots and dark shadows often occur in the same image. Compressing such a wide range of brightness into a JPEG image becomes quite a challenge. When you process a RAW file manually and then render it to JPEG, you have the option of expanding or compressing the tonal range to get a much smoother blending of tones before the data is locked into the final JPEG file.

To give you an example of this, I created a setting where white, black, and colored objects were exposed to direct sunlight right beside a black area in deep shadow. This is perhaps the worst possible scenario a digital camera could ever encounter, which makes it a perfect example of how much tonal range is recorded with each file type. In Figure 4-6, the two files on top were captured in a single shot with the camera set to produce both JPEG and RAW at the same time. I exposed the shot to push the histogram as far to the right as possible. In the original shots, you can see how much more contrast the JPEG file has compared with the image that was captured in the RAW file. When I pulled up the midtones (in both files) to reveal detail in the shadows, you can see the difference in the color bars and the detail in the typed page. Notice

also that I was able to compress the image data in the RAW file to fit entirely within the space of the histogram even though in the original shot, much of the shadow detail (left side) lay outside the space of the histogram. In the JPEG shot, all the shadow detail was clipped off permanently, so when I attempted to pull out shadow detail, the entire histogram was pulled apart, leaving visible gaps where there is no image data.

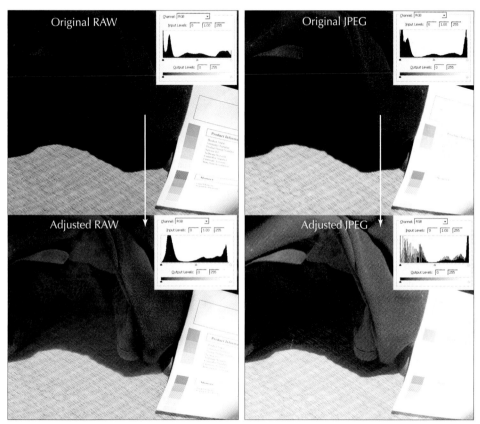

Figure 4-6: Black and white objects in direct sun provide the ultimate challenge for any camera. Neither image in this example can encompass the full range of brightness in the original shot. But when I adjusted both to pull out shadow detail while still holding the highlights and the colors, the RAW file is clearly superior.

Cheap insurance

When the camera produces a JPEG file, it first captures a RAW file and then it quickly runs a complex computer program to analyze the RAW data and choose which parts to keep and which parts to throw away. Because the JPEG file is so much smaller, the software must effectively discard $^{15}/_{16}$ of the total data, which sounds like a lot, but in reality that still leaves plenty of information to make acceptable images and prints. Fortunately most cameras are pretty

good at doing this job, and if you were so good that you could shoot every exposure exactly right in the first place, there would be little need for RAW files. However, a wedding is a fast-paced affair that often takes place in challenging lighting conditions that you mostly cannot control. This doesn't exactly set the stage for you to get every single exposure right on. In fact, it creates a set of conditions that almost guarantees you'll be getting the exposure a little bit wrong in most of the images you shoot and a lot wrong in a smaller but significant portion of the day's work. This doesn't mean you're a bad photographer (although you will notice your percentage of success increasing as you get better and better); what it does mean is that you are simply not perfect, nor will you ever be. Shooting in RAW format shows that you care enough to get these images right, even if you have to do it after the fact. Think of shooting RAW files as a cheap insurance policy that enables you to recover from most of your mistakes. The less experienced you are in this business, the more you need that insurance.

Summary

Whether you're interested in shooting a few weddings on the side or diving into it as a new career, you need a good set of equipment and you need to know how it works. This chapter gives you the basics on all the major camera settings that you can change in the menu as well as an overview of the basic exposure modes and how to use them to get good exposures. This chapter also covers the essential concepts of how and why to make a proper exposure that maximizes the data-gathering capability of your camera.

Getting the most out of your digital camera requires that you understand how to place your exposures on the histogram. If you do it wrong, you will either lose the detail in your highlights, or create unnecessary grain (digital noise) in your shadows. If you want to make proper exposures, it is critical that you learn to read the histogram to determine the best exposure for a given scene.

This chapter should also clear up some of the confusion about why you should shoot in the RAW file format. No matter what the temptation may be, there really is no good reason to shoot in JPEG format when you have paying clients and your reputation is on the line.

✦ ✦ ✦

Wedding Photography Techniques and Concepts

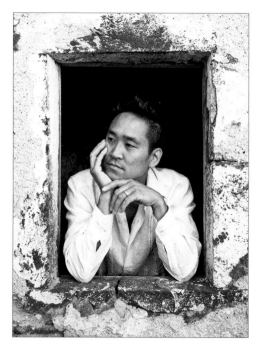

5 Composing Your Art

The rules of composition are designed to help maintain a tight sense of law and order in the art world. Just kidding! There aren't any rules to creating art, nor are there any rules to creating wedding images. However, if you happen to be a beginning photographer, having some guidelines can be helpful in your quest to become an artist. The composition "rules" discussed in this chapter are really just guidelines for the beginner. As you master the basics, you develop a feel for when you can bend or break the rules and still create images that work.

If you truly analyze how you feel when you view an image, you might come up with all these rules on your own, because when it comes down to it, the feel of an image is what is important. In fact, all of the rules or guidelines I discuss are based on gut feelings that the average viewer commonly feels. When viewers see an image that breaks the rules, it frequently creates a feeling of distress and they can almost immediately tell you that they don't like the image even if they can't tell you why. The opposite is true for images that follow the rules. Viewers can sense that the image has a natural balance to it and they feel comfortable looking at it. They may not have any idea which rules it follows; they just know it is pleasant to look at and they like it.

The Rule of Thirds

The Rule of Thirds is perhaps the most commonly known and used concept in the art world. As the name implies, the image is divided into thirds both horizontally and vertically, as shown in Figure 5-1. This division creates four lines and four spots where the lines intersect. Both the lines and the intersections can be thought of as the most powerful location for subjects or other items of interest in the image. For example, as shown in Figure 5-2, you might place the horizon on one of the horizontal lines. Which line you choose can depend on whether the main subject of the image is in the foreground below the horizon or in the sky above the horizon.

Figure 5-1: The Rule of Thirds divides an image into thirds both horizontally and vertically.

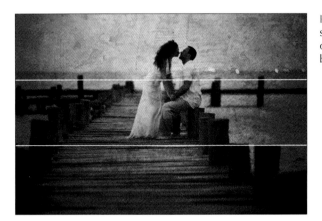

Figure 5-2: If you place linear subjects such as the horizon on one of the lines, the image has a balanced feel.

The intersection where two of the three lines meet is the most powerful spot to place singular subjects. When dealing with a person, as in Figure 5-3, the eyes are usually considered the true central focus point of that person's face. Placing the eyes on the intersection where the third lines meet generally creates a pleasing composition. It should be noted that the lines and intersections are not thought of as tiny points like those that you see when there is a grid placed over the image, but rather as a zone, or a general area where the subject should be placed.

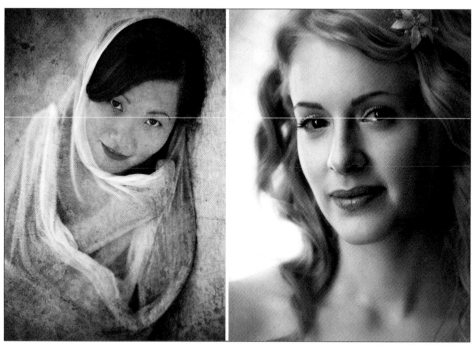

Figure 5-3: Placing the subject's eyes on one of the points where the lines intersect tends to provide a balanced composition.

Moving Into the Frame

If there is any motion or direction in your subject, always provide some space for the subject to move into, as demonstrated in Figure 5-4. Don't place a moving subject so near the side of the image that it feels like the subject is about to walk right out of view. And similarly, if your subject is looking to the side, don't place her so that so she gazes out the side of the image.

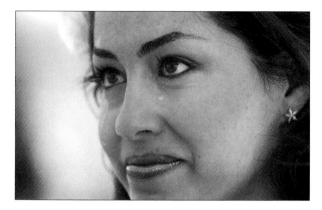

Figure 5-4: Whenever your subjects are looking out of the side of the image, you should place more empty space in front of the subject's face than behind the subject's head.

To understand why this rule exists, imagine you've just been placed in a small box and left there. When you get comfortable, you will invariably settle on a spot with your back to the wall and all the empty space out in front of you. You would never choose to stand with your nose against the wall and all the empty space behind you. Images are similar to that box in that they have very solid walls. Good composition places subjects so they are closer to one wall and either moving or looking into the open space of the box.

Using Empty Space

You can create a very dramatic feel by placing your subject with a lot of empty space all around or in one direction. If the empty space is in one direction, then it is preferable to have it in front of the subject, as mentioned in the previous section. The emptiness shown in Figure 5-5 is often referred to as "negative" space, and it gives the viewer a sense of place. It says something about where the image was made.

If you produce albums, sell wedding images as stock, or simply want to have something for your website, then you might purposefully create areas of empty space with the intention that this area will be filled with text later. If you make albums, you can create images with wide-open empty spaces that you can later fill with a montage of smaller images when you design the album.

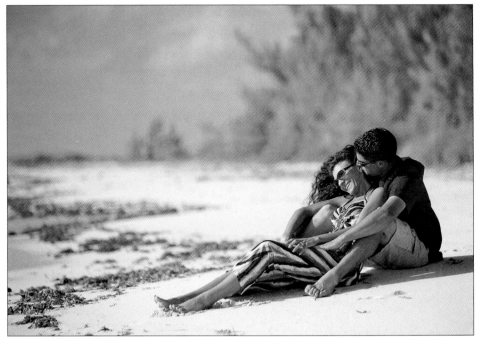

Figure 5-5: Use empty space to show off a dramatic landscape or to provide room to place text later.

Cropping People

When shooting group photos, you have two main compositional factors to consider. One is that most people like to purchase 8×10s because the manufacturers of cheap frames don't produce many 8×12 frames. However, your camera produces an 8×12 image. Figure 5-6 shows how you can frame your groups to allow for cropping. Leaving enough space on the ends of the frame allows for cropping one inch from either end of the 8×12 print.

The second consideration is where to crop your subjects. There are definitely good and bad places to cut someone off. Figure 5-7 shows the most comfortable places where you can place the bottom of the frame. Cut your group at waist level and nobody notices. However, cut everyone off at crotch level and you are certain to create some discomfort in your viewers. Also, people don't like having their feet or the tops of their heads cut off. You can comfortably crop at the waist, through the thighs, and through the shins.

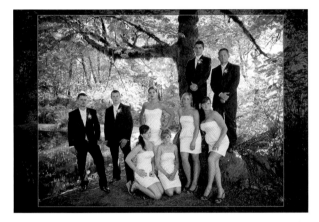

Figure 5-6: Make sure to leave room on your group shots so they can easily be cropped to an 8×10. The masked-out area around this image shows how it would fit in an 8×10 frame.

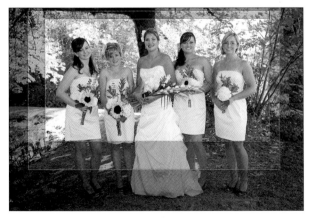

Figure 5-7: When cropping people, you can comfortably crop at the waist, through the thighs, and through the shins. The masked areas show how I might crop if I wanted a closer view. For an important group shot, I often make virtual copies in Adobe Photoshop Lightroom and crop each one differently.

Allowing room for cropping also affects the amount of print sales the image can generate. For example, if an image is shot without room for cropping, then you can only print it in the 2:3 format (4×6, 6×9, 10×15, and so on), which is the native format that most 35mm SLR cameras produce. However, if you leave empty space on the sides, you can print the image in the 4:5 format (4×5, 8×10, 16×20, and so on), giving it greater sales potential.

Shooting a Bull's-Eye

Most people know the word *bull's-eye* as a term associated with shooting guns. In photography, a bull's-eye is a composition term and means that you placed the subject in the exact center of the image. For wedding photography, this is usually a bad composition because the subject of most of the images is a person — and specifically, the eyes of that person. If you place a subject's eyes in the exact middle of the image, as was done in the left image in Figure 5-8, you tend to have a lot of wasted space above the subject's head.

If you accidentally shoot a bull's-eye image, you can often improve it with some cropping; however, it is better to make the best use of your image space in the first place. This compositional mistake most often leaves your viewers wishing there were something more in the bottom half of the image. This is especially true if the subject of the image is engaged in doing something, or looking at something that is just below the bottom of the frame.

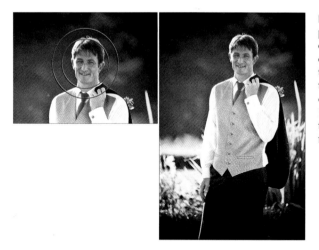

Figure 5-8: The left image is a perfect bull's-eye, with too much extra room above the head and on the sides, but not enough of the story in the bottom. When the frame is lowered, or in this case changed to vertical, there is less wasted space and more of the subject is in included in the frame.

Of course, there will be many exceptions where you may intentionally want to place the subject in the center. In Figure 5-9, the curvature of the trees above the couple adds a nice element to the scene, even though it puts the subject in the bull's-eye spot.

Even after learning about the Rule of Thirds, many beginners still shoot bull's-eye images quite frequently, and most professionals occasionally do the same. One of the reasons photographers take accidental bull's-eye images is that they become emotionally caught up in the wedding. They let themselves become participants instead of photographers — if only just

for a moment — but unfortunately it's these emotional moments that they've been hired to photograph. Emotional interaction automatically focuses your attention on the eyes of the subject because this is how we normally look at each other. New photographers often get so "into" the experience of the wedding that they forget they're there to photograph it. I've seen them standing there during the wedding with tears in their eyes and their camera hanging at their side as they think, "Awww, that's so beautiful." While this happens less and less as a photographer becomes more experienced, even an experienced photographer can shoot a bull's-eye when the action is emotional and fast paced. As your subject moves in front of you, you naturally focus on your subject's eyes; until you learn to detach yourself from experiencing the wedding as a guest would, you will naturally aim your lens at this part of the subject's face.

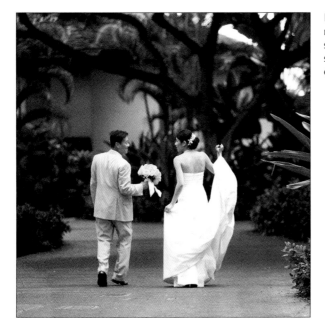

Figure 5-9: This framing puts the main subject in the bull's-eye spot, but the tree branches add a secondary subject that allows the composition to work.

The trick to avoiding the bull's-eye is to keep yourself mentally and emotionally detached from the wedding. Mentally remind yourself that you are there to photograph the event, not to be a part of it. Of course, you are a part of it just by being there, but if you maintain a detached state of mind, you'll find it easier to focus your attention on the photography and, at the same time, broaden your perception of the event as a whole.

Instead of focusing only on people's emotions as they say or do things, focus on composing the picture so that it tells the story. Instead of focusing your attention only on what the bride is doing, also be aware of what the grandparents and friends are doing off on the sidelines. If you work on maintaining an overall sense of the event, you will find yourself noticing the little details that make the day unique.

This sort of perception, combined with the technical skill to capture it, is what separates the average wedding photographers from the truly great ones. There is no magic to it. Anyone who truly cares about shooting weddings can learn to expand her vision and perception. It's not that some lucky people are just born with an artistic eye while others aren't. There is certainly a genetic component to artistic ability, but for the most part, it's a cultivated skill.

Leading the Focal Point

As a viewer looks at one of your images, the viewer's eyes tend to travel over the image in predictable ways. The usual pattern is for the viewer to first take in a brief general overview and then zoom in on the subject. If the subject is not obvious, the viewer's eyes may wander around searching for it. If the viewer finds nothing, the viewer is likely to feel dissatisfied and move on to something else. If that image was on your website, that "something else" may be another photographer's website.

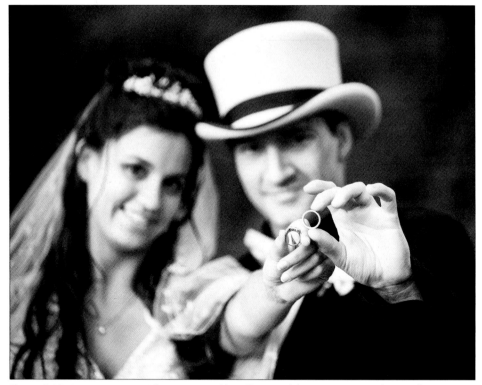

Figure 5-10: You can use a wide aperture to blur all parts of the image except that small portion you want to make sharp.

You have many tools you can use to lead a viewer around in an image. Figure 5-10 is an example of how you can intentionally blur parts of your image to lead the viewer to the subject. This powerful tool can isolate and separate a subject from the surroundings because our eyes naturally seek out the sharply focused points. Figure 5-11 shows how you can use lines in an image to draw the viewer up to the subject. No matter where your eyes wander in the image, the leading lines always draw you back to the subject. Figure 5-12 shows the effect of darkening the edges of an image. This is called a *vignette* and it is a very effective tool for drawing the viewer's attention toward the lighter portion in the center. In the old days, this lighting effect occurred because of deficiencies in the lens design. Today, you can create it or enhance it by darkening the edges of the images in the computer.

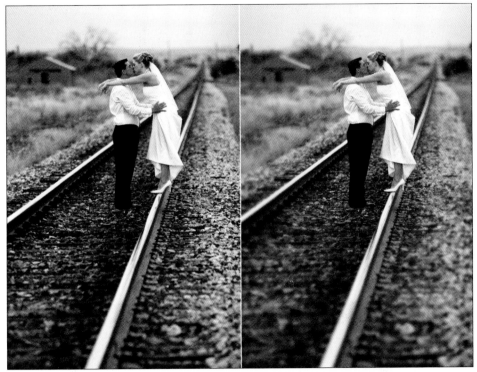

Figure 5-11: In this image, strong lines lead your view right up to the subject. In the version on the right, I used Photoshop to add an additional blur around the subject, which further focuses attention on the subject.

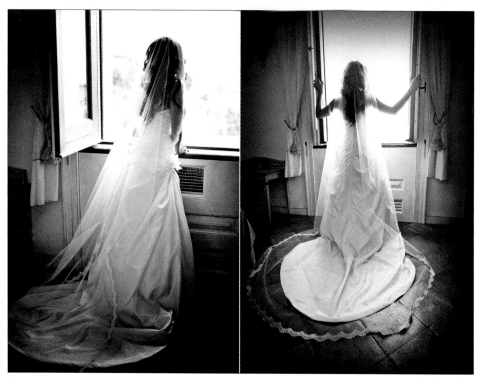

Figure 5-12: A vignette has been added to this pair of images (in Lightroom) to focus the viewer's attention toward the subject as well as minimize all the tiny distractions around the perimeter.

Natural Posing

Every photographer is familiar with the gruesome distorted face of a child who has just been told to smile. Yikes! Sometimes the groom is almost as bad. Maybe the last time he was in front of a professional photographer was way back when he was a ring bearer and somehow he still remembers how to do it. Most of the clients you work with in the wedding business don't have any experience modeling. In fact, it seems far more normal to find subjects who are shy, inse-cure about their appearance, and generally uncomfortable in front of the camera — at least for the first hour. If you have a friendly personality that puts people at ease, most of those fears disappear quickly. However, it's rare to find a subject who will completely loosen up and act completely natural when you raise your camera. The worst thing you can do to a camera-shy couple is give a lot of specific directions about how to smile and how to hold their bodies. The more you do this, the more likely you are to get the same results as you would with the child who has just been told to smile — the couple becomes stiffer and stiffer.

Getting over the camera-shy stage takes some time. I like to start the wedding day shooting in the dressing rooms because it gives me a chance to bond with the clients and for them to get comfortable being in front of the camera. During this time, I create a few directed pictures — not many because you can capture most of this time in a photojournalistic style, but a few to get the clients used to working purposefully in front of the camera. Occasionally, I see some

fleeting movement or glance that looked beautiful and I give the bride some direction to re-create it. Being more of a director by asking the bride to move to a patch of really good light so you can create a few window light portraits can also help break the ice.

With the guys, I try not to make them "pose" early in the day. If you simply capture them "doing" something (especially as a group), you're much more likely to see the real side of them come out in your images.

The Creative Portrait Session

During the creative portrait session, which usually takes place in the late evening, you can focus on finding beautiful locations with spectacular lighting, and then put the couple in there and let them do their own thing. By now, the bride and groom should be more comfortable in front of the camera but you still have to be careful about giving them too much direction. I find that a few general directions are helpful, and I make a point to give those directions in a little meeting before we begin taking pictures. This meeting gives me a moment to connect with the couple and put them at ease with what we are about to do. I also find that it helps to tell them these details when they are focused on what I'm saying instead of waiting to do so when they're trying to make a pose.

My speech covers these main points:

> ✦ I like to do very little posing because it tends to make your pictures more unique if you come up with ideas of your own. If you have an idea, please feel free to throw it out there, even though it may sound silly or impossible to do. Sometimes your idea won't work, but when you say it, the idea may evolve into other ideas that eventually create a great picture.

> ✦ When we find a good spot, I'll tell you roughly where to stand and then you can hug, kiss, play, dance around . . . anything you like — just don't look at the photographer because the goal is to make it look like you didn't even know you were being photographed.

> ✦ When I ask you to kiss, do it very slowly and give a little extra pause at the moment just before your lips touch — this is the most romantic part of the kiss. In addition, when you kiss, don't pucker your lips out; just relax your face and allow your mouth to stay slightly open.

> ✦ Your hands tell a lot about how you feel, so be aware of relaxing them and placing them on your partner in ways that feels comfortable.

Figure 5-13 was taken from a high balcony at the Villa Antonia near Austin, Texas. I told the couple where to go and they did the rest. Some of my favorite images from couple shoots involve motion. In Figure 5-14, it was too dark to shoot sharply focused images so I tried to make the blur work for me with a series of walking shots as the couple moved down this pier in the dark.

For Figure 5-15, I shot 20 or so images of the couple playing around in the rocks by the McKenzie River in western Oregon before the bride suddenly jumped up into his arms. They both threw their heads back and laughed before he put her back down. As soon as the shutter snapped, I knew we had the shot I was hoping for. Later I added a blur and some texture layers in Photoshop.

After spending 20 minutes working through various poses in this farm field near the wedding site, I decided to keep shooting as the groom helped his new bride through the tall weeds. Figure 5-16 is my favorite shot from the whole evening. Sometimes untrained models are at their best when they have to do something that makes them completely forget that they're still modeling.

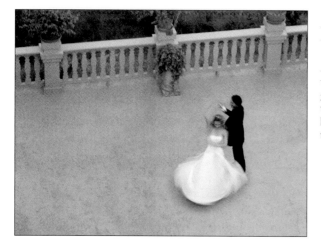

Figure 5-13: My only direction for this shot was to tell the couple where to go. I shot a bunch of images while they were dancing and none of them came out totally perfect. I used Photoshop to get the best shot of the groom and the best shot of the bride's dress blended together in one image that matched my original vision.

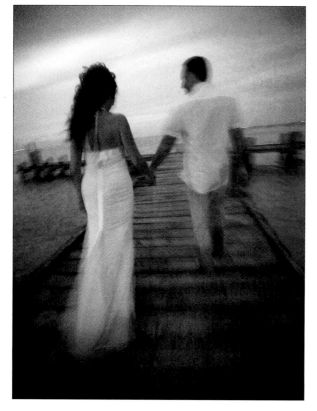

Figure 5-14: Capture the journey to and from the place where you intend to shoot images. Sometimes the way they move around naturally is the best part. In this case it was too dark to do anything but blurry motion shots, so I tried to work with that. You have to shoot a lot of test shots to get this to work, but it can create some really cool impressionistic art when it does finally come together.

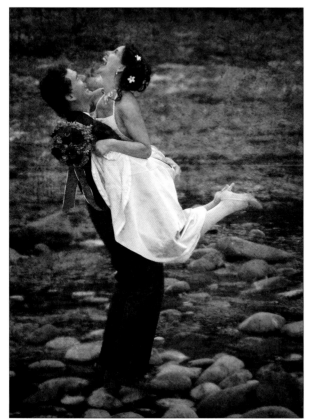

Figure 5-15: This shot is the result of placing the couple in this spot and simply asking them to do something with a bit more drama. They came up with this pose themselves and my only contribution was in knowing when to press the button.

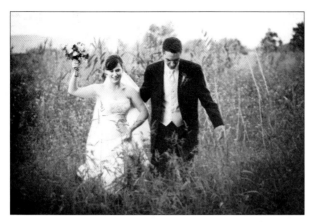

Figure 5-16: Once again, a little real-life action can break your couple out of "pose mode" and get them looking very natural. I like to get shots of them moving into, and out of, the locations where we go to make a portrait image. I placed a texture overlay on this image in Photoshop to give it a more aged, rustic feeling.

Think Creative Thoughts

When I first started to photograph weddings, another photographer offered to loan me his "system." The system consisted of a set of flash cards with pictures on them showing each of the standard poses that he would shoot throughout the wedding day. Even at that early stage, the thought of doing the same thing over and over again every weekend sent shudders through my body. Something inside me just can't stand the thought of repeating the same thing day after day.

This sort of mentality is what creates and encourages heartless wedding photography. Why not approach every wedding with a completely open mind? Don't try to repeat the successful things you did yesterday just because you can. Recognize the fact that there is absolutely no reason why the pictures you shoot today should have any similarity to the ones you shot yesterday, and in fact, it becomes your downfall when they do. Every day is a new adventure.

As part of your preparation for each wedding day, take a moment to clear your mind and say to yourself, "I'm going to forget about every wedding image I ever saw before this day. I'm going to keep my mind relaxed, but aware and open, and watch for the uniqueness of the people and the environment at hand so that I can act on the creative possibilities they present."

The truth is that anyone can practice, learn, and grow as an artist if they really put their heart into it. It's not about genetics — it's about determination. You can see the difference when you look through a photographer's Internet portfolio. Most of the online portfolios you'll find look as if the photographer is just going through the motions, doing the same thing day after day. The images they show lack heart. The few photographers that stand out from that crowd are truly inspiring and you feel amazed at the creativity and the beauty they capture in seemingly ordinary moments. To see some real inspiration, I suggest looking through the member websites at www.bestofweddingphotography.com.

Summary

There are no rules that determine what makes one wedding image beautiful and another bad; these are judgments that come from the viewer. In order to make a living at this craft, you must create images that please most, or at least some, of your viewers. With that in mind, there are a few basic photographic concepts that wedding photographers (an artists in general) loosely call "rules," but their real purpose is to provide some direction for beginning photographers, so they can see how an image will affect the viewer.

The rules eventually become meaningless as you develop your own unique and very heightened perception of two things: one is the perception of what viewers will find pleasant, which is required if you hope to make a living at this craft; the second is recognizing what you personally find pleasant. This is the part of your work that makes you unique.

As you master the basics in this chapter, you will slowly learn to venture away from these simple concepts while still creating images that please your customers. Somewhere along the line there is a point where a photographer slowly graduates from craftsperson to artist. A craft is something another person can teach you, such as the basics in this chapter. Art is where you make the craft your own by taking it where no one has gone before.

✦　　✦　　✦

6 Finding Beauty and Emotion in the Dressing Room

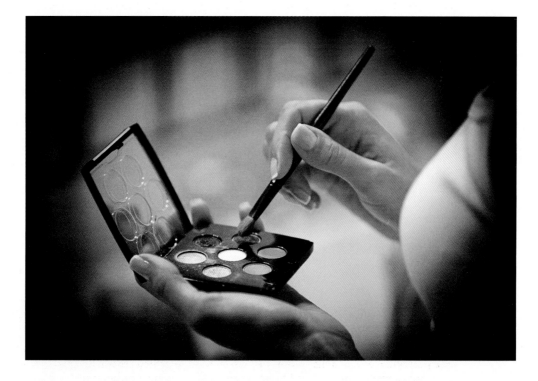

I n this chapter I discuss how to develop a comfortable relationship with people in the dressing room. It's important to know how to approach the bride's dressing room so that your clients trust you to capture great images while still respecting everyone's need for privacy. I also cover the equipment you'll need when shooting in a dressing room, dressing room etiquette, how to arrange the room, and how to create detail shots that capture the feeling of the day. The dressing room is where most of the behind-the-scenes action takes place in a swirl of activity around the bride. Without the images you capture for her, the bride would almost certainly not remember the events that occur during this hectic time.

For the average bride, getting married has been a lifelong dream. As the preparations start to come together and she finds herself in the dressing room, there comes a moment as the dress is held aloft by her mother and all of her most cherished friends, when she's suddenly struck by the overwhelming feeling that the day has arrived . . . it's really happening . . . and that's my dress! As the dress goes on, there is always a feeling in the air that this is truly a momentous occasion for these people. What a privilege it is as a photographer to be entrusted with capturing all that emotion and preserving it for them.

Choosing the Right Equipment

The list of equipment you might use in the dressing room can easily encompass every piece of photographic gear you own. Your needs on any particular day depend on the location. I've seen some dressing rooms that could easily house a small family and others that have barely enough room for you to squeeze in without bumping out one of the bridesmaids on the other side. The latter is by far the most common. Rarely do you get a room that is considered large by any standards. This is especially true with the groom's dressing room — if he gets a room at all. The bride's dressing room is usually slightly larger, and if you're lucky, it even has a few north-facing windows that let in some light. The main activity takes place around the mirror, so you'll still need to get in close to see anything. I can't count the number of times I've stood in bathtubs, shower stalls, and on top of toilets to get images of the bride in the mirror.

Wide-angle lens

To work in a small dressing room, you need a lens with a wide view. The wide-angle zoom is the most commonly used lens in the dressing room. Sometimes you may not be able to get more than a few feet away from your subjects, but even at this short distance, a wide-angle lens can include a surprisingly large amount of the scene. Figures 6-1 and 6-2 illustrate the close-range storytelling abilities of a wide-angle lens.

Figure 6-1: Everybody wants to help with the bride's dress and a wide-angle lens such as this 17mm includes everyone but the photographer.

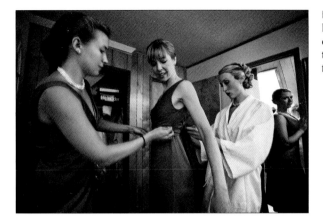

Figure 6-2: When the space is limited, a wide-angle lens can capture all the action, even though you may only be four or five feet away.

When you use this lens, remember that its major drawback is distortion — it makes close things look far larger than they really are, and it makes distant things look far smaller than they are in true life. If you want everything to appear a normal size, make sure that all of your subjects are roughly the same distance away from you. You can use the size factor to your advantage if you have something you want to emphasize because you can get it up close in the foreground and it will look huge.

Medium lens

Although the wide-angle lens excels at telling stories, it isn't very good at capturing romance. This is where medium-range lenses like the 50mm f/1.4 really start to shine. Some photographers prefer the 35mm f/1.4 because it provides a wider view than the 50mm while still retaining the same shallow depth-of-field effects these lenses are known for. In either case, this lens is wonderful for working around the bride's mirror to get close-ups of the makeup application and the attendants working their magic with brushes and curling irons. You could use a medium-range zoom lens like a 24-105mm. These zoom lenses work fine, but they typically don't offer the super-wide apertures that create the beautiful shallow depth-of-field effects.

You can't get a large view of the scene with these medium lenses, but much of the human perception of romance is achieved by leaving something to the imagination. Sometimes, as in Figure 6-3, showing a tiny slice of what was going on can be a lot more effective than showing everything because it lets your imagination fill in the missing details. The human mind is great at imagining romance and beauty — especially if you give it a little piece of something romantic to start with. If you shot the same picture with a wide angle, you would get the truth, which is that most dressing rooms are not that romantic. The shot in Figure 6-3 isolates a small portion of the dressing room action, leaving the rest to your imagination. The romantic feeling is further enhanced by the blurry motion of the bride sweeping back her hair. Does the blur detract from the image? Personally, I think it adds some life to it. Life isn't always sharp and it doesn't sit still; it moves constantly.

Figure 6-3: Isolating a small piece of the day creates the romantic feeling in this image by leaving so much to the imagination.

70-200mm telephoto lens

Another lens that sometimes works well around the mirror is the 70-200mm telephoto lens. If you happen to be stuck in a small room, you can use this lens by zooming in on faces and other small details. If you can place yourself a little farther away from the action, you can zoom in on your subjects while taking advantage of the fact that your distance puts them much more at ease.

I was able to take the image shown in Figure 6-4 by positioning myself in a nearby room and shooting through an open doorway into the bride's dressing room. Using a telephoto lens enabled me to get so far away that the bride didn't even know I was there. This is a huge advantage over using a shorter lenses like the 50mm, which can get a very similar image, but from a much closer distance.

Figure 6-4: Using a 200mm lens for this shot allowed me to stand in a nearby room so the bride didn't even know I was watching.

Lensbaby

The Lensbaby (www.lensbaby.com) also works well for creating romantic portraits, close-ups, and detail shots in the dressing room. The blurry effect this lens creates can easily be overdone, so I recommend using it sparingly. Figure 6-5 illustrates two versions of the same shot — one taken with the Lensbaby and one taken with a standard lens. If you have two camera bodies, putting the Lensbaby on one would be an excellent way to liven up your dressing room shots.

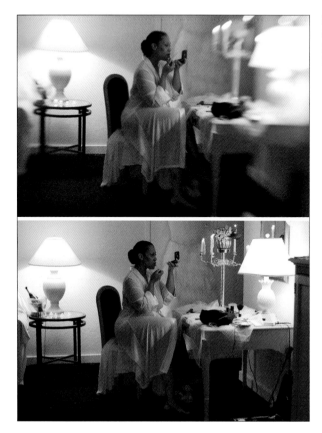

Figure 6-5: The Lensbaby can add a tremendous amount of romance to the images you create in the dressing room.

Lighting the Dressing Room

There are three types of images you might try to create in the dressing room: documentary, romantic, and detailed shots. Documentary images tell the story of what was happening and can be shot either with or without flash. Detailed shots and romantic portraits are best made without the use of electronic flash whenever possible. Occasionally a dressing room may be so dark it requires additional light, so I always make sure to have an on-camera flash with me; however, I affectionately call my flash the "romance sucker" because if you overdo it, you can completely remove the romantic feeling of natural light.

If you must use a flash in the dressing room, you can minimize the unnatural look one of two ways. The first method is to bounce the light off of the ceiling as was done to get the shot shown in Figure 6-6. This creates even illumination that looks much like a room that is lit by fluorescent ceiling lights. The second method is to set your flash to be a fill light at about 1 f-stop under the ambient light exposure. The term *ambient light* refers to the natural light, which is everything except the light created by your flash. If you set your camera to make a proper exposure for the ambient light, and then set your on-camera flash to produce a −1 flash exposure (do this with the flash exposure compensation control either on the camera or on the flash itself), you get a well-balanced indoor exposure with good color and some light shadows.

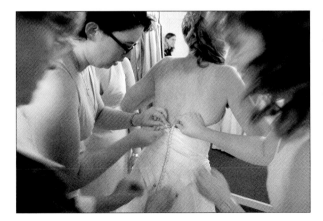

Figure 6-6: Documentary shots such as this do well with a little fill flash to brighten the colors and fill the shadows. You can make the light look a bit more natural by bouncing it off of the ceiling.

In most dressing rooms there will be plenty of window light and a single on-camera flash can be used as a fill light. However, for those rare occasions where you find yourself working in a really dark dressing room, remote flashes can also work well. To use a remote flash you need a flash slave set such as those made by RadioPopper (www.radiopopper.com) or Pocket Wizard (www.pocketwizard.com). You'll need one receiver unit for each flash unit and one transmitter to mount on the camera. Place the flash units in an area where they are unlikely to be included in your photos but where they can bounce light up into the ceiling or against a white wall. The number of remote flash units you use depends on the size of the room you're trying to light. One or two flash units are almost always sufficient for a small- to medium-sized dressing room.

Most modern flash units are already equipped with a built-in infrared slave capability. (In photography, the term *slave* is a term used to describe a piece of equipment that sends out a signal that triggers one or more flash units at the same time. For more information about using slaves, see Chapter 8.) The advantage of the radio version over the infrared version is that with radio signals, your flash can be hidden around corners or behind furniture and the signals will still work. With the infrared transmission, your flash must be visible to the transmitter in order to work. This means you can't place the flash units behind you because infrared transmitters always face the same direction as your camera. Occasionally you can get the infrared transmission to bounce around in a room and set off remote flashes, but if you really want to be able to count on this technique, you'll need to use radio slaves.

Window light

One of the best and most commonly available light sources in a dressing room is the natural light coming through a large window. If you have such a window available, the bride will almost always be able to save a few minutes for a window-light portrait. After the bride is dressed, her makeup applied, and her hair done, there is usually a little downtime before she heads for the altar. By then her nerves are usually starting to get the best of her and she will be more than happy to do something distracting. There are many ways to do this shot. You can shoot toward the window and get the bride in silhouette, you can put your back in the window and use the light coming in behind you, or you can place the bride near the window and shoot across the light so you get the light on one side of her and deep shadows on the other side. This type of sidelight is what I used to create the image in Figure 6-7. I chose a window that happened to be right beside a large mirror, then I had the bride adjust her veil while I shot over her shoulder to catch the reflection in the mirror.

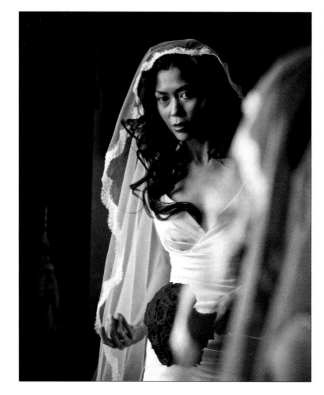

Figure 6-7: The bride's dressing room almost always has a window where you can create a few portraits. Finding a window and a mirror together is even better.

Giving the Bride Advice

If you have the opportunity to talk with the bride before she chooses her dressing room location, you could mention some of the following points to her so she'll know what to look for in a good dressing room. I have shared this information with many brides over the past years and I'm always surprised at how many of them follow every little detail. Brides are extremely interested in getting good pictures, and they've hired you for your expertise so of course they will appreciate every little tip you share with them to make their wedding day better or more photogenic. The primary benefit to you in sharing this information is that a good dressing room makes your pictures look better, so you should have as much interest as she does in the location. The following is a selection of tips I give the bride:

✦ Decorate the girl's dressing room just as carefully as you would any other part of the wedding location because a large portion of your pictures will be taken here.

✦ When you choose a location, pick a room with some r-o-o-m and lots of natural light.

✦ On the wedding day, have your girls clean up all the non-wedding messes, such as piles of blue jeans and tennis shoes or other clothing that are not wedding related, but don't make the room look too neat; messes are okay if they're wedding messes. Empty boxes and bags should be placed somewhere outside the dressing room.

✦ It looks wonderful to have all the dresses hanging and shoes lying around on the floor, but they look awful if they're still in the box, or if they have piles of plastic wrappers and cardboard boxes lying next to them.

✦ Flowers also look much better in some sort of vases instead of the cardboard boxes the florist packed them in.

✦ Cover up any ugly furniture with plain white cloth or sheets.

✦ Lighting is extremely important for the girl's dressing room. The windows absolutely must be open to bring in the natural light. If you have anything distracting or unsightly that would be visible through the open windows, place some light gauzy curtains over them to cut back on the view while still allowing the light to come in.

✦ If you have no window light, think romance, and get creative. Use lots of candles or little Christmas lights placed around the room.

✦ Shafts of sunlight streaming in the windows may look great to human eyes, but that extreme level of brightness in an otherwise dark room is a photographer's nightmare. If you must use a room with direct sun on the windows, put up some curtains to diffuse it. You can also put light cotton cloth over the outside of the window to cut down the direct sun.

✦ If you want the absolute best lighting for your dressing room, pick a room with large, north-facing windows — this is a photographer's dream come true because plenty of light will come in, but direct sunlight won't.

As the photographer, you may be thinking, "Would a bride really do all this?" Never underestimate how far a bride will go for good pictures. Some of the people who hire you will border on fanatical when it comes to getting good pictures.

Fake window light

Another technique that can be used successfully in a dressing room is to bounce your flash horizontally into a nearby wall. The light that bounces back to strike the bride will look very much like the light from an open window. To create this effect, make sure your flash has no diffusion attachments that will direct parts of the light straight at the bride, because you want the entire beam to go to the wall first. You can use this "bounce" flash technique at other times as well. The primary advantage of this technique is that it produces a soft sidelight similar to that of an open window. As you can see in Figure 6-8, the side-lighting effect produces beautiful shadows with a romantic feel that is far different from what you get when you shoot your flash directly at the bride. I made this shot in a large room, which created dark shadows because no light bounced back from the other walls. If the room was smaller, some light would have bounced back to fill the shadows in, making them less dark.

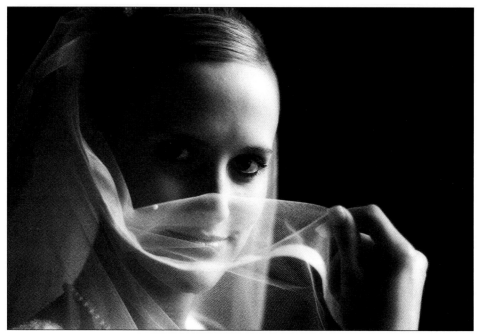

Figure 6-8: You can create fake window light by bouncing your flash horizontally off of a wall to the side of the bride.

Shooting the Guy's Room

The guys don't care about exact colors of their makeup, so the room they choose might have almost anything for light. Fluorescent seems to be very common and good windows are not so common. I always bring my on-camera flash to the groom's dressing room because it is very likely to be either dark, or lit by some strange combination of lights and the TV. Getting dressed is a far more low-key affair for the guys than it is for the women. When the guys finally decide to start dressing, they gather everything up and pack into the nearest hotel room or large bathroom where they will almost always help each other out with cufflinks and the ties, but you better be quick if you want to catch it because it usually consists of a little. . . tighten this, pull that strap, straighten here, pat on the back, and it's done. There isn't much standing around debating about hairstyles, and there definitely isn't a lot of emotional hugging and kissing or anything like that. The whole operation usually takes about 10 to 15 minutes.

As the photographer, you have to watch carefully for moments such as those shown in Figures 6-9 and 6-10, where the groom needs help with his tie or cufflinks. You should already be in position and waiting for it to happen so you can shoot it fast. You absolutely must be ready to shoot quickly and without interfering in the process because guys are notoriously impatient with photographers who want them to repeat something just for a picture. This encounter is your first chance to make an impression on the groom and his crew. If you make it painless, you can earn a lot of respect, which translates into the guys being much more willing to work with you later in the day.

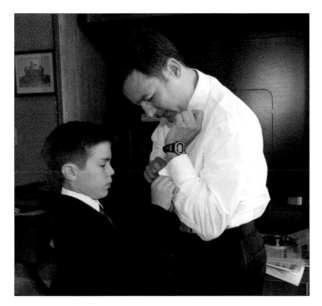

Figure 6-9: A tender moment between father and son is a rare treat in the guy's dressing room.

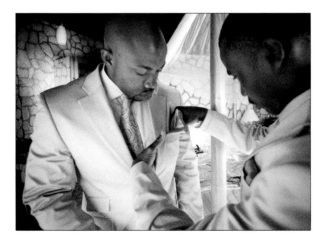

Figure 6-10: Moments such as this don't last long in the guy's dressing room — you have to be ready to shoot fast.

Getting the Detail Shots

A medium lens such as the 50mm f/1.4 is great at isolating small details in the dressing room. I always enjoy the challenge of roaming around the room with this lens while searching out the tiny details the bride prepared for her wedding day. Each detail gets its own portrait. As you can see in Figures 6-11, 6-12, 6-13, and 6-14, everything in the room is fair game: the curls in her hair, the pearls, the rings, makeup, shoes, flowers, wine bottles, cards from the family, and so on.

Figure 6-11: Detail shots like this preserve little things about the dressing room that the bride may not have even noticed at the time.

Figure 6-12: Small sets such as this one are loosely arranged and when possible, it's great if you can get them to look as though they might have actually been found this way.

Figure 6-13: Turning the bride's shoes into a bit of art will certainly be appreciated for years to come.

Figure 6-14: Every little detail you can capture about the bride's dress, makeup, and jewelry will become a cherished memory.

The shallow depth of field produced by a wide aperture lens works great to isolate small portions of each set you create. Pick a point of interest to place the focus on and the rest gets a soft blur. Be careful not to be too perfect with these setups — you don't want to create a look that appears too organized or too well lit. The goal is not to get the precise look of a studio photograph — just a casual portrait of the small details. To the untrained viewer, many of these scenes should look as if you might have just found it that way.

Dressing Room Etiquette

Working in a dressing room used by the opposite gender from yourself is obviously a little tricky. Many expectations and a lot of trust can be built up or destroyed depending on how you handle yourself during this delicate time. Almost every bride feels somewhat awkward around the nudity issue. They're torn between wanting you to leave and wanting you to keep taking pictures. The following tips are some ideas for ways to approach the dressing room in a manner that can avoid embarrassment and bad feelings for both you and your clients.

Knock before entering

Perhaps this sounds self-explanatory but you should always knock before entering any dressing room — even the one for your own gender, and even if the door is not closed. Most people have a certain amount of uneasiness associated with undressing in front of strangers. For them to trust you in the dressing room, they need to see that you have respect for their privacy. If you build this trust early in the day by always knocking and yelling through the door, "The photographer is here, is everybody decent?" they will soon trust you enough to allow you to come and go as you wish throughout the day.

Talk about the nudity issue

Everyone is different when it comes to modesty. Some brides I've worked with strip down completely naked without a care, and others have asked me to leave every time they adjust their veil. To make sure everyone is comfortable with you being there, it's best to approach the issue of nudity yourself, early in the day, and get it out in the open for all to hear. That way you can alleviate any stress and give everyone involved a feeling that you are acting in a professional manner and you will stay or go as they wish. I try to bring it up when I'm first entering the dressing room, right after introductions and before the picture taking starts. My speech goes something like this:

"Hello, everyone. My name is ___ and this is ___. We are the photographers and we'll be shooting photos with you today. While we're here in the dressing room, if you want us to step outside while you change, or for any reason at all, just let us know and we'll wait outside. If we don't hear any requests to leave, we'll assume that whatever you're doing is something you want recorded in the pictures. If there are any images that contain nudity, we put them on a separate disc so the bride and groom can control who sees them."

After giving a speech like this, you'll often hear a sigh of relief from the bride. It eases her tension and reassures her that you are simply there to capture images of the day. If she wants pictures of herself getting dressed, that's up to her.

Know what not to shoot

Taking photos of children in the dressing room is an extremely sensitive area. My general rule is never photograph nude or partially nude children unless they are actively involved in a photograph that was requested and arranged by the other adults in the wedding party — not you. For example, I once shot pictures of all the guys in their underwear at their request, and they wanted the ring bearers to be included. I can't imagine anyone complaining to me about something like that because I was simply doing what my clients requested and had nothing to do with arranging the shot.

Another general rule that keeps everything safe is the swimsuit rule. If a photo will show more than what you would see if the person were in a swimsuit at the public pool, don't shoot it, unless it's the bride and she's requested that you shoot the whole process — even if she's nude.

Older women often ask to be excluded from pictures in the dressing room — especially if they don't have their makeup on yet. Use your own instincts when deciding if you want to follow this request because many times the women have mild insecurities about their appearance, but at the same time, they and the bride will appreciate the photos. After everything gets going, the self-conscious crowd will usually loosen up a bit and forget you're there. The bride will definitely want to see all the moms and grandmas in the photos. Of course, any person who seems to feel genuinely uncomfortable with being photographed should be avoided if possible.

Summary

Developing a comfortable relationship with everyone in the dressing room is a key element in your ability to tell the full story of the wedding day. If you set the scene with a professional attitude right from the beginning, your clients will soon learn they can trust you to capture great images while still respecting everyone's differing needs for privacy.

Equipment for lighting and shooting in dressing rooms runs the entire gamut. All your lenses and lights can be useful depending on the size of the room and whether or not you have any windows. The guy's dressing room can be the worst, often involving funky lights and very cramped quarters. If you're lucky, you will have talked the bride into finding a North-facing room and decorating it to look a bit more elegant and wedding-like than the average hotel room. But no matter what sort of physical accommodations you find yourself working in, this chapter gives you some great ideas and pointers for shooting in the dressing room.

7 Shooting Outdoors

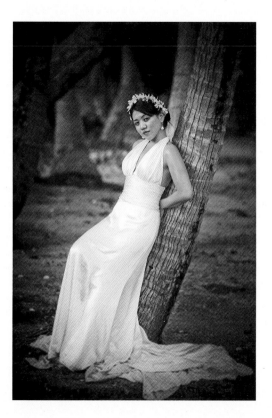

Any discussion about photographing outdoor weddings should include the different lighting conditions you may encounter during different times of the day. In this chapter I cover general concepts of outdoor photography as well as specific techniques to help you deal with different lighting conditions, from bright sun to complete darkness and everything in between.

Knowing how to take a good photograph is only half the problem when you work outdoors. You also have to know how to look around and pick places where the light has certain desirable characteristics that will enhance your group shots or your romantic portraits.

Choosing the Right Equipment

The good news is that you do not need to have special equipment to shoot an outdoor wedding. You won't need anything more than your standard set of gear: a camera, three lenses, a couple of memory cards, and a hot-shoe–mounted flash. You could add a couple of reflectors to bounce light in on your subjects, and of course, as always, a good tripod is worth its weight in gold when it comes time to shoot an hour's worth of family group photos.

Except for the time spent in the dressing room, many weddings take place completely outdoors. You may find yourself going from the dressing room straight out into one of the most challenging lighting situations a wedding photographer can experience — bright sun. Later in the evening, you may have to deal with low light as twilight approaches, and then darkness as the reception carries on into the night. One thing is for sure: a wedding photographer's job is never the same — it changes drastically from one job to the next, and when it's outdoors, the job also changes from moment to moment throughout the day.

The type of equipment does not change from indoor to outdoor pictures; what changes is how you use that equipment. For example, the same flash that provides your only light indoors can be used as a fill light to brighten up the shadows in an outdoor shot. Or you can use the same wide-angle lens you might use indoors in the bride's dressing room to capture the ceremony outside.

Shooting in Bright Sunlight

Bright sunlight is one of the most difficult conditions you must learn to deal with as a digital wedding photographer. Wasn't it only a few short years ago that we all shot film and didn't worry so much about exposure? Film captured such a wide range of brightness that we could be pretty careless about exposures, and the lab could always correct it. In fact, overexposing negative film a stop or two actually improved it.

Those days are long gone, and unfortunately so is the ability to be carefree about your exposure on a sunny day. Direct sunlight and the shadows it produces create an extremely wide range of light values. You have to worry about overexposing the highlights and underexposing the shadows at the same time. Understanding how to address this problem requires you to know a little background on the limitations of your digital camera. Much of the information about RAW files in Chapter 4 is extremely important when you shoot in bright sun. Hopefully by now, you're convinced that any paid photography job absolutely must be shot in RAW file format — I don't think I could ever preach this too much.

Know your camera's dynamic range

The problem you encounter on a sunny day is that there is a difference of roughly ten f-stops between those areas in direct sun and those in complete shadows. When you expose an image in these conditions, you can set your exposure for either the sunny side or the shady side, but you can't make a correct exposure for both at the same time. This is a limitation of all cameras — film or digital. The total range of light that a particular camera can capture in one image, from the brightest white that still contains detail to the darkest black that still contains detail, is called

the *dynamic range* of that particular camera. If you shoot film, each film has a different dynamic range; therefore, the dynamic range is a quality of the film and not the camera. With digital, there are many different manufacturers of digital chips, and each type of chip has a different dynamic range. However, after a chip has been built into a camera, the dynamic range becomes a fixed quality of your camera and cannot be changed.

The light recording chip in a digital camera is referred to as either a CMOS (complementary metal oxide semiconductor) or CCD (charge-coupled device). Both types of light-gathering chips have a similar dynamic range, which is growing steadily as the technology improves, although the dynamic range does, and always will, have a limit. Currently, the dynamic range of most professional-level cameras is great enough that you won't encounter problems with blocked-up highlights or shadows unless you expose the image incorrectly. At the time of this writing, technology has progressed to the point that most high-quality digital cameras have at least an 11 f-stop dynamic range. (For a great database with comparisons of the current cameras, check out www.dxomark.com. This website provides information about many popular camera models, including their dynamic range, tonal range, color sensitivity, color response, and signal-to-noise ratio.)

On a bright sunny day, the range of tones from brightest to darkest very closely matches the maximum dynamic range of most professional-level cameras. What that means is if you only slightly miss your exposure, you begin to get pure white highlights with no detail, or pure black shadows with no detail, depending on which way your exposure was off. This makes it easy to miss your exposure just enough to ruin an image, especially if you miss in the direction of overexposure, which creates blown out highlights that are extremely noticeable. Conversely, the increased digital noise resulting from underexposure is much less noticeable to the average viewer, especially considering that you normally use a low ISO setting on a sunny day. So even though I previously said that underexposure is never good, on a sunny day it is practical to underexpose slightly just as a safety measure. I don't do this in situations where I have time to check the histogram and get it right (like for group photos), but when I'm trying to shoot fast to get candids at a wedding, I frequently set my camera for a –1 exposure compensation just to be safe. This is one of those times when you'll just have to get to know your camera and how it performs in bright light situations.

Watch the histogram and blinking highlight warning

Most professional-level digital cameras give you the option to turn on the histogram and the blinking highlight warning. On a bright sunny day it's much easier to see both of these features than it is to look at an image on the LCD. The blinking highlight warning is particularly helpful for making sure you don't blow out the highlights. Each area that approaches pure white (no detail) starts blinking in a different color, which is usually black on most cameras. Of course, all brightly lit photos will have some small areas of super bright highlight (called *specular highlights*) that will be perfectly acceptable without detail. You must use your own judgment about how big these highlights can be before they become unacceptable.

One thing to keep in mind when using the blinking highlight warning is that the blinking area is a *warning*. It does not mean that all detail will be gone in the entire area that blinks. It means the blinking areas are *approaching* pure white, and as the blinking area gets larger, the brightest areas will indeed begin to lose all detail.

Push It to the Right

Your camera does not record light evenly from left to right across the histogram. In fact, it records the vast majority of the exposure data in the third of the histogram on the right side. This is the area of the histogram where the majority of the light actually is, while the left side of the histogram represents the darker tones. And because darkness is basically the absence of light, this portion of the histogram simply doesn't have as much to record.

If you'll remember from previous discussions about digital noise, the noise appears in the shadow areas where there is not enough light striking the sensor for the camera to know what to do. It has little or no information to work with in these dark areas so it has to make something up to fill in the gaps. No matter what ISO setting you use, you get digital noise in dark shadow areas, but the digital noise will become more and more pronounced as your ISO setting gets higher and higher. In every exposure that contains digital noise, there are probably other areas where plenty of light strikes the sensor, and those areas will have far less digital noise — if any. In the bright areas, the camera has plenty of information about how much and what color the light is so it doesn't have to make up anything.

As mentioned in Chapter 4, when you make an exposure, if you can push it to the right side of the histogram (by overexposing) as far as possible without losing highlight detail, this will bring the shadow areas more to the right as well. The result of this slight overexposure is that it gives your shadows more light, which cuts down on the amount of guesswork the camera must do in the shadows, thus lowering the amount of digital noise in the shadows. This technique will make your image seem too bright, but with the exposure and brightness controls in your RAW processing software, you can very easily bring the exposure back down to normal. The benefits you reap with this technique include having better color overall, and in the shadows you'll get much better detail and very low levels of digital noise. This technique is not necessary at all times. But if you use it at times where there are very dark shadows, and especially late in the evening when the light is generally low, you will see a definite improvement.

Shade your lens

No matter what lens you place on your camera, you should always have two things on the front of it: (1) a high quality clear filter and (2) the standard lens shade made specifically for that lens. Using the lens shade is important even when you're shooting indoors, but it becomes absolutely vital when you're shooting outdoors. The standard factory lens shade will block out much of the stray light that would otherwise come into your lens from the side. You can easily see the effects of this stray light when the sun hits directly on the front of your lens. However, not so obvious is the smaller effect stray light makes on all your photos if you don't use the

lens shade. Sometimes when you shoot almost directly toward the sun, even the factory lens shade won't be enough to block the light from hitting your lens and you'll need to use your own hand to reach out and block the light. You can see the effects of this in Figure 7-1.

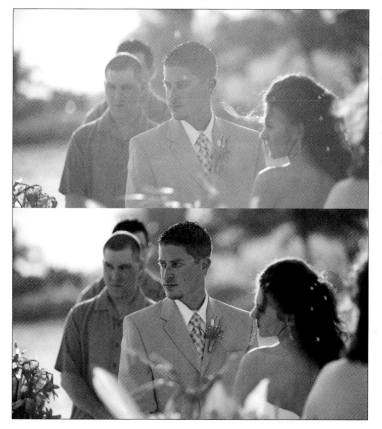

Figure 7-1: I shot both images with a 200mm lens with the standard lens shade in place. In the second version, I held my hand out in front and to the side of the lens to further block the direct sun from striking the glass.

Another way to keep the light out of your lens is to use a longer focal length. For example, in Figure 7-2, I shot the first image at 21mm. After noticing the sun flare, I backed up and shot basically the same framing, with the same lens, but at 40mm. Both shots had the standard lens hood in place. The reason this works is that a zoom lens moves the inner glass elements very close to the front for the wider portions of the zoom range and then it pulls the glass elements back toward the back of the lens as you zoom out. When the glass elements are near the front, the sun hits them far more easily than when they are retracted toward the back of the lens.

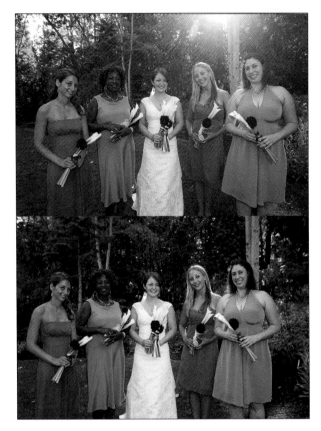

Figure 7-2: The top image was captured at 21mm. The bottom image was captured at 40mm. Zooming out draws the inner lens elements to the back of the lens and helps cut down on lens flare.

Shooting in Overcast Light

Shooting in overcast light is far easier than shooting in direct sunlight. The clouds create a huge cover that seems to radiate and diffuse the light at the same time. To the human eye it appears as if there are no shadows anywhere. However, all it takes is a couple test shots to see this isn't true. Overcast light still has some direction because it all comes from the general direction of the sun, even if you can't see exactly where the sun is at the moment. The light it produces still creates shadows, and just as with direct light, the quality and severity of those shadows still depend on the angle your subject is facing to the sun. Finding the angle to the sun may be difficult because the sun is above the clouds and you might not be able to see it, but you can be assured that this angle still affects your images as it did in direct sunlight — although with a much less extreme effect.

Overcast light appears so even and mild that you may be lulled into thinking that you don't need any flash at all. This is true if you're shooting romantic portraits, but a fill flash can add a sparkle to the eyes and just enough direct light to fill in the shadows under the eyebrows and brighten up the colors. The trick is to set the flash so low that it isn't noticeable to the

untrained eye. This requires an exposure compensation setting of roughly –1 on a mildly overcast day to –2 on a heavily overcast day. Despite the shadows, journalistic and romantic images both work well with natural light on overcast days.

Shooting in the Late Evening

When you shoot with natural light in the late evening, you will need to use fast lenses or a flash. Much of the information about the various cameras and lenses and flash units to use at this time of day was discussed previously in Chapter 3. However, the way you must mix these different techniques together in the late evening at an outdoor wedding is new.

As the evening gives way to the darkness of night, you might go back and forth between the low-light technique of shooting with extremely wide aperture lenses, to the more widely accepted look of flash. You can easily accomplish this if you have two camera bodies (which you always should); one set for low light and the other for flash shooting. I recommend using a wide zoom with the flash because most of your flash work at this time of the day will be close-range documentary work for things like cutting the cake or throwing the flowers. On the other camera body you can set up a wide aperture lens such as the 50mm f/1.4 to catch images using only available light. These two types of images are vastly different in character and they create a completely different feel. I personally consider both types of images to be essential in telling the story at this time of the day. And as you can see in Figure 7-3, the wide apertures are essential at this time of day because you absolutely cannot do the same thing with cheap lenses.

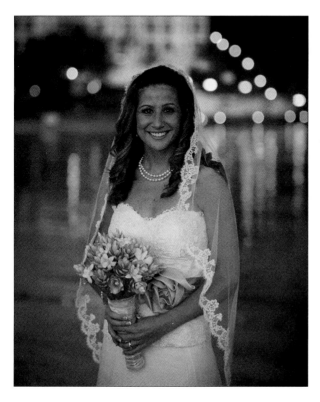

Figure 7-3: This late evening image would have been impossible without a wide aperture lens. I shot this at ISO 1600, 200mm, f/2.8, 1/20 second, hand-held with Canon's internal stabilized lens. Handholding anything at this slow shutter speed would have been impossible without the image stabilization and the wide aperture.

Taking Outdoor Group Photos

Creating a good group shot outdoors is a lot more complex than simply lining people up. The hardest part actually happens before your subjects are even involved; this is when you must survey the available landscape to pick out the location with the best light. There are factors to consider, such as how far can you make the grandparents walk in order to get to a great spot? Are you going to include the background, or are you going to blur it out? Do you need a flash, or are you going to use natural light? You must calculate all these factors and more before you ever fire a shot, and preferably before you even begin to gather your group.

As you scan your wedding venue in search of a place to do your group shots, the first and foremost consideration is to get even light on all the faces. It doesn't matter whether the light is from direct sunlight, backlight, shade, or anything in between. All that really matters is that you get the same light on everyone in the group.

Shooting in direct, midday sun

Shooting group shots in direct midday sun should be your last option. Direct sun will work great in the early morning (that is, before 10:00 a.m.) and in the late evening when the light is low and much less harsh. If you absolutely have to shoot a group in direct midday sunlight, you can make the best of the situation by knowing a few tricks. The first is that the entire group must be in the same light. If you place one part of the group in shade and the other part in sun, you're wasting everyone's time. You should also watch to make sure that one person doesn't throw a shadow on other people in the group. In the top of Figure 7-4, I placed the group facing about 45 degrees from the sun so that it hit everyone evenly. However, in the next shot (lower image), the tall groomsman on the far right stepped forward and blocked the sun off the man next to him. A shadow like this is enough to completely ruin a group shot.

Shooting in direct, late-afternoon sun

A late-afternoon sun that is low on the horizon typically produces extremely warm color tones. This warm glow can be beautiful, but be prepared to spend some time on the computer if you're determined to get your colors balanced back to true. The real problem in this light is that you want to get the light striking everyone's faces evenly, but if you turn your group straight into the sun, everyone will squint their eyes. Squinting can be a problem in midday but it becomes extremely troublesome in the late afternoon when the sun is low. If you turn your group too far away from the sun, each person will create a shadow that falls across his or her neighbor. Your challenge will be to turn your group at just the perfect angle so that the sun hits everyone evenly without any one person throwing a shadow onto the face of the person nearby, and at the same time, everyone can still manage to look at you without squinting. As a general starting point, try facing your subjects at roughly a 45-degree angle from the sun as was done in Figure 7-5; then fine-tune the angle to get the best background.

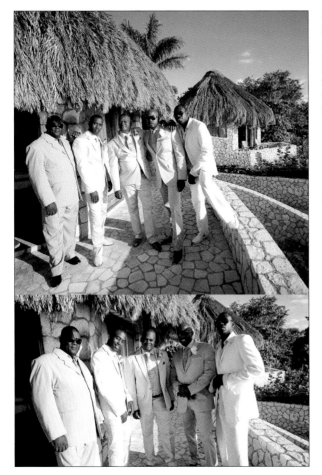

Figure 7-4: This pair of sunny group shots shows what happens when one person throws a shadow across someone else in the group. In this case it was the groom who was shaded out when the tall groomsman stepped forward as I was shooting.

Figure 7-5: For this shot I turned the bride and her mother roughly 45 degrees away from the evening sun. This angle cuts down on squinting while still keeping both women in the same light.

A Quick Formula for Shooting Groups in Direct Sunlight

If you absolutely have to shoot your groups in direct, midday sun, try these techniques:

✦ Choose a location that has the same light hitting the entire group.

✦ Set your flash on TTL with no exposure compensation.

✦ Set your ISO to 100.

✦ Put your camera in the mode that allows you to lock in the shutter speed, and then choose the highest shutter speed that will sync with your flash. This enables the camera to automatically choose the correct aperture for each exposure.

✦ If possible, turn your group so the sun is on their backs and use your flash to light their faces. If that isn't possible, turn your group to face 45 degrees away from the sun to cut down on squinting while still allowing even light on every face.

✦ When shooting toward the sun, shade your lens so direct sun doesn't strike the glass.

Finding shade

The shade under a large tree, near a building, or behind a hillside can provide the perfect spot for group shots on a sunny day. Figure 7-6 shows an example of the light I found in the shadow of a cliff right beside the beach. At midday this was the only shady spot in the entire area, so I talked the entire family and wedding party into trekking down the trail just to get in this one patch of perfect shade. An added advantage of expending so much energy to find such a spot is that it enables you to get your group shots finished early in the day, thus saving the late evening light for working with the bride and groom alone.

Perhaps the single most important aspect to look for in choosing a location for portrait and group images is the availability of a big solid block of shade. The even light you can find under a nice thick shade tree or beside a tall building can create a softness that will almost always be a vast improvement over the results you would get from shooting in direct sunlight.

If you're looking at a tree as a potential shady spot, bear in mind that you need solid shade, not the patchy, dappled light you get under a small tree. This sort of mixed light is difficult to use because no matter how you move people around, it seems like the tree always gets a puff of wind just before you press the shutter, and a shaft of light sneaks through, creating a big bright spot on somebody's face.

Figure 7-6: This afternoon shot was taken in the shade of a high cliff along the beach. The cliff does not appear in the image, but the beautiful shade it created was not available anywhere else in the area.

Here's a tip for using trees for shade: Don't position your subjects too far under the tree. Place your subjects slightly under the tree, on the side opposite the sun and facing out away from the tree toward the open sky, as was done to create the shot shown in Figure 7-7. This allows the tree to block the direct sun while the open sky provides enough reflected light to still brighten up the faces of your group. If you put your subjects far under the tree, dark shadows will appear on their faces.

The background should also be uniform in texture and a bit on the dark side. Bright backgrounds are difficult to expose properly and they tend to detract from the subjects.

Figure 7-7: I placed this group under the shade of a tree and chose a background of uniformly dark foliage. I also placed the group about 20 feet out away from the trees in the background so those trees would not fall within the zone of focus. I shot the scene at f/8 and used a fill flash set at –1 to get bright colors without the obvious look of a flash.

Using Fill Flash

On-camera flash is an extremely effective tool when used outdoors during the day. Figure 7-8 shows how much brighter the colors appear when you use a fill flash. The term *fill flash* means to set the flash so that it produces less light than the ambient (naturally available) light. You want it to produce just enough light to "fill in" any dark shadows and at the same time brighten up the colors. To do this, simply dial in a flash exposure compensation in the direction of underexposure. How much underexposure depends on the type of ambient light you have that day. My general rule is to set fill flash exposures as follows:

Bright sun: –0 stops

Cloudy: –1 stop

Overcast: –2 stops

This provides just enough light to brighten up the colors and eliminate or reduce the shadows under the eyes, but not so much as to make the image look obviously flashed. The brightly flashed look can be fine for group shots, but it does nothing to add to the realistic feel of a journalistic-style image, and it definitely takes away from any feelings of romance in your couple shots.

Figure 7-8: Fill flash adds just enough light to brighten the colors and add a little sparkle to the eyes. Notice also that I moved my group into a patch of sunlight to get some rim light on the hair, and I placed them away from the background to throw it out of focus.

Backlight Techniques

Backlighting refers to the technique of turning your subjects so that the sun hits their backs, and their faces are completely in shadow, as shown in Figure 7-9. This technique creates a beautiful glowing highlight, or "rim light," around the subject. With backlighting, you can create the image two ways, and each one produces a very different look. The first method is to simply expose for the faces and let the background be extra bright. The second method is to expose for the background and use a fill flash to light the faces. Either method produces excellent results, but for group shots where you want the subjects to be well lit and easily recognizable, you will typically get the best results with the fill flash method.

With group photos, a problem you may often encounter is that your group will usually take up the middle of the scene and the camera will want to expose for that. The easiest way to compensate for this is to set your camera to Manual mode to lock in the proper exposure for the background. Once that exposure is set, you can use the fill flash techniques described previously to light the front of your group.

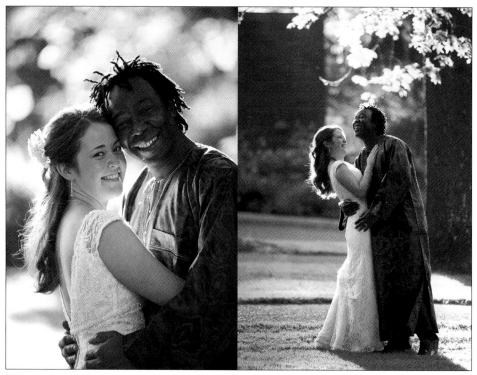

Figure 7-9: Backlighting creates a nice halo of light around the edges of your subject. In this image I exposed for the faces and let the background get really bright.

Using Light Reflectors

One type of location you should always be on the lookout for is a shaded area with a large reflective surface nearby that throws light back into the shadows, as shown in Figure 7-10.

These conditions are not exactly common. Fortunately there is a portable version that produces similar results. Figures 7-11 and 7-12 show the effects of using a commercially available light reflector to bounce light into a shaded area. Using a reflector such as this requires an assistant, but even if you shoot weddings alone, you can almost always find a bridesmaid or groomsman who would love to help out by holding the reflector for you.

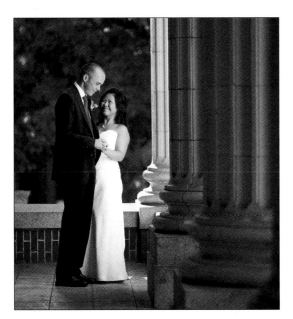

Figure 7-10: A large reflective object near a shady spot can create beautiful light. In this case, I noticed a beam of sunlight hitting one of the large pillars so I moved the couple into a position where the reflected light bounced back toward them.

Figure 7-11: Portable light reflectors can add just the right touch for brightening up a shady spot without the artificial look of an electronic flash.

Figure 7-12: At a destination wedding I almost always shoot alone so I often enlist the help of a friend or relative to hold the reflector. In this case, Mom was all too happy to get in on the action.

Background Choices

If you want your subjects to stand out, your best bet is to find a background that is somewhat uniform and has a medium to dark tone. Darker-toned backgrounds allow your subjects to stand out much better than light ones.

Including the background

If the background itself is interesting enough to make it an attractive part of the image, you can place your group close to the background and use a smaller aperture like f/8 or f/11 to make them both appear sharp and clear. This gives you a large depth of field that captures every detail of the background while keeping your subjects in focus as well.

With groups of people, there will always be some faces that are closer and some farther from the camera. To get everyone in focus, you'll need to use an aperture of f/8 or f/11 to ensure you get everyone in focus from the front of the group to the back. These apertures will automatically render your background fairly sharp even if it is far away. You can still adjust how prominent you want the background to be in the composition by adjusting how close, or how far away you place your group from the background.

Minimizing the background

In general, a background is just that — a background. As such it should complement the scene while commanding much less attention than the subjects. My favorite way of accomplishing this feat is to put some distance between the subject and the background. When this is done correctly, the background is recognizable but slightly blurred at the same time. Some of the worst group shots I've ever created were done by placing my subjects too close to a group of bushes or trees and then shooting with a wide-angle lens, which gets a lot of depth of field no matter what aperture you use. This creates a background that is full of confusing detail and it actually detracts from the image because the subjects blend in with the background instead of standing out clearly. A background with too much detail is called a "busy" background.

The best way to minimize the detail in a busy background is to put some distance between your group and the background, then choose a wide aperture (such as f/4 or f/5.6) and back yourself up far enough that you can use a medium telephoto lens. The result will be a background with enough blur to minimize the distraction of the busy details.

The most obvious way to minimize the background is discussed in Chapter 3, in the section on the angle of view you get from different types of lenses. Telephoto lenses get a very narrow angle of view, which makes them the perfect tool to use when you can only find a really small section of the background that is acceptable. And, of course, an added bonus of using a telephoto is that it can get a really shallow depth of field, so you have the option of minimizing the background a little with an aperture like f/5.6, or using a wide aperture like f/2.8, which will throw it so completely out of focus as to make it totally unrecognizable.

Letting the background pick your lens

The size and beauty of your background can determine which lens you use to shoot your group and portrait pictures. For example, if you have a large, beautiful background like the one shown in Figure 7-13, you can use a wide-angle lens, which includes a big chunk of real estate behind the subject. If you have a less attractive background, you can use a telephoto to capture only a small piece of the background behind the subject.

Deciding whether or not to include the background also determines what sort of aperture you will use. Large apertures (small numbers) get a very shallow depth of field, which de-emphasizes the background by blurring it out. Smaller apertures (bigger numbers) create much more depth of field, making foreground and background details sharp.

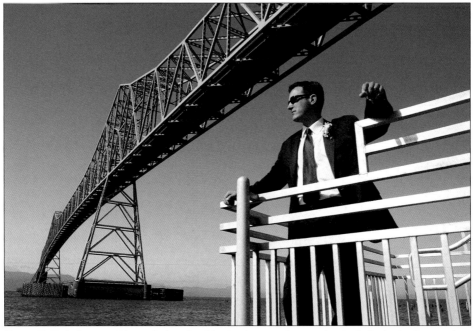

Figure 7-13: I chose a wide-angle lens for this shot because I wanted to include the background and allow it to become part of the subject of the image.

Summary

Knowing how to take photographs in direct sun is one of the most difficult of all the skills a wedding photographer must possess. This chapter helps you understand what is happening inside your camera that makes shooting on a sunny day so difficult. For your next wedding, the only fear you'll have about working in the sun will be whether or not you have enough sunscreen.

Overcast and late evening light also present a few challenges — although neither is as daunting as direct sun. Knowing when to use the fill flash and how much exposure compensation to use to match different levels of outdoor light can improve your images tremendously by brightening up colors and skin tones while still preserving the natural look.

Knowing how to shoot is no more important than knowing where to shoot. Finding a place that has great light, arranging the group, and knowing which lens to use to achieve the desired result, are skills that may take years of practice to develop. With the guidance and knowledge you gain from this chapter, you should start to see these opportunities much more quickly.

8 Shooting Indoors

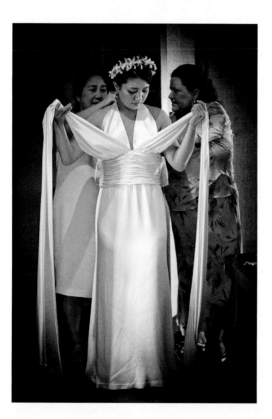

P hotographing indoor weddings requires some specialized equipment as well as a lot of knowledge about how an indoor ceremony works. Topics I cover in this chapter include how to set up your lights, how to avoid reflection, and how to choose locations that will make a good background for family group shots. I discuss reflections in detail because they are a constant threat to your indoor images, and you need to know why they happen and how to avoid them if you want to be successful shooting indoors.

Choosing the Right Equipment

Depending on the type of images you shoot, indoor weddings may require a bit more specialized equipment than outdoor weddings. The majority of your camera equipment remains the same, but very few churches or other indoor locations will be well lit, so you will frequently find yourself needing a tripod; and if you don't have fast lenses, you may also need to supply your own light sources. No matter what your style of shooting is, you will almost always need to use extra light sources for the family group shots at an indoor wedding. However, regardless of how large or small, or bright or dark, the venue may be, most photojournalistic-style photographers, and many portrait journalists, will bring no more lighting equipment than the standard on-camera flash because it captures the true character of the location regardless of what that may be.

Tripods

Some ceremony locations such as the one shown in Figure 8-1 are so dark as to practically require the use of a tripod. A tripod enables you to use the slow shutter speeds necessary to get some ambient light in the image, and this ambient light is the easiest way to get light on your background without having to light it up with your own flash units.

Family group photographs are easily the most demanding and challenging type of images you'll create at an indoor wedding. They are also the best sellers when it comes time for the bride to order prints for her friends and relatives. Some of these images may be printed at 10×15 and larger. To create files under low-light conditions that will make acceptably sharp large prints, you absolutely must use a tripod to steady your camera.

Aside from increasing the sharpness of your images, a tripod also frees you up to move around without a camera dangling from your neck. The topic of using a tripod for group shots is discussed in Chapter 3 but I believe its importance justifies repeating.

After you get the tripod set up and the scene carefully framed in the viewfinder, the tripod keeps it that way as you arrange your subjects and move the lights here and there. I cannot overemphasize the importance of keeping the framing stationary. The tripod slows you down and practically makes you arrange the subjects carefully while also calculating the amount of extra space needed on the sides of the frame to allow for cropping into the 8×10 format.

One of the most important aspects of using a tripod is that it frees you up to look at your group without the camera in front of your face. This allows you to talk and joke with them while watching for just the right expressions. Of course, it's much faster and easier to shoot hand-held, but it's also much less deliberate, and these images are important enough that they deserve the careful consideration necessary to get everything just right.

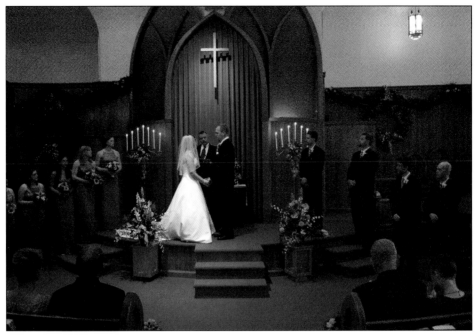

Figure 8-1: Shooting in a dark church requires that you either use a tripod or set your ISO up very high and suffer the consequence of digital noise in the image. This image was shot at ISO 400 and 1/20 second.

Slaves

Should you choose to bring lighting equipment, you may also want to purchase a set of radio slaves. In photography, the term *slave* is a term used to describe a piece of equipment that sends out a signal that triggers one or more flashes at the same time. A flash-triggering system allows you to place your flashes at various points around the room without any connecting cords for you and the wedding guests to trip on. A slave set comes in two parts: the transmitter, which attaches to your camera and transmits a signal when you press the shutter; and a receiver, which attaches to the flash head to receive the signal and fire the flash. Many of these units can be set to change from transmitter to receiver with the flip of a switch (see Figure 8-2). Three basic types of slave triggering signals exist: flash, infrared, and radio.

Flash (optical) slaves

Slaves that are triggered by the light from another flash are impractical at a wedding because every flash in the room sets them off and it's impossible to stop all the guests from shooting their own flash images, thus rendering this triggering system completely useless for wedding work.

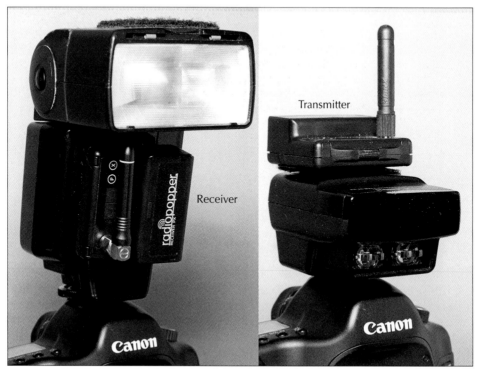

Figure 8-2: A radio slave, such as this RadioPopper system, can make it easy to control many small flash units from a long distance away, and even through brick walls. The transmitter attaches to your camera and each flash unit needs a receiver.

Infrared slaves

Infrared slaves have several weaknesses. Occasionally, they can be sensitive to fluorescent lights, which cause them to trigger every time the flash recharges. Further, because infrared is a light wave, it will not penetrate through walls or other solid objects and it reflects off surfaces in an unpredictable manner. This means you need to have all of your flash units sitting out in front of your camera — in direct sight. This is far from the perfect place to have all your flash units. This type of slave also has a very short range outdoors, especially on sunny days.

Radio slaves

Experienced wedding photographers prefer radio-signal slave units for several reasons. A radio slave produces signals that pass through walls and across distances up to several hundred feet depending on the model you purchase. The radio signal transmits in all directions so you can easily have your flash units behind your camera position. And a radio slave unit

cannot be triggered by someone else's flash, so you have very little to worry about when it comes to missed exposures.

You obviously can use a slave setup to trigger your lights for the group photo session and bridal portraits, but a slightly less obvious use is to place several flash heads with receivers around the reception location and point them up at the roof or down at the crowd. When you fire your camera, all the flashes go off together and provide an even light for the entire room. The only challenge is setting up the lights so that they don't appear in the image. If this happens, you get a very bright hotspot where the light is. Some photographers prefer this effect and they simply point the flash units down on the crowd and shoot away. Other photographers point multiple flash units up into the roof to create a room that is well lit with a very white light source. Two brands of radio slave units in common use today are RadioPopper (www. radiopopper.com) and PocketWizard (www.pocketwizard.com).

Lighting the Set

You can use almost any sort of flash system to light an indoor location, but you will want to keep portability and the option to use battery power in mind. Large flash systems may have enough wattage to light a stadium, but when the bride says, "Hey, let's shoot another one over there," a large system won't seem so attractive. Wedding photography doesn't require a lot of flash power. Most hot-shoe–mounted flashes have plenty of power for the distances involved in wedding photography and several of these small units can easily be mounted on stands to light up a portrait location.

Basic lighting setups for groups

You can use many possible combinations of lights at a wedding, but the three I discuss here are the most common setups used for the family group photo session. The descriptions include the absolute basics of each setup. As you become more experienced, you will certainly develop your own set of equipment and exposure combinations that make your work unique.

Single small flash

As you might guess, this method uses a single flash unit that is usually mounted on the camera. This method may work fine if you can set your shutter speed to take advantage of whatever ambient light is available. If the background is totally dark, you risk getting a black-pit look unless you set up additional flash units to provide some background illumination. A major drawback to the single flash system is that it produces a lot of reflections because the light is going straight out to your subject and straight back to the camera; any reflective surfaces in the scene will create a very bright reflection from your flash. (More information about avoiding reflections appears later in this chapter.)

One way to improve the single light setup is to put the flash three or four feet off to the side of the camera as shown in Figure 8-3. This makes small shadows, creating a natural three-dimensional look. To do this you can use a simple sync cord, a slave unit, or a TTL cord.

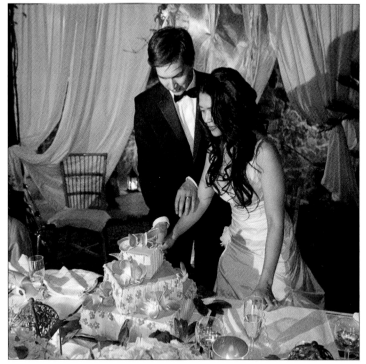

Figure 8-3: Moving your flash off to the side creates a feeling of depth that you can't achieve with the same flash on top of your camera.

Single main light plus on-camera flash

With this system, you set up two lights. The first is your main light. It is mounted in an umbrella to soften the effect and throw shadows across your subject from the side to create a three-dimensional look (see Figure 8-4). Place the light about 20 feet from the group and off to the side of center (your position) by 10 to 15 feet. The second light is your on-camera flash unit. Set this unit with an exposure compensation of –1.5 stops. This secondary light fills in the shadows to keep them from getting too dark.

The easiest way to set these exposures is to start with the main light alone and shoot test exposures while watching the resulting histograms on your LCD. Watch the right (highlight side) of the histogram and adjust the power on your main light until the histogram touches the bottom of the graph very near the right side without climbing up the wall on the right side. Now turn on your on-camera flash unit and adjust the exposure compensation up or down to get the shadows lighter or darker.

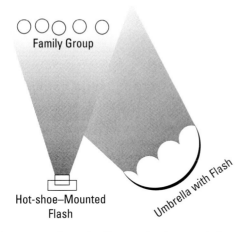

Figure 8-4: The umbrella provides the main light source, while the on-camera flash fills in the shadows.

This system produces a very even light on smaller groups but because the main light is off on one side, larger groups can tend to look brighter on the side with the main light. To counteract this problem, simply angle the flash head (or umbrella) so that it points across the front of the group toward the people on the far side. This projects the central part of the flash beam toward the far side while still allowing enough light to hit the closer side. This technique is called "feathering" the light.

Dual umbrella

This light system requires two portable flash units set at about 45 degrees off on either side of center and about 20 feet from the group. If the group is large, you can get the most even light by feathering both lights across, toward the far side of the group. This light setup tends to create very even illumination from side to side, which is perfect for large groups. For smaller groups you can create some shadows for a more three-dimensional look by setting one of the lights to put out roughly 1.5 stops less than the other.

These basic setups are only a starting point for many photographers. Adding additional lights for each portion of the background is another option. Some photographers may even choose to add a hair light, which shines down from above and behind the group to add a little sparkling highlight to the hair.

Distance = Power

The distance from the light source to the subject is very important. If you set the lights too far away, you may not be able to get the f/8 or f/11 that you need in order to have enough depth of field to keep both the front and back rows of your group in sharp focus. However, setting your flash too close is a far worse concern. The reason for this is that the light from your flash drops off very rapidly at close distances and much less rapidly as the distance increases. For example, if you have a group where the closest person is at 6 feet (from the light) and the farthest is at 8 feet, the farthest person is going to be noticeably darker because the difference between the two people is roughly one-quarter of the total distance. This means the farther person is a very noticeable 25 percent darker. However, if you place your closest and farthest subjects at 18 and 20 feet from the lights, the same 2-foot difference between the two people is now only one-tenth of the total distance, which means the farther person is now only 10 percent darker. This is a small enough difference that the average viewer won't notice it.

Also, setting your lights at roughly 20 feet gives you a large working area where you can move your subjects side to side and several feet forward and backward without having to constantly change your exposure or reposition your lights to keep the exposure correct. If you place your lights closer, every time they move, you have to move the lights and re-meter the scene.

Indirect flash techniques

When shooting indoors with flash, there are several possible ways to modify both your technique and your equipment to create effects that are very different from what you might get with a straight flash shot.

Bounce flash

Bouncing is when an on-camera flash pointed up toward the roof (or horizontally toward a wall) bounces back onto your subjects with a very even and natural look. This technique is a favorite of many photographers but it does have limitations. For example, if the ceiling is very high, brightly colored, or very darkly colored, you should probably avoid this technique completely. If you are low on batteries for your flash, you should also consider other options because bounced light has to travel much farther than direct light, thus requiring a lot more power from your flash. This is compounded by the fact that ceilings are never made of highly reflective materials, so a large portion of your flash output will be absorbed by the ceiling instead of reflecting back down where you want it.

One of the main drawbacks to using bounce flash occurs when you get very close to your subject. In this case, the light coming down from the ceiling is brighter at the top and tapers off in brightness toward the bottom. This becomes particularly noticeable if you happen to be shooting with a wide-angle lens that captures your subject from head to toe. The easiest way to get around this problem is to attach a reflector (called a "kicker") to your flash, or use a flash diffuser — both of which will throw a little bit of the light straight forward to your subject.

Another potential drawback to this technique occurs when your subjects are very close to you. In this case, your bounce flash will come down from directly above the subject's head, which often results in harsh facial shadows.

Bounce flash + "kicker"

Most on-camera flashes come with a small plastic reflector called a "kicker" that you pull out of the end of the flash head. When you direct the main beam of the flash at the ceiling, this little piece of plastic catches a small portion of the flash burst and deflects it directly forward toward the subject. When you mix this small amount of direct light with the larger portion of bounced light, the effect looks quite natural and even.

If your flash does not include a built-in kicker, you can use a rubber band to hold a small piece of white paper on the end of the flash head. This is how the kicker technique originated and many photographers employed the technique like this for years before the manufacturers started building it into the flash.

Using Indirect Flash Outdoors

I often see amateur, and even occasionally professional, photographers using some sort of indirect flash method outdoors. This is a total waste of time and battery power. Indoors, these methods work because there are walls to contain the light and cause it to bounce all around the room. Outdoors, there are no walls! Any light that you send off in any direction other than straight at the subject is totally wasted.

This is obviously true for techniques like bouncing, where the light would have to bounce off the next nearest star before it could return to your subject. However, the use of modifiers like the Omnibounce diffuser and the Gary Fong Lightsphere (www.garyfongstore.com) also fall into this category. Many photographers use modifiers outdoors because they think that the light will be softer and more diffused. This is a myth. The light may look less intense because much of it is being wasted, but the same low intensity light can be achieved by simply dialing down the power on your flash.

Other photographers say these light modifiers add softness because they are larger in diameter than the flash head. If you were to put your flash into a 2-foot-wide softbox then you could easily make such a claim, but the difference between a 3-inch-wide flash head and a 5-inch-wide flash head with a light modifier on it is too small to be worth the trouble. And, although the diffuser is slightly larger, it will always throw large amounts of light off in the wrong direction, thus wasting most of your battery power and causing your flash to take much longer to recharge between shots.

The only real result you get from using small light modifiers outdoors is you use up your batteries quickly. Save these gadgets for indoor photography, where they can really make a difference.

Diffusers

Another type of light modifier that attaches to the end of your flash is called a *diffuser* (see Figure 8-5). Diffusers act to redirect the light. Some models redirect the light in all directions equally, but most allow the majority of the light to go straight out the end as normal, while still diverting smaller amounts in all directions around the room. There are many larger and more elaborate diffusers on the market, but I prefer the simplicity, durability, and small size of the Omnibounce diffuser, which can be found at most photography stores. An example of the even light that results from using an Omnibounce diffuser can be seen in Figure 8-6.

Figure 8-5: The Omnibounce diffuser is small and very effective at illuminating the room with a soft, even light while still throwing the majority of the light in the direction the head is pointed.

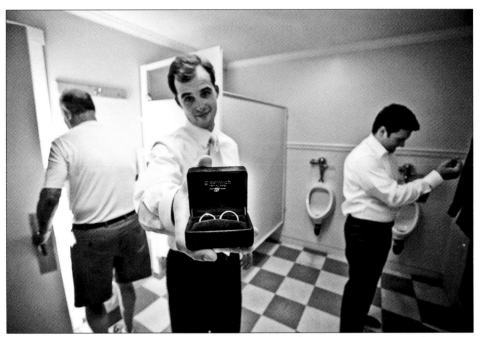

Figure 8-6: The open door behind this groom created a strong backlight, so I used an Omnibounce diffuser on my flash to provide a subtle fill light on his face.

Adjusting White Balance

When shooting indoors you constantly encounter different types of lighting and each one adds a strange color to the image. Your eyes have the wonderful ability to balance all of the lights out so everything appears as white light to you. To a certain degree, your camera has this same capability — it's called "auto white balance." When you use the auto white balance (AWB) setting, the software in your camera assesses the light and adjusts the white balance as best it can. The results will vary depending on the particular brand of camera you own, and the number of different types of lighting involved.

JPEG shooters

As mentioned in previous chapters, I don't recommend that any wedding photographer ever shoot a single wedding image in anything other than the RAW file format. However, if you insist on using the JPEG file format, you'll need to be far more careful about getting your color

balance right as you go along; otherwise you'll spend days in front of your computer adjusting the white balance in your photos. To make a custom white balance setting for the specific type of light you are encountering at a given moment, you can shoot an image of a white piece of paper or a Kodak gray card (with this light striking it) and then use the resulting image to set the white balance in the LCD menu. This is a fairly quick process once you get the hang of it.

An alternate and far more accurate method is to use a product called an ExpoDisc (www.expo imaging.com). This little disk looks much like a lens filter and you simply place it over your lens and shoot through it at the light source you want to balance. You use the resulting image to set the custom white balance in your camera's LCD menu. This process is extremely quick and accurate but once again, you need to take into consideration that a wedding photographer never stays in one place for long; if you use this method, you must constantly re-shoot your white balance throughout the day.

RAW shooters

RAW files are quite simply the greatest thing to ever happen in the world of photography. The color balance tools are quick and infinitely adjustable in any of the major RAW file-processing software programs. The specific techniques used to achieve good color will depend on the type of software you use. (I go into more detail about color correction techniques in Chapter 15.)

To get the best possible color for your files as you shoot them, I recommend setting your camera to the auto white balance setting. Many experienced wedding photographers will disagree with me here, but I believe that for the beginning to intermediate photographer, no other white balance method produces the same high level of consistency in the majority of conditions and with a total lack of fuss; this, of course, allows you to spend more time shooting pictures and less time fiddling with your camera. The auto white balance setting creates good colors that you can perfect once you get all the images to your home and download them into your computer.

Minimizing Reflections

Shooting indoors requires that you pay special attention to the way your lights bounce back from reflective surfaces. At the altar area you may have flat panels of wood that undoubtedly will cause headaches. In the reception hall there may be mirrors and windows to work around. All of these surfaces can cause a bright glaring reflection that will ruin your picture.

You can easily avoid reflections once you understand the basic principle of reflection. That is, light reflects out at the same angle it went in. For example, if a light beam approaches a mirror (or other reflective surface) at 45 degrees, it will reflect out at 45 degrees on the opposite side. You can apply this concept at a wedding when placing your lights so they don't cause reflections. For example, if you have a mirror on the wall behind a family group shot, you can easily remember that the reflection will show up halfway between your camera and your flash. If your flash is mounted on your camera, then the reflection will be directly in the middle of the

group. If you move the flash to the side, for every two feet you move the flash over, the reflection will move over one foot. Therefore, if your group is 10-feet wide, you need the reflection to move at least 7 feet (5 feet for the group plus 2 feet for some extra space on the sides) before it is out of the image. That means the flash must be moved over at least 14 feet. The sketch shown in Figure 8-7 illustrates how this works.

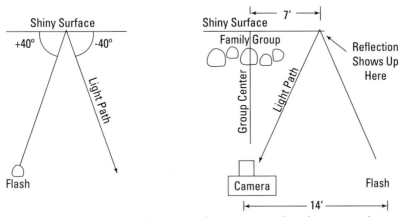

Figure 8-7: Reflections have the same angle coming in as they do going out from a reflective surface. After you understand this basic principle, you can arrange your lights or your groups to minimize reflections in your images.

Another way to move the reflection is to move yourself to an angle that avoids shooting directly into a shiny surface. If you must put your subjects in front of something shiny, turn them so you can shoot at an angle toward the surface. This allows the reflection to bounce off in another direction, where you won't see it. You can solve most reflection problems this way. In the real world, all you have to do is step sideways a couple of steps and your subjects automatically rearrange themselves to face you, thus turning just enough for the reflection to disappear without much fuss.

Or you can solve the problem by rearranging your group. Simply shoot a test shot to see where the reflection is going to show up, then move one of the people in your group to stand between you and that spot. This effectively blocks the reflection. This method works particularly well if your camera is on a tripod because you can make small adjustments to the group without moving the camera. And you can watch over the top of the camera as the shot goes off to see where the reflection will be. If you look through the viewfinder you will never see reflections because the mirror is up and your view is totally blacked out at the instant the shot is made.

Another common reflection problem comes from eyeglasses. This problem cannot be fixed if the lenses on the glasses are highly curved on the front. If the lenses are relatively flat, try asking your subject to raise the part that goes over the ear until it is about an inch above the ear. Raising this piece tilts the lenses slightly downward, which usually eliminates the reflection.

Choosing Your Locations

When you shoot indoors, you need to be able to look around the wedding location and see places that can work for different types of images. The locations you choose are determined by several factors, such as your shooting style, the couple's requests, and most likely, the amount of time you have.

As you look around an indoor wedding site, what qualities should you look for in a photo location? What should you watch out for in a bad location? Many of the same principles used for outdoor locations (discussed in Chapter 7) apply.

Architectural features

For your indoor groups, you'll be looking for architectural features that make an interesting background while watching out for reflective surfaces and bright spots of sunlight that could prove troublesome. If you want to give the background a little blur to provide some separation between the subject and the background, you'll need to determine if there is enough space for you and the subject to step out away from the background a bit.

Type of lighting

The quality and type of light on the background is also a consideration. For example, if the background light is fluorescent and you light the front of your subjects with a flash, the fluorescent lights will make your background look green. The same problem exists if the background is lit with tungsten lights (old-style light bulbs), except that the golden tones produced by tungsten are not nearly so objectionable as green ones.

Another consideration is the strength of the room lights. If they happen to be very bright, it's easy to use them as they are or tone them down by adjusting your shutter speed to underexpose the ambient light a little. If the lights are very dim, a tripod helps keep your equipment steady, but you still may not be able to use a slow enough shutter speed without getting a small amount of ghosting as your subjects move. In general, people who are posing for group photos will not move very much, but still, any shutter speed below 1/60 second risks being blurry from even slow movements. In some cases, the light may be so low that you have to rely on lighting both the subjects and the background with your flashes.

Time considerations

You may find six or eight great locations but when it comes right down to it, the time the bride originally allotted for photography is rarely the actual time you end up getting. This shouldn't upset you. In fact, after ten or so weddings you'll see that it is more common than not for multiple factors to push back the schedule, shortening the original time allotted to shoot photos. This is all part of the territory. It may upset the bride, but as the photographer, you quickly realize that this is a very normal part of your workday.

Given these normal time delays, you may want to look over your six or eight great locations and prioritize them so that you make sure to catch the best ones first and then use as many as possible during the amount of time you actually end up getting.

The altar area

If your wedding couple sets up an elaborate altar area for an indoor wedding (which they usually do), you are almost certainly going to be expected to use it for the family group shots. This is the normal location where you set up your lights and prepare the scene for the group shots.

If you are doing photos before the ceremony, there are a few details to consider about working around the altar area. In most locations, it is acceptable for you to rearrange the furniture, flowers, candles, and so forth as long as you remember where they were and return them to the exact same location after the pictures are done. I can't stress enough that you get the locations exact because many ceremonies are planned out very carefully and a slight rearrangement can cause serious problems if it goes unnoticed until the ceremony is underway. Be particularly careful not to remove any small pieces of tape on the floor, as these are used as reference spots and the bridesmaids and groomsmen will be looking for those tape markers to tell them where to stand during the ceremony.

Check with the bride to see if you can light candles for the pictures. On many occasions there are two complete sets of candles, one for the pictures and a fresh set for the ceremony. When the candles are lit, be especially aware of dripping wax. Most candles have some sort of cloth placed beneath them to keep the drips off the carpet and other furniture. Be sure to keep the cloth in place if you move the candles.

Be extremely wary of liability issues when working with candles. If you move the candles (even at your client's request) and something happens while they are in this new location, you could be held responsible. For example, someone could bump into the candles and knock them over or bump into them and catch on fire; or the candles could fall out of the holders and catch something else on fire. There are too many possibilities to list. I once witnessed an amateur photographer back up into a set of candles and catch her long curly hair on fire.

Snuff the Candles

If you happen to be working with the candles at a wedding altar and you need to put them out, use the snuffer to cut down on the smoke. I once blew out all the candles after the pictures for a large wedding ceremony and I had no idea how much smoke all those smoldering wicks would create. In fact, it was enough that after a few minutes it rose up into the second floor and set off the fire alarm. Luckily the photo session was taking place after the ceremony because within minutes, two big pumper trucks, four police cars, and two ambulances arrived. Despite my story about the candle smoke, the firemen came rushing in with their fire suits, axes, and air tanks. Then they quickly herded everyone out the front of the church. After a half hour of searching the building, they calmed down a bit, and we got some great photos of the bride and groom posing with the firemen on the back of the pumper truck. Then, as if all that wasn't enough chaos, as the fire trucks were leaving, a big pumper truck pulled out and collided with a city bus, creating even more excitement. I didn't know my little town of Eugene, Oregon, had so many police cars.

At smaller weddings there may be many occasions where the altar area is not the most photo-genic location around. When you encounter this, you may need to do some delicate maneuver-ing to talk the bride into using a different location. You obviously won't be able to just come out and say the altar is ugly. You might say something like, "That stairway over there has wonderful light. What do you think of shooting pictures over there?" Most brides will trust your judgment and appreciate that you found a better location; just be careful about how you request the move so no one gets offended.

Summary

Shooting indoors presents a unique set of challenges. Dark locations require you to make deci-sions about whether to set your ISO high and go for the natural look while risking a little blur, or to use artificial light and lose the natural quality in favor of having everything brightly lit and sharp.

The equipment you use shooting indoors is exactly the same as for any other aspect of the wedding; however, adding in a tripod, radio slave, and few extra flashes can come in handy. On rare occasions, your location may be so dark it practically demands these items.

The tips you gain in this chapter can help you to choose the right file type and the types of equipment you'll need, such as flashes and slave units to fire them. You'll also find information on how to use on-camera flash units by bouncing them off the ceiling and placing light modifi-ers in front of them, as well as valuable information about reflections and how to choose loca-tions that avoid them.

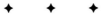

CHAPTER

9 Documenting the Ceremony

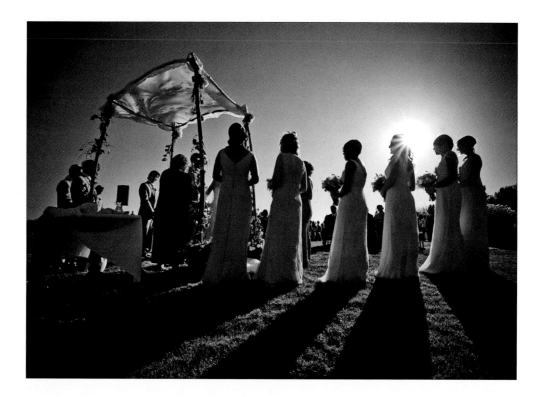

The ceremony is not only the pinnacle of the entire wedding day, but it is also the pinnacle of the months of preparation and planning it took to put together all the little details leading up to this one moment. And yet, when the ceremony actually happens, it seems to go by so fast that I often find myself standing there thinking, "Is that it? Is that all of it?" As a photographer, you may very well be the only one in the audience wishing it would last longer. Thankfully, in the United States, most weddings follow a predictable sequence of events. Granted, various religions have a few specific traditions, but for the most part, an experienced wedding photographer can easily manage to be standing in exactly the right spot at exactly the right time to catch the most important events. The predictability of the event is a blessing that enables an experienced photographer to walk slowly from one key spot to the next, just

in time to be ready for each of the big events in the story. In this chapter I share some of the insight and the thought process that goes into choreographing every movement a professional photographer makes during those fleeting moments of the wedding ceremony.

Must-Have Shots

Most photographers have a list of shots that are considered the "must-have" shots of the ceremony. My "Top 10" list of the main events is as follows:

1. The bride walking down the aisle with her father

2. The bride's father giving the bride to the groom

3. The bride looking at the groom during the ceremony

4. The groom looking at the bride during the ceremony

5. A close-up of the officiant

6. A close-up of anyone doing a reading or singing a song

7. A wide shot from the back showing the entire ceremony

8. The bride and groom exchanging rings

9. The kiss

10. The bride and groom walking back down the aisle

This list of must-have ceremony shots gets even longer if you add the following important images, which you should capture if at all possible:

✦ Close-up shots of the wedding party members — especially if they are crying or doing anything unusual

✦ Shots of each family member and the entire wedding party as they come and go down the aisle

✦ Shots of the parents — especially if you can get them crying or wiping tears

✦ Wide shot from a distance that shows the entire scene of the wedding taking place

✦ Wide shots from back center of the ceremony and from each back corner

✦ Signing the marriage license (this may not be a part of the ceremony at all as it often happens in private after the ceremony or at the reception)

I recommend that you actually write this list down on paper and carry it with you to your first few weddings, but after that I think it best to avoid carrying shot lists of any sort. At first a list can be helpful by keeping you on track and helping ensure that you don't forget anything important, but after about ten weddings it will only get in the way. The list tends to focus your attention on getting just those images on the list, and that amount of focus prevents you from being open and aware of what is happening around you at the moment. That awareness is what enables you to see the really unique and unscripted moments that make the best pictures.

It should be noted that the ceremony is one time during a wedding day when you have some solid obligations to the couple that has hired you. You should get all of the ten images listed previously in a way that is clear and clean, and doesn't include any gimmicky effects. This is the time to fulfill your professional obligation to document the moment. After you've accomplished that, you can feel free to exercise your creativity. Figures 9-1, 9-2, and 9-3 are images from my Top 10 list.

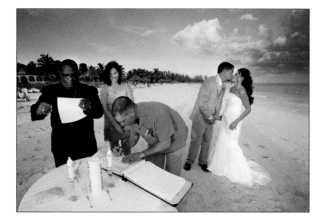

Figure 9-1: Signing the wedding license sometimes happens as part of the ceremony, sometimes right afterwards, and sometimes at the reception. In any case, you should have asked the bride when it will happen so you can be ready and standing in the right spot to tell the story.

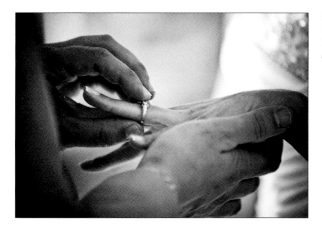

Figure 9-2: The ring exchange is always on the Top 10 list of images to capture during the ceremony.

Of course you will occasionally miss one or two of the Top 10 shots. For one reason or another, things might conspire against you and you won't get the shot no matter how good your intentions. For this reason, I include this sentence in my wedding contract, which states that I am not guaranteeing that I will capture every single event at the wedding:

(Your name here) makes no guarantee to capture any specific image or scene.

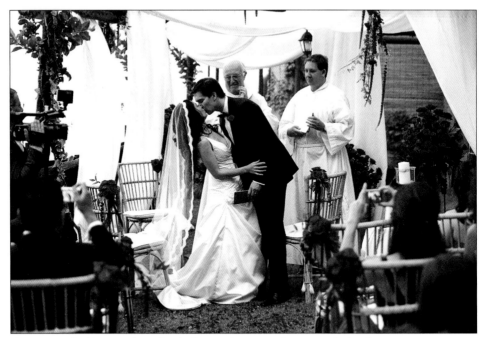

Figure 9-3: The kiss is perhaps the single most important shot to get during the ceremony.

You can find my entire wedding contract on my website at www.aperturephotographics.com. I will not be offended if you copy it and simply replace my name with your own — although of course I can't accept any legal liability if it gets you into trouble. In any case, a good contract is a very important part of your business and it will do you well to find several to study and adapt to your own needs.

Ceremony Etiquette

As easy as it is to think of the ceremony as a photographic opportunity, it should always be remembered that it is foremost a significant spiritual, legal, and often religious ceremony that formalizes the bond between this couple. As such, it should be given a certain amount of respect and reverence. We photographers must tread a very fine line between reverence and that little bit of irreverence that is sometimes necessary to get the shot. How much attention can you attract without really disturbing the event in an unacceptable manner? Does the click of your shutter constitute sacrilege? Some guests may think so, but what it comes down to is: The only opinion that really matters is that of the wedding couple. You should make a point of talking with them about where you can go, how close you can get, when you should stay quiet, and when they don't care. If you stay in this business long, you will experience the full spectrum of weddings, from those where you can't even set foot in the church with a camera, to outdoor affairs where you can get as close as you like.

Small Ceremonies

Some couples choose to sneak off by themselves to get married but they still want the event documented. I've been a part of several ceremonies where the only witnesses and, in fact, the only people to attend the service, were the photographers. In cases like this rooftop wedding on the Greek island of Santorini, shown in the following figure, minimizing our presence was impossible. In fact, we were the only ones there to share the cake and champagne, and even sign as witnesses on the marriage license. For weddings such as this, your job becomes even more important than usual because the story you create becomes the only story the couple's friends and relatives have for the entire wedding.

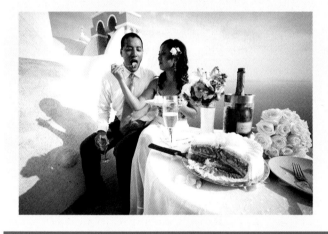

Your client isn't the only one that matters, however. All of the guests are there to experience the wedding as well. Do you have the right to disturb them or block their view? To a certain extent you do simply because of the long tradition of expectation that photographers must capture certain shots regardless of where they need to position themselves. The adult guests know this and accept that your presence is necessary. They put up with your clicking shutter and the floor creaking loudly as you walk by. Most of the time you can even stand right in front of them without ruffling any feathers. Here are a few tips you can use to minimize the amount of distraction you cause:

✦ **Move slowly.** Any quick motion is distracting to the guests, but a photographer who walks slowly from place to place is easily ignored and soon disappears into the background of the event.

✦ **Move around.** Don't stay in one place too long. It's better to annoy everyone a tiny bit than to completely ruin one person's experience by standing right in front of him or her the entire time — not to mention the fact that your coverage will be awful if you don't move around.

✦ **Wear dark clothing.** Dark-toned clothing attracts much less attention than lighter tones, and bright colors are absolutely unacceptable for the photographer. The only

exception is if you wear certain clothing to fit in with the dress code for that particular event. For example, a bright red shirt with a floral pattern may get you banned from the church in your hometown, but it fits right in at a Hawaiian beach wedding.

✦ **Wear quiet shoes.** Walking around with shoes that squeak or clomp heavily on the floor will be a serious distraction in a quiet church atmosphere where the floors are often made of wood, which transmits the sound throughout the room.

✦ **Don't do any acrobatics.** Never attempt to jump over something, stand on a chair, climb to a vantage point in a small tree, or any other acrobatics that can potentially result in you falling on your head right in the middle of the ceremony. Any great shot you might possibly get by such antics would certainly be overshadowed by the embarrassment and the distraction of you falling on your face in front of a large crowd. Don't risk it.

✦ **Time your disturbances.** Certain moments in the ceremony are better at camouflaging a disturbance. For example, the best times to move quickly to a new spot are when the guests are standing up, sitting down, or praying because they are all in motion at that time and nobody will notice your motion. With a prayer, all the guests' heads are down and their eyes are closed. This is your chance to quietly walk around to a new location. Every time the guests come up from a prayer you should be standing still — but in a different spot.

✦ **Keep away from the couple.** In my opinion, 10 feet is about as close as you should ever get to the bride and groom. At that range you can easily see the tears on a bride's face with your 200mm lens. If you get any closer to the couple than that, you had better be doing so at their request; otherwise you risk annoying everyone involved. Instead of worrying about getting closer, spend that energy finding a better angle to see the action.

You're in My Way!

One afternoon as I was wandering slowly around the side of the ceremony shooting pictures, I came to a spot where I could see a great shot of the couple but a post was blocking me. I was standing on the side of the crowd and I just knew that if I could get a little more toward the middle, I could shoot around that post. I noticed a row of empty seats. The seats behind these were filled with people but I figured I could walk down this empty row for a couple of shots without disturbing anyone too much. After all, everyone knows that it's okay for the photographer to do such things, right?

So I slid in there and had just barely got my shot when a five- or six-year-old tyke behind me stood up with a scowl on his face and proclaimed loudly, "Hey! You're standing right in front of me!" His little voice echoed around the room and everyone in the entire wedding looked over to see what was happening. His mother turned bright red as she quickly clamped a hand over his mouth and pulled him back down in his chair. All the other adults chuckled at the fact that he simply didn't know the rules about photographers yet. I'm sure I turned more than a little red, too, as I whispered an apology and quickly got out of his way. Through his mother's fingers I could see that he was still scowling indignantly at me as I moved away.

Flash Etiquette

Rarely do you need to set up any lights for an indoor ceremony, and more often than not, you will be banned from using any sort of artificial light during the most important middle section of the ceremony. This is entirely understandable because a professional-level flash unit puts out enough light to briefly stun anyone it catches in the face — especially in a dark room where eyes are dilated wide open. Officiants are usually the ones dictating the no-flash rule because they are the ones most likely to get stunned. One good blast in their eyes could distract and annoy them enough that they lose their place in their readings. It could also annoy them enough that they stop the ceremony to ask you to stop, or even leave.

The no-flash rule in most churches applies to that portion of the ceremony that takes place between the time the bride is given away to the groom, and the kiss. So you can use flash until the bride reaches the altar, then turn it off through the middle of the ceremony, then turn it back on for the kiss shot and anything after that.

To find out the rules about flash use, you should always make it a point to introduce yourself to the officiant before the ceremony and ask him or her if there are any rules or concerns about photography. Sometimes the officiants set boundaries on how close you can get to the altar or they might indicate certain places where you can't go after the ceremony is underway. Some officiants may have no limits whatsoever. It has been my experience that the more genuinely concerned and respectful you are when talking with this person, the more they try to help you out and the less restrictive they are. Whatever rules they set out for you, by all means obey them. It's far easier to obey the rules than it is to suffer the embarrassment of being kicked out of the ceremony in front of a huge crowd of people.

If in the unlikely event an officiant or other person sets some limit on you that you feel is unreasonable or will severely limit your ability to do your job, you should immediately discuss your concerns with your client — the bride. If she doesn't agree with the requested limitation, you can respectfully approach the person and tell him or her that your client has asked you to shoot pictures in a way that differs from the rules and that you are obligated to do as she requests. If there is still some disagreement, this person can discuss the matter directly with the bride. Whatever you do, be sure to make every attempt to be respectful while trying to make it clear that whether the limit is observed or not is between the person and the bride — not you. Bear in mind that a coordinator who works for a location has the power to ban you from ever working there again, and in fact, it is not uncommon for a popular location to have a list of photographers who are no longer allowed on the property. However, all this must be tempered by the fact that even the clergy are being paid by the bride to perform the wedding, and as such, they are service providers just like you and the florist and the DJ.

General Ceremony Information

Following I list a few additional general wedding tips that are worth mentioning.

Networking

If you want to succeed in this business, you need to make friends! Any effort you make to talk with the other wedding vendors at each event will be well worth your time. Not only will these people take care of you by making sure you have food and drinks, but also they will clue you in to many little things that are happening around the wedding that you might miss without their help. And when the wedding is over, every wedding vendor gets calls from brides who don't yet have a photographer. Who do you want them to recommend? In Chapter 17 I go into much more detail about how to grow and nurture these relationships.

Strange situations

Occasionally you will run into some really strange situations at a wedding. People faint, they fall down on the dance floor and break bones, they get into fistfights, sometimes a "colorful" person will wander in off the street, and so on. Whether or not you take pictures of these events is up to you. Will the bride and groom want to remember these things? Maybe, maybe not. Some things are best forgotten. I tend to shoot everything on the theory that it's always safer to shoot first and have the option of deleting images later. If Grandma falls out of her chair, I wouldn't shoot it, but when a groomsman has the brilliant idea of pouring beer on the dance floor so that he can run and slide through it, and then he falls and breaks his arm, I'm right on top of that! Unfortunately at one event I missed a chance to get shots of the mother of the bride getting into a fistfight with the coordinator. I guess I was just too shocked to remember I had a camera in my hands. Maybe that's for the best!

Emotional moments

There are moments at almost every wedding where someone gets extremely emotional — sometimes crying uncontrollably. Times like this can be very tender moments that the bride and groom will certainly want to remember. However, after having seen photographers jump up and run over to a father who was crying on his daughter's shoulder and start snapping wide-angle shots from about a foot away, I will add this little reminder to observe the sanctity of the event. Remember that this is not a photo shoot; its real life for these people and you shouldn't do anything to cheapen a real moment by dancing around with your camera. You can shoot a few shots with your telephoto and nobody will even know you're there. The best compliment you can get after capturing a delicate scene like this comes when the bride tells you later she thought you must have surely missed it because she didn't know you were there.

Working with Extreme Light

Taking pictures of a wedding ceremony is often made more difficult by the two extremes of light. Occasionally you are blessed with an overcast day that provides beautiful, even illumination to your subjects, but more often you will find yourself shooting in much more extreme lighting conditions, such as a dark church or under a blazing hot sun. This section provides tips and helpful information to make either experience a bit less difficult.

Direct sunlight

Direct sunlight can create all sorts of headaches for you during the ceremony, but one of the worst is that it's difficult for you to see the image you're getting because the LCD screen appears so dark in the sunlight. To deal with this problem, try setting your LCD to show a histogram. This graphic display is always far easier to see than a picture. As mentioned in Chapter 4, interpreting the histogram takes some practice, but the easiest thing to remember is that your image will be well exposed if the curve comes down to the bottom right corner of the graph. If the curve rises up the wall on the right, this indicates a highlight area with no detail, and you should reshoot the image with an exposure correction until the curve ends at the bottom right corner. This is true whether you are shooting in RAW or JPEG format, but as always, RAW format will provide far better results in the end.

Low-light ceremony shots

Shooting an indoor ceremony will push the limits of your equipment and your own low-light photography skills. If you have fast (wide-aperture) lenses, you may be able to get away with handholding your camera as you move from place to place. If you don't have fast lenses, you can still place the camera on a tripod or a monopod and shoot with the fastest shutter speed you can manage. Shooting really slow shutter speeds can result in many ruined images because one person or another almost always moves during a long exposure. However, if you're persistent and you use a tripod, it's very possible to get good ceremony shots with shutter speeds as slow as 1 second. You may have to shoot six or eight shots before you eventually get a sharp one where everybody is standing fairly still for the full second, but it can be done.

Fast lenses often give you enough shutter speed to enable you to shoot handheld if you push your ISO up to 1600 or 3200. The resulting grainy look of the digital noise may be completely acceptable — although not optimum. Even if you do have fast lenses, you can diminish the grain a great deal by placing the camera on a tripod and lowering the ISO to 400 or 800. This setting gives you much smoother images without all the grain.

I once attended a wedding in a couple's house and just seconds before the ceremony, the groom approached me and said, "Has anyone told you about the candle thing?" "Uh, no," I said. Then he proceeded to explain that all the lights would be off during the ceremony and there would only be a single candle between him and the bride for the entire ceremony! My eyes went wide and I scrambled for my tripod and the 50mm f/1.4 lens. Thankfully, modern cameras are absolutely amazing in their ability to find light where there seems to be none.

As I've mentioned before, setting up the tripod is immensely helpful for maintaining the perfect framing on your subject while you watch for the best expressions or a laugh, as shown in Figure 9-4. After you get your framing set, you can move your face to the side where it's more comfortable to watch for long periods of time. Just keep your finger on the shutter release button and you'll be ready to catch any action.

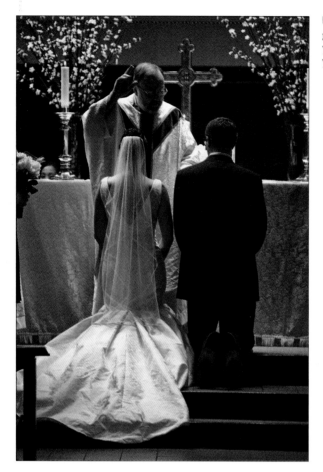

Figure 9-4: Using a tripod guarantees more sharpness when you're in a dark area that limits your shutter speed.

Catching the Guests

One of the most difficult parts about photographing a wedding ceremony is that with the obvious central focal point being the bride and groom at the altar, it's easy to forget the parents and other guests who are part of the ceremony. Of course, there will be times when you absolutely must be focused on catching one of the big "Top 10" shots. Usually this still leaves you a lot of time to move around to get images of both parents watching from the front row, the grandparents, friends, and so on. You should also be looking for emotional shots of anyone in the crowd who may be laughing or crying.

I always like to try to catch a shot of the parents that shows their bond, with the newlyweds in the background. One of my favorite ways to show this can be seen in Figure 9-5. Sometimes it may be that the parents are holding hands or looking at each other, or Mom may be leaning into Dad as she wipes a tear from her eye. Better yet, you may catch Dad wiping this tear away.

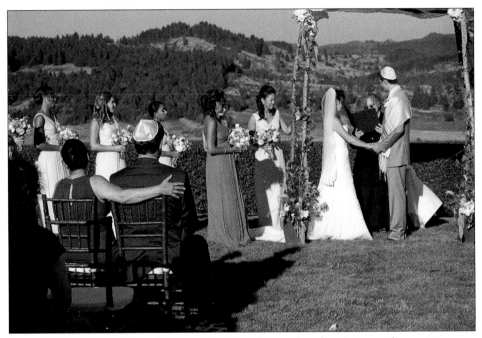

Figure 9-5: The juxtaposition of two couples in love is one of my favorite types of ceremony images to capture.

How do you make your ceremony work stand out? Obviously you won't be the first photographer to shoot a ceremony, so making your work look unique can feel like a challenge. I recommend that you resist the temptation to try to be drastically different or artistically unique during the ceremony. The ceremony is a good time to focus on catching expressions and documenting the event in a way that tells the story for the couple. Your clients will appreciate that you captured every smile and every tear and every event that took place. They will love it if you catch someone laughing just as much as they will love it if you catch someone crying. As shown in Figures 9-6, 9-7, and 9-8, your clients will be delighted if you catch a look of sheer joy and elation as the bride and groom are leaving down the aisle. Your work during the ceremony won't be judged on how different it is from that of other photographers. Instead, it will be judged by how much emotion it captured.

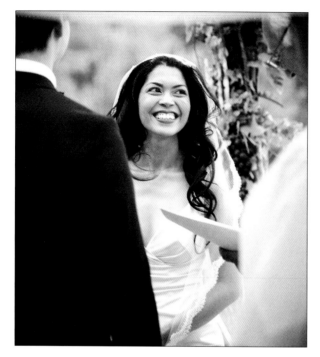

Figure 9-6: A look of sheer delight in a bride's face is something you may have to wait patiently for, but it's worth it when the moment finally arrives.

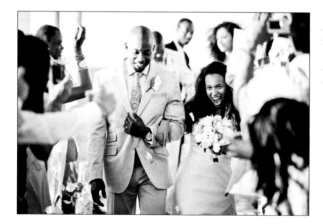

Figure 9-7: Watch carefully as the couple leaves down the aisle. This is a time when they are highly likely to show how much they've been looking forward to this day.

Figure 9-8: Kids never cease to provide a bit of humor at a wedding ceremony — sometimes without even knowing it.

Where to Be and When

Ever wonder what a professional photographer is thinking while the ceremony is taking place? She walks slowly from one location to the next and always seems to be right there in the perfect spot when something happens.

If you could crawl inside the mind of a professional photographer and walk with her throughout a ceremony listening to her thoughts, you might hear the following internal and external conversations taking place.

Prep Your Equipment Before the Ceremony _____

Put the 70-200mm lens on one camera and set it Aperture Priority mode. Put a wide zoom with a flash set to −1 exposure compensation on the other camera and set it to Shutter Priority (S) mode. If you haven't already done this, make sure both of your cameras (and your assistant's cameras, if you are using one) have the exact same time and date set on their internal clocks so all of the images will mesh together when you get home and sort them by date in the computer. Have your tripod and light setups ready if you're working in a dark church. Always have a power bar or other snack stashed in your bag. Grab your hat and a water bottle and put on some sunscreen if you'll be out in the sun.

Pre-ceremony

Talk with the second photographer to discuss where each person is going to be and remind him to try to duck out of the way if he sees your lens pointed in his direction. Check the clocks on all your cameras to make sure they are within a minute of each other.

Start out with the bride and her father in the dressing room with the goal of capturing a more romantic look. Shoot the bride and her father from different angles, always watching for a smile or a glance.

Talk to the bride and ask if there are any unusual things happening in the ceremony that you should be ready for. (You should have asked this before but it doesn't hurt to check again.) Watch for shots of the bride looking around the corner or through the curtains at the ceremony. Try to get a shot of the bride looking at Dad, then switch sides to get Dad looking at the bride. Switch to a 70-200mm lens set at f/2.8 as they head for the ceremony. Follow them out and shoot as they walk arm in arm toward the aisle with the ceremony blurry in the background. Move to the left side of the ceremony and shoot from the side as the bride and her father come down the aisle. Move to the front left side and look for a good angle to shoot Dad passing the bride to the groom.

In the beginning of the ceremony, I'll usually follow the bride and her father while the second photographer shoots from the front to get the family and bridal party members as they enter the ceremony to be seated. If there is not a second photographer, I'll shoot a couple of shots of the bride and her father as they wait near the ceremony and then I'll go up near the front of the ceremony to shoot the wedding party and family as they walk up the aisle. Be standing on the bride's side as she arrives. This puts you in the right spot to see Dad and the groom's faces as Dad passes the bride's hand to the groom. Watch for Dad giving the groom a handshake or pat on the back. Get Dad kissing or hugging the bride before he takes his seat. Watch for smiles from the bride and the groom. Figures 9-9, 9-10, and 9-11 are examples of images taken just before the ceremony.

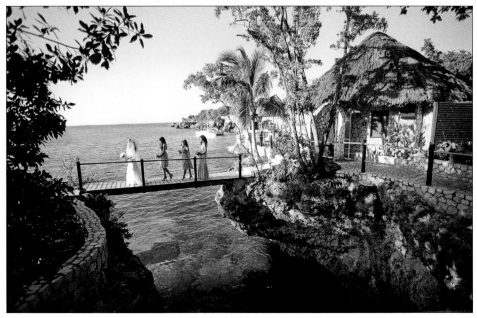

Figure 9-9: When I've got scenery like this to work with, I preplan the shot and take a few test exposures so I'm ready when the bride makes her way to the ceremony.

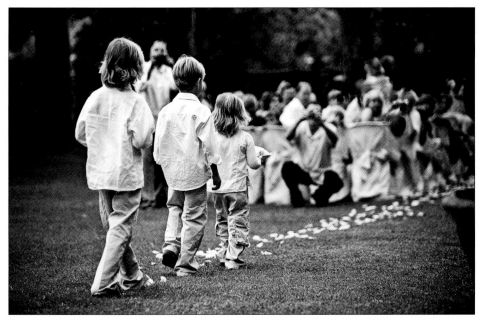

Figure 9-10: I like to shoot images of the kids headed toward the ceremony location while my second photographer shoots the same thing from the other side.

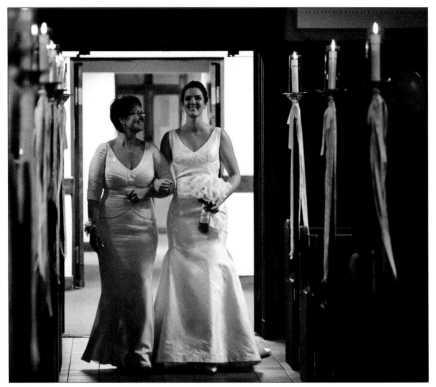

Figure 9-11: As father, or in this case mother and daughter wait to go down the aisle, there are almost always a few glances exchanged that make beautiful images.

Mid-ceremony

Mid-ceremony is a time to wander around the perimeter looking for emotional stories. As you circle the event, look for minigroup shots of the bridal party and family members sitting together. Other shots may single out one person at a time — especially when you can get some sort of emotional expressions. Shoot over the bride's shoulder to get the groom smiling back at her, and then do the same for the groom when you're on the back side of the altar area.

Next I'll move to the back of the ceremony and shoot wide shots from both corners and down the center aisle. While I'm in the center aisle, I'll use the 70-200mm telephoto lens to get shots of the officiant and the couple up at the front. Once I've got a good overview, I'll move back to the front and watch for tears from the bride, groom, and parents as the vows are being read. If there are singers or speakers, you'll want to get a couple close-ups of them, preferably from the back so you can get the couple, or at least some of the guests, for a background. As the ceremony nears the end, move to get a good angle and the best light as the bride and groom put on rings. As ring time approaches, focus on the officiant and wait for him or her to ask for the rings, as shown in Figures 9-12 and 9-13. Try to get the ring bearer delivering the rings to the officiant. Get waist-up shots of each one putting on rings, and then quickly zoom in close to get only the hands.

Figure 9-12: The 200mm tele-photo lens is perfect for capturing a close-up of the rings waiting on the officiant's Bible.

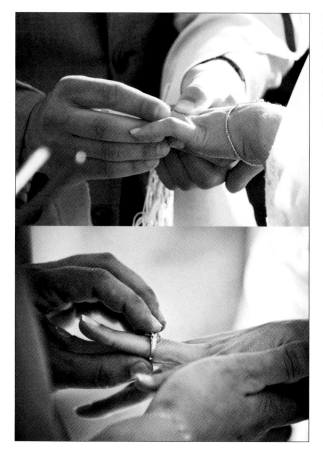

Figure 9-13: This pair of images illustrates why you should coach your couple on how to hold the rings by the top and bottom so that you and the guests can see the rings as they go on the ring fingers. Holding the rings the wrong way covers up the view completely.

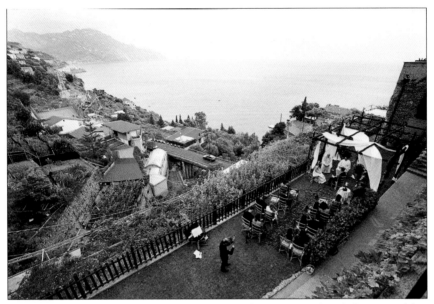

Figure 9-14: Don't forget to back up and get some shots showing the whole scene of the wedding location. This cliffside villa near Amalfi, Italy, looks pretty normal until you back up and get the big view of the breathtaking scenery in the surrounding countryside.

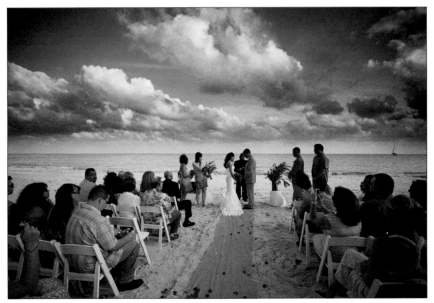

Figure 9-15: Try to show off as much of the landscape as possible by including some wide shots of the ceremony.

If the ceremony is long enough, I'll walk away a bit so I can get some shots from a distance that show the whole ceremony location and the surrounding scenery, as shown in Figures 9-14 and 9-15. The couple chose this location because it really spoke to them in some way and they will want to remember what the entire ceremony location looked like. If I'm outdoors and I know nothing critical will be happening in the next few minutes, I'll walk 50 yards or so off to the side to get a wide shot of the whole event and the landscape around it. If the wedding is indoors, I'll check to see if I can get up in the balcony for a wide shot.

End of ceremony

As soon as the rings are on, walk to the back end of the aisle, preferably with two cameras: one bearing the 70-200mm telephoto lens and the other with a wide lens and a flash. Capturing the kiss can be done in many ways but the two most common approaches are to shoot from the back with the telephoto (shown earlier in Figure 9-3) and then switch to the wide-angle camera as the couple approaches; alternately you can walk down the aisle to the front and shoot with the wide lens as the kiss takes place. If the backdrop is really beautiful, or if the guests will be throwing flowers or rice at the couple, I would probably use the wide-angle approach to include as much of that as possible. If the background is not that special, I would probably shoot from the back with the telephoto lens. In either case, once the officiant starts pronouncing the couple husband and wife, you can feel free to move up the aisle as close as you think necessary to get the kiss shot. If you shoot from the back row with the telephoto, be prepared for the possibility that guests might step out into the aisle in front of you as they attempt to get their own perfect shot of the kiss.

If you approach the front, after the kiss happens you'll need to stay ahead of the couple (by walking backwards) and keep shooting while looking over your shoulder as the couple moves away from the altar (the recessional). When I'm doing this, I like to step to the side just behind the back row of seats and keep shooting as the couple passes close by, as shown in Figure 9-16. And last but not least, you should shoot the wedding party, couples, and family as they file out — although I don't think it's necessary to get every single one of these unless the bride specifically requests it. If you shoot with an assistant, let them shoot the family members leaving while you follow the couple.

Once the ceremony is over, you can divide your attention between getting a few shots of the receiving line, and scouting out locations for group shots and romantic shots. If you have lights to set up, this is the time to get them ready. If you're outdoors, look around to find a shady location for the group shots and get it ready by cleaning up the ground and moving anything that detracts from the background.

One more thing to consider is that you shouldn't pick a group photo spot that is either too close or too far away. Grandparents can't walk to locations that are far away, but if you don't get a bit away from the ceremony or reception location, all the guests will be milling about, walking through the background, trying to talk to the couple, and basically distracting people who are supposed to be involved in your photos. You definitely don't want a group photo location that is right on the side of the reception area. Find something that is a bit out of sight, but not too far away.

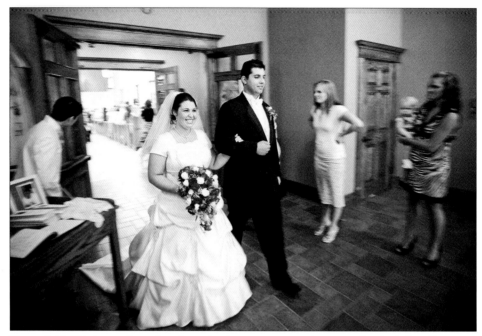

Figure 9-16: This is one time when the action happens way too fast to predict; I rely heavily on my camera's ability to take shots in rapid succession to get a lot of images as the couple walks past and I just hope that one or two of them turn out like this.

Summary

The best and most unique wedding photos are not the ones you can plan for on a shot list. Of course, you must have your mental list of the important shots, but it's the things you didn't expect that make the most interesting images. Keep an open mind, watch the people involved, and anticipate when something interesting is about to happen. Watch for ways to use the environment to make an image with interesting lines, or unusual light, and as always, focus your attention on the story and the emotion of the moment.

Shooting the ceremony is less about showing off your creative skills and more about documenting an event in a way that captures the beauty and the emotion of the moment. There are certain decisive moments where everyone involved will expect you to capture a decent image simply to record the passing of the moment. These "must have" shots needn't be particularly artistic. The true art of capturing the ceremony is in capturing the emotion.

Your clients will appreciate that you got every smile and every tear and every event that took place. They won't be looking for any special effects from the ceremony. They'll be looking for that I-love-you-so-much-I-could-just-die look in the bride's eyes as she stares up at the groom. They'll be looking for that I-can't-believe-my-baby's-all-grown-up look in Mom's eyes. They'll want to see the tears on Dad's face when he was so choked up that he couldn't even get the words "her mother and I" to come out of his mouth. It's all about capturing emotion.

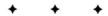

10 Capturing Candid Moments

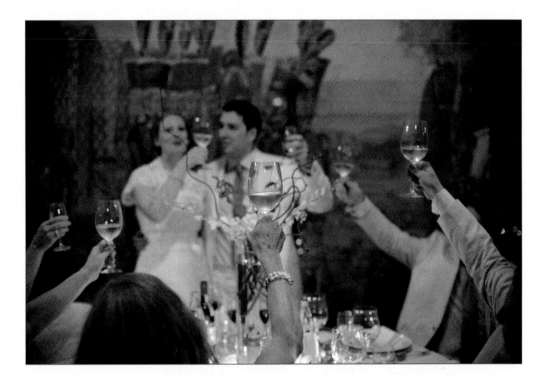

A good candid image captures a spontaneous natural moment. It represents a small slice of time, and tells a story about real people's lives. Candid images are not contrived or posed. They catch fleeting moments of beauty without an emphasis on perfect photographic technique or getting the subject to perform perfectly for the camera.

Can a picture really say a thousand words? Even the greatest candid image can't capture the whole story about anything, because a story is something that unfolds over time. Nevertheless, during almost any event, there comes a single decisive moment when many elements of the story align themselves at the same time and place. A photograph that encompasses all of these colliding factors can convey pretty much all there is to know about what was happening at that moment, though maybe not in a thousand words. Pictures don't speak to us in words at all; good candid images speak in the language of emotion.

Seeing Candid Moments

A truly beautiful candid moment such as the one shown in Figure 10-1 is one of the most elusive shots you may ever try to capture with your camera. When shots like these happen in real life they're such fleeting moments that the average person may not even notice them. You may see something happening — an expression, a gesture — and think about how great it would look frozen in an image, but by the time you process all of this in your head, the moment is already long gone. To capture such moments, you have to learn to react before they happen.

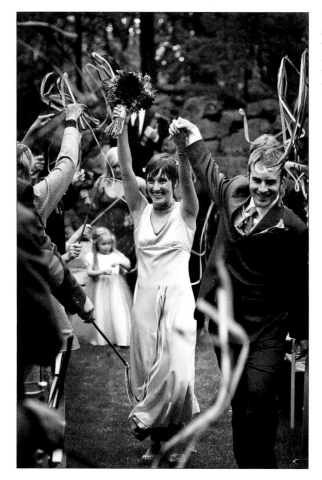

Figure 10-1: Pressing the shutter at the right moment is not something someone can teach you. It's a gut feeling, and your reaction to that feeling is what makes your work unique.

Perhaps this chapter should have been titled "Zen and the Art of Capturing Candid Moments" because it really is a Zen-like challenge to chase these moments with your camera. To catch them, you have to learn to turn off the logical part of your brain and trust your intuition about when something interesting is about to happen. This is all about studying human nature, and as much as it may initially seem impossible to predict when something is about to happen between two people, it is a skill you can learn. The fact that skilled photojournalists can capture such moments on a regular basis is sufficient evidence that it's not about luck.

Of course, capturing such a moment requires not only that you first see it coming and get into position, but also that you know when to push the button. This may seem like a simple thing, but it eludes most new photographers for several years; eventually this sense of knowing when to push the button becomes the essence of your own unique style. While it is impossible for anyone to tell you the perfect moment to press the shutter, there are techniques and thought processes that can help you learn to anticipate when something good is about to happen and get you in the right position to capture these moments on a regular basis.

Character studies

One of the tricks to predicting a candid moment is to study the personalities of the individuals at the wedding and learn which individuals are most likely to cause interesting events to happen. For example, early in the day, while you're in the dressing rooms and around the family, you can make mental notes about the different characters involved in the day. Notice which ones are likely to laugh, which ones are prone to crying, which ones are the energetic dancers, and which ones are just plain wild. And take note of the folks who bring strong reaction out in the bride or groom. Watch these people like a hawk and if one of them heads toward the bride or groom, get ready because there is a high likelihood that something interesting will happen.

Face the faces

One of the hardest aspects of storytelling for the new photographer is realizing that you can't tell the story from the same angle that a participant sees it. For example, if you take images of the couple and the wedding party signing the wedding license, there are two possible perspectives. One is the perspective of the participants. They stand on one side of the table and look down at the document they are about to sign. The other perspective is that of a viewer. If the viewer were on the same side as the participants, all the viewer would see is the people's backs and that obviously won't tell much of the story. If you want to tell the story, you have to get on the other side of the event so you can see the faces of the participants, and what they're doing, as shown in Figure 10-2. A composition such as this incorporates two subjects: the people themselves and what they are doing. Both parts are necessary to tell the story and either part alone would be meaningless.

In the real world, this means you have to move around a lot. Eventually, it becomes second nature to automatically move to the opposite side of the action from the participants.

In newspaper photojournalism, pictures accompany the text and the reporter, not the photographer, is responsible for telling the majority of the story. However, as the sole storyteller for the entire day, the wedding photojournalist has a much more difficult task. Any part of the story that you miss is fleeting and you cannot use words to fill in the gaps if your images don't tell the whole story by themselves.

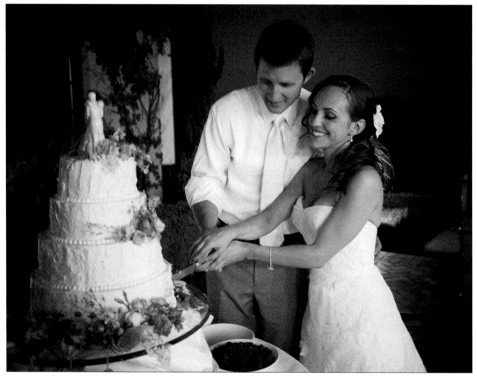

Figure 10-2: To tell the story, you have to get on the opposite side of the action from the participants.

Watch and wait

For candid portraits of a single person, as shown in Figure 10-3, you can focus your attention, and your lens, on this one person and simply follow her while watching for facial expressions, hand gestures, or laughs. This takes a lot of patience, but your perseverance will occasionally be rewarded with stunning images that are impossible to catch otherwise. For example, an average laugh may last one to two seconds. If you walk around with your camera at waist level, it could easily take you longer than that to raise the camera up, check the settings, and shoot. Even if you just try to raise your camera up and shoot, you still may not have time, and you're highly likely to blur the shot by moving so fast.

My favorite technique for getting good images like the one shown in Figure 10-3 is to find a good vantage point that is a little out of the way and just let my lens roam from person to person around the crowd. I spend most of my time following the bride and groom, but if they wander out of view, I concentrate on family members or bridal party members. I watch each person who falls under my lens, waiting for any expressions or interesting hand gestures that might make the image stand out.

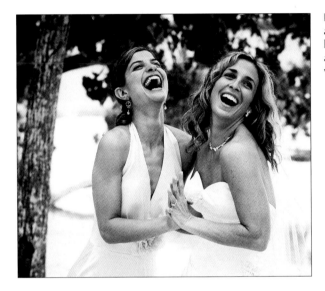

Figure 10-3: A good laugh can be a difficult shot to catch unless you have the patience to get ready in advance and then just watch and wait until something happens.

Choosing the Right Equipment

No single combination of equipment and camera settings is required for candids. In fact, you can capture candid moments with virtually any piece of camera gear and any camera setting. However, it will quickly become evident that anything that increases the speed with which you can take a well exposed and nicely composed shot will be worth its weight in gold. Candid action happens fast and the people you're shooting may not even be aware of your presence, so you won't be able to rely on any cooperation from them. You'll want to avoid things like Manual mode and tripods, and it may be well worth the money to get the higher priced camera body just for the increased focusing speed — especially in challenging light conditions. Keep in mind, however, that although having equipment that works fast and well will help you immensely, in the end, capturing fleeting moments is more about being in the right place at the right time than it is about what equipment you use.

American photojournalist Arthur Fellig, who used the pseudonym Weegee, was once asked what he considered the key to his success. Weegee answered, "f/8 and be there." F/8 is about as generic a camera setting as there could possibly be, so he was basically saying there is no magic camera trick to it — it's about perseverance and knowing how to get yourself in the right place at the right time.

Dennis Reggie, who is widely accepted as the founding father of modern wedding photojournalism, was asked the same question as Weegee and his answer was, "f/2.8 and be there." Obviously playing on the famous quote from Weegee, Reggie put a twist on it to reflect the current use of wide-aperture lenses that capture a very narrow depth of field, but his statement also emphasizes the fact that what Weegee said still rings true after all these years. The only trick is perseverance. The image in Figure 10-4 resulted from a combination of skill and being in the right place at the right time.

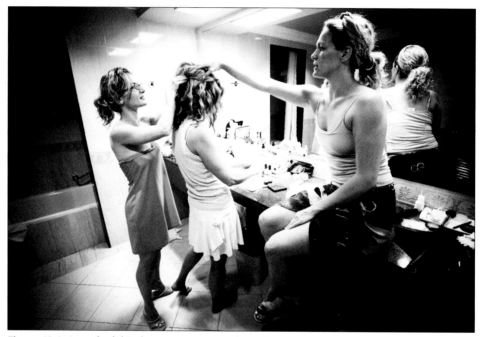

Figure 10-4: I watched this dressing room scene for at least an hour before all the different elements came together. That level of perseverance made all the difference.

When to use a long lens

Shooting with a long lens has several distinct advantages. It isolates the subject by creating a strong blur both in the foreground and in the background, and it also places you far enough away from the subject that your presence is much less noticeable. Even if your presence is detected while you're shooting with a long lens, the distance tends to put your subjects far more at ease than if you were standing beside them with a wide-angle lens.

When you shoot with a long lens, you don't necessarily have to use a wide aperture that gets very little depth of field. More depth is often an advantage in storytelling because

frequently several people are in the scene and you'll want to get them all sharp. Using a medium aperture such as f/5.6 or f/8 creates more depth of field and gets more people in focus. In the real world, you might have to vary your aperture based on the amount of light. If you're shooting in the middle of the day, you can easily use medium apertures, but if you're shooting in the late evening, you might need to use a wide aperture to get an acceptable shutter speed.

Telephoto lenses can be much more difficult to use for candid images because candids must tell a story, and the elements of the story are often spread out several feet apart. Many beginning photographers make the mistake of isolating single elements in a story, only to get the pictures back home and realize that a small piece of a story means nothing. You look at their pictures and they say, "_____ was happening when I took that shot." If you have to explain the story with your words, the image is a failure. A good candid image needs no title or personal explanation from the photographer.

A telephoto lens is great at isolating and zooming in close to the subject. Use it for candid portraits of single people or very small groups of people. As you can see in Figure 10-5, when the whole story is in one person's face, you've got the perfect opportunity to use a telephoto lens.

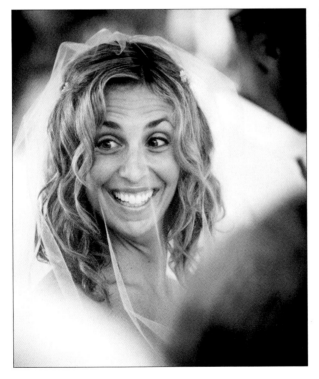

Figure 10-5: Some candid portraits tell the whole story in one person's face. This is a perfect time to use a long zoom lens.

When to use a wide lens

The wide-angle lens is a storyteller. It excels at capturing everything in the room but the photographer. The drawback to using this lens is that it requires you to be very close to your subject. Being close isn't a drawback as far as the pictures are concerned, but it can have a huge effect on the behavior of the subjects you hope to photograph. The closer you get, the more stiff they may act because this stranger (you) is way too close. Your very presence cuts down on your chances of catching your subjects in a genuinely natural state, and the closer you get, the more you may throw them off.

There are exceptions to this rule that depend on the physical space you are in and the activity taking place. For example, people don't seem so intimidated if the space is small and everyone has to be close, or if they're involved in some action that distracts them from the fact that they're being photographed (see Figure 10-6).

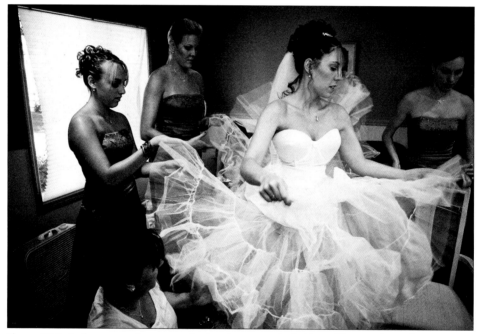

Figure 10-6: In the cramped quarters of a dressing room, the bride and her maids go about their tasks.

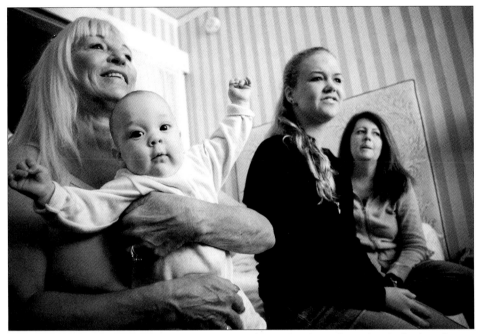

Figure 10-7: Children are often more interested in what you're doing than what the bride is doing.

With this in mind, the optimum places to capture candids with a wide-angle lens include:

✦ Small rooms where the space is so tight that everyone has to be close anyway

✦ Any activity where everyone is too busy to notice you

✦ The dance floor at the reception after the first few formal dances

If your subjects happen to be drinking a little alcohol later in the evening, your presence can even have a reverse effect. The closer you get, the sillier they act and the more they show off for the camera. All of which, although not exactly candid, makes for some great images. Figures 10-7 and 10-8 are examples of candids shot with a wide-angle lens.

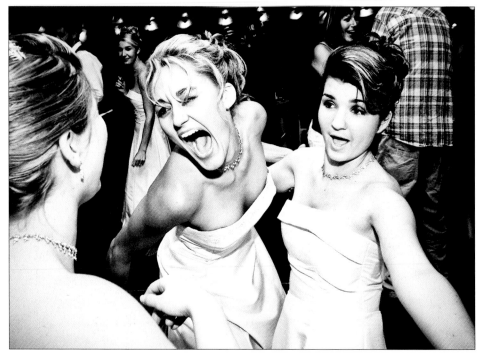

Figure 10-8: On the dance floor people tend to either forget you're there, or show off just for the camera. This is a perfect time to use a wide lens and get in close.

Summary

Capturing candid moments is quite challenging, even for the most experienced wedding photographers. Most people find it practically impossible to pick the skill up on the first few weddings and then slowly but surely, they become more and more in tune with the flow of the event and the way certain charismatic people always seem to be at the center of the action. The next step is to learn to see the characters coming and anticipate the fact that these people are likely to cause interesting events and expressions to happen all around them.

This is a game of observing human nature. When you stand aside from the group and observe, you begin to notice the convergence of all these little pieces that make up each story. Then you learn to place yourself in the perfect location to capture all the elements together from the point of view of observer rather than participant. Finding all these pieces as they come together and composing them into one image is truly an art; and I believe it is perhaps the single most difficult aspect of the entire wedding photography business.

Use the tips in this chapter to guide you on when to use a long lens and when to use a wide lens to capture candid moments. The lens you choose will be different in different locations. Not only will the lens determine the way you compose each shot, but also choosing the right lens will keep your clients and other guests feeling comfortable enough that they act naturally while you concentrate on anticipating and capturing candid moments.

✦ ✦ ✦

Creating Romance in the Magic Hour

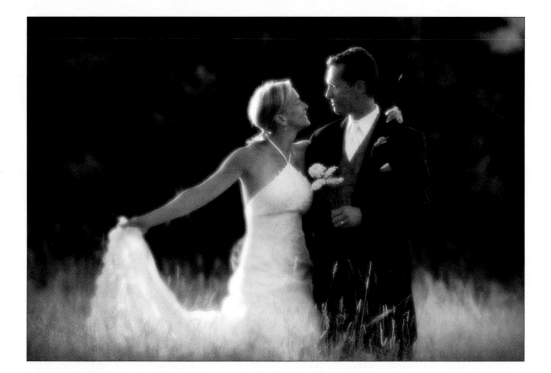

F or thousands of years artists have been trying to capture or create images that portray "romance." Photographers, painters, and sculptors alike have all struggled with the same question, "What does romance look like?" For that matter, what is romance? We have romance novels, romance languages, romantic music, and even romantic places. You can have a childhood romance, you can have a romantic encounter, and an old car can even have a certain romance about it. However, none of that really tells us what romance *is*.

Like beauty, romance is an elusive trait that can only be judged in the eyes of the beholder. Every person knows it when he or she sees it, yet no two viewers see it in the same place. Teaching someone how to create an image that can't be fully described is a daunting task — especially in light of the fact that everyone's perception of romance is different. I may be attempting the impossible in this chapter, but the best I can do is explain a few of the

techniques and thought processes that I use when creating my own version of romantic images. As you read through this chapter, bear in mind that this is one of the areas of wedding photography that is most open to individual interpretation; and as such, your own personal version of romantic images will become a unique aspect of your work that draws in your customers.

Choosing the Right Equipment

Romantic images don't demand any specific type of equipment. However, it is safe to say that a large majority of them benefit greatly from the use of extreme lenses — either long telephoto lenses or very wide-angle lenses. The choices you make here will be determined more by your own personal vision than anything else. As your experience grows, you may find yourself gravitating toward a particular "theme" of romantic images, and it can be a great branding tool to cultivate something that becomes known and easily recognizable as your particular style. However, wedding photography is different every day. Each wedding is different, the location is different, the lighting is different, each bride has different tastes, and image styles change over time — making today's cool, tomorrow's cliché. Therefore, it can be to your advantage to learn and develop a lot of techniques so that no matter where you are or what the wedding is like, you can always pull something out of your bag of tricks to make that bride feel as if her photos are unique and they fit her style and her location just perfectly.

When to use a long lens

The telephoto lens brings three valuable characteristics to the creation of romantic images:

✦ The telephoto has a shallow depth of field.

✦ The telephoto compresses the subject and background so that they look very close together.

✦ The telephoto has such a narrow angle of view that it captures only a small piece of the scenery behind the subject.

This narrow angle makes it easier to find a good location because you only need a very small piece of pretty background to work with. If there are people or trash cans nearby, for example, just find one little section of beauty, then crop in tight to get rid of everything else and nobody will ever know. I shot Figure 11-1 in a very busy area but the telephoto lens cut out all of the surrounding distractions.

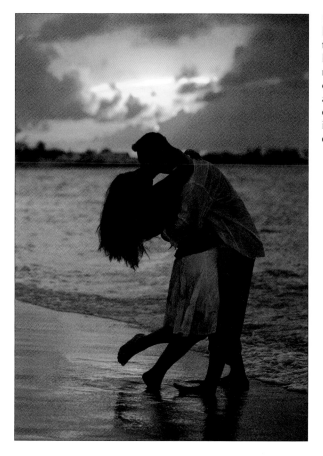

Figure 11-1: I used a telephoto lens to crop the distractions for this romantic sunset shot. The location was in front of a busy resort in the Bahamas, with crowds of people and boats all around the couple, but if you didn't know this, you might imagine I shot the image on a quiet, secluded beach.

One of the primary advantages of using a telephoto lens is that it puts a lot of distance between you and the couple. This distance not only helps the couple feel more at ease, but also it enables your viewers to form the impression the couple didn't even know you were there when the image was taken — almost as if you were spying on them as they shared a quiet moment together. Figures 11-2, 11-3, and 11-4 illustrate examples of effects created with a telephoto lens.

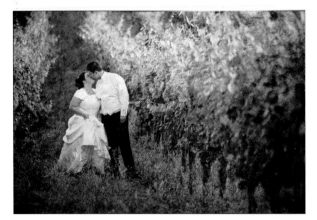

Figure 11-2: Telephoto lenses are perhaps best known for producing a shallow depth of field, as seen in this vineyard shot. For this lens I also used Adobe Photoshop to place a texture overlay on the image to give it an aged, rustic feeling.

Figure 11-3: Telephoto lenses (200mm f/2.8) can create the illusion of compressing the foreground and background elements closer together than they actually are. This shot was taken at a vineyard with gently rolling hills but the telephoto lens compressed the foreground and background to the point that it looks as if the whole vineyard were growing on the face of a cliff.

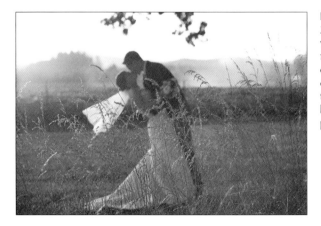

Figure 11-4: I always bring the 200mm f/2.8 IS telephoto lens when I'm trying for a romantic feel. I love the shallow depth, the extreme sharpness, and the way I can shoot through foliage to give the impression the couple might be completely unaware of being photographed.

When to use a wide lens

The wide-angle lens is a bit harder to use for romantic images, but on those occasions when you have a large expanse of beautiful background, a wide-angle lens can create some truly dramatic results. The images shown in Figures 11-5 and 11-6 were made with very wide lenses.

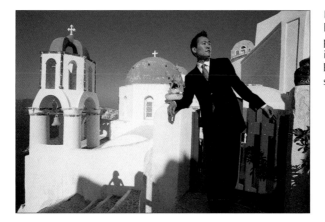

Figure 11-5: Finding a dramatic landscape is no problem in a place like the city of Oia on the island of Santorini. Working the bride and groom into the composition is the fun part.

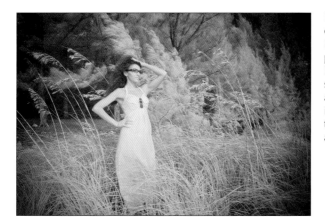

Figure 11-6: I have one camera body that I've converted to infrared. I don't do close-ups or portraits with infrared because it makes the eyes look really spooky. Instead, I shoot it with a wide lens and try to find some interesting foliage or other features in the landscape to use as a backdrop.

When to use art lenses

Art lenses such as the 50mm f/1.4 and the Lensbaby, as well as fisheye lenses and even pinhole cameras, can all be used successfully to create romantic images. (See Chapter 3 for more information on the various types of art lenses.) Most of my romantic images are shot with either the 70-200mm f/2.8 lens or the 50mm f/1.4 lens because that is my own personal preference; however, of course it is possible to create a romantic feel with any lens imaginable and sometimes lenses with major imperfections are completely acceptable. For example, the

old Holga and Diana plastic cameras had lenses that were absolutely horrible from a technical standpoint, but they sure made some cool "artsy" effects that were beautiful. Don't be afraid of experimenting by putting things like that in front of your digital camera.

Defining the Romantic Image

According to definitions I've found, a romantic image is idealized, not based on fact, and remote from everyday life. It displays, expresses, or is conducive to love. It is imaginary. Perhaps it's not completely imaginary, but certainly a romantic image does get much of its appeal and expression of love from the fact that it leaves a lot to the imagination. Upon seeing a romantic image, one person may imagine, and even actually feel, just a bit of the deep feelings of the love a bride has for her new husband. Another may imagine that there is more going on in the scene than what is shown. Another may imagine what it would be like if she were actually there — if she were the one in the picture. A romantic image like the one shown in Figure 11-7 sets the viewers' minds free to imagine the love and emotion they themselves want to experience. If you can create images that inspire romantic feelings in a woman, you can bet she will remember your name when she finds "Mr. Right."

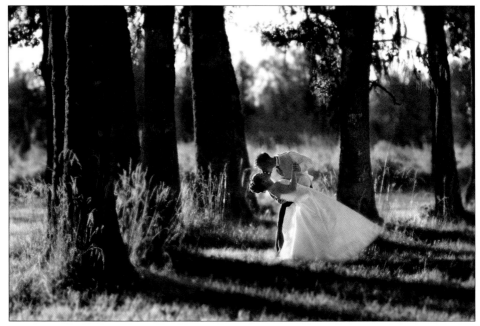

Figure 11-7: Somewhere in the back of our minds, we all have dreams of a fairytale love affair and a fairytale wedding. A good romantic image triggers those dreams, and enables us to imagine romantic possibilities.

Deconstructing Romance

Is it possible to make a list of the photographic elements that give an image a feeling of romance? To some degree, many romantic images share similar qualities we can define, but it would be impossible to rely on a single formula for the creation of a romantic image.

One element of note is that very few of the images in this chapter were shot in a journalistic fashion. If it seems as though they might have been, then the goal of creating images that look completely natural has been accomplished. While I did purposefully contrive and orchestrate these images, they aren't "posed" in the traditional sense of the word. Much effort was spent on creating the feeling that the subjects are at ease in a natural scene. Perhaps the most difficult aspect of working with clients who are not professional models is that they don't know how to fake looking natural, and you, as the photographer, must somehow coax them into it. One of the most helpful concepts I've learned is that when you're working with novice models, the less instruction you give them, the better. Too much direction may only serve to make them stiff and uncomfortable as they try to act out some pose for you. Simply put them in a beautiful place and give them very basic instructions. Doing this may not get the "perfect" pose, but it will get something that looks and feels genuine and real to them.

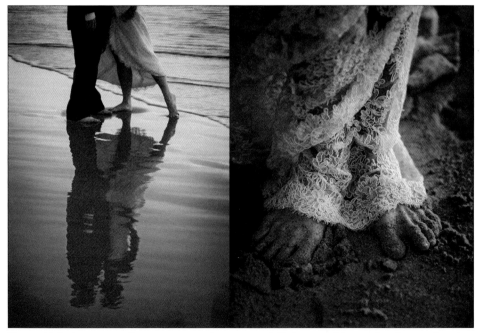

Figure 11-8: Anonymous images are great for your portfolio because it's easy for clients to imagine themselves there.

The most fundamental element of a romantic image is that there is no interaction between the subject and the viewer/photographer. If the subject looks at the camera, you have a portrait, not a romantic image. The difference is that a portrait is about a person, while a romantic image is about a feeling — an imaginary, idealized, and fictitious feeling that relies in part on the notion that the subject of the picture is the one experiencing the romantic feelings. The viewer experiences the same romantic feelings through empathy with the subject. The dream can only exist while the subject is experiencing it. If the subject looks up at the photographer, the dream disappears.

Romantic images that don't show faces, such as the image shown in Figure 11-8, are great for your portfolio because the anonymous quality makes it easy for viewers to imagine themselves in the photograph.

When you work with your clients to develop a "pose," pay particular attention to helping them relax their hands. Hand positions communicate an amazing amount of detail about how

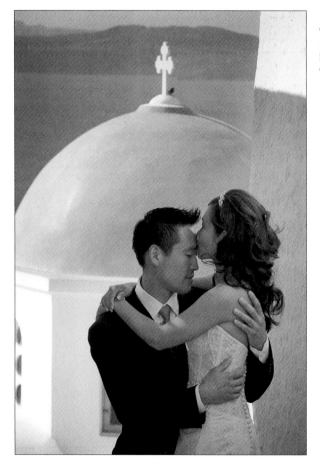

Figure 11-9: Notice the casually draped hands, which communicate a feeling that these two people are very comfortable with each other.

a person is feeling about him- or herself and about the person he or she is with. Notice the relaxed hand positions in Figure 11-9 and throughout the images in this book. Most viewers will not be able to tell you that a problem stems from the hand positions, but they will be able to tell you that an image feels stiff or "uncomfortable" when the hands are positioned in a stiff or uncomfortable manner.

The eyes also communicate a lot of feeling. As you can see in Figure 11-10, posing the couple with eyes closed creates the feeling they are enjoying a blissful moment together. This evokes a different feeling than if they had their eyes open and were looking at each other, and yet another different type of feeling than if they were looking at the camera, as shown in Figure 11-11. You can use each of the three "looks" for different purposes: eyes closed for a quiet blissful mood, eyes gazing into each other for a romantic moment, and eyes looking at the camera for a portrait. I frequently try to create one of each of these three types of images every time I have the couple in a space that works well.

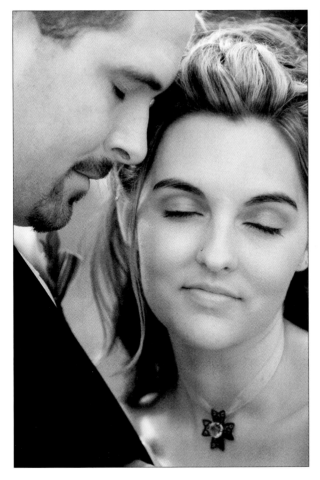

Figure 11-10: In most romantic portraits, the bride and groom look at each other and interact in some way. When they close their eyes, it creates a very relaxed feeling.

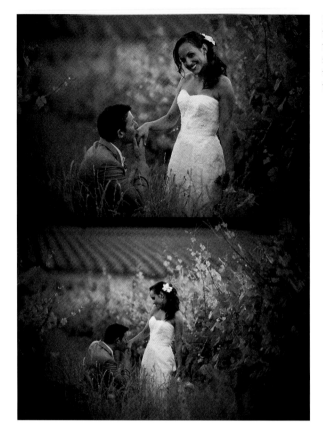

Figure 11-11: The lower of these two images has a romantic feeling. Once one or both of the subjects looks into the camera, the romantic spell is broken and the image changes to a portrait.

Technical perfection is not a requirement for romantic images. Blurred, grainy, and poorly lit images can add quite a lot to the mystery by departing from reality and leaning toward the imaginary or fictitious. The images don't rely on sharpness to convey a feeling of romance. In fact, they seem to gain more of a romantic air because the identity of the subject is somewhat veiled and blurry. These somewhat impressionistic images convey feelings that a technically perfect photograph simply can't come close to. Given this, you will want to throw out all pre-conceptions about technical perfection being a requirement for this part of the day. Feel free to experiment with extreme grain and blur — both from motion and from funky lenses. These effects also work quite well when the light is so low that it's difficult to get sharp images any-way; in fact, that may actually be the prime time of the day to attempt these effects as there isn't much else that you can do during this time. The images shown in Figures 11-12 and 11-13 are examples of images I created with this process.

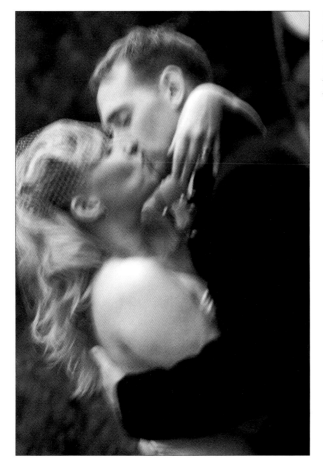

Figure 11-12: Sharpness is not required in a romantic image. In this case, the motion and blur it creates serve to express the romantic, sexy, and passionate feelings the bride and groom have for each other.

Understanding the Golden Hour

The term "golden hour" is a common photographer's term that refers to that time in the evening when the sun is very near, or just below, the horizon. While the sun is still visible, the light is a warm tone from the low angle. Once the sun goes below the horizon, the light takes on a mellow character because it is still coming from the general direction of the sun. And when the direct sunlight is gone, you suddenly have a huge soft light source in the western sky. Shadows practically disappear and the colors are particularly rich and saturated. As the sun drops lower, the light disappears rapidly; but even in the last remnants of light, you can play with techniques like silhouettes against the sunset colors. Further, because shutter speeds eventually become so slow the image will be blurry regardless, you might as well try some panning shots with your couple walking past you as they laugh and play together. Basically, if you vary the techniques and types of images you take according to the amount of light remaining, you can keep right on shooting until it gets dark.

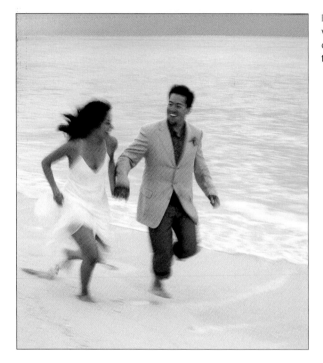

Figure 11-13: Having the couple walk or run by in the late evening can make for some beautiful motion shots.

Another strong aspect of many successful romantic images is that they appear as if the photographer was spying on the couple as they shared a quiet moment alone. Of course, as the photographer creating these images, you won't be spying on them, but you can create a bit of this feeling by shooting through objects. For example, when you're indoors, you can shoot through a small opening in a doorway, or through a crack in the curtains. When you're outdoors, you can shoot through some foliage that partially obscures the scene to get the same effect. The viewer will subconsciously consider the foliage or other obstacle as a validation that the scene must be completely natural. Perhaps we think, "If the photographer was posing the scene on purpose, he would have certainly taken the time to remove those distractions before taking the shot." The goal of this technique is to give the impression the couple was completely unaware of the photographer and of the fact that they were being photographed. Figures 11-14 and 11-15 are examples of this effect. Figure 11-16 is another example of a romantic image.

Creating the Photo Shoot

Unfortunately, one of the most frustrating aspects of wedding photography is that your clients often expect you to create a work of art in twenty minutes or less. They usually have no idea how unrealistic it is to expect such things because they have never tried to do it themselves and often have never been involved in a serious photo shoot before that day. The real irony is that your clients hire you for the beautiful images you create, and then schedule the day with little or no time for you to create them.

However, almost all brides want you to be able to "do your thing," and they will bend over backwards to help when they know what they need to do. Therefore, the responsibility of getting sufficient time for your photo shoot falls squarely on your shoulders. You have to make sure this time is on the schedule. It's your job to educate each new client about the importance of this time and then make sure she plans accordingly. And don't forget to talk about the importance of scheduling enough time for photos to the groom and the coordinator as well so everyone is on the same team. Creating beautiful images takes time, and getting that time doesn't happen by accident. I have written an article about this on my website that my brides can use to plan out the timing of the day (www.aperturephotographics.com/downloads/schedule_your_day.pdf). Feel free to link directly to the article from your website if you'd like to share this information with your own brides.

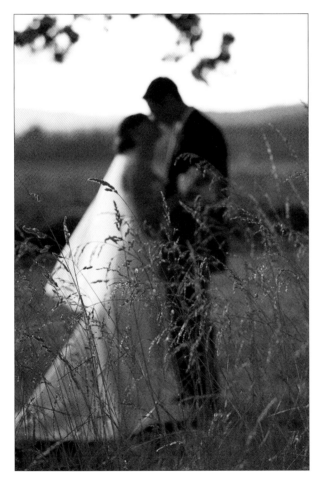

Figure 11-14: Focusing on the plants in the foreground adds to the feeling that this is a perfectly natural moment captured by the photographer. Only the couple and the photographer know that it took careful positioning to get it just right.

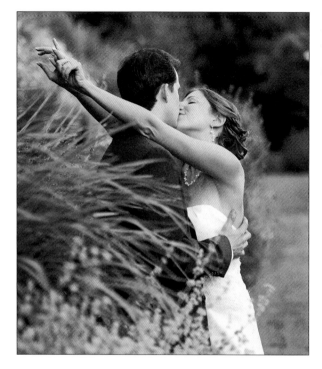

Figure 11-15: Focusing on the couple while shooting through a veil of plants in the foreground is another way to achieve the same feeling.

As mentioned earlier, the absolute best time to schedule a romantic photo shoot is the hour before sunset and then approximately thirty minutes past sunset. Often this time falls after the ceremony and in the first half of dinner. If you and the bride have planned it out perfectly, the bride and groom will finish eating in time for you to slip away with them for a half hour without the guests even noticing. This requires that you and your assistant eat your meals at the same time as the bride and groom so that all of you are finished eating and ready to go at the same time. If you talk with the coordinator about your plans, he or she will make sure it falls into place right on time and will also usually be very accommodating about holding your food plates or prepping them in advance.

How much time do you need? One fact is certain: You'll rarely get enough time to feel like you've worked anything over to perfection. Occasionally you might schedule an hour but frequently other events at the wedding will conspire to put the schedule off and you may only end up with twenty minutes. Is it possible to shoot even one romantic picture in twenty minutes? It is if you plan your shots carefully. That means walking the area in advance (early in the day) to scout your favorite locations. After you get some ideas for places, you can get your

assistant to stand in the scene and act out some potential poses while you decide which lens and camera settings you want to use to get the desired results. If you've selected three or four places and have all the details planned out, you can definitely get through two or three of them in twenty minutes. (Note: This is another time when a tripod is worth its weight in gold. You need to be able to compose carefully because you may need to run out to adjust the bride's dress or break off a sprig of tall grass, then run back and still have the camera ready to go.)

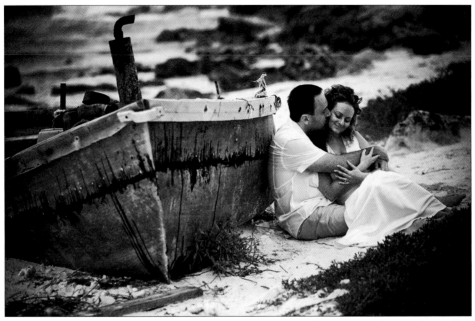

Figure 11-16: For this quiet pose, I told the couple to "get comfy by the boat." They tried several different ideas. Each time they came up with a pose, I would shoot a couple shots and then have them walk away a bit before coming back to create a new pose that was completely different from the last. Every time they did, it gave the images a totally new look. Most of these shots are deleted because I only need one or two keepers to make all that effort worthwhile.

The series of images shown in Figure 11-17 comes from a single wedding, and all of these images were shot on a quick walk around the grounds of the venue that lasted roughly half an hour. As mentioned earlier, my assistant and I went through the buffet line right behind the bride and groom so we could all sneak away while everyone else was still eating.

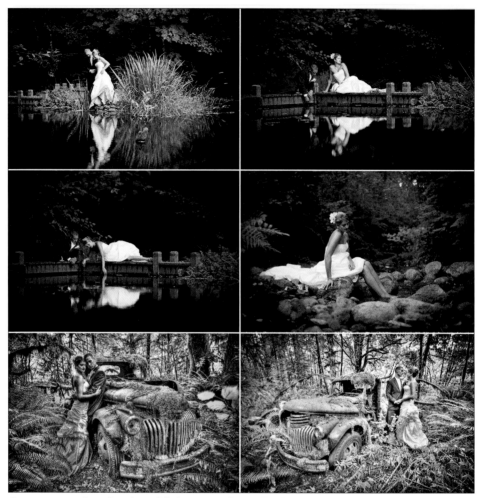

Figure 11-17: After a bit of careful planning earlier in the day, these six keepers (plus a ton of out-takes) were created during a thirty-minute walk around the venue.

For this wedding, my assistant and I arrived early in the day (before everyone got there) and spent time just walking slowly around the grounds gathering ideas and trying out poses in various locations. When the time arrived, we walked the couple quickly from one location to the next without any hesitation or stopping to think, "Hmmm, where do we go next?" We simply hit each place, worked through several poses, and moved quickly to the next spot. It's amazing how much you can accomplish in half an hour when you plan ahead.

Pre (or post) bridal shoot

Some couples want so many group shots of themselves with all of their family and guests that by the time it's all done they're ready to quit taking photos and get back to the wedding. Because of this, I always try to talk my couples into a pre (or post) wedding shoot on a different day. If you can convince them to do this, you can spend as much time as you like creating a really good set of images of just the two of them, without all the craziness of trying to do it on the wedding day. This is a great relief because on the wedding day, often the images of the couple alone are given a lower priority than the family group shots. If you can schedule this shoot for a different day, then you don't have to stress out about it at the wedding.

Doing a separate shoot of the bride and groom alone also enables you to travel to a different location. This is great if the wedding is in a church, or if the wedding venue is just not all that photogenic. And even if the location is photogenic, using a completely different location adds diversity to the image collection, which can greatly assist your album sales.

If you can talk the bride and groom into doing this shoot the day after the wedding, then they can wear their wedding outfits without worrying about getting them dirty. This takes a lot of stress away when you're getting the bride to sit on things, or climb into someplace that looks cool but may not be all that clean. And if you want to take the dirty factor up a few notches, you might try to talk the bride into doing a "trash the dress" type shoot. I've never been into doing this sort of thing personally, but if you do a search on Google or YouTube, you can find many examples from other photographers who do this quite often.

Sometimes a bride will look at you like you've just lost your mind when you mention trashing the dress, but then after the wedding is over and you're out on the beach, eventually one wave leads to the next and before you know it, she and the groom are splashing in the surf and having a great time trashing the dress, as the couple in Figure 11-18 did on a remote island in Fiji. The image in Figure 11-19 was created with a couple who chose to bring special clothing just for the "day after" photo shoot.

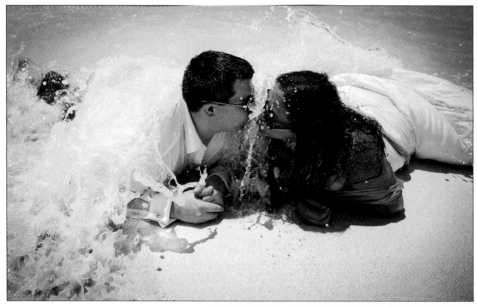

Figure 11-18: Occasionally even the most reluctant bride will trash the dress because it's just so much fun.

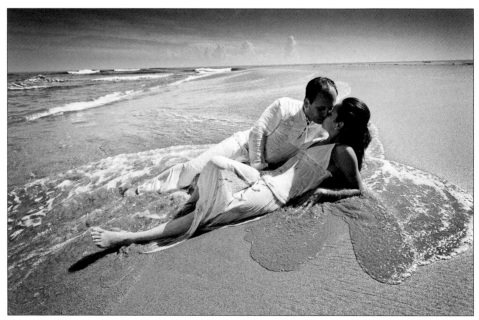

Figure 11-19: This couple was determined to do a beach shoot in a remote area of the Dominican Republic near the villa they rented for the wedding. They planned by bringing special clothing.

You may ask, "Is it really worth it to give away, or even charge good money, for these short photo trips that take up the majority of a day?" Even if I give this photo session away, I think it is very much worth the time and effort it takes for several reasons. First, this short, creative photo session generates the sort of dramatic and unusual images I can put on my website, and once I do, I'll be reaping the benefits for years to come. Sure the bride in the pictures will love the images, but to be perfectly honest, you have to attract the attention of future brides if you want to stay in the game. Second, if you can schedule this shoot before the wedding, it enables you to get to know the bride and groom on a far more personal level than what you can ever experience if you just walk in on the day of the wedding and start shooting. Third, a pre-wedding shoot also gives the couple some time to get over the initial strangeness of having someone pointing a camera at them. After a couple hours in front of the camera, even the most camera-shy couple will eventually lighten up and begin to feel comfortable in front of your camera. By the time the actual wedding rolls around, they'll be ready to completely ignore you and go about the day.

Pep talk before the photo shoot

It is important to coach your couples a little bit before you start taking pictures. Some of the following information also appears in Chapter 5 in a discussion about composition. I elaborate on that information here because I believe it is vital to the success of the romantic portrait session for you to be able to coax your couples into poses that are good compositionally as well as look natural and relaxed.

During the photo session, which hopefully takes place in the late evening, I focus on finding beautiful locations with spectacular lighting and I put the couple in the scene and to a certain extent, I let them do their own thing. By this time of the day (late evening), the bride and groom should be more comfortable in front of the camera but you should still be careful about giving them too much direction. I find that a few general directions are helpful, especially when you deliver them before taking pictures; if you wait until the couple is in the middle of trying to come up with a pose, the same information becomes distracting and confusing. So stop everything and talk to them about how you will approach the session before you get rolling. My speech goes something like this:

> "I like to do very little posing because it tends to make your pictures more unique if you come up with ideas of your own. I can come up with ideas, but I want to avoid having all the weddings I shoot look alike. So if you have an idea, please throw it out there even though it may sound silly, or even impossible to do. Sometimes your idea won't work but when you say it, someone else may think of some other way to make it work and before you know it, that silly idea turns it into a great picture. When we find a good spot, I'll tell you roughly where to stand and then you can hug, kiss, play, dance around, and do anything you like."

I especially like to coach my couples on kissing for the camera. I tell them to kiss straight on (almost nose to nose) without tilting their heads over to the side much. I also tell them the best part of the kiss is the moment just before contact is made, so they should try to hover a bit at a point where they have about an inch between them. Once they have their faces smashed together, I might get a good passionate kiss shot, but for the most part, you can capture a feeling of anticipation that leaves something to the imagination in the moment just before the lips

touch; this mystery contributes to the feeling of romance in the image. If their faces are close together, I tell them to relax their faces and jaws even to the point of letting their mouths open a little bit. After all, most people actually do have their mouths slightly open when they feel relaxed and calm.

I like to do a lot of walking shots with my couples. I have them walk back and forth through some particularly beautiful scene and I tell them to talk or play and occasionally lean in for a kiss as they go along. Most important, they need to smile and keep interacting with each other as they walk. When I find a beautiful location where I want to try this technique, I might have the couple walk back and forth three or four times before moving on.

The following are a few general guidelines for things the couple can do to improve their romantic pictures, and as with all photographic guidelines, every one of them can occasionally be ignored with very good results:

✦ Don't smash your faces together when you kiss. The most romantic part of the kiss is that moment just before the lips actually make contact. Take it slow as you get in close and linger at that place where there is about an inch between your lips.

✦ Try not to tilt your head to the side when you kiss. Face your partner straight on so the photographer can see both faces from the side.

✦ Don't pucker your lips out when you kiss. Kiss with a relaxed face. When you're not kissing, relax your face so much that your mouth hangs slightly open.

✦ Don't smile when you kiss. Smiling lifts the cheek muscles and turns the romantic feeling into a playful feeling. Playful can be good, but most romantic images are a bit more serious.

✦ When you're walking, try to occasionally lean in for a kiss without completely stopping.

✦ Be aware of draping your hands over your partner in a very relaxed way. Clenched fists and stiff fingers give the whole image a strained feeling.

Digital Romance: Creating Passion with the Computer

Many images are not very romantic straight out of the camera. As a digital wedding photographer, it's not required that you master Adobe Photoshop or Lightroom, but I think I can safely say that it puts you at a distinct advantage if you know these tools well. With a wide variety of artistic effects, your portfolio and website can shine far above and beyond your less digitally inclined competitors. The time you spend learning even a moderately high level of skill with Photoshop will come back to you many times over in the form of higher paying clients who appreciate your artistic abilities.

If you don't think you have the time to spend learning Photoshop, your options include hiring someone to do the work for you or purchasing some good Actions for Photoshop or Presets for Lightroom. Actions and Presets enable you to automate a series of steps. Each one is a formula

that contains a set of instructions for the specific steps the software is to perform on your image. Running Actions and Presets is as simple as opening an image, choosing the Action or Preset from the list, and pressing the Play button. You can make Actions and Presets yourself or you can purchase them from several different photographers. If you purchase a set, you can even modify them to fit your taste.

Good places to find commercially available Actions and Presets are from photographer Fred Miranda (www.fredmiranda.com) and from Kubota Photo Design (www.kubotaworkshops.com). Adobe (www.adobe.com) also has a library of free actions and presets that you can download.

Another good source for help with the creation of some beautiful digital effects is a program from Nik Software called Nik Color Effects (www.niksoftware.com). This package is actually a plug-in that works within Photoshop to create some stunning digital effects. The great part about Nik is that you can adjust the filter effect as you first apply it, but then when the program renders the effect, it does so on a new layer, which is masked out. This enables you to paint on the mask to adjust where the effect shows up in the image. Nik is a huge timesaver for Photoshop users who want to add quick creative digital effects to photos.

PhotoTools from onOne Software (www.ononesoftware.com) is another excellent way to improve your romantic images. With PhotoTools you can stack multiple effects on top of each other just like you would filters over a camera lens. You can then control the order of each effect and how they blend together for a truly unique look. You can even save your effect stacks for future use and share them with friends who have PhotoTools. You can also access them through Aperture and Lightroom to speed-up your workflow.

I also have my own set of Lightroom Actions available for sale on my website at www. aperturephotographics.com/presets. You can see a few of the results you can achieve with these Presets in Figures 5-1, 5-10, 5-12, 5-15, and 5-16 in Chapter 5, and in Figures 11-6, 11-7, 11-9, 11-15, 11-16, and 11-17 in this chapter. Pretty much every image in this book with a look other than a standard color image was done with my Lightroom presets. These are the same presets I use every day when working on my own wedding and portrait images.

Summary

Romance is an elusive quality that is difficult to capture with a camera. After all, camera manufacturers go to extreme pains to build cameras that capture reality — they simply don't build cameras to capture qualities like mysterious, fictitious, dreamy, imaginary, or idealized. You have to work those elements into your image through posing, lens selection, choosing the right background, and perhaps even a few digital adjustments.

Often a beginning digital artist can save hours of work using an Action or Preset; and even when you've become a seasoned pro, you may find yourself clicking these jewels simply to save time and energy. Whether you choose to really master the digital tools or just purchase a pre-made recipe to help you do the job, digital effects can quickly elevate your work above your competition. Soon you will begin to see your raw digital images as the basis for your artwork — a canvas to paint on — instead of seeing them as the end result.

12

Jazzing Up the Reception

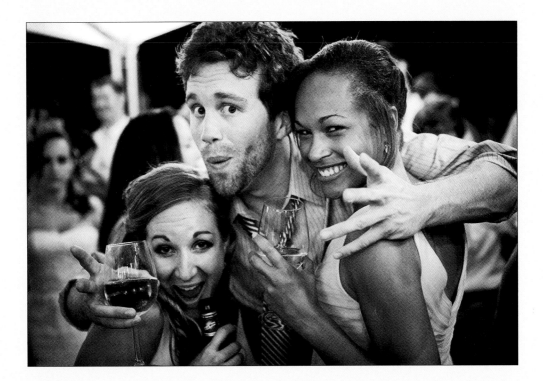

After all the ceremony and formal pictures are done, you can breathe a deep sigh of relief. You've captured almost all the "must have" shots and you finally have time to sit down and grab a bite to eat, sip a glass of wine, and prepare for the fun part of the job.

During the hours that follow, you have only a few responsibilities. Most couples want shots of the food, the first dance, the cake cutting, the garter and bouquet tosses, the guests dancing, and perhaps their grand exit. Other than that, you have free reign to photograph whatever else you find interesting. You may discover a unique portrait opportunity that you can talk the bride and groom into doing, or you might spend your time wandering the dance floor trying to capture that elusive perfect dance shot. Whatever you find yourself photographing during the reception, it's almost certain to be one of the most enjoyable parts of the average wedding day.

Must-Have Reception Shots

In this first section I focus on the specific "must have" shots you're expected to get during the reception. These "must-haves" are similar to the "must-haves" from the ceremony in that they are entirely predictable. You know almost exactly when and where each event will happen. This knowledge enables you to get your camera set up properly and beat the crowd of spectators armed with phone cameras who will also be jockeying for the prime shooting location. As you will soon see, getting there first is far easier than trying to ask someone to move over.

The decorations and location

A good collection of images from the reception should start with a few "scene setters." These are images that record the physical space where the reception took place. The shots might include the location sign out on the road, the building, pretty scenery, table settings, the bar, and perhaps even the cooks in action as they prepare the meal in the kitchen.

You can take shots of the facility early in the day when there's plenty of light, and then again later in the evening when it's almost dark, as shown in Figure 12-1. If you have the time to walk around and do a couple of these shots right at dusk, you can get some light in the sky in combination with the location lights. This is almost always preferable to the empty black sky you get when it's really late at night.

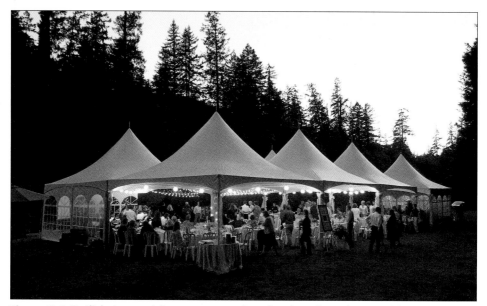

Figure 12-1: Twilight is a good time to get some shots that show the wide view of the location where the reception took place.

Make Friends with the DJ

You can do yourself a huge favor by befriending the wedding coordinator and the DJ as soon as possible at the reception. If these people are on your side, they'll watch out for you and make sure that you're notified when anything important is about to happen. Frequently it is the DJ who announces each reception event as it is about to happen. If you have a good rapport with the DJ, he or she will make sure you're at the right location and ready to shoot before announcing the next event in the wedding schedule; for example, before letting the guests know that it's time for the bride and groom to cut the cake. If the reception location is particularly small and you know there will be a tight crowd around every event, it's especially helpful to have the DJ alert you first, so you can be standing in your favorite spot before the announcement is even made.

It should be mentioned that these shots are always in high demand among the owners of the location. Sending the owners a disk with these images will keep your name high on their list when they meet new brides. These shots may end up on the website for the location (with a link back to your website) or in albums that are displayed at wedding shows.

The food and beverages

The food and beverages are a big part of each wedding. I try to get shots of the food preparation (especially if the family is helping), food being served, guests going through the buffet line, drinks being served at the bar, and maybe even a couple of shots of full plates held by guests as they exit the buffet line.

I like to get a couple of wide shots of the wedding party at the table with full plates, and a couple of shots of the bride and groom enjoying the meal. I then take a break to eat as well. It's easy to annoy people if you shoot them with their mouths full of food, so aside from the wedding party, I try to avoid shooting a lot of images of guests eating, unless the food is something really exceptional and visually interesting.

The cake cutting

The cake-cutting ceremony is a standard part of the average wedding day. As the DJ announces that the bride and groom are about to cut the cake, and the couple approaches their spot behind the cake, you may see them look at the knife . . . then look at each other . . . then back at the knife . . . because neither of them has the slightest idea how to do this. You are usually the closest person around with any experience on the subject of traditional cake cutting methods, and if you can manage to discreetly whisper some instructions, the couple will certainly appreciate your help.

My speech goes like this:

> "The bride holds the knife first and the groom places his hands around her hands. Together you cut a slice off the bottom layer and then you pull the slice out on a plate, break it apart with your hands, and then feed it to each other."

I always tell them to cut the bottom layer of the cake because sometimes the upper layers are poorly supported and it is very possible for the bride and groom to push the whole cake over (yes, I have seen it done). I also never recommend using forks at this point simply because the temptation to smear cake in each other's faces runs high, and not only can forks be dangerous, but also they almost guarantee that there will be no cake smashing, and I personally find a little cake smashing far more entertaining and "photographable" than a quick civilized exchange of small bites. I don't actively encourage cake smashing simply because it's not my job to "create" the wedding for the couple, but I do try to be ready to catch it if they get into that sort of thing.

For the photographer, the most critical part of capturing the cake cutting is getting yourself into position before the guests get the prime spot. The diagram in Figure 12-2 shows the standard angle and composition for the cake-cutting shot. The best place to stand is about five feet in front of the cake table and about 45 degrees off on the bride's side. The prime spot in the diagram puts you a few feet away from the cake table, which unfortunately opens a gap for kids to step in front of you right at the last minute so you have to watch out for this.

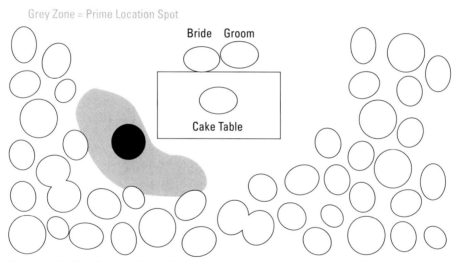

Figure 12-2: This diagram shows the prime location for getting the standard cake-cutting shot. If you have a choice to go to either side of the table, choose the bride's side. Placing yourself anywhere in the grey zone will be acceptable, but the dark spot shows the absolute best location.

If you position yourself on the groom's side (see Figure 12-3), you may find that when he bends over with the knife to cut into the cake, the bride is almost completely obscured behind his arm and shoulder (this assumes the groom is the bigger person, which is not always the case). This bride would be more visible if I was on the bride's side, but then I would be shooting the couple against a blank wall. Instead, I placed my back against the wall and shot the couple with the crowd as a background. Even though this puts the groom in front of the bride, I still prefer this shot over having a blank wall as the background. Figures 12-4 and 12-5 show different versions of the cake cutting shot.

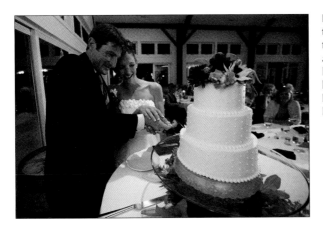

Figure 12-3: Correct framing tells the whole story of the cake cutting by showing both the people and the cake. This shot might have been better if I was on the bride's side, but then I would be shooting the couple against a blank wall.

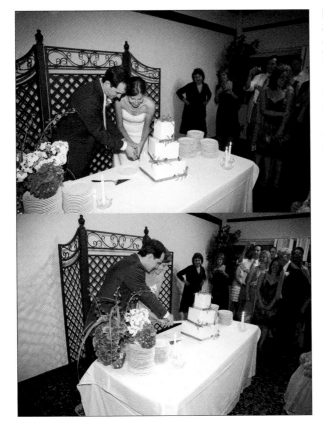

Figure 12-4: In this pair of images, I shot the top image and my assistant, who was standing just to my left, shot the bottom image. You can see from the difference in the two shots that it really is important to be in "the spot." If you are too far around the side of the table, you won't be able to see both people when they lean over to cut the cake.

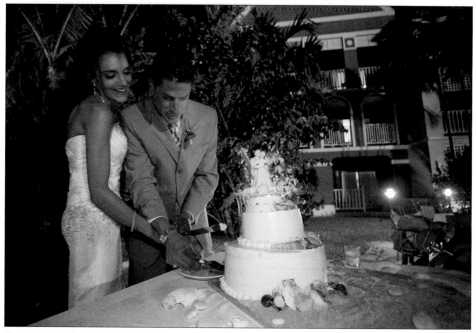

Figure 12-5: This would have been a totally acceptable cake-cutting shot if not for the red spot on the groom's face that was caused by the focusing beam from one of the guest's cameras. If I had used a faster shutter speed (as I should have during the cake cutting), the red spot would have been practically invisible.

Claiming the prime spot may be a bit disconcerting to you as a new photographer because it puts you directly in front of a large portion of the surrounding crowd. Some new photographers are shy about getting up there at all, while others try to crouch down low to be out of everyone's way. My advice? Get over it! You're the hired photographer and have been paid a large sum of money to get this shot. Don't be shy. All the adults in the crowd know you're not being rude — being in the prime spot is your job.

As soon as you get the prime spot, you can concentrate on getting the right lens for the framing you want (usually a wide zoom lens), and then on setting up your flash. Configuring your flash may seem easy here but in fact it is definitely not. The temptation is to keep your normal flash settings because the cake cutting ceremony starts out so innocently, but you should definitely *not* do this. If the couple does break out into a cake-smashing battle (which you can rarely predict in advance), you will be expected to freeze fast motion and still get some light in the background. This takes a very different setup than what I usually recommend for general reception shooting. (See the section on flash setting scenarios later in this chapter for specifics about how and why to set your camera up to catch fast motion.)

The first dance

The couple's first dance is an emotional moment that you certainly don't want to miss. The event usually takes place on a dance floor with the wedding guests either seated at the dinner tables or gathered on one side of the dance area. The first time you see the event, your natural

reaction may be to stand with the guests and shoot pictures from their point of view. However, if you do this the background for the couple's dancing pictures will be either the band or a bare wall. To get the full story in your images, try moving around to the other side until the crowd becomes the backdrop for the dancing couple. This gives the dance images a feeling of being in a certain "place," as opposed to shooting the dancing couple with a blank wall in the background, which says nothing about where they are or what was happening.

As shown in Figure 12-6, the first dance is a very personal and emotional moment much like the quiet parts of the ceremony. This is not a good time to put on your wide-angle lens and get out on the floor right next to the couple; this is a good time to give them some space. Shoot with a long lens so you can stay back on the edge of the floor where you won't attract much attention. This allows the crowd to focus on this very special moment without much distraction from you. When the parents make their way to the dance floor, you can get a little closer, and by the time the whole dance floor fills up nobody will notice or even care what you do.

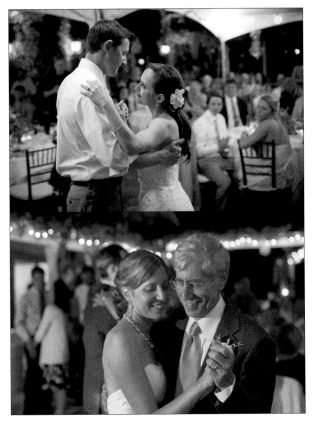

Figure 12-6: In these first dance shots, the crowd appears blurry in the background and the couple is sharp and clear.

You can capture the first dance and the parent dances in stages. First, I use a wide-angle lens (from a distance) to show a broad view of the whole event. Next, I switch to a medium zoom lens or a 50mm to capture the couple's facial expressions. As the dance progresses, the couple will turn slowly, giving you new opportunities for a shot every few seconds. It takes a lot of patience

to capture good facial expressions on each person, but if you can manage it, your efforts will be much appreciated. The images shown in Figures 12-7 and 12-8 are variations on the first dance.

Figure 12-7: Parent-child dances are always emotional and full of smiles. Shooting against the hanging lights creates a beautiful sparkle in the background.

With these first few dances, I try to use two different approaches. First, I go for the safe shot by capturing the scene with my wide angle and flash. Then I turn off the flash, pop on the 50mm f/1.4, set at an aperture of about f/2, and proceed to shoot many images with the idea that most of these shots will be deleted because of the chancy nature of this method. I'll get many shots that are too blurry and many more where the focus missed, but for those few shots that do connect — wow! All you need is a couple of "keepers" to make this technique well worth the effort because they really can be stunning and quite different from what the couple may have expected.

The bouquet and garter tosses

Technically speaking, the bouquet and garter toss shots are some of the most difficult to capture during the entire wedding day. The combination of rapidly moving action, darkness, and the fact that the subject is so far separated from the action, make for a very difficult challenge indeed. If you use a single on-camera flash system, the challenges are even greater because the light from your flash can only be properly exposed for one distance at a time.

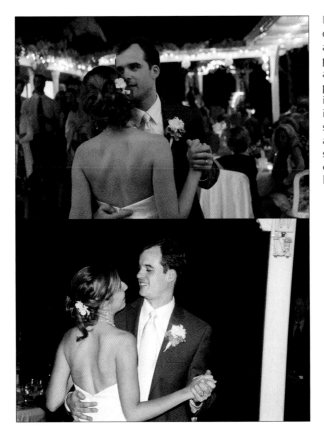

Figure 12-8: This pair of "first dance" images was taken at almost the exact same time and place. I shot the top image with a 50mm and calculated the exposure to get some ambient light in the background. The bottom image (shot by an assistant) was shot facing away from the crowd and the aperture was accidentally set on f/11, which eliminated all chance of getting any ambient light in the background.

You can solve the light problem in one of three ways. The first (and most complicated) method is to use a second flash on a slave to light up the crowd, while the on-camera flash lights up the bride or groom as she or he throws the bouquet or garter. The second method is to try to capture the event in several shots. For example, the first shot might be of the bride holding the flowers and looking over her shoulder at the crowd of girls, and the second shot would be of the girls leaping into the air to catch the flowers as they drop from the sky. The third method is to stand off on the side to capture both the person throwing the flowers or garter and those trying to catch it in one image. My favorite is the multiple shot technique because it enables me to focus in on one part of the action at a time, without trying to catch it all in one shot. The sequence of images shown in Figure 12-9 is an example of this technique.

As with the cake cutting, the bouquet and garter tosses also take place in a matter of seconds, but you have plenty of time to prepare for it. During this time, you should set your camera and flash settings to accommodate fast action: a fast shutter speed and high ISO. (See "Freezing fast action at night" later in this chapter for more specific guidelines on a good "fast action setup" to use for such shots.) These settings will maximize your ability to freeze motion and to shoot follow-up shots as rapidly as possible — both of which are extremely important when shooting this particular event.

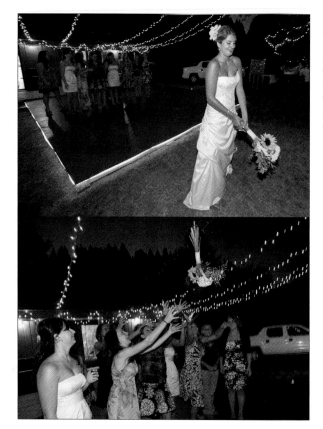

Figure 12-9: The bride looking over her shoulder is a great opening shot in a sequence of images about the bouquet toss. The bride throwing the bouquet into the air is the next shot. Peak action for the bouquet or garter toss is about a foot away from the catcher's hands.

Timing is everything with this shot, and because there are only two chances to practice this at each wedding, you would do well to practice by having some friends toss a ball back and forth while you try to catch the peak action just before the catch. It takes a lot of practice to get a feel for where you need to start pressing the button to catch an object in the air. Ideally you want to catch the garter or flowers as they are just about a foot out in front of the catchers, as shown in the bottom image in Figure 12-9.

This point is the peak of the action but it's definitely not the end of the action. As the catch is made, you can quickly move in close just in case anything interesting happens. Occasionally you may see two people grab the bouquet or garter at the same time and a mini wrestling match breaks out. You may get a pack of guys rolling around on the ground after the garter, or several women ripping the bouquet apart, flower petals flying everywhere.

If you can find a few minutes to talk with your bridal couple before these events take place, you might spare them some of the troubles that are almost standard for this event. The first and most common mishap is that the bride throws her bouquet up and hits either a light fixture or the ceiling and it falls down before the women can get to it. The second most common mishap is that the groom thinks he can throw the garter twenty or thirty feet but the garter is so light that it only goes half that distance. Talk to the groom about throwing hard and make

some suggestions to the bride for places with a high ceiling that won't obstruct the flight of the bouquet. And you might also mention that it's okay to call for a "do-over" if it goes wrong. I once had a groom close his eyes, spin himself around, and then shoot the garter right into the back of my head! Then a little kid scooped it up and tried to run off with it. Thank goodness the groom knew it was okay to call for a do-over.

The dance floor

For me, getting shots of the guests on the dance floor is easily my favorite part of the reception. All the must-have shots are done and you really only have an obligation to get 20 to 30 good dance images. After that, you could go sit down and rest if you're feeling lazy or you can join the action on the dance floor. I find the challenge of getting a good dance shot simply irresistible. I love getting out in the middle of the crowd and trying all sorts of different techniques, both with and without flash. In the following sections I describe some of the types of images I try to create and the settings I use to make them.

Standard clean flash

The average "safe" dance shot is a stop-action setup with a high ISO (1600 or above) and a relatively fast shutter speed, which eliminates ghosting and freezes even the fastest motion. Shutter speeds of 1/90 or 1/125 second work well for this. The image shown in Figure 12-10 is an example of a "safe" dance shot.

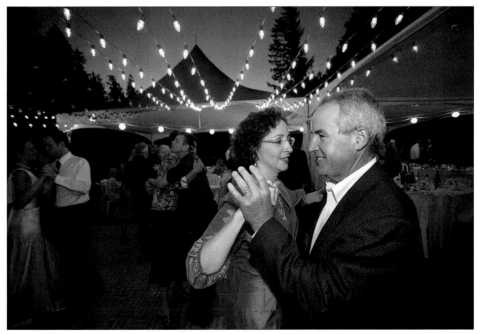

Figure 12-10: This image was created with a standard exposure (f/4, 1/125 second, ISO 1600) that creates "safe" dance images that don't have much ghosting or blur, but do have a decent amount of ambient light in the background.

Flash that shows motion

Whether or not you choose to show motion on purpose is completely a matter of personal taste. For me, objects in motion need some blur in the background to communicate that motion. If everything in the image is completely frozen, the image appears still and lifeless. I like to move myself and my camera along with the subject (a technique called *panning*) and shoot when the action peaks. This combination of subject and camera in motion together creates some great blur in the background and you can almost feel the movement that was happening when the shot was taken.

Achieving this effect is easier said than done. You must juggle camera settings to achieve a fine balance between too much blur and not enough. All the camera settings mentioned in this section assume that the base exposure on the subject is made with an on-camera flash with no exposure compensation. The subject receives a burst of light from the flash, which effectively freezes the subject and produces a sharp image in that portion of the frame. The remaining portions of the image receive some small amounts of light from the flash, but these areas are primarily getting light from sources other than the flash. These "other" lights are not as intense as the flash, but they do stay on throughout the full duration of the exposure. This means that no matter how long you leave your shutter open, these lights will continue to accumulate brightness and anything that moves will appear blurry. If you hold the camera still, then only moving objects like people will be blurry. If you move the camera, then every source of light in the background will appear as a streak across the image. For example, if you move your camera down as the exposure is taking place, every light source will appear to make a streak upward.

We normally think of the shutter speed controlling the amount of blur in an image, but in the dark (or near darkness) it's the combination of ISO and shutter speed that produces the blur. If the ISO is set very low, little or none of the ambient light will be recorded and you will get little or no blur. If the ISO is set too high, you'll get too much ambient light and the amount of blur and ghosting will overwhelm the rest of the image and ruin it. Each room is different and the lighting may be changed several times throughout the evening, so there is no easy formula I can give you for your exposures. Instead I discuss the theory behind why you set your exposure different ways so that you can mix your own combination depending on the light you're dealing with at the moment.

It is important to remember that the intensity of the room lighting (ambient light) determines which settings you must use to get the desired effect, and you can get exactly the same results by using different camera settings for different amounts of ambient light.

You can create ghosting and blur with these settings:

✦ **Really dark.** Start with a shutter speed of 1/10 second combined with an ISO of 3200.

✦ **Moderately bright.** Start with a shutter speed of 1/20 second and an ISO of 1600 to get the same effect.

✦ **Really bright.** Start with a shutter speed of 1/20 second and an ISO of 800.

Now I throw in another variable. The speed of motion also determines how much blur you get. Think about it this way: If you move your camera with the subject, you've effectively reduced the amount of motion between you and the subject, so now all of the motion appears in the background. If your subject is moving *really* fast, you'll get far more blur than if your subject is moving slowly. The settings I listed earlier work well for average dancing motion, but if the dance really speeds up, you may want to limit the blur with a faster shutter speed.

The images shown in Figures 12-11 and 12-12 are different types of dance images; I included the exposure settings I used to create them.

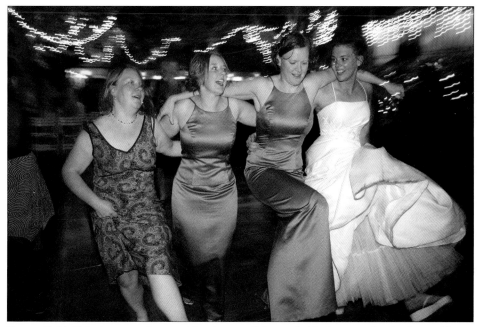

Figure 12-11: This shot was taken outside where no light was behind me to strike the dancers' faces. Behind the dancers was a large area with tiny lights hanging in the trees. The lights recorded well as I panned with the dancers at f/3.5 and 1/4 second. And because my flash provided the only light on the faces I was able to capture a sharp image even though the shutter speed was only 1/4 second.

Figure 12-12: A shutter speed of 1/20 second at f/4 and ISO 1250 is perhaps my most standard exposure for an average brightness dance area. At 1/20 second, I definitely get some background blur, but the amount of blur on the flashed subjects is pretty minimal unless they happen to move really fast.

The grand exit

Not every couple plans an official exit strategy. Some couples will dance the night away until all the guests get tired and wander off to their own rooms. For those couples that do plan an exit, catching it will be the last item on your list of important shots for the day; however, capturing this event fully often requires that you start photographing the preparations several hours earlier in the day. For example, if the bride tells you that she and the groom will be leaving in their own car, find out where it's parked and then ask the groomsmen (in private — not in front of the bride or groom) if they're planning to decorate the car. If they say yes, which they usually do, ask them to alert you when they head out to do the decorating so that you can come along and get a few shots of it. Once you know when and where the decorating is taking place, you will probably want to go back and check the progress every 20 minutes or so while you also keep shooting the wedding as normal.

Some couples choose to leave in a limousine, on horseback, or on a boat to name only a few choices. In all of these cases, the couple will almost always plan a grand exit during which time the guests line up on either side of the exit path and throw things such as bird seed, flower petals, or confetti, at the exiting couple. Having the guests wave sparklers in the air or blow bubbles is also common these days. In any case, after this walk, the couple will drive, gallop, or float away and be done for the night. This whole process is identical to the scenario you may

encounter as a couple leaves the church and heads to the reception, except that the final exit almost always happens in the dark, which makes it a lot more difficult to photograph.

The number one concern in this situation is to set your camera up in a manner that allows you to catch fast motion, while still getting a decent amount of background light — a fast shutter speed and high ISO. (Again, see "Freezing fast action at night" later in this chapter for more specific guidelines on a good "fast action setup" to use for such shots.) The image shown in Figure 12-13 is an example of a grand exit I captured using this technique.

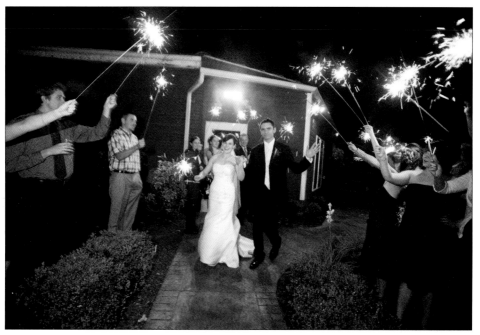

Figure 12-13: To get this shot I chose a shutter speed of 1/45 second to help prevent ghosting. After a few test shots, I found that an ISO of 1600 would capture enough ambient light to record the sparklers well.

Other reception shots

The "must-have" images are certainly important but they are by no means the only events you can photograph during the reception. There are people making toasts, singing songs, and smoking cigars; children playing; and a lot of other opportunities for candid images of guests interacting. The bride will also certainly appreciate a few shots showing all the tiny decorations she created just for this day. The best time to capture many of these images will be in the early evening before the guests fill the room. You can get a shot of the place settings, the cake table, the bar, and the food. You will also want to be sure to capture any people who do readings or play music. Toasts are almost always a part of the reception and occasionally you will have people approach the mic carrying several typed pages of things they want to embarrass

the bride and groom with. On these occasions, take a shot or two of the speaker and then find a good angle to get the bride and groom because there will almost certainly be a lot of laughing, and perhaps even a few tears.

Flash Basics for Shooting at Night

The following section is a collection if tips and tricks that I use for shooting at night with an on-camera flash. All the information here pertains only to shooting after dark, and as such it may be quite different from the methods and concepts used for daytime flash. You may find it difficult to separate the techniques used for daytime flash from those used after dark, but with the simple formulas I give in this section, it should eventually start to make sense.

Getting the most from high ISO settings

Modern digital cameras have a tremendous ability to capture light in near darkness, and as time goes on, this capability will only improve. Your job as a wedding photographer is to know how your particular camera performs in low-light situations. You need to know how far you can push your ISO before the digital noise becomes unacceptable — and after that, how much farther you can push it if you use noise reduction tools in Adobe Photoshop Lightroom or some other image-editing software.

One of the main things to remember about digital noise is that you can minimize it with a little bit of overexposure. As long as you give your camera some light to work with, it will make beautiful exposures. It's when you fail to feed it enough information that you get digital noise. What this means in the real world is that you should never intentionally underexpose images when you're shooting at high ISO settings. In fact, you should intentionally *overexpose* images and then reduce the exposure in the computer in order to maximize the amount of light recorded, thus reducing digital noise in the end result. How much should you overexpose? Just watch that histogram and remember to push your exposure as close to the right wall as possible without letting it climb up the right wall.

TTL Flash in Plain English

Through-the-Lens (TTL) flash metering means the flash exposure is metered directly through the lens. To accomplish this, two separate types of information are gathered: the distance and the reflectivity of the subject. First, the flash emits a very short preflash that strikes the subject and is reflected back through the lens, where it is read on a special sensor inside the camera, thus coining the term "through-the-lens." This little flash burst happens so quickly that most people can't even see it. Second, the lens communicates the focus distance to the camera, which then analyzes this distance and the reflected light from the pre-flash, to calculate a final flash exposure. Your camera then communicates this information back to the flash, which enables it to produce a very accurate exposure. All this happens rapidly if you've purchased professional-level camera and flash equipment. If you're using "prosumer" equipment, the process might happen a bit more slowly.

Avoiding flash shadows

With on-camera flash at night, some photographers prefer to use a flash bracket, which enables them to flip the flash into position directly above the lens when they shoot vertically or horizontally. The advantage of using a flash bracket is that the shadows always fall down behind the subject because the flash is always directly over the lens. If you shoot a vertical shot without a flash bracket, the flash is off to the side, which throws the shadows up on the wall behind the subject.

If you know a few simple flash concepts, you can leave the flash bracket at home and still avoid nasty shadows on the wall. First, as a general rule, avoid shooting subjects that are backed up to a wall. In fact, I think it's safe to say that one of the main differences between a beginner and a professional photographer is whether or not the photographer is controlling the background. Bare walls make horrible backgrounds, so you should always move either the subjects or yourself until you have something in the background that is more interesting than a bare wall. In addition, you can minimize shadows by shooting horizontally whenever possible — which is almost all the time. If you do shoot a vertical shot, you can get close enough that the subject fills the frame, leaving little or no space around the subject for shadows to show up in.

The real trick to avoiding flash shadows is to set your shutter speed slow enough and your ISO high enough so that the ambient light in the background shows up behind your subjects instead of just a black pit. It is the lack of this ambient light that can make a shadow from your flash really stand out. Finding just the right combination of shutter speed and ISO might take a few test shots, but once you get it dialed in, the ambient light in the background should be bright enough that shadows from your flash will practically disappear.

Camera mode

I prefer to set my camera in Manual mode for shooting at night with flash. I do this for two reasons: First, the light is fairly constant at the reception, so once I get my exposure worked out, I can use the same settings for several hours without having to change anything. Second, I want to be able to control all the different settings without worrying if the camera will pick some outrageously slow shutter speed — which it will if I use Aperture Priority mode.

I could use Shutter Priority mode at this time and the camera would adjust the aperture to get the right exposure. However, because the lighting is generally consistent at a reception, it's actually easier to go with Manual mode. One of the main reasons for not using any of the "auto" camera modes is that I believe the camera functions quite a bit faster in Manual mode than it does when it has to calculate the exposures itself. Every little bit of speed matters when things are moving quickly on the dance floor. When you push that button, the camera needs to go off — exactly then — not a half second later.

TTL flash difficulties

TTL flashes work so well it almost takes the challenge out of photography. Gone are the days of trying to calculate an exposure on the little sliders at the back of a Vivitar 283. Today the worst mistake most beginners make is to look at the LCD screen (in the dark) and decide that it looks like all the flash images are too bright, so they lower the flash power down to something like –1.5 and think "Ahhh, that looks better!" But then later when the images are in the

computer, they realize that all camera LCD screens look particularly bright at night, just as they all look particularly dark when you're standing in the sun. At both of these times, you should be checking your exposure on the histogram and ignoring the brightness or darkness of the LCD screen.

One particularly difficult flash moment that you'll eventually run into will be when you try to shoot very close subjects while the camera is set to a very high ISO. There comes a point with all flash units where they simply can't emit a small enough amount of light. For example, if I try to shoot a ring shot from three feet with my camera set to ISO 3200, the flash simply can't go that low, so I have to lower my ISO or change to a smaller aperture before I can get the shot to work. A beginner who doesn't yet understand this concept will see the overexposed ring shots and wonder if maybe something is broken.

Another challenging flash scenario is to try to shoot between or past things that appear in the photo. The image shown in Figure 12-14 shows that flash units are not well equipped for that task because they have no way of knowing which of the objects in the scene are important to you. If there are multiple objects in the scene, the flash always exposes for the closest one. This can spoil your photo if you were intending to get the farthest object exposed properly. Many beginners make the mistake of trying to shoot through a crowd, or through a bush, or past something. It just won't work. It's crucial that the entire viewfinder is clear of any objects that are closer than your intended subject. If that isn't the case, you need to either move, or zoom in to exclude the closer objects.

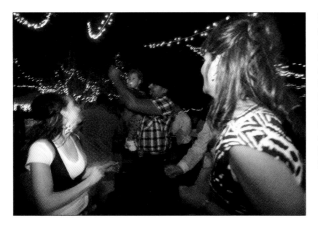

Figure 12-14: Shooting between objects doesn't work well because the flash tends to detect the distance to the closer object and stop the exposure there. Or, the camera sends information to the flash about where you've focused the lens and the flash does indeed expose out to that distance, but anything closer is totally blasted out. Either way, the photo is ruined.

Flash to ambient exposure ratio

For most work with on-camera TTL flash, you simply set your flash with 0 exposure compensation and start shooting. However, for one reason or another, you may occasionally wish to adjust the amount of brightness in the background separately from that of the foreground.

Usually, the goal is to make your subject a bit brighter so it stands out from the background. You can accomplish this in many different ways and the most tempting method is to lower your ISO to underexpose the background. But I don't recommend doing this. Instead, the method that actually improves the quality of your image is to raise the exposure compensation on your flash by up to +1 full stop. This makes your subject (hit by the flash) appear overly bright at first, while the background appears properly exposed. Remember from the previous discussions on digital noise, images that are a bit overexposed (without blowing out the highlights) are actually preferable to those that are underexposed and dark. When you load the image in the computer, you can darken the exposure to where the subject looks normal, which will also make the background look a bit on the dark side (remember this was the original goal). The fact that the background had sufficient light to start with will result in much less digital noise than if you had achieved the same effect by underexposing the background. This concept is the same for shooting in daylight or dark.

Ghosting

Ghosting is a blurry, hazy area that shows up around moving subjects when you shoot flash images with slow shutter speeds (see Figure 12-15). What causes it? Your flash emits a very short duration burst of light that effectively "freezes" any amount of motion that we humans can possibly make. However, if you use a slow shutter speed, the shutter remains open for a much longer time than that short flash burst, and as long as the shutter remains open, the digital sensor continues to be exposed to light from the other lights in the room. These other lights continue to hit your subject, causing a blurry area in the places your subject moved to while the shutter was open. Thus, the speed of your subject's motion determines the amount of ghosting. For example, if your subject moves quickly, there may be a lot of ghosting. But using the same camera settings and location, if your subject stands still while you shoot, no noticeable ghosting may appear at all.

How do you get rid of ghosting? First, you should shorten your exposure time. How much shorter depends on the amount of ambient light and on the amount of motion. Fast motion requires a much shorter exposure time. A bright room also requires a much shorter exposure time. If the room is brighter than normal, set your shutter speed at 1/90 second and then shoot some test exposures while readjusting your ISO up or down to get the background exposed to your liking. Using that speed will be enough to stop all ghosting. If the room is really bright, it's beneficial to stick with that shutter speed and lower your ISO, thus reducing the digital noise (as opposed to using a much shorter shutter speed, which offers no added benefits).

When should you try to create ghosting? I recommend that you first shoot with the "safe" exposure settings to make sure you've got a decent sized collection of properly exposed and sharply focused dancing pictures. Once you've achieved that, you can start to get creative.

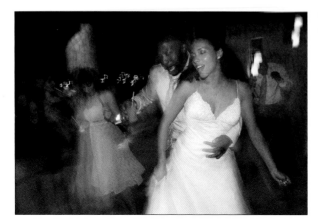

Figure 12-15: I intentionally exposed this image for 1 second at f/6.7 and ISO 1600 to get an extreme amount of ghosting and blur around the dancers.

Flash Setting Scenarios

In this section I address the different types of scenarios you will be required to shoot at a wedding reception and how to set up your flash to accomplish the specific goals of each one.

Shooting the average reception

The average wedding reception image involves very slow motion and very low light. This is not a demanding situation, and in fact you don't have to use a flash at all if you have a wide aperture lens. When you do use a flash, the possible range of settings is all over the chart. While each type of setting can get a good exposure, each also creates a different "look," some of which will appeal more than others to your taste and that of your clients. Your personal taste about how you want the image to look is the most important criteria in setting up your camera/flash settings during most of the reception.

The following are two completely different "looks" you can achieve in the flash photographs you take at the reception:

✦ **The black pit.** This is the traditional way of doing things. In the old days, 400 speed was considered the standard high ISO film and anything over 800 was outrageously grainy. Combine ISO 800 with a shutter speed of 1/60 second or faster and you get really sharp images exposed by the flash, but very little (if any) background light, thus the name "black pit" (referring to the lack of any background).

✦ **Standard digital flash exposure at night.** Modern professional-level digital cameras are fully capable of shooting great images at ISO speeds of 3200 and even higher on some cameras. Combine that with a slower shutter speed like 1/10 to 1/30 second and you've got a setup that gets beautiful color in the background (if there's any light there at all) while still freezing most subjects with the light from the flash. This setting works great in average to very low lighting situations and with subjects who are moving slowly if at all.

Freezing fast action at night

When the action speeds up, you'll need a faster shutter speed as mentioned earlier in this chapter, but you should keep two additional considerations in mind as you try to maximize your exposure and the speed at which your camera can shoot.

The first consideration is a fast exposure. Shutter speeds in the range of 1/60 to 1/125 second are necessary to freeze fast motion, while ISO settings of 800 and above will still allow you to bring in the desired amount of background light. This is a good "fast action setup" that can freeze motion and eliminate ghosting effects.

The second consideration is how to help your camera take exposures as rapidly as possible. When the action is moving fast, you may want to shoot several images per second in an attempt to catch the scene just right. You can actually do quite a lot to speed up or slow down how fast your camera can take rapid-fire shots. For example:

✦ **Never bounce the flash or put on any diffusers.** Always shoot the flash straight toward the subject. This method frequently only uses up a small fraction of the total flash power for each shot, which results in far less recharge time between shots.

✦ **Attach a more powerful battery pack to the flash.** This speeds up your flash recharge time dramatically, and if the ceiling is low and white, a big battery pack may even give you enough speed to use bounce flash or use flash diffusers, even though they do waste a lot of flash power.

✦ **Pre-focus your lens.** If you begin with your finger up off the shutter button and wait until the action starts before you touch the button, you'll get significantly slower first shots than if you start with your finger on the shutter release button just enough to keep all the electronics activated and the lens focused on your subject while you wait for the action to begin. Keeping the camera "on" like this enables the lens to stay focused and ready to go in an instant.

The cake cutting and the flower and garter toss events lend themselves well to this fast-action setup. Most of the other events at the reception happen much more slowly and depending on your taste, they may even benefit from a little bit of ghosting and blur to show the motion that really was there.

Lighting large areas with little strobes

In Chapter 3 I mentioned that many commercial photographers have made the switch from using large studio strobes to using many small on-camera strobes with slave units to accomplish the same jobs. This trend is growing among wedding photographers as well.

There are two different approaches for lighting up large reception halls. One is to light up the whole area by placing many small flash units around the room. Another is to use only one or two flash units to light up the immediate area around the subject, while allowing the remainder of the area to be exposed by ambient light. The approach you choose may determine the type of jobs you get, or vice versa. (I'm not sure which one comes first.) For me, I tend to get a lot of outdoor weddings — especially destination weddings — so I travel light and don't try to light up the whole area. Photographers who work mostly in large reception halls may want to bring in some more light.

To light up a large area such as a large reception hall you will need a radio strobe set, which consists of a transmitter that attaches to your camera and one receiver for every flash unit. The flashes are then spread out around the room either on light stands, or attached to something via gaffer's tape or some sort of straps. When you shoot your camera, the whole group goes off all at once. Some photographers point these flashes toward the roof to light up the entire room. Others point the flashes downward toward the crowd. The difference between the two techniques is that in the first case, the flash produces even light in the room with little or no evidence of where the flash units actually are. In the second technique, pointing the flashes down toward the crowd means they will frequently show up in the background of your images as a big burst of light — or many bursts of light depending on how many of them you use.

Cross-lighting the dance floor

A much smaller version of the setup mentioned in the previous section is using one or two remote flash units to "cross light" the reception area where you are shooting. The image shown in Figure 12-16 is an example of this technique. Ideally one of these lights is carried by your assistant so it is always positioned off to your side and aimed at whatever you happen to be shooting at the moment. Many photographers who employ an assistant for this purpose place the flash on top of a seven- or eight-foot light stand with the legs folded so that the assistant can easily carry it around and direct the flash toward your subject.

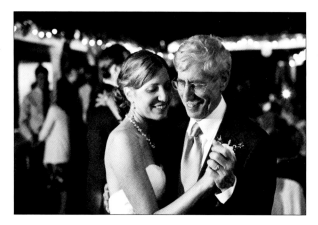

Figure 12-16: Having an assistant hold a flash off to one side can create some dramatic lighting on the dance floor.

Fun Motion Techniques

The normal technique for properly using your flash is to hold your camera steady and push the shutter button slowly so you don't add any extra camera shake. However, as the night wears on and you feel you've got enough sharply focused images to satisfy your obligation to document the event, you can afford to do a little experimenting on the dance floor. If you slow your shutter speed down into the range of 1/4 to 1/15 a second, you open up a whole new world of creative flash possibilities.

The techniques I describe here evolved from many happy mistakes that made me go "Hmmm," and then do a lot of experimentation to develop the effect and make it predictable. These types of images can be fun and attractive additions to your wedding work, but they are so unpredictable that you should only attempt them after you've already gotten plenty of sharply focused images to satisfy your client. And you should be prepared to delete the vast majority of these shots because the techniques described here are certain to ruin more images than not. However, when these effects work they can be truly spectacular and all it really takes is a few good shots to make the effort worthwhile. Don't be dissuaded by your mistakes. Analyze them until you know exactly where you went wrong. Your mistakes are your greatest teachers.

The following techniques can help you purposefully create effects with ghosting, light streaks, and blur. They use a few basic concepts that are vital to your understanding of how the light is recording in your camera. If you can really grasp these basic ideas, you should be well prepared to understand why your dance shots turn out the way they do. And that understanding will ultimately enable you to create these effects intentionally.

Following are four important concepts to keep in mind when using your flash to create special lighting effects:

✦ **A flash is a short burst of light that essentially freezes the subject.** If there is no other light, the flash will create a sharply frozen subject no matter how long the shutter stays open, even if the subject moves out of the scene.

✦ **Ambient light accumulates as long as you leave your shutter open.**

✦ **Background lights that start out behind the subject will appear to burn through the subject if the subject moves out of the way during a long exposure.** Avoid shooting moving subjects that are in front of a light source.

✦ **When you move the camera, light sources (such as light bulbs) appear as streaks that move in the opposite direction on the image.** For example, if you move the camera down, every light bulb will create a bright streak that goes up on the image.

The twirl

This first fun motion technique involves twirling the camera in front of you as you press the shutter. I like to start with the camera held out in front of me and tilted around to the side at about a 45 degree angle. As I rotate the camera and flash back toward the normal upright position, I press the shutter roughly at the point where it passes the normal vertical camera position. You don't need to spin it very fast to get a good effect. You also don't need to spin it very far. As you get some practice, you find that a very short spin works just fine. After you find a comfortable speed at which to spin the camera, you then need to experiment to find a shutter speed that creates just the right amount of background blur. Every person feels comfortable with a slightly different rate of spin. To start off, try a shutter speed around 1/4 second. After you settle on a shutter speed, adjust the ISO until you have a pleasing amount of light in the background. The ISO setting needs to be changed for different rooms with different levels of light, but the shutter speeds needed to create this effect are the same anywhere you go. The image shown in Figure 12-17 is an example of the effect you get by spinning the camera.

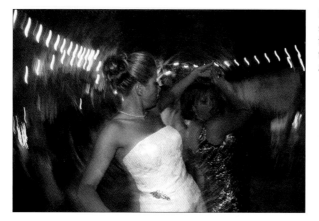

Figure 12-17: This image uses a shutter speed of 1/10 second for the spin effect. Vary the shutter speed until you get the right amount of blur.

The shimmy

When you happen to be lucky enough to attend a reception with a lot of small lights above the dance floor, here's another trick that is fun to experiment with. Set your shutter speed on 1/2 second or even 1 second. Frame the image as usual, but when you press the shutter, give your camera a tiny side-to-side wiggle (shimmy) as you turn it slowly to point down toward the ground, all the while continuing the shimmy through to the end of the exposure. This freezes your subjects with the flash burst and then all the little points of light in the background make wiggly lines running upward away from the subject. The image in Figure 12-18 shows an example of this.

Figure 12-18: With an exposure of about 1 second, you can wiggle the camera slightly as you rotate the lens down toward the floor. This creates light streaks that go up and away from the subject.

Panning

Panning is the technique of matching the motion of a moving subject with your camera so that your camera and the subject are effectively motionless to each other. When it is done properly, the background blurs and the subject stays relatively sharp. The blurred background creates a very convincing feel of motion in a still picture. This is my favorite technique to use with dancing people. To use this technique you have to find a subject who is moving with a predictable sideways motion.

To prepare your camera, set your flash, shutter speed, and ISO the same as for the twirling technique: direct flash, 1/4 second, ISO (depends on the room light). Then, move the camera and perhaps even yourself so that you match the motion of your subject. Sometimes you can do this by staying in one place and rotating your body as the subject moves past you. You can also try moving your whole body along with the dancers, almost as if you were dancing with them for just a few steps. The image in Figure 12-19 is an extreme example of this technique.

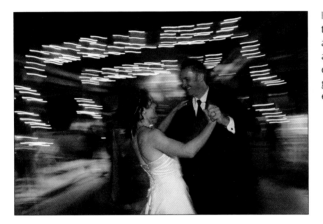

Figure 12-19: Panning works well to create a sense of movement in a dancing picture. Move yourself and the camera in sync with your dancers and you can get some great background blur with dancers that are still sharp.

Using a guest flash

Another fun trick is to have a guest (or two) make the flash portion of the image for you as shown in Figure 12-20. To do this you can talk to a couple of guests and have them act as models for you. Have them act just as if they are taking photos of the bride, or the cake, or the first dance, and then you can stand off to the side with your camera either on a tripod or braced against something so that you can use a shutter speed of 1/2 second or more. Then tell the guests that when they see your flash, they should shoot off their own cameras immediately afterward. This captures them and the subject being flashed from the side. Occasionally you can see a situation like this coming, and you can change your exposure in time to catch the guests taking photos. Good times to do this are at the cake cutting and during the first dance.

Seeing these opportunities coming and catching them without posing anyone may sound impossible, but in reality, all you have to do is keep you finger on the button and let your camera take consecutive, 1/2 second exposures until you think you might have captured something. In the end, getting a really good shot like this is probably 70 percent skill and 30 percent luck. If you manage to capture something truly outstanding with this method, you won't know whether to pat yourself on the back or thank the gods for the gift.

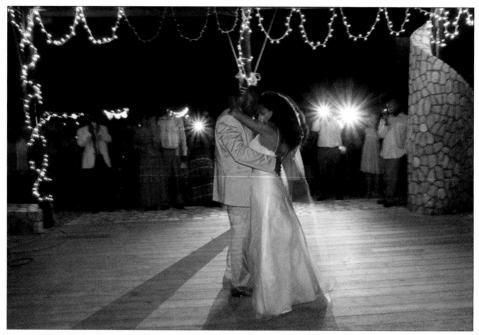

Figure 12-20: Long exposures can catch the guest's flashes and use them in your photo.

Working with moving Spot, Strobe, and Disco Lights

Okay, not all lights are good for photography. Bright disco lights and strobe lights will definitely make your life more difficult. Not only are these lights often colored bright red or green, but they also move and change brightness constantly, so you have very little chance to actually

use them in your exposure. If you shoot with these lights behind your back, you run the risk of having the light beam strike your subject in the face as shown in Figure 12-21, which creates a huge bright blur where that person's face should be.

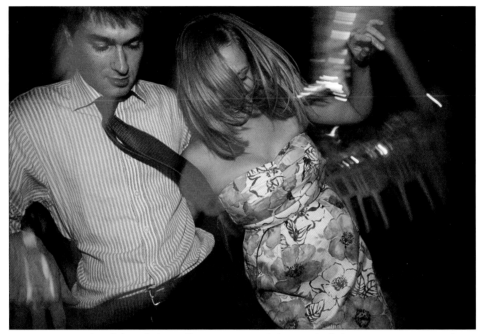

Figure 12-21: Colored disco lights will ruin many good shots as the light passes across your subject during the exposure. The tips listed here will help you minimize the number of images this affects.

When you find yourself working in this situation, you have the following choices:

✦ **Overpower these lights so the only light that records in your image is from your flash.** You do this with settings like those mentioned in the section on freezing fast action. A shutter speed like 1/125 second combined with a low ISO such as 400 should do the trick, but if you're still having problems, you can try also using a medium aperture like f/8. A combination like that should give you the "black pit" look, but it will also tone down the effects of bright strobe lights and allow you to keep working.

✦ **Go to the opposite side of the dance floor and shoot toward the "disco" lights.** This allows the lights to create a strong backlight in the image, but it won't affect your exposure too much because it only hits the back of your subject and your flash fills in the faces. Now the bright lights create a colorful rim light on your subject. At worst this rim

light is far less damaging than a bright spotlight across a face, and at best It actually adds some cool colors to your subject.

✦ **Set your shooting mode to aperture priority.** This is not something you would normally do after dark, but if you're shooting in a room with spotlights from the dance floor or from videographers, this may be your best option because it enables your camera to choose a shutter speed that will match the level of light. This may have limited success because the lights are often moving around very rapidly, but it will work great when the lights move more slowly.

✦ **Ignore the lights and hope for the best.** Then take all the images that got blasted with a colored light and convert them to black and white. This simple "cure" can often save an image that would otherwise go in the trash.

✦ **Talk to the DJ.** Perhaps your best bet is to notice the funky lights when the DJ is first setting them up. If you ask nicely, the DJ can easily cut the disco lights down really low, or point them up at the ceiling so they don't strike directly on the dance floor. At the very least, you might get the DJ to hold off on using these lights during the first dance and the parent dances.

Spotlights

If you're lucky enough to have a real spotlight on your couple, consider yourself blessed and take advantage of every second. This is beautiful light and because it's constant, you can actually work with it. You can turn off your flash and use the spotlight as the only light source, shoot with the light coming from the side, or shoot straight into it and create a silhouette. In any case, this is a rare opportunity to create some dramatic dance images.

Videographer lights

If your couple hires a professional videographer, this person will almost always bring a light to use when shooting in the dark. The good news is that these lights produce a consistent brightness that you can work with, as shown in Figure 12-22. Another bit of good news is that this light has a fairly low intensity, so it is possible to overpower it with your flash by using a fast shutter speed, a small aperture, and a low ISO speed — which when combined will serve to basically cut out all light except that from your flash.

The bad news is that the videographer tries to save battery power by turning this light off until a few seconds before its needed. What this means to you is that you'll be all set up for the cake cutting and just as the couple starts to cut the cake, the videographer turns on this bright spotlight and ruins your shot. This usually catches me so off guard that I get flustered, and mad, and by the time I figure out how to reset my camera, the moment is gone. By turning the flash off completely, and changing to Aperture Priority mode, your camera can easily make use of this light source, but doing all that when you're caught by surprise can take a few seconds at the very least, and cutting the cake only lasts a few seconds.

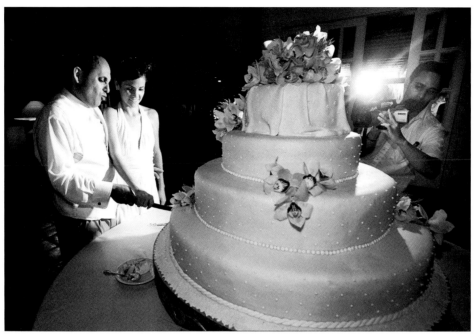

Figure 12-22: I tried to work more closely with this videographer so I would be ready to use his light when he turned it on during the cake-cutting ceremony. I included him in this shot just to show where he is in the scene.

Lights in your contract

I've had all the "other" lights mentioned in this section ruin enough images over the years that I finally put a clause in my contract that specifically states that I won't be responsible for images that are ruined by this type of lighting. This clause came about after a bride complained that I had no shots of the cake cutting. I tried to explain that the videographer ruined them but she seemed unimpressed. After that, I added this clause with enough explanation that it educates the bride (in advance) on how these lights can potentially ruin a few images. The following is reprinted directly from my contract:

> Occasionally videographers use powerful spot lights that will inevitably result in ruined images, as these lights will turn on and off at unpredictable times and they produce small spots of intense light that are impossible to expose for in a still photograph. Background lighting and other stationary light setups will not cause this problem because they do not change rapidly. It is agreed that client assumes all risk for loss of images caused by amateur photographers, videographers, or moving spotlights.

Shooting with Candle Light

Throughout this chapter, I emphasize mixing your flash with ambient light, and as a beginner, mastering these techniques should be your primary focus. But once you purchase your first really wide aperture lens, you'll realize that you don't actually have to use the flash for all of your reception photography. As I've mentioned many times before in this book, you can shoot with a 50mm f/1.4 or other similar lens and get great shots in low light. The reception is your chance to put that wide aperture lens to work. Figure 12-23 is an example of an image, and a romantic mood, that you simply cannot make with a flash.

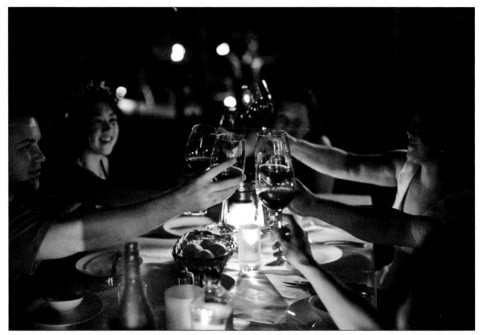

Figure 12-23: I prefer to carry two cameras around during the reception: one set up for flash and the other set up with a wide aperture lens that can still function very well with hardly any light at all. This shot of the family toasting the newlyweds in Fiji was shot handheld with a 50mm at f/2, 1/45 second, and ISO 3200.

Reception Advice for the Bride

Most brides and even most coordinators have little or no idea about how to decorate for the camera. They arrange the room to please their own eyes with no consideration for how it will look in pictures. In the following sections, I offer some tips that you can pass on to the bride and wedding coordinator to help them help you make the wedding pictures look better. Naturally, this makes it much easier for you to get great images, which in turn increases your sales and adds to your portfolio. (This information is reprinted from my website:

www.aperturephotographics.com/downloads/photographers_dreams.pdf. You are more than welcome to make links directly to this article from your own website.)

Light the reception carefully

Personally I don't like having a black background for dancing photos. A little bit of light in the background makes a huge difference. Christmas lights, hanging bulbs, and rope lights all look good in the background. If the reception is outdoors, placing your dance floor under a tent will make a world of difference because the photographers can bounce the flash up into the tent roof. A tent also provides a structure on which to hang a lot of small lights that create a warm background glow. Trees are also great for hanging lights and small jars with candles inside. Tiki torches provide great light and ambiance at the same time.

Don't rush the bouquet and garter tosses

Take a few minutes to play with your crowd. This gives the photographers time to get a shot of you holding the flowers and looking back over your shoulder at all the gang getting lined up. Before you throw, I recommend chasing off all the little kids because they are quick little rascals and they will almost always beat your bridesmaids and friends to the flowers. Now look up and make sure you don't have anything low like lights and ceiling fans that are going to intercept your flowers before they get to the crowd.

When you throw the garter or flowers, be ready to call for a do-over if it doesn't go as planned. I've seen it go wrong many times. One time I was standing beside the groom and he somehow managed to turn far enough around to shoot me in the back of the head with the garter, then it fell to the ground and a little kid grabbed it and ran off. If something strange like that happens, please call for a do-over and try it again.

Dance to the photographer

During the formal dances such as the first dance or the father-daughter dance, you should try to ignore us completely. However, later in the evening when we come around to shoot some fun dancing shots, it would be wonderful if you and your wedding party would occasionally turn and dance facing toward us. Otherwise we get a lot of dancing pictures with your back-side showing. Don't worry about doing this all evening, but once in a while, if you just turn and show off for the camera a little, the pictures usually turn out really good.

Meals for the Photographers

Depending on what sort of time packages you offer, your wedding work day may frequently end up lasting more than ten hours. Granted, shooting photos is not the hardest job in the world, but no matter how you look at it, ten hours is a long time to be on your feet and totally focused on trying to see everything around you.

To keep yourself going through the day, you'll need plenty to eat and drink. Rarely is there any shortage of things to drink but you may find that you get dehydrated simply because you're so busy that you forget to stop and drink enough.

Eating takes more planning. Because the average wedding day starts somewhere between noon and 2 p.m., you should have no trouble making time to stop for lunch before you arrive at the wedding. However, if you eat a really big lunch, all that food in your belly will make you sleepy. Instead, you might try eating a moderate-sized lunch and then packing some snacks in your camera bag. Spreading out your food intake like this will keep your body fueled and you won't feel the need to curl up for a nap in the middle of the wedding.

Getting a decent evening meal also takes some planning, and frequently a discussion with the bride. Most brides have never planned a wedding before, so when they count up the guest list for dinner arrangements, it may not occur to them that you should be on that list, too. You have to talk to them about the fact that you'll need dinner, and that you prefer to eat it near them so you can continue watching for photo opportunities while you eat. You'll also need to talk with the servers to make sure they serve your plate even though you may be up walking around taking pictures when the salad comes out.

I've had my days of being totally forgotten, and I've had days of being served PB&J in a back room, far down the hall and around the back of the building from where all the guests were seated. Eventually I got tired of all that and put the following paragraph in my wedding contract:

> Meals for the Photographers: We won't be happy if we don't get anything to eat for the whole ten hours that we'll probably spend shooting your wedding — and I'm certain you don't want us to wander off down the street looking for our own food while your wedding is under way. Because of this, we do require that you provide our meals at the same time as yours, and at a location that is within sight of you and your guests so we don't miss anything important. We tend to get very comfortable visiting and blending in with your guests throughout the day, so we prefer to be seated at a guest table. This allows us the best chance to keep shooting during the meal and very often we can catch some incredible candids of people laughing and talking. Please don't forget to tell your coordinator about this detail because the coordinator will most likely be responsible for seating everyone, and will tend to want to hide us away in some distant back room.

A Note About Drinking Alcohol

You will almost always be offered alcohol at a wedding. The guests will typically be drinking from the time you arrive (sometimes too much) and it is tradition to offer everyone in the room a drink — including the photographer. Should you take it? The risk is that if something goes bad with the pictures, someone is certain to bring up the fact that you were drinking and that would only make the situation worse. If someone gets mad at you for any reason, one drink may quickly be translated into, "Your photographer was drunk!"

When someone offers me a drink early in the day (which they always do), I tell this person that I want to keep everything in focus for now, but I'd be happy to join him or her for a drink later in the evening. And then later in the evening, after I've taken all the dancing shots I really need and I know there will be few demands on my skills after that point, I do have a drink.

I once witnessed a scene where the DJ was out on the dance floor dancing around and groping the maid of honor while guzzling beer out of a full pitcher. I'm sure you won't be surprised to hear that I've never seen that guy at a wedding again.

Summary

The reception is both an enjoyable and challenging time of the wedding day. With the tips you gain in this chapter, you should have no trouble getting into position for each of the must-have reception shots and then framing them to tell the whole story.

You now have specific exposure formulas for how to set your camera to accomplish different goals, such as stopping action and creating blur on purpose. This chapter also provided an introduction to some advanced flash techniques that are so much fun to experiment with that you may find yourself staying at the reception far later into the night than your contract requires. As you become familiar with these techniques, the wild effects they produce may actually increase your sales, but at the very least I think they can add a tremendous amount of spice to your portfolio.

✦ ✦ ✦

The Business of Digital Wedding Photography

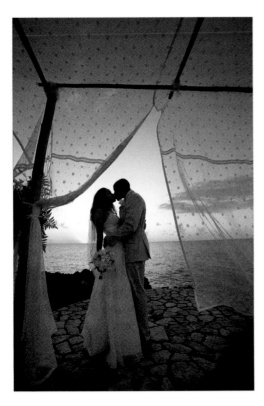

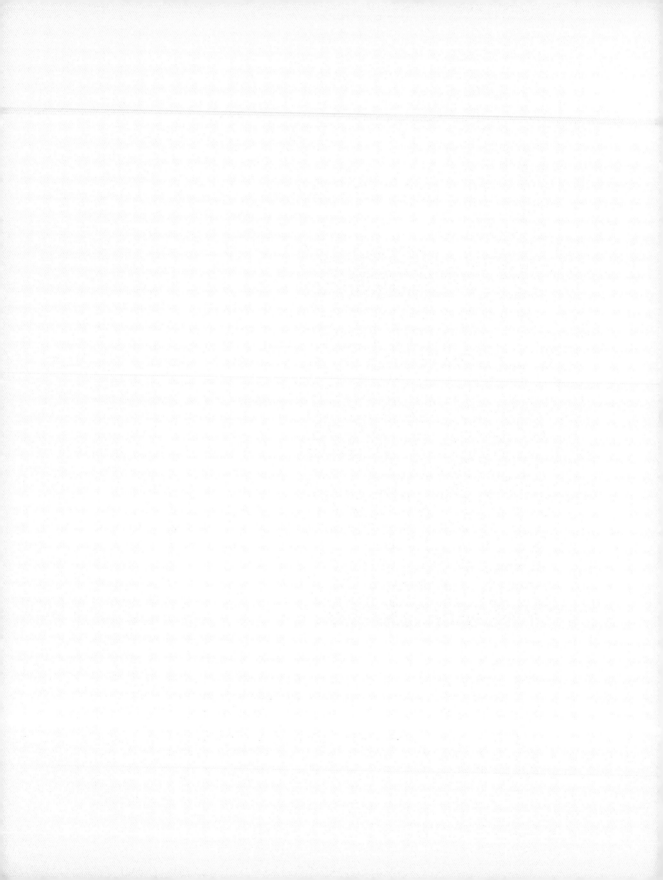

13

Creating Your Own Workspace

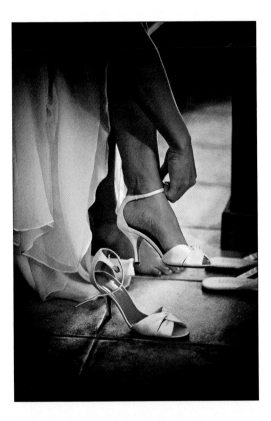

The modern digital wedding photographer has a lot of freedom when designing a work-space. There is no requirement that you own or rent a studio space unless you also do other types of photography that require it. Many very successful wedding photographers operate out of a small office space or a spare bedroom in their home. Destination wedding photographers can even manage to run an entire business with no more than a laptop computer and a wireless connection. The days of elaborate studio and gallery setups are not gone; they've just become a choice.

By its very nature, wedding photography takes place on location. However, contrary to what you might imagine, the majority of a wedding photographer's job is not spent shooting pictures. In fact, the vast majority of a wedding photographer's workweek is spent sitting in front of a computer editing images, answering e-mail, talking on the phone, burning discs, and creating albums. The space needed to perform these tasks may be as small and unassuming as a spare bedroom, and will not affect the style or the quality of the final product. In this chapter I look at options for the physical space where you will work on a day-to-day basis, as well as the different types of equipment and software you will need to run a successful photography business.

Workspace Options

In general, you can create a workspace in one of three places:

✦ A studio with shooting space and office space

✦ A rented office space away from your home

✦ An office space in your home

Each option has benefits and drawbacks. The option you choose depends on the type of photography you want to do, where you live, what your home life is like, and to a certain extent, your personality.

Studio

The photo studio is primarily used by photographers who do a mixture of photography jobs, rather than specializing in wedding work. A studio photographer typically has a staff of at least one other person, which enables the photographer to concentrate on shooting while the color correction and other tasks are delegated to the employee. The workweek may involve shooting family portraits, high-school senior portraits, model portfolios, babies, pets, and commercial work for various businesses around town. If shooting such a wide variety of subjects interests you, owning or renting a studio space is the perfect choice. Of course, if you like to shoot in the studio, you will find an occasional bride that wants a studio portrait as well. If you can produce images similar to what brides see in fashion magazines, you may find that there is a lot of interest in your studio work.

Naturally, your studio space must also have an office space included, either in a separate room or off to the side of the shooting space. The office portion of the studio does not differ substantially from what you might find in a home office.

Office

An office is a commercial space away from the home. There are many advantages to such a space:

✦ Clients don't come into your home.

✦ An office adds a sense of professionalism for visiting clients.

✦ If you have children who are home, you may have to leave home in order to get work done.

✦ An office separates "work time" from "nonworking time" so that when you are at home, you can focus on being at home and not on your work.

Having an office away from home is much better if you tend to be a workaholic because it forces you to stop working and go home at some point. If the location is away from your home, you can't just walk back into the other room and keep working all night. This situation is more expensive than the home office, but it may be perfect for those who want more separation between home and work. The drawback is that your rent will be on par with the location, so if you want a great location, you'll pay a premium.

Home office

The home office is for the person with exactly the opposite views of work as the person with an off-site office. This type of work situation requires that you don't mind having clients in your home, don't mind working around the schedules of your children, and even like being able to step into the office to get some work done after dinner. The difficulty of separating home life from work life is always present, but if you enjoy mixing work and regular life together into one way of living, then a home office just might be the perfect workspace for you.

Designing Your Workspace

The modern digital wedding photographer's office has several basic attributes. It has one or more computers, each with a comfortable chair and a high-quality monitor that presents accurate colors and is easy on the eyes. The office may also have a phone, a fax machine, a credit card swiper, a DSL (digital subscriber line) modem, a small printer, and perhaps a large printer for making finished prints. This list of equipment is not long compared to many other types of businesses. The entire setup may be purchased for well under $20,000.

Wall colors

Ideally, the walls of your workspace should be painted anything from white to medium gray to help cut down on any color casts that may be created by light bouncing off different colors of paint. Any color (other than white, black, or gray) on the wall that is immediately behind your computer monitor can influence your visual perception of the colors on your monitor, so as boring as it sounds, your wall colors really should be limited to white or some shade of gray.

Seating

Invest money in a high-quality chair for each person who works in your office. This one piece of equipment doesn't seem as glamorous as many of the digital toys, but you may find yourself working long hours in a photography business and a good chair enables you to maintain a comfortable posture with proper back support. Good posture can't be overemphasized; you need a chair that adjusts in height so your legs can rest with feet on the floor and thighs horizontal to the floor. Your upper arms should hang straight down and your forearms should be

parallel to the floor. Everything I've ever read says to keep your feet flat on the floor, but I've found that placing a small box or other object on the floor in front of my feet allows me to continually move my feet into different positions on the box and floor for some variety.

Lighting

Another facet to consider as you create the layout in your office is the location of the windows and other sources of bright light. If you place your computers with a window behind them (in front of your face), you may at first think you've given yourself a great view of the neighborhood, but after a few minutes you quickly begin to experience eyestrain because your eyes are trying to adjust to see a relatively dark computer screen surrounded by a bright area. Another mistake is placing your computer facing directly away from a window or other bright light source. The light coming from behind you creates a glare on your screen that also contributes to eyestrain. You also want to avoid viewing your computer in a dark room. Provide enough room light that you're your eyes don't have to adjust much when going back and forth between the computer and other things in the room. The ideal office setup is: light gray walls, ample room light, and windows placed to the side of the workstation.

Conducting Client Interviews

The only time you really need a space more presentable than the average office is when you meet with clients. If you happen to be neat enough to have a presentable office space, then you can do interviews there, but most photographers don't keep their workspace quite that clean. Instead, some photographers choose to do interviews at a quiet public location, such as a coffee shop or rented meeting space.

Digital projector versus flat-screen TVs

One advantage of conducting interviews in your own office rather than at an off-site location such as a coffee shop is that you can set up a very impressive system for displaying your images. Many photographers use digital projectors or large plasma screens to show images with great results. You can use these displays both for showing your portfolio before the job and for showing images to generate sales after the job. Viewing images on a large screen is also conducive to selling large prints. After all, when you've just seen your image projected at 4×6 feet, an 11-×-14-inch print looks pitifully small.

Digital projectors

The digital projector (see Figure 13-1) is by far the most commonly used display system for anyone with a large showroom. You can install a pull-down screen as large as 4×8 feet for a very dramatic presentation. The drawbacks to digital projectors are that they can often be difficult or impossible to color-calibrate, and they have a bulb that burns out after a certain number of hours. When the bulb does burn out, it may cost as much as $350 to $500 to replace. This drastically increases the expense of your display when you try to calculate how much it will cost to run it for several years. In the current market, a decent digital projector with a 6-×-8-foot screen costs somewhere around $2,500 to $3,000.

Figure 13-1: Digital projectors and flat-screen TVs are popular for showing large images to clients.

Flat screens

Plasma and LCD screens are so similar that, for the average viewer, it just isn't worth distinguishing between the two, and they seem to be becoming more and more alike as time goes on. So for the purpose of this discussion, I'll lump them both into the category of "flat screens." These big flat screens are a very attractive alternative if you have a medium- to small-sized showroom. Screen sizes range from 30 inches to more than 50 inches. Anything more than 40 inches will seem plenty large in the average showroom. The advantages of flat-screen TVs are that you can easily color-calibrate them with the same equipment you use to calibrate your computer monitor. In addition, they have a life span of approximately 30,000 hours without noticeable color or brightness shifts, which is equivalent to using it 5 hours a day for 16 years. A medium-sized 40- to 50-inch professional-quality flat-screen display and a sturdy stand or wall mount runs $2,500 to $3,000. This initial purchase price is roughly equivalent to that of a digital projector.

The significant difference between projectors and flat screens is apparent when you calculate how much it will cost to run each one for several years. If you compare the price of running the two displays for 30,000 hours (assuming a bulb life of 400 hours and a cost of $200 each), the digital projector will require 75 bulb changes at a total cost of $18,000 for the projector and all the bulbs. The flat-screen display will cost only the original price of $3,000. In reality, neither of your displays is likely to last that long before you get tired of it and move on to something else. However, the cost savings with the flat-screen displays are obviously significant over time, and this is without calculating the downtime, the hassle of ordering new bulbs, and the potential embarrassment of having to change the bulb in front of a client.

To run your digital projector or flat-screen TV, you also have the option of creating your show in a DVD movie format that you can play in a regular DVD player, or running the presentation directly from your computer. For client presentations, I recommend always using the computer because a computer enables you to create a color calibration profile, and you can use different software programs mentioned later in this chapter to help you with print sales.

Music

With either a digital projector or flat-screen TV, you should also plan on purchasing a good stereo amplifier and speaker system. The difference between a show with music and the same show viewed in silence is simply so great that you cannot afford to skimp on the music. To run a big set of speakers from your computer, you will need a decent amplifier to power all of the speakers. You can play the show and the music from your computer, but you need to run a cable from the speaker output on your computer to the input on your stereo amplifier because your computer does not supply any power to run speakers — the amplifier must supply the power for the speakers.

I recommend purchasing a surround sound amplifier and speaker system, as this will fill the room with sound in a far more flattering manner than a simple two speaker setup. Surround systems are commonly listed as 5.1 or 7.1 type systems. The number 7.1 indicates that the amplifier has power to run seven normal speakers plus one bass speaker, which usually has its own power supply built in.

Viewing area

When all of the physical aspects of a good visual and auditory presentation are in place, you will have treated only two of your client's five senses to a wonderful treat. What about the other three? If you try to provide something for each of the five senses, your show will have much more impact. You've got sight and sound covered. Now you need to do something for touch, taste, and smell.

Providing a comfortable seating arrangement takes care of touch. You can create a nice aroma with incense or flowers, although both run the risk of irritating a client with allergies or an extra-sensitive nose. Some photographers have been known to bake cookies or bread, or brew a pot of coffee for the comforting smells they produce. You can also provide clients with a glass of wine, beer, or ice tea.

The Portable Interview

You may occasionally find that you must interview clients at a coffee shop or in the client's home. In this case, you will need to bring a selection of albums or a laptop for showing your images. I personally prefer the laptop for its portability and the ease with which you can update your slide show as you get new images from each new job. While a laptop screen is not anywhere near as impressive as a 40-inch plasma display, modern clients are generally technologically savvy people and they seem perfectly comfortable viewing images on a laptop. Showing images on an iPad or even an iPhone could work in a pinch but these screens lack the size and computing power you'll find in a good laptop.

It should be noted that the method of display will not improve the quality of your photography. However, no matter what quality level your images, a high-quality presentation definitely adds a whole new dimension to the viewing experience as well as the impression of your professionalism. If you want to sell large prints, showing your images on a large screen is the absolute best way to make it happen.

Just as you carefully prepare the lighting for your photos, you need to give the viewing area special attention. You need to be able to cut the lights down very low while the show is in progress. This allows the screen to show up better, and it also directs your client's attention toward the screen. After the show is over, you need to have a bright white light shine down from above and behind the client so that he or she gets the best possible view of your albums and print samples.

Interview-free bookings

Most local clients will want to meet you in person before they hire you. However, distant clients that might hire you for a destination wedding are not so concerned about the face-to-face meeting. If they like the work you show on your website, and your presentation and business seem professional, clients will not hesitate to hire you. You may exchange a million e-mail messages and phone calls with the bride because destination brides are usually fanatics about good photography, but a face-to-face meeting will usually not make or break the deal.

However, everything has a potential downside and as much as I'd like to say that interview-free bookings are the way to go, there is a catch. Sometimes you might get an interview-free booking from a parent, or a wedding coordinator who is working for the bride and has full authority to hire you for the wedding. This might sound like a great thing, but every time it's happened for me, I've found it to be a very uncomfortable affair. If the bride doesn't personally choose you, it may very well be due to the fact that she just doesn't care about photography very much. This may mean you'll have limited access to following her around all day, you might not be kept informed of all the details, and you might not even be fed a meal. Basically, it could mean that you're there because she's "supposed" to hire a photographer — not because she's personally invested in getting great photos. You'll be paid the same, but her lack of interest probably won't inspire you to do your best work, and you may even find yourself getting treated like a second-class citizen.

Setting Up Your Office

In this section I outline the different types of equipment and software needed to run a successful photography business.

Essential computer hardware

The job of a digital wedding photographer involves a lot of computer work. You manage your finances, create your website, upload images to the lab, purchase new equipment, create client slide shows, manipulate images, print images, e-mail clients, edit new images, and burn images to CD or DVD. You do all of these jobs on the computer, and you often need to perform several of these tasks at the same time. This section provides an overview of the basic computer hardware necessary for a successful photography business.

Operating system

PC or Mac: which one is better? If you're starting out in the photography business and you don't have a computer system, your first task is to decide between Mac and PC. The choice is a

bit like choosing between Canon and Nikon — in that either tool works well in skilled hands. PCs still tend to have an edge when it comes to price and software availability, and some programs that are available for the PC are not available for the Mac until a while later.

Mac computers tend to cost considerably more for the same physical features and speed of a PC. Macintosh claims to compensate for this price difference by including a lot of small software programs as a standard part of the computer, but unfortunately these are not programs you'll need to run your business. If you look through all the essential programs listed in the section on software later in this chapter, there are only a couple of small essential items that will come preinstalled on the Mac; you will still need to purchase the vast majority of your photography-related software. No matter how you look at it, dollar for dollar, you will always get more features and performance from a PC.

In the early days of personal computer development, it could be said that Mac computers were more "user friendly"; that is to say you didn't have to have much computer knowledge to make them function smoothly. Today, and even moreso in the future, Mac and PC computers are similar in this respect, so the choice is now more about which platform offers the best value for the money.

Which system is right for you will be an easy choice if you already have one that you're familiar with. In this case, the Canon-versus-Nikon analogy doesn't hold up at all because most cameras function in basically the same way, so if you have experience with one, you can pretty much just pick up another one and start using it right away. Not so with Mac and PC computers. The two types are so fundamentally different that even if you're an expert at one, you can't just sit down with the other and understand all the controls immediately. So if you've spent years with one system, even if the other system seems to offer some advantages, the difficulty of learning a whole new system should weigh heavily on your choice.

PC computers are far easier for you to work on yourself, so if you're the type that likes to work on your own car, fix your own leaky faucet, and so on, then you'll probably appreciate the fact that you can easily open your PC, buy new parts for it, and plug them in without any real serious computer education. You can also buy your PC one part at a time through various online retailers (as I do) and assemble the entire system yourself. Assembling your computer system this way does require you to study up a bit, but it's not rocket science by any means. And the advantage is that you can build a cutting-edge machine for about half the price you would pay to have someone else assemble it for you.

If you're the type that doesn't have a clue what it looks like under the hood of your car and you don't really care to know, you'll probably want to get either a Mac or a preconfigured PC from a company such as Dell, Gateway, or one of the many other PC manufacturers.

Computer size

After you decide on a PC or Mac, the next decision is to determine what size of computer you should get. Computers come in three basic sizes: desktop, portable, and notebook.

Desktop

The desktop computer, often called a *tower*, is the size most commonly used in an office or studio because it provides an extensive feature set and maximum adaptability. By adaptability,

I mean that the tower-style box has many slots where you can add and subtract parts, such as hard drives and controller cards, to give the computer new features. Tower-style computer cases are designed with standard-sized spaces inside to accommodate all sorts of add-on parts.

Desktop tower systems (see Figure 13-2) also have room for a lot of fans. This is important because the fast processors in these systems generate a lot of heat. Each processor has a huge aluminum or copper heat-dissipating block mounted right on top of it with a large fan blowing cool air over the block to cool it down. The ability to cool down the processor is a major advantage with the larger computer systems because it enables you to use faster processors that produce far more heat than can be handled in a smaller case.

Figure 13-2: A desktop system offers the most flexibility, speed, and bang for your buck, but a laptop is essential if you travel a lot.

Portable

Laptop and portable computers are smaller and generally come equipped with an LCD screen that folds down when not in use. These two smaller types of computers come in a range of sizes and weights. Those that weigh in at 7 to 15 pounds are generally called portable, though while you can easily pick up and move a computer of this size, you wouldn't want to carry it in your backpack all the time. The advantage of this size is that it is large enough to pack a lot of features, a moderately fast processor, and a large screen. If you do only occasional portable interviews, this size of computer might be just right.

Notebook

Notebook-size computers weigh less than 7 pounds and are the only truly portable computers. Notebooks are perfect for destination photographers and anyone else who travels a lot. These tiny computers pack an amazingly powerful system into a box that is less than 2 inches thick with viewing screens that can range in size up to 17 inches.

Both the portable and the notebook sizes cost far more than the desktop models because you pay a premium for miniaturization. Portables and notebooks also offer fewer features and very limited options for adaptability compared to the larger desktop-sized computers. Further,

smaller computers are much more difficult to work on if they malfunction. Your local computer store can probably fix anything that goes wrong with a desktop, but if a laptop goes out, you most likely have to send it back to the manufacturer. About the only repairs or improvements that even the most computer-savvy person can do to a laptop is change the battery, the memory chips, and the hard drive. Each of these three components has an access door built in for easy replacement or repair. Everything else is buried deep inside the tiny body of the computer.

The moderate speed processors used in these miniature computers will work with very quiet fans, and the heat buildup under the computer will be minimal. These processor speeds may be only a fraction as fast as the fastest processors on the market; however, if you add a couple gigabytes of RAM, you still have a computer that can function at a very comfortable pace for average tasks. Handling jobs like rendering RAW files to JPEG in Adobe Photoshop Lightroom will be agonizingly slow on a computer like this, but of course it can be done in a pinch.

Most photographers get the greatest amount of use from the desktop style of computer. The only real reason to choose a laptop is for portability, but even if you do need a laptop for travel purposes, you will still want to have a desktop for your primary office computer. I don't recommend that anyone try to run their whole business from a laptop computer. The slower speed of the laptop will reduce your daily workflow to a crawl compared to the productivity of a larger and much faster system.

RAM

RAM stands for *random access memory.* RAM comes on thin strips of computer circuit board that snap into special slots on your computer. Your computer uses RAM to temporarily store the information it must access when programs, images, and so on are open. Each time you open a program, the code for that program is read into this memory and remains there, waiting for you to use it. When you close the program, the code is deleted from the RAM. It is important to note that RAM is different from your hard drive. The hard drive stores information permanently while RAM only stores information while the computer is turned on.

RAM is particularly important for photographers because every time an image is opened, it is read into the RAM. If you open Adobe Photoshop, all of the code for the program is also read into the RAM. If you run a filter on the image, the processor chip makes changes to the image in the RAM, but if you don't have enough RAM, the image is temporarily written to a hard drive. Much of what photographers do on their computers takes place between the processor and the RAM chips. Given this, the amount of RAM in your computer becomes extremely important in determining how fast your computer functions. Not having enough RAM can be an extreme limitation to your computer. For example, if you only have 1GB of RAM and you try to open an 8GB file, the computer is forced to use the hard drive for temporary storage of the file, and at that point your computer can only work as fast as the hard drive can read and write the information. Hard drives are many times slower than RAM, so you want to avoid a situation where your computer is limited to the speed of the hard drive.

What is a good amount of RAM for a photographer's computer? In the previous version of this book, which I wrote only five years ago, I listed 1GB as a healthy starting point for the average photographer. Today that amount would be laughable. Just a couple of months ago I built a

new office computer with 16GB of RAM. Things change fast in the computer world. I remember that my previous computer took about 18 seconds to render one RAW file to JPEG and it was pretty much useless for several hours as it processed through an entire wedding with an average of 1,500 images. My new computer takes 2.5 second to render a single JPEG, and while rendering out a big wedding I can simultaneously (and effortlessly) listen to music, burn a DVD, check my e-mail, and continue to edit images in Lightroom.

Hard drive

Computer hard drives are constantly improving. The storage capacity gets larger and the speeds get faster every day. If you want to create a fast computer system, the hard drive is one of the most important links in the chain. Two key elements influence the speed of the hard drive: the speed of the drive itself, and the method used to attach the drive to the computer circuit board (called the motherboard).

Drive speed is not just the speed at which the disk spins, but more important, the speed at which the drive can read and write data. When you shop for a hard drive it is important to compare the read/write speeds of various drives.

The second consideration is the connection method, or the type of cable used to transmit the data from the hard drive to the motherboard. All computer systems built today should be using Serial Advanced Technology Attachment (SATA) for connecting the drive to the motherboard, and eSATA (External SATA) for connecting external drives. Older connection systems are far slower at transmitting data through the cable, so if the computer and the hard drive are capable of running faster than the data can come through the cable, you've created a bottleneck, or a slow spot. This creates a weak link in the chain and just as a chain is only as strong as its weakest link; a computer is only as fast as its slowest component.

Another method of increasing drive speed is to put two (or more) hard drives on SATA connections and configure them to run as a RAID 0 array. RAID, which is an acronym for *redundant array of independent disks*, is a system for using two or more drives together as if they were one large drive. The benefit of a RAID 0 system is that it divides the information in half and puts one half on each drive. When that information needs to be accessed again, each drive only has to read half of the total. (See the section on RAID options later in this chapter for more information.) With the SATA cables, the information can travel to, or from, both drives simultaneously. This essentially cuts in half the amount of time it takes for your hard drives to read or write an image file.

A solid-state drive (SSD) is a hard drive that is the same as the compact flash drive you use in your camera, only bigger. SSDs have no moving parts and they can access information far faster than the best conventional hard drive. The fact that they have no moving parts means they don't have catastrophic instant failures like conventional drives sometimes do. But SSDs don't last forever. They wear out very slowly as the years go by and as each tiny bit wears out, the computer simply ignores that space from then on. So the drive will get smaller and smaller over the years, but it is unlikely to die instantly, even if it experiences very high G forces as it might do if you were to drop your laptop. Currently the only drawback to SSDs is that because the technology is new they are still very expensive for the size, but this cost should decrease steadily over time until SSDs eventually become the standard. Currently, the only practical use

for these drives is to hold your computer operating system and the main software programs like Lightroom and Photoshop. Installing all your programs on an SSD can make your computer function significantly faster than if your programs were installed on a normal drive. For example, Photoshop and Lightroom each take about three seconds to open when installed on an SSD.

Standard hard drives are made up of many moving parts and they eventually wear out. However, using conventional hard drives to store your images has become a very affordable method of archiving your work — if you take the proper precautions. To use hard drives as your primary image storage method, you should back up your drive by maintaining two identical drives: one stored in a fireproof safe or at another location and the other in your computer. Every time you finish a set of wedding images, pull out the backup drive, pop it into an external drive bay, and update that drive so it's identical to the first. You can use an external eSATA drive bay, like the one shown in Figure 13-3, to swap hard disks in and out in a matter of seconds. This is especially useful for accessing current backup drives and older drives that may be used to store archives.

With hard drives in the 1,500GB to 2,000GB range costing only $100 to $150, storing a full year's worth of weddings on a single drive is not a problem. Purchasing an identical drive for backup will only cost you another $150, so for under $300 you can get a pair of drives that will hold all your work for a year or longer depending on how much you shoot. When the drives are full, store one in the fireproof safe and the other in a desk drawer where it can be easily reached when you need to pop it into the external disk bay to retrieve an old image.

Figure 13-3: Docking stations like this Thermaltake model, which can connect two sizes of hard drives via eSATA cables, enable you to easily swap drives of all sizes and use them at the same speed they would achieve if mounted inside the computer.

RAID options

Configuring a pair of hard drives to run in a RAID setup is another method of backing up your work, and if your work is extremely important, this option will provide you with an instant backup. RAID, which stands for *redundant array of independent disks,* works by placing two

identical drives into your computer and setting them up (there are various ways of doing this) so that they run together as one drive.

A RAID 0 array uses two disks as if they are one, but all of the data is split so that it writes half to each of the two drives. This enables the computer to read and write from both disks at the same time, effectively doubling the speed of the disks. Any disk failure destroys all of the data on both disks, so while RAID 0 is very fast, this is not a backup option.

A RAID 1 array also uses two disks as if they are one; however, unlike the RAID 0 setup, each disk gets identical information so that if one fails, all of the information is still available on the second disk. This creates an instant backup but does not provide any insurance against fire or theft. Using another external drive to periodically back up the information on your RAID 1 array, and storing that drive in a fireproof safe, creates the final layer of backup protection.

CD and DVD burner with software

Each workstation should come equipped with two optical drives and the software for burning data to DVDs and CDs.

Graphics card

Using a moderately high-end graphics card greatly speeds up how quickly images display on your monitor. If your computer does not have a graphics card, the main processor chip runs your monitor in addition to all of its other jobs. This creates a noticeable delay when you scroll through the images in a browsing program, or when you edit images in software like Photoshop. You can take the pressure off your main processing chip by using a graphics card with at least 1GB of built-in RAM. What this means in low-tech language is that the graphics card runs the monitor while the main processor chip is left free to work on other things, such as generating the thumbnails while you edit images.

Another key consideration with your graphics card is to make sure that it has an HDMI (high-definition multimedia interface) output built in. This enables you to plug a cable directly from your computer graphics card to the stereo amplifier that controls your flat-screen TV. In conjunction with this you'll want to use the SPDIF (Sony/Philips digital interconnect format) sound connector on the back of your computer, which uses a fiber optic cable to attach the computer to the stereo amplifier. With these two cables, you'll have the highest possible quality video and sound going from your computer to the TV.

Central processor

The central processing unit (CPU), or central processor, is essentially the brain (or brains) of the computer, and is perhaps the fastest evolving of all computer parts. As of this writing, the most popular variety of CPU consists of four (or more) sets of processors packed into one tiny unit. As time goes forward, more and more individual processors will probably be packed into each CPU, because this basically enables the computer to divide the workload between the processors. It's a bit like having an office with four people. Each person can work on a different job without affecting the others, or you can divide one large job into four smaller parts and get it done four times faster. Each single processor in the CPU is capable of working

independently from the others. What this means for the photographer is that you can now do a big job that would have previously taken the complete resources of the computer, and while one or two processors are working on that job, you can easily work on other jobs such as editing in Lightroom, and the computer will divide the workload among the remaining processors.

Computer network

Any photographer with more than one computer workstation absolutely must set up a network between them. Having a network enables you to access images or anything else from any computer on the network. For example, if one person is editing images on Computer A and you need to print a document on the printer that happens to be attached to Computer B, all you have to do is send your document through the network to the printer without ever disturbing the other person using that computer. Another example is while a new set of images is being edited on Computer A, a person working on Computer B can browse those same images, open (directly onto Computer B) the ones that need color correction or artwork, and then save them back through the network to the hard drive on Computer A.

The physical method you use to attach the computers together can be either a cable or a wireless connection. With wireless, each computer must have a transmitter/receiver card installed. If you choose a wireless connection, be aware that the wireless signal travels quite a bit farther than the walls of your home or office. If you fail to properly set up security features, a stranger can pick up the signal and log onto your network. Also, wireless connections are always far slower than connecting directly via wire, and considering that a photographer often needs to transfer large numbers of large images from one computer to the next, direct wire connections usually make the most sense.

All PCs and Macs are equipped with the connection ports for networking cables. You can connect these ports from the computer directly to your DSL modem if you only have one computer, or you might plug into a separate hub to split the signal between several different computers. A *hub* is basically a small box with several network cable plugs. Each computer is connected to the hub, and the hub allows the signals to travel back and forth between all of your computers. Your DSL modem may function as a hub if it comes equipped with several network cable connections. If you have a large business with many computers, you can purchase a hub with many cable connections. Setting up a network is a topic that deserves a book all its own, and of course there are many. You can either read up on the topic and do it yourself, or simply hire a computer technician to help you with the setup. In either case, you may eventually run into problems that require you to know the basics about network setup, so it will benefit you greatly to take the time to learn how to do this yourself.

Monitor

LCD monitors like the one shown in Figure 13-4 have become the standard in the photographic industry, and you rarely ever see the larger CRT monitors any more. Bright colors and sharp, flicker-free text make LCD screens a perfect match for digital photographers who spend large amounts of time staring at the screen.

Figure 13-4: A large calibrated monitor is an essential piece of equipment for the wedding photographer. Several companies have models that will produce the full Adobe RGB color spectrum, which makes them ideal for viewing images.

Most computer monitors display the sRGB color space, but the newest generations of LCD monitors are capable of producing the entire Adobe RGB color space. One company, Eizo (www.eizo.com), is leading the way with this new technology. This company already has several monitors that display the full range of colors in the Adobe RGB color space, and they can also be set to view in CMYK or sRGB. Dell (www.dell.com) also makes a very highly rated 27-inch monitor that displays 96 percent of the RGB spectrum at a price that is significantly lower than the competition.

There is no single monitor on the market that photographers agree is the best. However, there are several monitor companies that seem to show up in photographer's offices more often than others. Here is a nonscientific listing of the most common brands:

Apple	LaCie
Dell	Samsung
Eizo	Sony
Hewlett Packard	Viewsonic

Calibrating your monitor

While there are several types of low-tech monitor calibration methods, I don't recommend using them because the profile they produce is based on your ability to determine what a neutral gray

is and then match several other options visually. This method simply cannot compare to the machine measurements that happen with a real color calibration kit, and if you're going to be in the business of making images, you absolutely must use a properly calibrated monitor.

Every single monitor that comes off the assembly line is an individual. It has image characteristics that are somewhat like its siblings, but not exactly so. Somehow the combination of parts, small differences in alignment and how tight the bolts are, and a million other tiny factors that are slight production variables add up to create slightly different color-producing abilities on each monitor.

To neutralize these differences and set every monitor to a standard, you must calibrate it. Not only that, but also you must repeat the calibration every few months to correct for changes that occur as the monitor ages.

Calibrating your monitor is a reasonably simple process. After you purchase a calibration kit, you need to install a software program that walks you through the various steps required to calibrate your monitor. Most systems provide a sensor that you place directly on the face of the monitor while the software makes the monitor produce various colors under the sensor. As the process ends, the software compares the colors the monitor actually produced with the colors it should have produced, and a "profile" is created that corrects the monitor's actual colors and causes the monitor to produce perfectly standardized colors instead.

The following companies produce kits for calibrating your monitor. Some kits also contain equipment for calibrating a printer:

> Datacolor (http://spyder.datacolor.com)
>
> Integrated Color (www.integrated-color.com)
>
> LaCie (www.lacie.com)
>
> Pantone (www.pantone.com)
>
> X-rite (www.xritephoto.com)

Color profiles

A *profile* is a set of instructions that a calibration device creates to correct the inconsistencies in a device to make it produce standardized colors. Profiles can be created for monitors, printers, cameras, scanners — anything that produces color. These profiles can also be called color "spaces" because they represent a range of colors; however, in this case, the new color space will only be useful for a particular monitor because it is actually a skewed color space. In other words, this color space is created kinda wacky, but in a way that compensates exactly for the ways the monitor was off to begin with. For example, if the green was two points off in one direction, the new profile shows green to be two points in the opposite direction, thus negating the original bad color and bringing it back to the center.

Adobe RGB and sRGB are also color profiles. These types of profiles represent a range of colors and they have no connection to any monitor, printer, or anything else. These are said to be "device independent" because they are not made for any particular type of device. The profile

you produce for your monitor is a "device dependent" profile because it only works on that one specific machine that you created it for.

Adobe RGB and sRGB are often called a color "space" because they each represent a standardized range of colors. When you work on your images in the computer, you should ideally be working with RAW files that have no set color space. However, when you render an image into any other file format, you will need to specify the color space you wish to use. Each color space has a purpose. sRGB is great if you want to send the image to a color printing lab or if you want to place it on your website. Adobe RGB works great with home printers. CMYK is required if you send an image to be reproduced by a four-color printing press. Knowing the use of the image will determine which color space you use.

Office printer

An office printer need not be anything fancy, and it definitely is not meant for photographic printing. Its main job is printing documents for your records and for communication with clients. Models from Hewlett-Packard, Epson, and Canon work perfectly well for these tasks. However, for a small amount of extra cash you can get a few features that can be extremely useful for a photographer. One of the most valuable of these is the ability to print directly onto DVDs and CDs. The software provided is easy to use, and it enables you to create beautiful custom discs for each job. Many all-in-one office printers can also function as a fax, scanner, and copy machine — all of which come in handy at various times.

Essential software for photographers

The digital wedding photographer must perform several basic jobs on the computer. For each job, there are often several different software options that range in price and complexity. The following list provides examples of the types of software needed for the major tasks of a digital wedding photographer:

✦ **Image manipulation:** Photoshop, Lightroom

✦ **Image browsing and organization:** Adobe Bridge, ACDSee, Lightroom

✦ **Downloading flash cards:** Adobe Bridge, Lightroom

✦ **Creating video slide shows:** ProShow Producer

✦ **General administrative tasks:** Microsoft Word, Outlook, and Excel

✦ **Accounting:** Intuit's QuickBooks

✦ **Uploading and downloading files:** FileZilla

✦ **Web browsing:** Firefox, Apple's Safari, Google Chrome, Microsoft Internet Explorer

✦ **Creating PDF files:** CutePDF

✦ **Website creation:** Adobe Dreamweaver

✦ **Burning DVD, CD disks:** Nero Burning ROM, Roxio Creator

Other essential equipment

In addition to the basic computer hardware and software necessary for a successful photography business, it is also important for the wedding photographer to have a reliable Internet service as well as a fireproof safe for storing archived material.

Internet service

Before you can log on to the Internet, you need to pay for the service of an Internet service provider (ISP). This is a company in your area that you pay a set fee per month for your connection to the Internet. Usually this service comes with free e-mail and a free space where you can create a small personal website.

If a digital subscriber line (DSL) is available in your area, adding that to your regular Internet service greatly improves the speed of your web-surfing experience and is vital if you want to use an online print service that enables you to send images over the Internet. The ISP often provides your connection to DSL for free, but the phone company then charges you a monthly fee to use it.

If you do go with DSL, you must purchase a DSL modem that connects to the phone line in your office. DSL operates at a completely different frequency from phone conversations so you can use your DSL service to surf the 'net while talking on the phone at the same time.

DSL modems can be purchased with a wireless feature for only a few dollars more. If you have a laptop computer or computers in distant parts of your office, using the wireless feature may be far easier than running wires, although wire connections allow faster transmission times.

Fireproof safe

A fireproof safe should be an essential part of every digital photographer's office. In it you can store original image discs, portable hard drives, and client contact information. If you want something to store large amounts of material inside, consider a gun safe. A gun safe can be the size of a small closet and is extremely secure and provides fire protection. This would be the perfect place to store all of your cameras and expensive lenses. Not only do these safes weigh about 500 pounds, but also when you bolt them to the wall, they become practically impossible to remove without tearing your entire house or office apart.

Summary

Having a workspace of your own is essential to every digital wedding photographer. Depending on the type of business you do and your personality, you may want anything from a large commercial studio space to a small office in a spare bedroom. Both spaces work just fine, and neither has the slightest effect on the creativity or the quality of the images you can produce.

This chapter gave you a brief overview of options to consider when setting up your office and the office equipment you need to create a full-featured digital wedding business capable of handling image processing and client contacts.

✦ ✦ ✦

14

Digital Workflow: Getting Images from Camera to Client

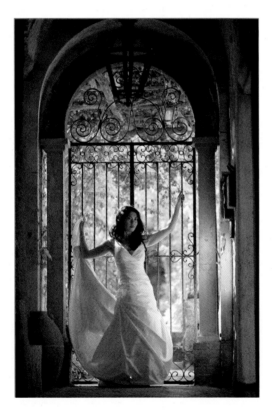

In your day-to-day business as a photographer you must develop an organized system that facilitates the flow from one task to the next as each job progresses from beginning to end. The term *workflow* refers to the sequence of steps you take when completing a job from start to finish. In theory, it might seem as if someone could simply jot down a workflow for you to follow and you would be ready to go. In reality, developing a workflow for your business is a

process that evolves from your own unique preferences and the way you like to work. There are many variables and many different ways of accomplishing the same task. The technology involved is also constantly changing — which, of course, demands that you change right along with it. Developing the optimum workflow is a challenge you'll face every day when you work in the wedding photography business. In this chapter I give you an idea of the many options you can choose from when creating your own workflow.

Understanding Workflow

The world of photography is changing quickly. If you pay attention to these changes, you will almost certainly find new cameras, electronic products, software, digital retouching techniques, album companies, and ways to use the Internet. Any one of these facets has the potential to change your business enough that you have to throw your current workflow right out the window and start over. It's safe to say that you shouldn't expect your workflow to remain exactly the same for more than a few months at a time.

Since most photographers are creative and independent types, it is natural that every photographer in this business will develop a unique workflow that helps him or her consistently achieve the ultimate in efficiency. Your own workflow will be specific to you. It will reflect the type of clients you serve, which products you promote, and what sort of sales strategy you use. For example, someone who shoots in a Traditional style and projects images on a screen while taking print orders will have a very different workflow from someone who shoots in a Photojournalistic style and provides a DVD to the client with all of the images.

I like to think of workflow as having two distinct parts: the work and the flow. The *work* is provided by you; the *flow* is provided by your system. There is a definite relationship between the two parts. The more your system flows, the less work you do. If something jams up the flow, you have to make up for it with more work. The goal is to set things up so they flow as smoothly as possible from one job to the next.

Before you review the details of each step in the wedding-day workflow, keep in mind that many aspects of a wedding photography business can be considered part of the whole wedding workflow. And each part of the business requires a mini-workflow all its own. For example, you may have a workflow for advertising, another for interviewing clients, another for filling print orders, another for making albums, another for uploading images to a website, and most important of all, a workflow you use to create the wedding images and prepare them for the client. Each has repetitive tasks that you must do for every client in order to maintain a successful wedding business.

Wedding Workflow Overview

Most digital wedding photographers follow the same basic steps in their wedding workflow. The first part of the workflow consists of the process of preparing for the wedding day and shooting the images. The second part of the workflow consists of processing the images.

Part 1: Shooting the Images

Step 1: Prepare for the shoot.

Step 2: Shoot the pictures.

Step 3: Transfer the images from the camera to the computer.

Step 4: Copy the full set of images to the backup hard drive from the fire safe.

Part 2: Processing the Images

Step 5: Import and convert to .dng format.

Step 6: Organize the good images and delete the bad ones.

Step 7: Color-correct the "keepers."

Step 8: Rename all the "keepers" to consecutive numbers.

Step 9: Output the RAW files to the JPEG format.

Step 10: Copy the final set to the backup hard drive stored in the fire safe.

Step 11: Produce the final products for the client.

Step 12: Mail or deliver the final products to the client.

The remainder of this chapter expands upon the details of each step of this process.

Part 1: Shooting the Images

Part 1 of the digital wedding photographer's workflow consists of the steps necessary to take a wedding shoot from beginning to end. It starts sometime before the day of the wedding and ends when the images are in the computer, backed up to a second drive, and ready for use in the image-processing portion of the workflow. Part 1 covers the steps necessary to perform a successful shoot, from charging your batteries to downloading the images after the after you get back home.

Preparing for the shoot

Preparation for a digital wedding shoot should start several days before the event. You have batteries to charge and cards to format, and of course, you have to confirm all the details of the day with the bride. As you formulate your own system for the preparation phase, bear in mind that a wedding is not a good place to go unprepared. The last thing you need is to arrive at the location only to realize you forgot something and you have to go back home to get it. To prevent this, make a checklist of all the things you need to do and all the gear you need to pack to ensure you arrive on the scene with everything you need to do the job.

Charge batteries

Charge those batteries! Digital cameras and flashes take a lot of battery power. Before you purchase a single alkaline battery, do yourself (and the environment) a favor by purchasing a couple sets of high-capacity nickel metal hydride (NiMH) batteries. By purchasing NiMH batteries, you can save yourself hundreds of dollars over the lifetime of the battery set. Think about this: one NiMH battery costs roughly $4 while one alkaline battery costs roughly $1. Every time you charge each NiMH battery, you are essentially saving $1. Many NiMH batteries claim to last 500 charges. That's a savings of up to $500 per battery! (If you're like me, however, you'll never know if this is true or not because you'll lose them long before you wear them out.) On my gear page at www.aperturephotographics.com/photoproducts.htm, I have a listing for a great battery company that sells all types of batteries.

If you know you're going to be shooting a lot at night, an external battery pack for your flash can be quite valuable. Both Canon and Nikon make external (AA) battery packs that plug directly into your flash and speed up the recharge time from the normal five to seven seconds (for a full power burst) to about two seconds per flash. There are also larger battery models by Quantum Instruments (www.qtm.com) and Dynalite (www.dynalite.com) that can provide more than a hundred full-power flashes per charge.

The reality of the average wedding shoot is that you won't find you need this much power unless you bounce your flash up into the roof all night long. When you shoot with a high ISO setting, your flash will hardly ever produce a full power burst, so the amount of power contained in a set of four AA batteries will almost always take you through an entire wedding day. If you have rechargeable batteries, it wouldn't hurt to put in a fresh set at the beginning of the reception just to speed up your recycle times for the dance photos, but doing so will rarely be required.

Most professional-level cameras come with a battery that is unique to that camera model. These batteries are made of several smaller batteries that are simply bound together in a small plastic package. If you want spare batteries, look on the Internet to see who else (aside from the camera manufacturer) makes batteries for your camera. There may well be several other companies that make batteries that are significantly more powerful than the standard battery produced by the manufacturer.

When you shop for batteries, look for the highest milliamp-hour (mAh) batteries you can find. In simple language, the mAh number translates into the amount of power the battery can hold. The higher the number, the more power it can hold. It's impossible to tell you what a good number is for your battery because every battery is different, and the manufacturers are constantly developing new technology that increases the power.

Rechargeable batteries will slowly lose power whether you use them or not, so two weeks after a charge, they may be dead. If you happen to be traveling to a destination wedding in a faraway place like that in Figure 14-1, you might want to carry a couple sets of standard alkaline batteries because they hold a charge for years and you won't have to worry about

them losing power before you get there. Also, don't count on buying batteries in a third-world country. I once purchased 16 new alkaline batteries from a hardware store in Port Antonio, Jamaica, and none of them had enough power to turn on the flash.

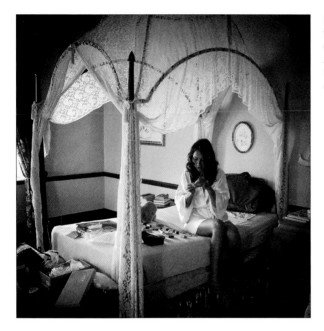

Figure 14-1: Never count on getting equipment in a third-world country. At this wedding in Port Antonio, Jamaica, I shot a lot of natural light photos because I couldn't get batteries.

Format your memory cards

Always format your flash memory cards before you leave for a wedding. Nothing is worse than realizing that you just shot 50 pictures on a flash card that was already nearly full because you forgot to format it after the previous wedding. Now you can't format it without losing the new shots and you don't have time to stand around deleting all of the old images, so you're stuck with a flash card that is out of commission with only a few new images on it. It's always a good idea to carry a few extra memory cards in case this happens.

For compact flash cards that are to be used in a camera, you should make a practice of never using a computer to format the cards — always use your camera. You should also never copy images or any other data from a computer to a memory card. If you do, you risk losing images and possibly corrupting the card. If you have done any of these things, format the card with your camera, shoot some scrap images, and then format it again. Do this several times to make sure the card is clean and functioning properly before you trust it to work reliably on a job. Any time you mess with your memory card on a computer, you risk causing problems.

Should You Format Cards on the Job?

The prospect of owning a bunch of expensive memory cards may tempt you to simply bring your laptop to the wedding and download each card as you fill it, then format the card and shoot it again. Theoretically, with this method you could work with as few as two memory cards — perhaps even just one if you download at times when there is a break in the action. However, I want to caution against trying this. The reason is that occasionally image downloads don't work. Perhaps the cord isn't plugged in all the way or the software just gets things wrong. Whatever it might be, the result is that you may get nothing, you may get a list of files that show data but won't open in any image editor, or you may get partial images with big sections missing. Maybe someone will unplug the electricity while the download is in progress; then they'll plug it back in before you get back and it will look like everything went fine but none of the images transferred. If listing all of this makes you think I worry too much, let me tell you, it has all happened to me.

If you have enough memory cards to shoot the whole event without formatting any cards on the job, you can relax with the knowledge that if there is a mistake in an image transfer, you can just pull out your memory card and download the bad images again. Rarely is the problem actually in the memory card itself. Usually the download process is where interesting things happen. Later in this chapter I provide much more detail on the subject of downloading malfunctions and media card corruption, as well as list a number of software programs that can probably rescue you from such disasters.

Confirm wedding day details with the bride

A day or so before the wedding, it's always good to check in with the bride one last time. If the wedding is at a place you've never been before, you should look up the address and print out directions to both the ceremony and reception sites. And just on the off chance that you might have some travel delay or get lost, you definitely want to be sure you have the bride and groom's cell phone numbers handy.

If you're traveling by car, make sure to give yourself enough time to deal with any foreseeable, and most unforeseeable, travel delays. I try to always leave early enough to change a flat if I have to. It's amazing to me how often I get lost or stuck in traffic and that 45 minutes of extra time that should have been ample time to get me there early ends up just barely enough to get me there on time. And if I do end up getting there early, it's great to have a few minutes of downtime before the show. When you arrive early, you can spend the time walking around the grounds as shown in Figure 14-2, looking for any promising spots to use for the creative portraits later in the evening.

Figure 14-2: I snapped this shot while checking out angles to use on this old truck I found in the woods near a wedding venue in Oregon.

Prep your cameras

One of the most important preparation details is to make sure that your cameras, and those of your assistants, as well as all your backup cameras, are set to exactly the same time and date. If you do this before the wedding, later you can put all the images together in a single folder on your computer and sort by the date to have them appear in the order they actually happened.

When you first take your camera out of the box at the start of each wedding, it will typically still be set just as it was when you stopped using it at the end of the previous wedding. In preparation for the upcoming wedding, you'll need to go through each camera and make sure the settings are appropriate for the average daytime wedding shot so that, if necessary, you can simply walk in the door and immediately start shooting. I set my cameras to Aperture Priority mode, f/2.8 at ISO 400. I also like to zero out the camera and flash exposure compensation adjustments, verify that the image capture mode is set to RAW, and that Auto white balance (AWB) is selected. The final step to preparing the cameras is to clean all the lenses and blow the dust off the CMOS sensors.

Pack your gear

At some time on the day before the wedding, or on the morning of the wedding, spend some time going over a checklist of the gear you need. Having such a list, and using it before each wedding, can help ensure you arrive with everything you need to do the job. I also recommend that you keep your shoot bags/boxes packed and ready to leave so that every time you take them out, you know the entire set is always there. This is especially important with memory cards because these tiny jewels are so easy to leave sitting on the desk next to your computer. Always, always, always put the cards back in your camera box immediately after downloading the images to the computer.

Shooting the pictures

Shooting the images is not really part of the workflow in the same sense as the other jobs listed here, but it is obviously a necessary step before you can continue on to the next two jobs that are part of the wedding shoot workflow. I won't mention all the little parts that concern the picture shooting as that is the subject of this entire book. (If you really want a list, just mentally insert the table of contents for Chapters 5 though 12 right here.)

Transferring the images from camera to computer

Transferring the images from camera to computer is a critical step that I try to keep simple and foolproof because I've had bad experiences with images that mysteriously disappeared in the download process. This series of steps is the result of the paranoia those experiences produced.

Before I start the download process I stack all full memory cards on one side of the computer. After each card is downloaded, I check the count of images on that card and write down the number. Then I move that card to the other side of the computer, being extremely careful not to miss any cards in the process. When all cards have finished downloading, I add up the image count from all the disks and compare that number to the total number of images in the computer. If the numbers don't match up, I repeat the process or attempt to find the missing images until I'm satisfied that all images are accounted for.

You should attach your compact flash card reader to your computer via the USB 2.0 or FireWire connection. The newer USB 3.0 standard is even faster and will probably become more common in the future. If your downloads seem to be taking forever, the problem is most likely a conflict with the USB port and the reader which is causing the system to default to the older USB 1 standard.

When you plug your memory card into the card reader, do not try to view, sort, delete, or do anything else to the images while they are still on the memory card. Remember, this is a fairly delicate time because you do not yet have a second copy to use as a backup. The only action you should do now is simply select the entire set of images (without producing thumbnails) and drag and drop them into the destination folder on your hard drive.

Some photographers prefer to use a downloader program designed specifically to move images from a memory card to a folder on the hard drive. Both Adobe Bridge and Lightroom have options that perform this function very well. Some photographers also choose to rename images as part of this step but I don't recommend doing this just yet simply because it complicates this critical step and could possibly open the door to potential mistakes. Don't be worried that you won't be able to sort the images out later unless you rename them; your camera automatically embeds all the metadata you'll need for sorting and puts this data inside every image as the image is made.

Following are some points to remember about downloading:

✦ Never set your downloading software to "move" the images because this automatically deletes the source images as they are downloaded. Always leave the images on your memory cards until you have to format the cards in preparation for the next job.

✦ Never interrupt the download process or turn off the power on the camera or computer until the download is complete.

✦ Always count the number of images on every memory card and add up the total, and then compare the card total to the total you have on your computer.

✦ Always view large thumbnails for every image before you consider the downloading process successful. Occasionally you'll encounter problems that necessitate re-downloading the images from the memory card, and in almost every case, the problem is visible in the thumbnail and preview images rendered by programs such as Bridge and Lightroom.

Download problems

Images don't always download properly. This doesn't happen very often but it does happen to me at least once or twice per year, and all it takes is once to get you in serious trouble if you don't notice it in time to re-download the images from the memory card. The images shown in Figure 14-3 are from a download that didn't work properly. About a quarter of the images from this memory card came out looking similar to this. I didn't discover it until I started looking through the previews. At first all the thumbnail-sized previews looked fine, but when I tried to view the images full size and the computer had to render a full screen–sized preview, these strange patterns started appearing. The bad files occupied the normal file size, but they had no metadata. Fortunately I still had the memory cards so I just went through and downloaded the bad ones again. The second time around, they all came out fine.

I have encountered similar problems on multiple occasions and I've heard every experienced photographer I know talk about the occasional mysterious download problems he or she has encountered. Considering all this, the only prudent course of action is to always have enough memory cards to shoot an entire job without having to format the cards and reuse them in the field. Even if you are able to use some sort of data storage device or a portable DVD burner, or even a laptop, you never really know if the download worked until you get home; and if it didn't work, you'd better hope you still have the memory cards so you can go back and try the download again.

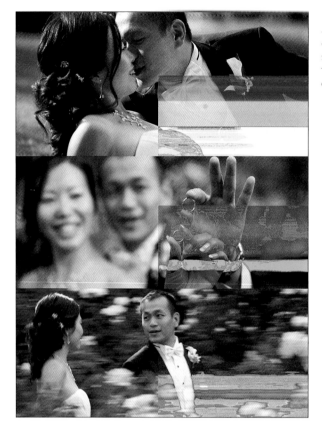

Figure 14-3: Many images taken at this wedding didn't download correctly the first time, but the second time I downloaded them from the memory card, they came out fine.

Fixing corrupted memory cards

Although there are occasional problems with the process of downloading from memory card to computer, it is rare for images to be corrupted while they are still in the camera. The corruption of the memory card itself usually occurs when you place it in a card reader and try to access the images on a computer. It can also happen when you put a memory card in one camera and then switch it to another brand of camera. If you format the card before switching, there won't be any problem, but each camera has its own file addressing system, and occasionally one will override the other.

If you do encounter a corrupted memory card, the following software companies sell programs that may be able to bail you out:

DataRescue (www.datarescue.com)

Image Recall (www.imagerecall.com)

Prosoft Engineering (www.prosofteng.com)

Remo (www.photorecovery.com)

Memory card problems usually occur because there was a problem with what I call the "file address." In simplified terms, each memory card has a table that contains the directions to where each file is located — somewhat like your street address. If there is a problem with the table, then some or all of the addresses for the files may not be visible. That doesn't mean that the files aren't there; it just means they can't be found. Data recovery programs by companies such as DataRescue can analyze the memory card and look for the missing table information. If that can't be found, the program searches for data groups that it somehow recognizes as being a single image. The software usually finds every image that was on the card. You can even use this software after you've formatted a card in the camera because formatting simply deletes the address table. All the images remain on the memory card, but without the table, your camera thinks the card is empty and it starts writing new images over the old ones. When you run PhotoRescue or one of the other programs listed previously, it will retrieve the most recent images you just shot, plus any remaining images from previous uses that haven't been written over yet.

Creating backups

As soon as you get all of your images loaded on the computer and you've counted them and scanned through them to make sure all the thumbnails are there, STOP. Before you do anything else, make a backup by copying all of the images to a different hard drive — preferably the one you keep stored in the fire safe. This backup is left untouched in case you somehow manage to delete or damage the original images during the image-processing part of your workflow. When you've completely finished editing the images, you'll make a final backup set that contains only the keepers; after that is done, you can go back and delete this original backup set.

Why Not Format in the Computer?

Computers have more formatting options than your camera does. This can cause problems if you try to format a memory card in a computer. For example, many cameras can only read memory cards formatted with a setup called FAT 32. If you format your memory card in the computer, you have the option of using FAT 32, FAT 16, or even NTFS (New Technology File System) formats. The wrong format usually makes the memory card completely unrecognizable in your camera. Your camera may not even notice that it's there, or it may give you a strange message such as "file is locked." You probably won't even be able to reformat the card in the camera until you first reformat it in the computer — this time using the right format type for your camera. I haven't encountered any problems with erasing files on a memory card, but I have created other near disasters by messing with my memory cards in the computer. Through those experiences, I've come to believe very strongly that using a computer to do anything to a memory card except read and copy the images is flirting with disaster.

Part 2: Processing the Images

The first four steps of a wedding photographer's workflow pertain to shooting the images. Now it's time to take a look at Steps 5 through 11, which cover completing the image-editing process and delivering the finished images to the client. Bear in mind that each of these steps is a major event, having its own workflow with several small steps that are used to accomplish that one major part of the process.

Import and convert to .dng format

The first step in a Lightroom workflow is to import the images. Once this is done, I strongly recommend that you convert all your RAW files to the .dng format. To do this, first press Ctrl+A to select all the image files, then choose the Library module on the top right, then click the Library tab on the top left. Doing all that will open the menu shown in Figure 14-4, which gives you the option to convert the images to the .dng format and delete the old files if the conversion is successful.

This format has several advantages. One is that it is an "open" format that any manufacturer or software maker can easily read. However, the most important advantage for a wedding photographer is that each file can contain all the instructions for your changes, and the history for all the changes you've made. What this means for you, is that if you move one of these files, or give the set to your bride and she tries to open them up at a later date, all the edits you've made to the file are right there ready to go. There is no need to access a Lightroom library file or deal with .xmp files or anything. Each image is a self-contained unit with all your edits conveniently packaged inside.

Figure 14-4: Convert your images to the .dng format so you don't have to deal with libraries or .xmp files. With .dng, all your Lightroom work is saved into the file itself.

Organizing the good and deleting the bad

After the images are downloaded to your computer and backed up to another drive, you can safely start the process of deleting the bad ones and sorting the keepers into different categories. You might mark some images to go into a slide show and others to go into your portfolio.

The software you choose determines the exact details, but the general process remains virtually the same no matter which software tools you use.

You will need to obtain at least one of the media management programs listed in Table 14-1 (or something similar) to complete this part of the process. These programs seem to have captured the most attention among professional photographers and each one will enable you to do far more than the simple task of deleting the bad images.

Table 14-1 Media Management Software

Software	URL	Platform	Cost*
ACDSee Pro	www.acdsystems.com	PC	$130
Adobe Bridge	www.adobe.com	Mac and PC	N/A (You can't buy this product because it comes bundled with some Adobe products)
Adobe Photoshop Lightroom	www.adobe.com	Mac and PC	$300
Aperture	www.apple.com	Mac	$300
Breeze Browser	www.breezesys.com	PC	$70
Photo Mechanic	www.camerabits.com	Mac and PC	$150

* Prices are approximate as of the time this book was written.

These are all very powerful programs that work with every image type you can imagine, and all have systems for tagging images as you edit them. My favorite is Lightroom, but all of these programs work incredibly well, and you won't be disappointed with the performance you get from any of them. If I had limited funds and could only afford one media management tool, it would be Lightroom. Lightroom allows you to manage and organize your images as well as manipulate images with an amazing amount of speed and creative control.

The selection process

As you begin the process of deleting the bad shots, you have several options for how to proceed with the task. The obvious part is that you select the bad images and press Delete. However, as you go through your image set, you should consider other uses for the images and prepare them for these tasks as well. For example, if you decide you want to make a DVD slide show, you'll need to pull out the best 100–300 images from the entire set. You can do this by marking, or "tagging," the good images at the same time as you look through and delete the bad ones. Having the best images tagged also comes in handy if you want to make web slide shows or load images to an online storefront for print sales. Each time you need to use the "best images" group, you can simply sort the entire set by the tag, and all of your tagged images are instantly grouped together.

The process of tagging images is as simple as selecting an image and then clicking a number from 1 through 5. This places a "tag," or "rating," on that image. You can tag an image with numbers or colors, or both. Afterwards, you can sort according to numerical rank or by color

and your images will instantly be grouped together. My preference is to give a number ranking to the images I think are really good. This allows me to pull out this group of "best" images whenever I want.

Deciding what to show the client

The basic goal of organizing your images is to edit out the bad images and mark the best ones, but depending on the final products you produce, you may need to edit more carefully, or hardly at all. For example, if you sell prints and albums without giving away the digital files, you don't need to waste time editing out any bad images, because the client will never see them anyway. If you provide images to clients on a DVD or disk drive, you'll need to edit very carefully to make sure all the bad images are gone.

If your business model involves giving your clients the original images, you should spend a lot more time editing. As you edit, bear in mind the old adage, "What they don't know won't hurt them." In other words, if you delete images, your clients won't be upset because they won't know they ever existed in the first place. If you choose to include an image, you better feel confident that it has some redeeming quality that is worthy of keeping it in the set.

Your clients usually do not have experience viewing and editing images. Given this, they look at your images and make judgments about your professionalism and your artistic ability. For example, say you took 1,000 images at a wedding. Of those, you have 500 decent images, 150 really impressive ones, 10 superb ones, and 2 that are absolutely breathtaking. If you give your clients all 1,000, including the good, the bad, and the ugly, they'll probably think you're the worst photographer in the world. If you only give them 150, they'll certainly be wowed at first, but after they have a while to think about it, they'll probably start to wonder what you were doing all day. If you give them 500–800 images with a folder of 150 labeled "favorites," you're much more likely to make them happy.

I once had a MOB (mother of the bride) come to me several months after the wedding complaining about how much I charged her daughter. She said in a very New York accent, "Ya took 200 picshas of the bride but ya didn't get a single shot o' my sista Karen that came all the way from Florida! Look at this, — " she continued — "ya got ten shots o' the bride puttin' on 'er shoes!" Then she pulled four 5×7s out of a folder and threw them down on the table. "And look at these!" she exclaimed. "You call yourself a photographa!? I want my money back!"

I have to admit, she picked out four of the most awful shots I had ever seen and I have no idea how they slipped through my editing process — but there they were! I didn't give her money back because I know that my assistant and I actually did do a great job despite those four images. However, I learned a few important lessons from this encounter. One is that she was so upset by the four bad ones that she couldn't see anything else. The second is that she could look at ten shots of the bride putting on her shoes, and it was so overwhelming for her that she couldn't see the really good one. I should have picked out the best two images and deleted the rest. Also, when an inexperienced person looks at a series of ten dance shots that are almost exactly alike, they don't know that it only took you three seconds to shoot all those images — they think you were standing there for a long time just shooting the same thing over and over. So shoot your big sequences of images when you need to, but don't forget to delete all but one or two of them.

In the final products I give to clients I always include many generic images that show off the grounds and provide a general overview of what was going on at the wedding. However, I would never purposefully give a client a blurry or poorly exposed image unless it has some other serious redeeming qualities. Sometimes a little blur can impart an artistic feel, or it can convey the motion that was occurring in the scene. Of course, you should keep these in, even at the risk of having a client who doesn't share your artistic vision and just sees a blurry mistake. Some of my favorite shots came about through serendipitous mistakes that created a beautiful image. In general, though, I recommend deleting any images of questionable technical quality. I created the image shown in Figure 14-5 when I accidentally left the camera on Aperture Priority mode and took a shot in a very dark area. The shutter stayed open for two or three seconds before I realized what was happening and clamped my hand over the front of the lens. The images shown in Figure 14-6 were shot blurry on purpose, and in fact, I shot about 15 images in each instance, trying to get just one keeper. Will the bride see art, or a blurry mistake?

Figure 14-5: Mistakes happen. Sometimes they end up looking pretty cool … maybe even better than what you would have gotten had you taken the shot correctly.

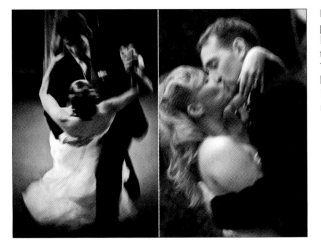

Figure 14-6: It's possible to purposefully create blurry images like these that show motion. Will the client like my artistic vision? The point is, I like them, and brides who like the same things I like are the ones who hire me. It's not about pleasing everybody.

Finally, if you intend to provide images on disk, you can make your clients' lives a bit easier by categorizing the images into the basic parts of the wedding day:

✦ Getting dressed

✦ Ceremony

✦ Couple portraits

✦ Family group portraits

✦ Reception

When your clients want to view images or order prints, it's much easier for them to find the particular image they want if they don't have to sort through the entire set to find it.

Color correcting the "keepers"

The actual process required to color correct your images depends on the software you choose to use for the job. I cover this step extensively in Chapter 15, so for the moment, I'll just say that this is where the color correction job falls in the overall workflow.

I prefer to delete the bad images before doing any color correction, as opposed to trying to do it all in one pass. This saves the time of deleting images I've already worked on. You might think it would save time and energy to do everything on one pass, but in reality you may find yourself spending a lot of time working on one image, only to find another version of that same shot that got sorted so it appears later in the stack. Now you've wasted all that time on the first image and you may even end up deleting it because you like the second one more. For this reason, I believe it actually saves time to do the deleting and the color correction in separate steps.

Although I call this stage, "color correction," I do all sorts of things to the images as I go through them on this pass. I think it goes without saying that white balance is the major consideration at this point, but I also include things like cropping, spotting out blemishes, adjusting saturation, converting color to black and white or some other tone, adding a vignette, split toning, sharpening, reducing noise, and so on. These are all things that can be done in Lightroom, but if I see a good image that needs a little change in Photoshop, I'd go ahead and do that now, too.

The big challenge at this point is to limit the amount of time you spend on each image. You'll have to learn how to blaze through the average images and stop to give the really good ones a couple minutes of your time. In general, I wouldn't recommend making a huge number of "art" images at this point unless you've charged your client for them. I might throw in a few just to give the client the feeling you've gone farther than required, but I'd save these extensive art projects for your portfolio and resist the temptation to give this extra time away for free. Your computer time is money! If you feel inspired to create a work of art "on spec" (without the client requesting it), you might consider providing only a watermarked sample file of the image you've created so the client can have the option of paying you for your time it if she wants it. (A *watermark* is a word or symbol that is set over the top of the image, thus rendering it unusable but still viewable by the client.)

If you spend too much time manipulating your images, you end up earning less money for the job. You have to come to a place where your editing is good enough to make your images really shine, without taking so much time that you can't keep up with the weekly flow of work. The software you work with to create images like that shown in Figure 14-7 will make a huge difference in your speed, and the tools it provides greatly influence the quality of your image as well.

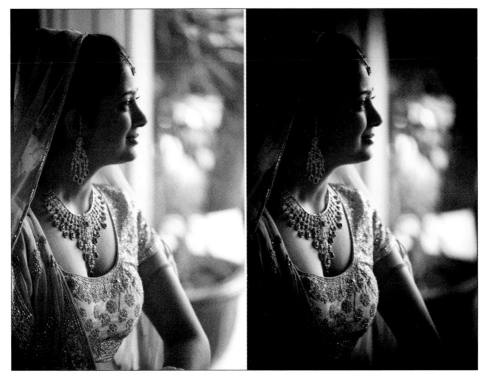

Figure 14-7: Lightroom is great at transforming an image from "blah" to "wow" in a matter of seconds. This conversion took one click to a preset that I named after this bride.

Renaming the files

Whether you keep the original images or provide them to your clients on disk, I recommend that you always rename the images to something more meaningful than the names provided by the camera. Many photographers integrate complex naming formats that contain part of the client's name, or the wedding date, as well as the sequential number. For example, image 0001-220511gj.jpg starts with a sequential number (for sorting purposes) then you have the date the image was taken, 22/05/11 (day/month/year), and the initials of the photographer. If you plan on supplying images to your clients on disk, you should probably keep things simple

by using only a sequential number such as 0035. If you choose to renumber the finished image set, make sure you do this before you make a copy for the client. That way you'll both have the same numbers when prints are ordered.

Lightroom and all the other programs listed above have batch-renaming features with powerful systems that enable you to configure your output filenames any way you can imagine. You can also add information to the metadata in the files at the same time you rename them. This allows you to embed notes, copyright information, shoot details, contract details, or any other text you like, and all that information becomes embedded into the image itself. Make sure that you rename your files *after* editing out the bad images. This erases the fact that there ever were any bad images to start with. If you kept the original file numbers, your clients could see the missing numbers in the sequence, and they would almost certainly ask you what happened to the rest of the files. It's always best to keep it really vague about how many images you deleted. Otherwise, you open up the possibility for the client to worry and question you over the ones that are missing.

Outputting RAW images to JPEGs

RAW files are unuseable for the average person. If you want your clients to have useable image files, you must use your RAW processing software to create a set of new images in the JPEG format. To do this, simply select all the images and click the Export tab. You will then be presented with a set of options that enable you to choose things like the file type, resolution, color space, sharpening, and the location where you want your new files to be placed. The process of creating new files is often called "rendering" because it takes all the color corrections and artistic touches you made when editing the RAW files and it uses those changes as instructions to render new image files in a format your client can use.

Some specifics about this process include making sure you have all the JPEG output settings set appropriately. The main options are to set the JPEG compression quality to 100%, the color space to sRGB, and the sharpening to a fairly low amount. You should always use some amount of sharpening. All digital files need to be sharpened before printing, and you should assume (unless you know otherwise) that your client doesn't know a lot technical stuff about printing images. Your clients will almost always print the files you give them without any further sharpening. If you sharpen your files a moderate amount, they can print anything up to about 11×14 without any additional technical help and the output should be completely acceptable. Larger prints should be made directly from RAW files by a qualified technician — preferably you.

Archiving the finished files

Now that you're finished making changes to the images, it's time to make a backup. This backup set contains all the RAW files that survived the deletion process. If you're using

Lightroom and you chose not to convert your images to the .dng format, then you'll need to export a separate Lightroom catalog for each wedding. The catalog will contain the RAW files, the image previews, and instructions for the adjustments you've made to all the RAW files.

If you do choose to provide your clients with images on disk, I recommend that you also provide them with the RAW files as well. Doing this ensures that they have full access to the files if you move away or go out of business. It also ensures that they can provide you with the RAW files if they come back ten or twenty years down the road, and you've deleted their files from your hard disks.

Once you've copied the .dng RAW files (or the Lightroom catalog) to the backup drive, you should end up with an identical set on your working drive and on the backup drive. I like to keep a copy of each wedding on one of the drives that resides inside my computer. That way I can access the images quickly if I want to use them for my website, producing a video slide show, or even in a book.

Producing the final products

The steps involved in this part of the process depend completely on the type of final products you provide to your client. Some photographers produce an album and offer prints for sale, while others provide the images on disk first and then offer albums and prints as an option. In Chapter 16 I discuss the various options for finished products you might supply to your clients.

Delivering the final products

This is another self-explanatory step in the workflow. The only words of wisdom I might offer here are: (1) always call to confirm the mailing address before you mail out a wedding package containing finished images. Every time I forget to do this, of course the wedding couple will have moved just that week and the package either disappears forever or gets returned; and (2) always use a shipping service that allows you to track your package. Of course, delivering the final product in person is always the preferred method if you live close enough for this to be possible.

I personally choose to deliver finished images on a small USB drive because these drives are relatively cheap and very easy to use. As you can see in Figure 14-8, I remove all the original packaging from the drive (except the warranty) and place it in a beautiful gold tin box from Independent Can Company (www.independentcan.com). I also include a small stack of business cards and a couple small mementos that I gather from the wedding.

In Chapter 16, I'll go into much more detail on the different types of finished products you can provide for your clients.

Figure 14-8: My clients receive a USB drive, a thank you note, a couple of business cards, and maybe a few mementos from the trip — all packed carefully into a beautiful gold tin box.

Summary

Developing your own wedding-day workflow is an ongoing process that you must continue to update and change to fit the technology of the time. At first, it may seem as if there are a million options and tiny details to consider. As long as you stick to the basic steps, it is hard to go wrong. Knowing how to back up, select, color correct, and archive your images is the very core of a workflow that prepares your images for sale and protects them from loss. Your creativity and your decisions about how you want to structure your business dictate the finer details of how it all happens.

The workflow information you gained in this chapter can help you streamline your business so that it functions as efficiently as possible, while the data protection information can help you to relax and sleep well at night, knowing that you're doing everything possible to prevent image losses.

15 Manipulating Your Images

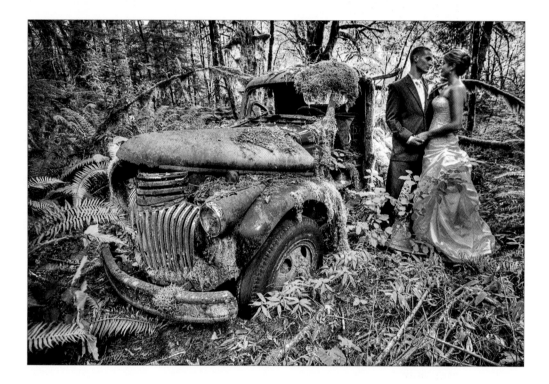

Digital wedding photography has evolved into two basic methods of working with images: *destructive imaging* and *non-destructive imaging*. Destructive imaging techniques don't destroy the image, as in make it ugly, but they do change the original pixel data. The changes become permanent when you save the file, and thus, you have technically "destroyed" the original image. Of course, you could always save the changes you make to a new image file, but storing double the amount of data is not a pleasant thought — especially considering how much digital information you already produce with each wedding.

Non-destructive imaging techniques don't change the pixels in your image at all. Instead, non-destructive imaging processes use the original file as a reference and keep a text record that describes every change you've made to the image. The software program you use for non-destructive imaging uses a Library or Catalog to store the text description of the changes.

The software also generates a preview image so you can see the changes on your computer screen, and this preview is also stored in the Library.

Today the majority of wedding photographers use non-destructive imaging in their daily workflow. Programs like Adobe Photoshop Lightroom and Apple's Aperture are used perhaps 98 percent of the time to work through the thousands of images that will be produced at each wedding. Destructive programs like Adobe Photoshop come into play only when it is necessary to change to the pixels in the image, which happens most frequently when making album pages, advertising materials, and portfolio prints. Pretty much everything else a wedding photographer needs to do can be done in the non-destructive workflow described in the previous chapter.

Figure 15-1 illustrates the basic differences between destructive and non-destructive imaging. Version 1 shows the original image. In version 2, I made non-destructive changes to the color, contrast, vignette, and cropping. At this stage the image could easily be a finished project. However, I wanted to take this one a little further so in version 3, I used Photoshop to darken the vignette, add a heavy selective blur to everything but the couple, and overlay a scene of a rock wall, which provided a light texture and the reddish color. These changes cannot be reversed once the file is saved because the original pixel data has been altered, thus these changes are considered destructive edits.

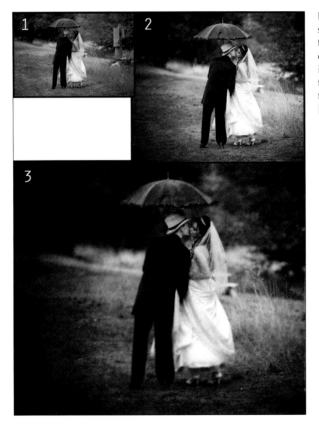

Figure 15-1: These three versions of the same image illustrate the basic differences between destructive and non-destructive imaging. In version 3 you can see that with Photoshop I was able to take this image to a whole new level by changing pixels.

In this chapter I take a closer look at both types of imaging. I discuss the absolute basics of both Lightroom and Photoshop to give you some ideas of how powerful and useful these two programs can be. Of course the information offered in this chapter is only the tip of the iceberg compared to all the things you'll eventually need to know about both Photoshop and the non-destructive imaging program you choose to use. The tips and techniques offered in this chapter aim to whet your appetite for all the wonderful possibilities, and are not intended to be a full education on this topic.

Non-Destructive Imaging

Non-destructive imaging software like Lightroom and Aperture was developed because most of the early digital camera makers kept their RAW files proprietary. They each produced a RAW file that could be opened and viewed by anyone, but only their software could be used to save the file again after changes were made. Independent software manufacturers like Adobe, Apple, and many others got around this limitation by creating a separate text file that records a detailed text and mathematical description of all the changes made to each image. This new file holds information for things like cropping, color correction, brightness, and color saturation, and these changes are only applied to the file when you save it to a different file format, such as JPEG or TIFF. This is basically equivalent to the "Save As" operation you use in many other programs.

What was originally considered an extreme pain in the neck by software manufacturers turned out to be the greatest blessing we photographers have ever had. Today non-destructive imaging programs have evolved to include the very capabilities we wedding photographers need and want the most:

✦ Adjust an image without actually changing the original pixels in the file

✦ Apply identical adjustments to many photos in one operation

✦ Interpret a single source image in multiple ways, without increasing the file size

✦ Step forward and backward in the history of changes

✦ Record a "recipe" of changes and apply it to other files with a single click

✦ Integrate seamlessly with other image-editing software and file-sharing programs such as Photoshop, Photomatix, Facebook, and ProShow Producer

✦ Group images on one sheet of paper for printing

✦ Export video and web slide shows

The list could go on and on.

Non-Destructive Imaging Programs

The following is a list of some of the software programs with non-destructive imaging capabilities:

ACDSee Pro Photo Manager by ACD Systems

Adobe Photoshop Lightroom

Apple Aperture

Canon Digital Photo Professional (DPP)

Capture One by Phase One

DxO Optics Pro by DxO Labs

Nikon Capture NX

Destructive Imaging

Most image manipulating programs like Photoshop fall into the destructive imaging category. These software programs are used to permanently change the image pixels and leave you with two options: (1) save the image file you altered over the original, thus destroying the original; or (2) save the file you altered to a new file with the "Save As" command. The second option enables you to save your changes without destroying the original, and you have the option of saving the altered file into any other file format you desire (JPEG, TIF, GIF, BMP, and so on). With this method you will not delete or destroy your original. Instead, you create a completely new file, which also increases the amount of hard drive space occupied.

Despite the disadvantage of doubling the space occupied, these programs offer some serious advantages in the way they work, the most obvious being that they can alter images in ways that are simply not available in non-destructive imaging programs. With Photoshop, for example, you have all the tools you have in Lightroom plus many more. You have the ability to work with layers, layer styles, opacity, masks, and blending modes as well.

Photoshop is the industry standard program in the photo manipulation category, but there are other options. Many cheaper, less powerful programs exist. When you first start out, it may be worth playing with one or two of them as you build your business. However, if you're certain you're going to be in the professional photography business for the long haul, it's imperative that you obtain and learn how to use Photoshop. Nothing else on the market even comes close to the capabilities of Photoshop. You won't have to use Photoshop every day, and I sometimes go months without using it, but when it comes time to make an album page (see Figure 15-2) or a promotional advertisement (see Figure 15-3), Photoshop is the tool to use.

Figure 15-2: A complex album page like this one, which consists of more than 20 layers, is the perfect job for Photoshop.

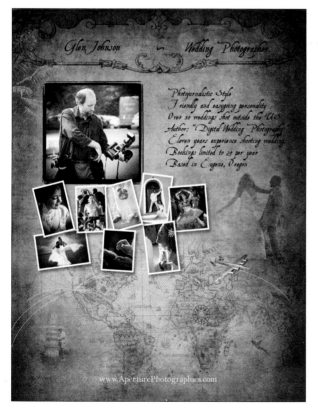

Figure 15-3: This is a full-page magazine ad I put together with Photoshop. The end result had 32 layers and it had to be converted to a specific CMYK color profile before I sent it to the magazine for publication.

Do It All in RAW

One of the absolute most important and basic concepts to remember about digital imaging is that when you need to use an image for any purpose whatsoever, you will achieve the absolute best results if you start with the image in RAW format and do all the necessary changes to the image while it is still in your RAW processing software. This is due to the fact that you have much more image data available in the RAW file than what you'll have in any other file format. Once the image is output to any other format, much of the power and flexibility of the RAW file is lost. Whether you need an image for your website, a magazine ad, a big wall portrait, or for an album page, it's always best to start out with the RAW file and do all your color correction, sharpening, noise reduction, cropping, and resizing to the RAW file, and then output the image to Photoshop with all those things already done.

Lightroom Tips and Techniques

The tips and techniques listed here are not meant to provide an exhaustive education on how to use Lightroom, but rather give you a basic idea of how important this software can be to your wedding business.

The user interface

Lightroom is organized into five different modules:

✦ The **Library** module is where you organize your images.

✦ The **Develop** module is where you find all the powerful image-editing and color-correction tools.

✦ The **Slideshow** module enables you to create slide shows and export them in various formats, which can then be embedded into your website or used alone.

✦ The **Print** module enables you to prepare your images for printing on your own printer and the specific paper you have loaded in it.

✦ The **Web** module helps prepare your files to produce image galleries for your website.

The list of modules is found on the top right side of the screen. Clicking on each one of the module tabs brings up a completely different set of tools and functions. This is the most basic division of Lightroom's capabilities.

Tool palette tips

On the extreme edge of each side of the screen you will see a tiny triangle. Clicking this triangle will hide or unhide the tool palettes nearest that side of the screen. This is a great way to gain some extra work space if you have a small monitor. Repeatedly pressing the F key will also change the outer edges of the screen to give you more space and fewer tools.

While editing through the files from a large wedding, you often need to switch back and forth between the thumbnail grid in the Library module and the Develop module. To do this quickly, remember that you only need to press the first letter to switch back and forth. For example, press the G key to return to the grid and D to switch back to the Develop module.

Adjusting color balance

Adjusting the color of your images will be the most frequent and important job you have to do in your digital studio. The ease and speed at which you can accomplish this job is what determines how many images you'll actually work on. For example, you may have a color-corrected monitor and an excellent eye for good color, but if it takes you five minutes to adjust each image because the software you're working with is difficult to use, you're just not going to work on very many images. On the flip-side, if you can color-correct one image in 30 seconds and then apply that same correction to another 20 images in only five seconds more, you have a workflow that will enable you to zip through a large wedding in a single day's work.

Every single image you take can benefit from some color adjustment, though you may choose to do nothing to many of the images simply because modern cameras can get the colors very close to perfect in some circumstances. How often that happens depends on the type of light you encounter at the wedding. As you edit, you will soon see that every single light bulb has its own unique color, and when you put several different bulbs in the same room, especially if they're different types, there's no possible way your camera can get a perfect white balance. This is true mostly because "perfect" becomes purely a matter of personal preference.

The Color Sampling tool

The Color Sampling tool, which looks like an eyedropper, is the main color-correction tool in Lightroom. To use the Color Sampling tool, first click the tool and then click on a portion of the image where you want to neutralize the color. Anything black, white, or some shade of gray will work perfectly. Clicking on such a spot with the eyedropper tool will instantly convert that area to a neutral shade of gray. The trick is to find just the right spot to sample. Bride's dresses are rarely ever true white — most are actually off-white, which makes them awful sources for white balance sampling. My favorite sampling points include the collar or cuff of the groom's shirt, white molding around doors and windows, and white dinner plates and coffee cups. A white shirt on a guy will work if you use only a seam or other place where the fabric is doubled up. Any place on the shirt where a single layer of fabric is near the skin will almost always show skin tone through the fabric and cause the image to go green (the opposite of red skin tones). The same is true of the bride's veil, which is almost always truly white but other colors show through unless you sample an area where the veil is bunched up in multiple layers, such as near the top of the head.

Personal preference

The real trick to using the Color Sampling tool is understanding that even a truly neutral-colored object is not guaranteed to provide perfect results unless it happens to be in the same type of light as the subject's face. For example, if you have an open window that throws light

into a room, you must choose whether to color-balance for the outdoor light or the indoor light. The two colors will be vastly different and it falls on you to choose which one makes your subject look the best.

The phrase "looking the best" is important here because color balance really comes down to your own personal taste. For example, I often like to grab the color slider and move it toward yellow just a bit, simply because I like warm tones much more than cooler neutral tones — even though I know the neutral tones match how the scene really looked. Sometimes I'll be working on an image that was shot in mixed lighting and I'll try clicking on the groom's collar only to watch the image turn green. Then I'll click on the other side of the collar and suddenly everything looks perfect because each side was being struck by a different color light. Sometimes neither side of the collar works very well and I'll move the Blue/Yellow color slider back and forth to fine-tune the image manually.

Using the Sync control

The Lightroom Color Sampling tool makes color correction quick and easy, but one of the greatest features about programs like Lightroom is that you can do something to one image and then apply that same recipe of changes to a large set of images. For example, if I shot 20 images in the dressing room, and then went outside to shoot more, and then returned to the dressing room and shot another 20 images, all I would need to do is correct one image in the set to get it exactly to my liking. Then I could select the rest of the images that were shot in that same light, and choose the Sync control to apply those settings to all the other similar images at the same time.

The Sync control is even more powerful when you learn to turn the parameters on and off as you need them. When you press the Sync button, a box pops up that contains all of the different things you can choose to sync or not sync. Selecting or deselecting the check boxes enables you to decide which adjustments are passed from the original image to the new image.

The Sync control is available in two modules. In the Library module, the Sync control affects only the metadata. In the Develop module, the Sync control works with the other image-editing features.

Making and using presets

When you work up a wild concoction of adjustments that produces the coolest effect you've ever seen, why not preserve a recipe of all those adjustments so you can reproduce that same effect on future images? Lightroom enables you to do just that with the Presets palette, which is available in the Develop module. Simply click the + at the top of the presets menu and a dialog box opens that gives you the option of selecting which settings (in the current document) you want to use for this preset. It is important to note that a new preset is created using the

settings for the image you are currently viewing. You can't just make a preset from the dialog box. You must first create the effect you like by adjusting an image, then use that image to create the preset. You can find a set of presets that I created on my website at www.aperture photographics.com/presets.

There are two basic types of presets and each type performs differently when you apply it. In this example, I'll make a preset to convert an image to black and white. I'll show the dialog boxes used to create each type of preset so you can more easily understand the difference in the way they work. The dialog box shown in Figure 15-4 would create what I call a "stackable" preset because it only changes specific settings while all the other settings remain unaffected. If you use a stackable preset after another preset, or after you've manually made changes to the image, the changes in the stackable preset are added to the previous changes. This enables you to use one preset after another, after another, and the changes just keep accumulating.

The second type of preset is what I call a "reset" preset because even if you've used other presets or made other changes to the image, this type of preset sets everything back to "standard" except the changes included in this preset. Figure 15-5 shows the dialog box used to make a reset preset that will convert your image to black and white and reset everything else back to the standard import settings. Notice that all the boxes are checked even though it really only requires that the Black and White box be checked. Using this type of preset erases all previous changes you've made (except cropping and spotting) and you are left with only the changes from this preset, thus the name "reset preset."

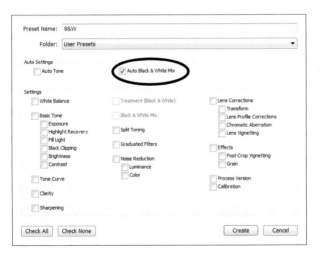

Figure 15-4: This is the dialog box used to create a stackable preset. Notice that only one box is checked and the remainder of the options are left unchecked.

Figure 15-5: This dialog box creates a reset preset. Notice that all the boxes are checked even though only one of the settings is actually needed to achieve the black-and-white effect.

Moving the histogram

On the top right side of the Develop module you'll see a histogram that represents the colors and tones in the image you are currently viewing (see Figure 15-6). You'll notice that a different part of the histogram lights up as you move your mouse over it. If you click directly on the highlighted section of the histogram, you can adjust that part of the image by holding down the mouse button and sliding it to the left or right. For example, if you click the shadows and slide your mouse left or right, the shadows will brighten or darken. If you watch the "Blacks" slider (down below the histogram), it also will move with you as you adjust the shadows. Corresponding segments of the histogram will also light up if you move your mouse over any one of the adjustment sliders. For example, move your mouse over the Exposure slider and the midtone area of the histogram lights up because this is what you will be adjusting if you use the Exposure slider. Click each of the Adjustment tools to see the corresponding part of the histogram that will be affected by that tool.

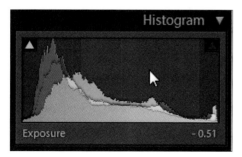

Figure 15-6: The histogram lights up when you move the mouse over it. Click the highlighted portion and you can adjust that area of the image by sliding your mouse to the left or right. This image shows the mouse hovering over the midtones.

Using the Adjustment sliders

The Adjustment sliders are located just below the histogram and they are used to manipulate the histogram. In general, you start with the Exposure slider to adjust the highlights until they are near the bottom right side of the histogram without climbing up the wall. This often causes your image to look darker than it should be. To fix this, use the Brightness slider to bring the midtones back up to the appropriate level, while watching to make sure the highlights don't get pushed too far to the right. If you do see the highlights climbing up the right wall, use the Recovery slider to bring them back down. Next, you can use the Fill Light, Contrast, and Blacks sliders as necessary. Once that is done, adjust the color balance and then the vibrance and saturation at the very end.

The order in which the sliders are used is actually quite important. Of course you can get things to work in practically any order, but you'll definitely achieve the best results in the shortest amount of time by adjusting all of the sliders in the order shown in Figure 15-7.

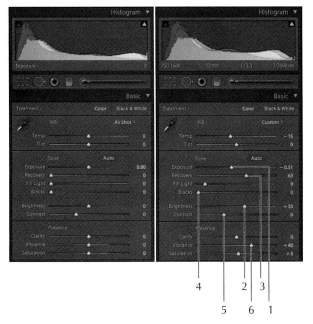

Figure 15-7: The Adjustment sliders each control different parts of your image. In this example, you can see in the histogram on the left side that I need to bring down the highlight values. Using the Adjustment sliders in proper sequence results in an image with good color and a full range of tones from textured highlights to textured shadows.

The following section describes the basic function of each Adjustment slider:

✦ **Blacks slider.** The Blacks slider increases the number of dark tones that become black as you move the slider farther to the right.

✦ **Brightness slider.** The Brightness slider moves the midtones the most, the shadows a little, and preserves detail in the highlights without blowing them out unless you use a really extreme setting.

✦ **Clarity slider.** The Clarity slider adds contrast to edges where light and dark areas meet. This gives a general sharpening effect but without the same amount of control you can achieve with the real sharpening tools found in the Detail palette. If you use this slider, be sure to view your work at 100% so you can see the full affect and avoid over-sharpening. Personally, I never touch this one.

✦ **Contrast slider.** The Contrast slider increases or decreases image contrast by brightening light tones and darkening dark tones.

✦ **Exposure slider.** The Exposure slider adjusts the entire tonal range fairly evenly, but it has a greater effect on the highlights. This slider will blow out the highlights by allowing them to go right off the chart if you try to use it to control the midtones. Instead, use this slider to control only the highlight position.

✦ **Fill Light slider.** The Fill Light slider will brighten the shadows without destroying the deepest blacks. Try this slider on images shot in bright sunlight and you'll be amazed.

✦ **Recovery slider.** The Recovery slider controls the brightest tones. Moving the slider to the right lowers the highlight values and reveals detail in the highlight areas.

✦ **Saturation slider.** The Saturation slider increases saturation in *all* of the pixels in the image. If there are some colors that are already bright, and others that are muted, the bright colors will tend to go into the realm of ridiculous before the muted colors start to look bright.

✦ **Temp slider.** The Temp slider fine-tunes the white balance using the Kelvin color temperature scale. Move the slider to the left to make the photo appear cooler (more blue) and to the right to warm the colors (more yellow).

✦ **Tint slider.** The Tint slider adjusts the color for a green or magenta tint. Moving the slider to the left adds green, while moving it to the right adds magenta.

✦ **Vibrance slider.** The Vibrance slider increases saturation unevenly, adjusting more on colors that are the least saturated, and less on colors that are already saturated. Vibrance also has less effect on skin tones, which makes it a great tool for portraits where skin tone must be maintained for the image to look realistic. I normally use 30-50 points of vibrance on almost every image.

Using the Adjustment tools

Just below the Histogram is a small bar with the five tool icons that you can see in Figure 15-8. The following section provides a brief overview of the function of each of these five tools starting with the crop tool on the left side of the box.

Figure 15-8: Starting on the left side, the Adjustment Toolbox contains the Crop tool, the Spot Removal tool, the Red-Eye Correction tool, the Gradient tool, and the Adjustment Brush tool.

The Crop tool

The most basic concept to keep in mind when cropping images in Lightroom is that cropping a RAW format image doesn't permanently cut or delete anything at all. When you select the Crop tool, you are presented with a set of guides that overlay your image. You move the guides around to your liking and then either press Enter or click again on the Crop tool. In either case, the parts of the image you cropped out will disappear. If you click the Crop tool again later, you'll see that the whole image is still there. You can reposition the crop guides as often as you like without damaging the original image file.

Cropping can be performed in a "free form" manner where you manually adjust the crop borders without any regard to the final shape except to create a pleasing image. Alternately, you can click the icon that looks like a tiny padlock, and it changes from locked to unlocked. In the locked state, the crop proportions are locked. When the locked option is selected, no matter which side of the image you drag, the whole crop border (on all sides of the image) will scale in and out as required to maintain the same proportions as when you first set the lock. Canon and Nikon both use the same 2:3 proportions as a 35mm negative or slide. This means the prints will come out as 4×6, 6×9, or 10×15 — all of which have ratios of 2:3. So if you leave the lock selected, you'll get these proportions no matter how you move the crop borders. Unlock the lock icon and you're free to make the proportions anything you want. You can take your 2:3 original and crop it to a square, or a long skinny panoramic image, or to anything your heart desires.

The Spot Removal tool

The cloning tool in Lightroom, called the Spot Removal tool, is very different from the cloning tool in Photoshop. In Photoshop you can paint large areas with the cloning tool. In Lightroom, the cloning tool works only as a "spot removal" tool.

The magic of the Spot Removal tool is revealed when you manage to get a big piece of dust on your sensor and it appears in the same place on hundreds of images. The first time this happened to me I shot a group photo on the beach in the Bahamas and when I looked at the LCD, I said to myself, "Wow, look at that cool bird in the background," then I looked up in the sky and realized there was no bird up there! It was a giant dust bunny inside my camera! This was before Lightroom came along and I had to export every single RAW image to Photoshop, where I painstakingly cloned out the offending dust spot on each of about seventy images.

Today, all you have to do to fix an issue like this is set the clone point over the dust spot in the first image, highlight the rest of the images that have the same spot, press the Sync button (being very careful to deselect all options except the Spot Removal tool), and in the blink of an eye you've added that cloning spot to all the other images.

Another cool thing about the Spot Removal tool is that you can adjust the size and position of the point you're cloning to and the point you're cloning from. You can drag the two points around, and you can click the border of a point and drag the border to make it larger or smaller. The borders only appear when you've chosen the Spot Removal tool. When you click the tool to go back to Normal mode, the borders disappear, and if you click the tool again while in Normal mode, it turns all the cloning points back on so that you can see them and edit them if necessary.

The Spot Removal tool also includes options to either Clone or Heal. The Heal option is generally the most useful because it attempts to copy the texture from the sampled area and then apply brightness adjustments that blend the new texture to match the surrounding area you're working on. In Clone mode, the tool will copy the texture, color, and brightness exactly as they are.

The Red-Eye Correction tool

This tool might be fantastic for the beginning photographer, but it is practically useless for professional photographers. Professional photography gear does not produce red-eye except on extremely rare occasions.

The Gradient tool

The Gradient tool is identical to the Adjustment Brush tool except that it enables you to create the mask as a gradient instead of something you brush on. To use the Gradient tool, simply click it to select it, then click and drag on the image to set the gradient.

Imagine being able to darken and saturate the sky in a way that graduates the effect very naturally from the top down to the horizon. You can also use this tool to darken or blur the foreground.

The Adjustment Brush tool

If you're at all familiar with working on masks in Photoshop, you'll love the Adjustment Brush tool. To use it, paint a mask onto your image in a manner very similar to Photoshop; then use the controls to adjust the mask so that it affects the image in various ways. Changes to exposure, brightness, color balance, sharpness, clarity, saturation, and contrast are all available on that one mask.

One of my favorite things about the Adjustment Brush tool is that it enables you to configure three separate brushes and switch back and forth between them. You have the A brush, the B brush, and the Erase brush. The brushes are only used to create the mask. Once the mask is to your liking, you can use the various sliders to apply adjustments to the mask.

In case you're wondering how you might use this on a real image, imagine being able to paint a blur around the edges of an image, or darken a bright spot where the sun hit someone's face, or brighten one shadow without affecting anything else. And, if you create a really cool Adjustment Brush, you can save it as a brush preset and it will be easy to use again in the future.

Photoshop Tips and Techniques

When it comes to image-manipulation programs that actually change the pixels in the digital file, Photoshop is the industry standard. The incredibly complex and powerful tools available in Photoshop provide unlimited options for the creative mind to explore. While not everyone will want to master Photoshop, if you can't do it yourself, you'll need to hire someone who can

do it for you, so it makes sense to dive right in and pick up at least a basic knowledge. If you don't learn Photoshop, you may have to hire out your retouching, album design, and website design — all of which are major portions of the digital wedding photographer's job.

While Photoshop is the program of choice for digital imaging professionals, there are several less expensive programs that perform the basic image-editing functions you will require. None of these programs can rival Photoshop's tools and capabilities, but for those of you who might just be "testing the waters" so to speak, it might be worthwhile to get a budget program until you know if this job is really for you. Once you're certain, you can feel better about handing over the large amount of cash (and worth every penny) required to purchase Photoshop.

Here are a few budget-friendly image-editing software options:

ACDSee Pro

Corel Paint Shop Pro

Photoshop Elements

Serif Photo Plus

The few techniques described here are extremely basic, but at the same time, absolutely essential to the daily workload of a digital photographer. Once again, this is but a small sampling of what Photoshop can do and it is intended only to pique your interest in learning more. If you'd like to find a few books about Photoshop, I recommend looking on Amazon.com to see reader reviews on current books. I also have a selection of links to my favorite books on my website in the "For Photographers" section.

Working in layers

The magic of Photoshop is that it enables you to work on a project by dividing it into layers. Imagine your image as a stack of clear glass plates sitting on a table. When you first open it, there is only one glass plate, and this plate contains the original image data. As you work, every change you make to the image is done on a separate glass plate, which is stacked over the top of the original. Before you know it, you may have 20 or more layers in your stack. When you look at your computer screen, it's as if you are looking down on the stack of glass plates. As you look down through the top of the stack, it is important to understand that each layer can contain elements that cover up the layers below it. Some layers may contain something that affects only a small portion of the image while other layers may fill it completely. At the bottom of the stack is the "background," which is represented by a checkerboard pattern simply to alert you to the fact that your image is transparent or void of any digital information in any place where the checkerboard shows up.

When you first open Photoshop, the Layers palette appears on the right side of your computer screen and the Tools palette will be on the left. The Layers palette shows a listing of all the imaginary glass plates for the open image. The layers on top in the Layers palette represent the glass plates on top of your stack, and the layers that appear at the bottom in the Layers palette correspond to the glass plates on the bottom of your imaginary stack.

This is a difficult concept to grasp when you first start out, and it is further complicated by the fact that you can turn each layer "on" or "off" by clicking the Eye icon to the left of that layer. The most basic idea here is that the topmost layers can contain actual bits and pieces of the image, or they can contain seemingly invisible characteristics like color balance, saturation, contrast, and exposure — all of which affect any layer beneath them in the stack.

The beauty of working with layers is that it enables you to separate each aspect of the image. This gives you a tremendous advantage when working on a project that may continually evolve as it goes along, and you'll soon see that album pages or complex images may take days or even weeks to complete. For example, if you start with a single image on the original layer and you want to change something simple like the color balance, you have the option of making that adjustment directly in the original image layer, or you could choose to create a new, separate layer that only contains that color balance adjustment. If you work directly in your image layer, any change you make becomes a permanent part of that layer. If you always create a new layer for each change, then you can come back later and easily delete or edit that layer as the image evolves.

Understanding masks

Now that you're thinking about this big stack of glass plates, it's time to think about masks. This new concept might add to your confusion at first, but once you understand how masks work, you'll be amazed at how often you find uses for them.

A *mask*, which as the name implies, masks, or blocks out, something in your image, can be applied to any layer (or all layers) in your stack, and you can always come back and edit or delete the mask later. To apply a mask, simply select a layer and click the Mask icon, which is located near the trash can. At first an empty white box appears on your layer, just to the right of the icon that shows the layer contents. This white box is where you paint the mask using a Brush tool or the Pencil tool. You can only paint in shades of gray, and the darker the shade you paint, the more your image disappears. Paint with 100% black and everything under your brush stroke completely disappears. Painting over the black mask with white causes the mask to disappear and your image to magically re-appear. Using this process of painting black to mask things out (hide), and white to unmask (reveal), you can continue to refine a mask until you get the desired result.

Adjusting levels

Many images come out of the camera looking rather flat and dull. A simple recipe for giving an image some sparkle is to open it in Photoshop and adjust the levels. To adjust the levels in an image, open it in Photoshop and click the New Adjustment Layer icon located on the Layers palette and choose Levels from the pop-up menu. This type of adjustment layer enables you to adjust each color channel separately. Click the drop-down menu in the Levels dialog box and choose red, green, or blue. A dialog box appears with three small triangles below a histogram, as shown in Figure 15-9. Leave the middle and left sliders where they are, but move the right slider to the left until it is under the spot where the image data begins.

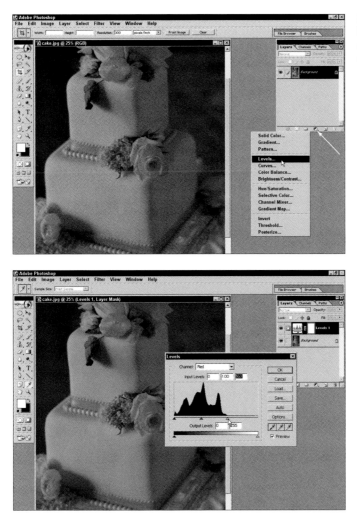

Figure 15-9: Adjusting each color channel creates a very odd look when you first start.

Follow the same technique for the other two channels. As you begin this process, the image takes on a strange color tone, but it should go back to normal as you adjust the last of the three color channels, as shown in Figure 15-10. Some additional adjustment of the sliders may be needed if there is still a color cast after you have done all three channels. Adjusting the levels is perhaps the most common and valuable basic skill to learn in Photoshop.

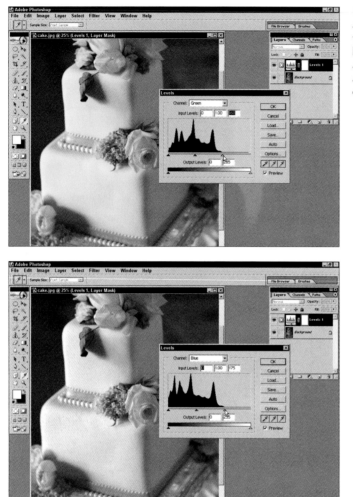

Figure 15-10: As you adjust the third slider, your image should come back to life. This simple adjustment often creates a dramatic improvement over the original image.

Changing brightness and blending with Layer modes

Another quick tip that I've found extremely valuable is to brighten an image very quickly by duplicating its layer and setting the uppermost of the two layers to Screen mode. This also works for fonts and other graphic elements as well. You can also achieve the opposite effect — darken an image layer by simply duplicating the layer and changing the upper layer to Multiply mode. To do this, open an image and click the image layer in the Layers palette. Drag the layer to the Duplicate Layer icon, which is located next to the trash can.

Now you have two identical layers, each containing a copy of the image. Click the upper image to select it. Now click the drop-down menu at the top of the Layers palette that contains a list of different blending modes and choose the screen option shown in Figure 15-11. This brightens all of the tonal values in the image at the same time without causing any color casts.

If the newly brightened image is a bit too bright overall, simply select the uppermost layer and move the Opacity slider (the box just to the right of the blending modes) to adjust the opacity down until you get the desired amount of brightness. The image shown in Figure 15-11 needed a little brightening in the foreground, but I didn't want the background to get brighter, too. By adding a mask to the layer, I was able to paint on the mask to hide and reveal the effect of that layer.

Painting on the layer mask allows you to hide and reveal different parts of the image.

Clicking here adds a layer mask.

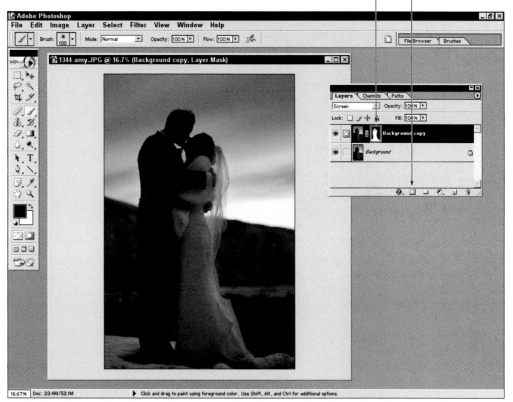

Figure 15-11: Setting the upper layer to Screen mode lightens an image without creating a color cast or changing the contrast. Adding a mask enables you to control which parts of the image get brightened.

Blending modes are also vital to every image montage where you wish to blend and match several images together. Often when I'm making a composite image for an album page, I'll place one image in a layer over another image. Then I'll click in the blending modes check box and use the arrow keys to scroll through the different modes. As I scroll through the list, the images blend together in different ways. Frequently there is one mode where the two images transform into something truly magical.

Sharpening images

Unfortunately, no amount of sharpening will fix a blurry image. However, all digital images, whether they come from a camera or scanner, will appear a little soft-looking in the original form. Once you apply the proper amount of sharpening, the softness disappears and the image appears bright and crisp. While it is possible to set your camera to do some sharpening, the preferred method is to turn off camera sharpening and do the job yourself after the image is manipulated and resized to the proper dimensions for printing or other final use. Using proper sharpening techniques is essential to your work as a digital photographer, but knowing when to sharpen and when not to sharpen is even more important. The sharpening process is different for each image type, but the general idea is that you never sharpen an original image. Only sharpen as the final step after the image has been resized to the dimensions you want. Then save the sharpened file with a new name so it won't overwrite the original.

RAW file sharpening

Hopefully by now I've managed to convince you to work on your images in the RAW file format. If you use Lightroom, you will make all your sharpening adjustments (while viewing the image at 100%), and then in the Export dialog box you can set the dimensions of the final image. All your sharpening and resizing to the actual print size will take place as the image is rendered into a JPEG or TIFF format.

If you open a RAW file in Photoshop, you are presented with the Photoshop RAW Processor. In this window, you have some (the bare minimum) of the same options found in Lightroom and you must first make all your adjustments to the image before you import the image into Photoshop. As always, working in the RAW form is the absolute best time to make as many changes to the file as possible before you import the image file into Photoshop. Remember, the RAW file has far more data than any other file format, so this is the best place to crop, resize, sharpen, color correct, and so on. The more you can do to the image while still in the RAW form, the better.

Non-RAW file sharpening

If you start from a file that is not in the RAW format, or if you've been working on an image project in Photoshop and you need to sharpen the end result, here are a few things to remember:

✦ Sharpen only after the image has been sized and cropped to the final dimensions.

✦ If a sharpened image is needed for use at a different size, start over from the original unsharpened version. Never sharpen an image that has already been sharpened once before — especially if the first time was at a different size.

✦ Never sharpen an original image. Always save it first without sharpening; and then after sharpening, save the sharp version with a new name so that it does not replace the original.

✦ When working on album pages, make sure to sharpen each layer separately and avoid sharpening graphic borders, text, and other graphic elements. Never flatten a complex image before sharpening — always sharpen each photographic layer first.

There is no single formula for sharpening an image because the amount of sharpening needed is dependent on the size of the image. A large image destined for a 16×20 print needs sharpening adjustments that would completely destroy a small image that has been sized for your website.

The most basic sharpening technique is to open an image and choose Filter ⇨ Sharpen ⇨ Unsharp Mask. This opens the Sharpen dialog box, where you can adjust three different controls. Figure 15-12 shows the approximate settings that result in a well-sharpened image. Notice that the sharpening dialog box is viewed at 100%. This is very important. You won't get a good idea of what your sharpening is going to look like unless you view your work at 100%.

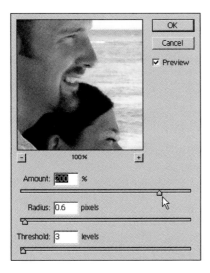

Figure 15-12: This image shows the sliders that control the sharpening process.

In the two examples shown in Figure 15-13 I magnified the view to 200% so the effects of correct sharpening and excessive sharpening can be compared. The image on the right has been oversharpened. The effects of oversharpening are easily seen in places where sharp black lines meet light toned areas (see arrows). Sharpening works by finding the lines between light and dark areas and emphasizing them. A small amount of this effect creates the impression of sharpness, while an overdose creates a white halo where light and dark objects meet.

The settings shown on the left in Figure 15-13 are a good starting point for the average digital camera image. However, you should fine-tune sharpening visually by adjusting the sliders while watching (at 100% magnification) for the white halo, which is the telltale sign of over-sharpening.

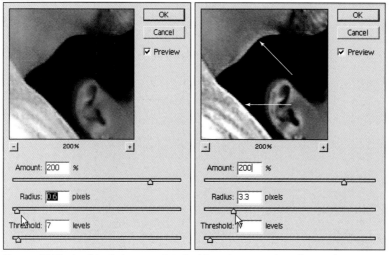

Figure 15-13: A white halo around dark objects is a sure sign of over-sharpening. View your image at 100% while sharpening and watch out for the white halo as you adjust the sliders.

Working with High Dynamic Range Images

Creating High Dynamic Range (HDR) images at a wedding is easy and fun to do, and the results are off-the-chart amazing. The first time I tried it, I did not have grand expectations, but when I got back home and played with the software in my computer, I was speechless. After shooting weddings for 11 years, I don't see too many things on my computer that surprise me like this did. I make a lot of cool images and I see a lot of cool images that other photographers create, but I rarely see anything that looks terribly different from what any other good photographer might have done in that same location and with that same bride. But I can say without a doubt, that HDR is different, and cool, and the results you can get from a seemingly mundane location will suddenly blow your socks off. The image shown in Figure 15-14 is the result from my very first HDR attempt.

Capture techniques

Creating an HDR image is really fairly simple, but it does require that you use a tripod or another method to hold the camera perfectly steady for three (or more) shots. One exposure is created two stops underexposed, the next exposure is created normal, and the last is two stops overexposed. These three shots (or more) are then imported into the software (I'll explain the choices later) and stacked on top of each other. The software uses the perfectly exposed highlights from the underexposed image, the midtones from the normal exposure, and the perfectly exposed detail in the shadows from the overexposed shot. The software basically keeps the best of each exposure and blends those parts together. The term *High Dynamic Range* only applies while the image is in the process of having the three shots mixed together. Once you output the finished image back to a TIFF format, it no longer has a High Dynamic Range, but the name sticks because HDR has become synonymous with the unique look of the images that result.

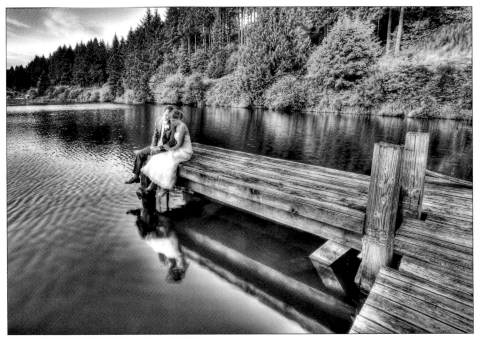

Figure 15-14: Getting a result like this on the very first try is certainly a good sign.

When I first attempted to create an HDR image, I set the camera on Manual and changed the exposure manually while my subjects waited — trying to be perfectly still — until I finished all three shots. The only way I could get it to work was to have them lean in on each other so they actually braced each other and created a very steady sort of pose. That worked but took far too long and it was practically impossible for one person standing alone to maintain the exact same position for that length of time. The image shown in Figure 15-15 is a sample of the "heads together" pose that is sure to keep your couple steady.

After shooting this way for the first couple weddings, I remembered the auto-bracket feature on my camera that I'd never actually used before. This feature enables you to shoot three shots in rapid succession while the camera automatically resets the exposure for each one. I set it for a two stop difference in each exposure. The first shot will be two stops underexposed, the second will be normal, and the last will be two stops overexposed. If you set your motor drive on high speed, all three shots will happen in rapid succession just as fast as the camera can manage it — which is much faster than you can do in Manual mode.

The most important trick to capturing HDR images successfully is to use a tripod to cut down on the amount of movement between the three shots. Including people in your image is somewhat frustrating because they tend to want to move around a lot. The bride and groom will be more than happy to sit still for you if you ask, but if any other people wander into your background, they will create ghost images that the HDR software may, or may not, be able to fix. Using a remote shutter release is also helpful in maintaining steadiness because you can keep your hands off the camera during the exposures.

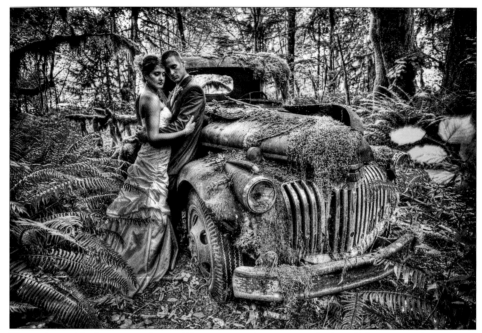

Figure 15-15: Finding a pose that enables your couple to stay perfectly still through all three exposures is critical to creating an HDR image.

HDR software choices

The three most common software choices for creating HDR images include the following:

 Adobe Photoshop

 FDR Tools

 Photomatix Pro

I've used Photomatix Pro and I really like that I can adjust my RAW files in Lightroom and then export them directly into Photomatix where I adjust the HDR image and then it automatically exports a finished TIFF file back to Lightroom. This creates a really smooth workflow. After I'm finished creating the HDR image, I use the stack feature in Lightroom to hide all the extra files behind the final result so I don't have to look at them all. Once the HDR image is back in Lightroom, you can proceed to treat it like any other image — add color tones, play with the saturation, convert to black and white, and so on. I like to think of the original HDR image as the raw material from which I can create several different finished versions in Lightroom. Figure 15-16 illustrates the progress from original file (only one of the three shots is shown) to the HDR version from Photomatix Pro, to my favorite final version with all the Lightroom adjustments.

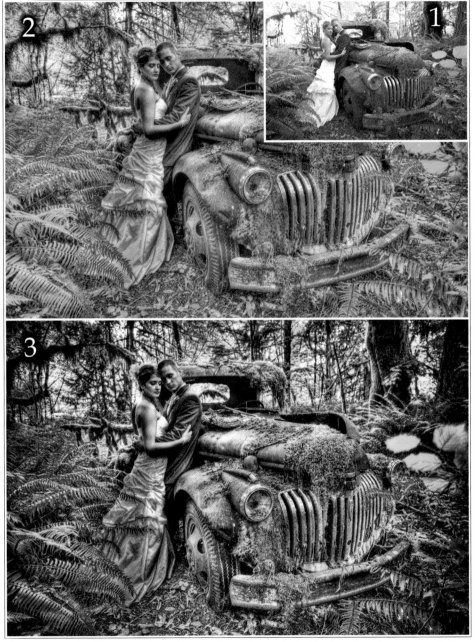

Figure 15-16: The file you get from Photomatix Pro is not the finished product. To me, that file is just another step toward the final HDR image.

Summary

Learning to use Lightroom and Photoshop may take a good deal of time, but the rewards are certainly worth it. If you plan on making a business out of any sort of photography, you will find it absolutely essential to obtain a reasonable level of skill with these two programs. With the few techniques covered in this chapter, you have the ability to accomplish some of the most basic tasks and understand some of the most basic concepts, such as presets, layers, and masks, necessary for processing digital images.

Working with HDR images can add a whole new dimension to your work. If you're trying to find ways to stand out from the crowd, mix a couple HDR images into your portfolio and you're sure to get some attention.

Creating the
Finished Product

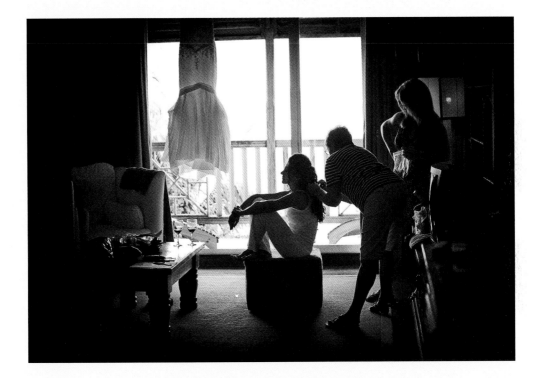

The digital age has created a multitude of products that you can offer to your wedding clients. The choices are so numerous that the job of researching the best offerings is a difficult and time-consuming task. In this chapter I look at the various ways you can deliver products to your clients, including online print sales, albums, image files on disc, slide shows, and more. The types of finished products you offer your clients determine how they experience the images. Do they look at albums, computer slide shows, DVDs, YouTube videos, or framed prints? Depending on how your business works, you may choose to offer all or none of these items. Some photographers only do the photography service, while others rely on the after-market products to generate a significant portion of the total sale. Many combine a selection of offerings into a package. Different packages with different combinations of items ensure that you have offerings that appeal to almost everyone, both in terms of budget and taste.

If you're starting out in the wedding photography business or considering the possibility of doing so, in this chapter I provide a quick overview of the various products you may want to offer to your clients. Along with each product is a discussion of how that product has traditionally been marketed and sold, as well as a look at where that type of product may be headed in the future.

Proofs

Generally photographers offer two types of prints: finished prints and proof prints. The term *finished prints* is self-explanatory. These are the highest quality prints that you sell to your clients with the expectation that they will be framed or placed in albums. The other type of print is a *proof print*. Proof prints, or simply *proofs* as they are often called, were originally printed on a type of paper that caused the image to fade away after a few weeks. This enabled the photographer to provide a small copy of the image to a client so that the client could see what was there, but the client had to purchase a finished print if he or she wanted something to keep. The point was simply to provide some "proof" of what the image would look like as a finished print.

Another method for achieving this same result is to place a "watermark" on the proof print. A watermark is a see-through overlay that might include your name or perhaps just show a big copyright symbol that is digitally placed over the print (see Figure 16-1). A watermark allows your client to see what the image looks like, but discourages anyone from keeping that print and showing it off as a final product.

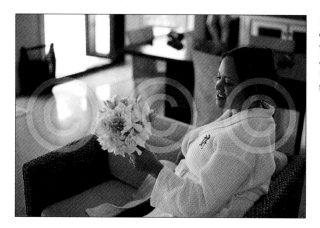

Figure 16-1: A see-through mark of some sort that you place over your image is called a *watermark* and using it enables you to show images to your clients in a form they won't want to keep.

Paper proofs

The tradition of providing proof prints for clients to review survived right up to the invention of the personal scanner. Now, almost everyone owns — or knows someone who owns — a personal scanner capable of copying even a small print at a high enough resolution that the print can be reproduced at a much larger size, thus denying the photographer a sale. In the case of a family portrait where the photographer's income is generated almost exclusively from the sale of finished prints, this can result in the loss of thousands of dollars for the photographer. Over the past few years, there has been a huge fuss over this issue in the photographic world. Many efforts have been made to educate clients about a photographer's rights,

but it seems you can't change human nature. Education about what a copyright legally means may help keep copying down to a minimum, but in reality, stopping people from copying paper proofs is a bit like trying to stop the rain.

If the possibility of your client copying your work bothers you, you have two options. One is to only allow clients to look at proof prints when they are there with you in the studio, and you keep the prints. The second option is to place a "watermark" in your proof prints as mentioned earlier.

Digital proofs

As digital technology develops, more and more alternatives to the paper proof are being developed. The most common are (1) providing digital proofs on CD, (2) an in-person digital presentation by the photographer, and (3) web-based proofing via an online storefront. All three options have specific instances when they would be the best choice. For example, if your clients can come in to your office for a personal presentation, that would be the first choice. If your clients are far away, mailing them a CD of digital proofs is a good choice. (Keeping digital proofs on a CD is also a good option for local clients who come in for a personal consultation, but want to take something home to show to other family members.) If there are many clients who may be interested in the same photographs, such as several family members and/or guests from the wedding, and they all live in distant places throughout the world, online viewing via the web is the logical choice.

Giving a presentation in your studio/office is the most effective method of showing images to a client. With this method, you can control the environment to make sure that the clients get the maximum emotional impact on the first viewing. Many photographers have a dedicated viewing setup that sometimes even resembles a small movie theater. Comfortable seats; a large, high-resolution screen; a little wine or champagne; and a selection of beautiful music played on a high-quality stereo system can all add a tremendous emotional impact to the slide show. When you display images on your own setup, you don't have to worry that your clients might be viewing your beautiful images on an uncalibrated 14-inch monitor that only displays 256 colors.

Digital projectors are popular for this sort of viewing, but make sure to get one with a resolution of at least 1024×768. Anything less than this and you won't be happy with the way it shows still images. Stills are much more demanding than video when it comes to digital display, so a low-end projector that may do fine with video may not do well with a slide show of still images. Flat-screen Plasma or LCD displays are more expensive, but they're capable of much better color and resolution that makes still images look absolutely stunning.

Slide shows on CD

If your clients happen to be a long distance away, you can either set up a slide show on the web to show off your images, or you can send them a CD with a copy of the digital slide show. The trick to this system is in making it so your client won't say, "Hey this is nice. I'll just be happy with this slide show and call it good." To do this you can place a watermark over the images.

Several companies produce excellent software for digital slide shows, but for the purpose of viewing images and ordering prints, a program called FlipAlbum by E-Book Systems (www.flipalbum.com) really stands out. The features I find most valuable about this program include:

✦ Images are embedded into an application (.exe file) and can't be extracted for printing.

✦ The view resembles a book with a cover, a table of contents, and pages that flip when you click them.

✦ Users can click backward and forward through pages at will to view and compare different images.

✦ Music (one song) can be added very easily.

✦ You can set an expiration date after which the show no longer works.

✦ You can place several different FlipAlbums on one disc. This is great for putting a portfolio on the same disc as a client's images.

✦ The same company also offers a shopping cart that operates on the CD and allows clients to order directly off the CD. The order is sent directly to you via fax or e-mail.

The only drawback to FlipAlbum is that it is a PC-only program that will not play on a Mac.

ProShow Producer by Photodex (www.photodex.com) and Adobe Photoshop Lightroom (www.adobe.com) are also capable of producing excellent slide shows in video format, and they have the benefit that they can be viewed on both PCs and Macs as well as on home DVD players. Some of the features I like about video slide shows include:

✦ Images are embedded into the video file and can't be extracted for printing.

✦ Music (multiple songs) can be added very easily.

✦ You can easily overlay a watermark and/or the file name on each image so the client won't find your slide show to be a satisfactory end product in itself.

✦ You can output in the correct resolution to fit anything from an iPod to an HD video screen.

✦ You can upload these videos to YouTube or you can post them on your website for the client to download.

✦ The video slide shows produced by both ProShow and Lightroom can be easily integrated into your Lightroom workflow.

The greatest risk with letting the client use his or her own computer to view your images is that you have no control over what sort of monitor on which the images are being viewed. A bad monitor and/or the lack of speakers to play the music will certainly not help your presentation, and depending on how bad the computer is, it may cut out a significant portion of your sales because the client will think your images look awful. You would be well advised to ask some questions about the computer and monitor that will be used before trusting your clients with something like this unless you absolutely have no choice. You might also include a disclaimer advising them that the finished prints will look far better than what they look like on the average computer monitor.

Prints

No matter how you structure your business, you will eventually want to make final paper prints of your photographs. There are two basic ways to do this: Print your own or purchase prints from a lab. Either way can produce excellent results, although as you may imagine, it takes a lot more work, research, and practice to learn how to print your own. If you decide to go with a lab, you simply provide the lab with a CD of your images, or you can even send your image files through the Internet. If you choose to make your own prints, you may soon discover that printing is a whole science in and of itself.

Purchasing prints from a lab

If you are a beginning photographer, often you are far better off using the expert printing service of a professional lab instead of trying to print your own prints. Not only does this save you the time and expense of learning how to make your own prints, but also a professional lab can consistently produce higher quality prints than what most beginners can hope to get from their own printers — at least within the first few months.

Finding a lab can be as simple as looking in the phone book to see what is in your area. Working with a local lab when you first start out can be extremely helpful. The technicians at a small lab are often much more willing to walk you through any difficulties than an employee working at a big national lab who may be more accustomed to dealing with seasoned professional photographers.

Also, many professional labs are happy to work with you even if you are out of the area. If you have an Internet connection, you have the ability to send your images to any lab in the world and receive finished prints back in the mail within a few days. Following is a list of companies that offer printing services via the web:

Bay Photo (www.bayphoto.com)

CPQ Professional Imaging (www.cpq.com)

Miller's Professional Imaging (www.millerslab.com)

Mpix (www.mpix.com)

White House Custom Colour (www.whcc.com)

Making your own prints

Photographers have a long history of making their own prints. In the past, this was often done in a darkroom, which was considered a standard part of every photography business. Many professionals and amateurs alike converted basements, bathrooms, and even closets into darkrooms where they spent countless hours bathed in a dim red light surrounded by an intoxicating swirl of odors from the various chemicals they used. Waiting in the dark, they watched patiently until, as if by magic, an image slowly materialized on the surface of a blank sheet of paper.

Today the prospect of making your own prints is thankfully much different. The digital revolution has made the process easier and much less hazardous to your health. In the current market, you can purchase a photographic-quality printer for less than $1,000 that will rival or exceed the quality and longevity of prints that were produced in the average darkroom. For those of you who have actually experienced trying to make a living by printing prints in the darkroom, the advantages of producing digital prints are practically uncountable. For the new photographer, there is a different type of darkroom to be concerned with: the digital darkroom.

Printers

The only tools you need to get started producing professional quality paper prints are a calibrated monitor (which you should already have), some high-quality paper to print on, and a printer. The most common companies that produce printers for photographers are Epson,

Hewlett-Packard, and Canon. All three of these companies have printers that produce beautiful color prints with inks that are extremely fade resistant. The concept of longevity is important to wedding clients because they are essentially hiring you to preserve their memories.

Printer color calibration

Printer calibration is significantly more expensive and complex than monitor calibration, and you have to do it for each and every type of paper you want to print on. There are several calibration options on the market and thankfully they're produced by the same companies that make calibration kits for monitors. Frequently, the printer calibration portion of the kit costs a substantial amount of money because it includes a completely different sort of hardware called a *colorimeter,* along with the additional software to run it. To start the printer calibration process, you simply print out a test page from a digital file supplied with the calibration kit. The test file has many small color squares; each one is supposed to be a very specific color. After you print the test page, the colorimeter is used to read the colors produced, and a profile is created that balances out any imperfections in the color. It is essential that you repeat the process for each type of paper you use because every paper and ink combination is different.

Bulk ink systems

Bulk ink systems, such as the one shown in Figure 16-2, can be beneficial to the photographer who wants to make large quantities of prints. A bulk ink system consists of a set of bottles where the ink is stored, along with tubes to feed the ink from the bottles to a new set of ink cartridges that are specially modified with a new digital chip to tell the computer that the ink is always full. Usually, when you print a certain number of prints, the digital chip on each ink cartridge tells the computer that the cartridge is empty; you have to put in a new cartridge before you can proceed. This doesn't happen with a bulk ink system. You simply keep an eye on the ink in the bottles and refill them when necessary. The cost of a bulk ink system is roughly equivalent to the price of ten ink cartridge sets. However, even the smallest bottles of ink you can get with such a system have more ink in them than ten regular cartridges, so the system pays for itself almost immediately, and it saves you considerable amounts of money thereafter. To find a bulk ink system for your printer, two good online resources are Inkjet Art Solutions (www.inkjetart.com) and Inkjet Mall (www.inkjetmall.com).

Figure 16-2: Bulk ink systems can save you a considerable amount of money if you plan on printing more than just a few prints a month.

Paper choices

You have so many choices of paper to print on that the selection can be a bit bewildering. There are many places to look online for information about the various types of paper, but my favorite is Inkjet Art Solutions (www.inkjetart.com). This website provides tests and comparisons of various papers as well as of other inkjet printing supplies. Another great online source for paper and printing supplies is Inkjet Mall (www.inkjetmall.com). Both of these companies offer packs of paper samples so you can test a lot of different papers without making a large investment in any single paper type.

A few of the many companies that produce high quality inkjet printing papers include:

Crane & Co. (www.crane.com)

Epson (www.epson.com)

Hahnemühle (www.hahnemuehle.com)

Hawk Mountain Papers (www.hawkmtnartpapers.com)

Ilford (www.ilford.com)

Legion Paper (www.moabpaper.com)

LexJet Corporation (www.lexjet.com)

Image Files as a Finished Product

If you decide to provide image files to your clients, you will want to produce something nicer than just a CD with their names scribbled on it. Such a presentation obviously doesn't create a very professional image for your business.

You may want to take a look at the various models of printers that are capable of printing directly onto the surface of CDs that have a white inkjet-compatible coating on the top surface. These printers can do double duty by printing on regular office paper as well as photographic paper. To print directly onto a CD, you place the disc in a special tray that slides into the printer from the front and moves the disc under the printing heads inside the printer. Epson makes several models that print beautiful colors directly onto the CD. Epson printers also come with software that makes it very easy to design the layout and get it to match up with the disc. Figure 16-3 shows some sample layouts created with the software that comes with an Epson printer that sells for less than $200. There is also a system called LightScribe, which uses special discs and a special DVD burner that can burn a monochromatic image directly into the top side of the disc. You can see samples and learn more about this system at www.lightscribe.com.

Figures 16-4 shows a small USB drive, which is a much more simple and reusable way of delivering your images. A USB drive is also far faster at reading image files than a DVD disc. Drives of this type are currently available for approximately $50, which might sound like a lot, but in reality, the amount of time it takes to organize and burn three or four DVDs, with labels, will cost you far more than $50 worth of your time. I ship these drives in an attractive little metal can that you can purchase online from the Independent Can Company (www.independentcan.com). You can even get your own logo printed on the cans if you like.

Figure 16-3: Examples of CD labels created with Epson software and an Epson R200 printer.

Figure 16-4: Small USB drives are a fast and relatively cheap way to deliver finished images to your clients.

Specify Home Use Rights

When you provide a set of finished images to a client, you need to make it very clear that you still own the copyright to the images. In legal terms, you are providing Home Use Rights, which means that a client can use the images for personal, nontransferable, and noncommercial uses. When you give this type of right to the client, you still retain the copyright to the images. The following is a sample of what you might include in your contract to spell out Home Use Rights:

> This contract includes "Home Use Rights," which means that you can use the images for personal, nontransferable, and noncommercial uses. You may make as many prints as you like for yourself or to give away as gifts. You may copy the disc to facilitate storing a backup in a separate location, but you may not give copies of the disc to any person outside your immediate family. You are personally liable for communicating the limitations of this contract to any person who receives a disc copy, and you are personally liable for any illegal uses that arise from the distribution of disc copies. You may not sell the image files or prints produced from the files, whether in original form or after any amount of alteration. Other persons may not use the image files as a basis for the creation of any artwork if that artwork is to be used for any commercial purpose. The images may not

be released or transferred to any other person or company, whether for profit or as a gift. The images may not be used in any commercial media, for any purpose whatsoever. If you have a question about any specific usage, please contact the photographer to ask for clarification before proceeding with such use.

Other files to include with your finished images

If you want to ensure that your clients have the best experience possible with the finished images, you may want to spend some time compiling a folder of additional items that you include on every disc set you send out. Some of the items I like to include are as follows:

✦ Instructions for finding a good print lab and how to work with the lab to get the best prints possible.

✦ Free software for viewing and browsing the images.

✦ A selection of my own portfolio slide shows in video format. These often inspire a bride to purchase her own slide show, or they can be used to show to her friends who might be getting married.

✦ A price list for other services you offer, such as albums, custom prints, slide shows, custom image retouching, and so on, along with samples of each of these types of work.

✦ Information about other types of work you do, such as family portraits or commercial work. This keeps you hooked in with the entire family of each wedding client, letting them know where to go when they have other photographic needs.

Albums

Albums have traditionally been the single most common method of displaying wedding images. Digital technology has brought about a few changes to the album market, but the popularity of albums still reigns supreme.

Modern digitally printed albums have a much sleeker look than albums of the past, with thinner pages and without traditional mats framing the images. The ability to produce a page with multiple images and text all blended into a single print has created a lot of excitement among clients and photographers alike. The beauty and uniqueness of these products is so far beyond what was available in the days of film that I think it's safe to say that high-priced wedding albums have never been easier to sell.

Some companies call these page layouts "magazine style" because you can use text and images pretty much any way you like. The pages of these digitally printed albums no longer have bulky mats around the edge; instead, the print is the page. Many companies now offer pages that have only a very tiny seam down the middle so that when the book is open, the two facing pages appear as a single giant layout with only a small crack or fold down the center.

With the skilled touch of a good graphic designer, each page has a layout that looks like it could have come straight from the pages of a coffee table art book or even a fashion magazine. The design styles are modern, and the albums themselves are actually real hard-bound books. The pages are often printed on thick watercolor papers with long-lasting inkjet printers before being assembled with traditional bookbinding methods.

The album contract

In my own album contract, clients must define their ideas in written form before I can start the creation process. After all, if you don't know what they want, how can you create it? You might say, "I'm the professional, so I'm just going to do it for them." And for many clients, that may be exactly what they want. However, I think it's best to ask clients how much input they want to have. You're welcome to download my contract and adapt the wording to your own needs. My contract is designed around Graphistudio albums (www.graphistudio.com), which I use for all my work, and you can find a copy of it at www.aperturephotographics.com/downloads.

The design stage

Many photographers design and build the album page layouts themselves. Others hire skilled Adobe Photoshop users to do the task on salary. Still others farm out the task to an independent graphic design artist. Several album companies offer a complete service that includes doing the graphic design, sending out customer proofs, printing, and binding. Zoho Design (www.zoho design.com), for example, offers high-quality graphic design services at a reasonable rate. Zoho Design also gives you the option of taking the finished files as layered PSD files and then getting the printing and binding done yourself, or letting them handle the whole package from design to finished album. I personally prefer to get layered PSD files so I can work with the bride to fine-tune the finished files. Figure 16-5 shows the before and after view of a two-page album spread. I got the top version from Zoho Design and then I modified it as the bride and I worked together. The bottom version is the final result. I normally use the Zoho layouts with very little modification, but this was a large album order so I spent a lot of extra time on it.

Additional companies that offer albums and design resources include:

AsukaBook (http://asukabook.com)

Blurb (www.blurb.com)

Capri Album Company (www.caprialbum.com)

CJgraphy Custom Album Designs (www.cjgraphy.com)

Cypress (www.cypressalbums.com)

Graphistudio (www.graphistudio.com)

JonesBook (www.jonesbook.com)

Laguna Albums (www.lagunaalbums.com)

Modern Album Designs (www.modernalbumdesigns.com)

White Glove Books (www.wgbooks.com)

Willow Album Design (http://willowalbumdesign.com)

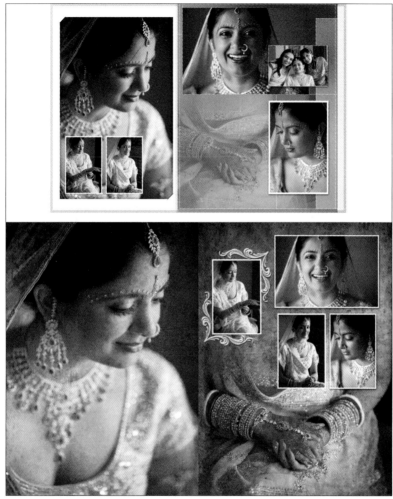

Figure 16-5: This layout contained some of my all-time favorite images so I started with the RAW layout in the top version and spent a lot of time doing artistic renditions of the images to match the warm tone theme I was using throughout the rest of the album.

Client review and input

Working with the bride is a large part of making an album. Sometimes we exchange 20 or 30 e-mails as we work together to complete the project. At the very least, the bride should get to see small JPEG versions of the layout as it progresses. The first draft is almost always a big surprise for the bride and you cross your fingers and pray that you at least got close to the style

she might like. If you're really lucky she'll say, "Wow! That's perfect!" Usually, however, she's say something like, "Wow, that looks really good but let's make some changes." And from there on out, you have to be really serious about making the bride write down *exactly* what she wants to change. Never make changes for a bride who says something like, "Take page 6 and make it more interesting." You could work your life away and never please that bride. Instead, coach her on making specific statements such as move this photo here; make this image brighter; crop in close on the top left image on page 5; take the top center image of the groom and move it to page 8 where it will be used to replace the lower-left image of the flower girl. Having a good contract that spells out the terms of how this stage will progress is absolutely vital. That contract serves as an educational tool whereby you can make sure the bride knows what to expect from you and what you expect from her as well. Making an elaborate album is a joint venture. Don't expect to be in complete control, but do expect that the average bride will welcome your advice and trust your judgment.

Making an album is a significant expenditure of your time and effort. Just as you would never consider taking on a wedding without a contract, you should also never take on an album without a contract and a deposit up front.

Videos

Putting your images together in the form of a video slide show used to be quite a difficult task that involved using very complicated linear video-editing software such as Avid or Adobe Premier. Thankfully, the second generation of video slide-show software is much less complicated to learn. ProShow Producer from Photodex (www.photodex.com) is one company that stands out from the crowd in this field. With ProShow Producer, shown in Figure 16-6, you have all the standard slide-show features, such as transitions, image timing, and multiple music tracks. The surprising part is that with ProShow, these standard effects are just the tip of the iceberg. You can make your image zoom in or you can slowly pan across a wide scene. You can create layers with text and other images appearing and disappearing for unlimited creative effects. You can make your images fade in and out on the beat of the music, and you can synchronize all or a portion of the images to fit the duration of a certain song. You can even buy packages of premade effects that are extremely complex and allow you to insert your own images into them with very little effort (or knowledge) on your part. The ProShow Producer software enables you to express your creativity in ways you never even imagined.

ProShow Producer also has a plug-in for Lightroom that enables you to choose images for the show and export them in a format that will match the type of video file you want to produce. These days there are many different output options, from tiny little videos that will play on an iPod to huge, high-resolution files to burn onto a modern Blu-ray disc. I enjoy being a photographer and I don't want to have to learn to be a videographer — thankfully, ProShow has a simplified output process that guides you through the complex maze of video options in a low-tech way so you get the correct type of video for the project.

As mentioned earlier in this chapter, Lightroom is also capable of producing simple video slide shows. With Lightroom, you can add a single sound track and you can set the timing for all of the slides and fades, but you can't set these options for each image individually. This is the absolute basic video system, but it works.

Figure 16-6: ProShow Producer from Photodex creates complex DVD movies, slide shows, and screensavers with an unbelievable level of creative control.

Once you get your video made, then what? The simplest and most obvious use of a good slide show is to sell it to your clients. If you want to do this, I recommend using YouTube to allow them to preview your work before they buy it. YouTube has several cool features that make it easy for you to do this. One is the privacy setting. You can upload a video and change the privacy setting so that only people with a certain e-mail address can view it. This works great when you want to let your client preview the video, but you don't want them to show it off until they've paid for it. You can also make the video hidden, but still be available to you, until you've worked out everything with the client. That gives you the option of showing it to the client for a short time and then hiding it, but the video remains on YouTube so you don't have to upload it again. YouTube can also play HD video, which is a really nice way to see an online slide show.

Whether you get a client to pay for your videos or not, once the videos are on the web, you've got free advertising for as long as you choose to keep them online. I go deeper into the different ways to advertise with online video in Chapter 19.

A few of the many software packages available for creating video slide shows include:

MyMemories (www.mymemories.com/mms/software)

PhotoStory (www.magix.com)

PowerDirector (www.cyberlink.com)

PowerProducer (www.cyberlink.com)

ProShow Gold (www.photodex.com)

ProShow Producer (www.photodex.com)

VideoStudio Pro (www.corel.com)

Studio Management Software

Many photographers, especially those who have a traditional studio, will want some sort of software package that helps them and their employees do all of the daily tasks from payroll and timecards to ordering prints and managing a client mailing list. For the average solo wedding photographer, much of that software is overkill. The main tasks for the small wedding business include:

✦ Uploading images to a storefront where clients can order online

✦ Showing images to clients on your own computer, in your office

✦ Ordering prints from a lab and sending the images via FTP

✦ Printing out a professional invoice and receipt to give to the client

✦ Tracking the progress of all print orders

Pro Studio Manager, shown in Figure 16-7, is a software package from Printroom that accommodates the tasks on this list perfectly and you can download it for free at www.printroom. com. This software enables you to customize the appearance of your online storefront, as shown in Figure 16-8. This software also integrates seamlessly with Printroom's online photo lab. You can choose to show your work to clients in your studio and place the finished orders directly from your computer to the lab, or you can choose to upload the images to your online storefront and let clients order for themselves — you can even do it both ways if you like. Either way the prints you order arrive in your mailbox a few days later. You can also have prints shipped directly to the client. The software that controls all of this resides on your own computer, so you can open the program and see all your orders right there.

If you don't want to meet with clients in your own office, you might consider showing your images online only. The Printroom online storefront is perfect for this. When an online order comes in, an e-mail notification summarizing the order is sent to you. When you open Pro Studio Manager, the order pops up and enables you to scroll through the images to make sure the order is ready to go. The Pro Studio Manager interface also enables you make all sorts of adjustments to each image — such as color correcting and cropping — before the order goes out. When you're satisfied that everything is in order, simply click Send and the images go straight to the lab over your Internet connection.

You can also use Pro Studio Manager for client viewing and ordering sessions in your office. For example, whether you sell prints from your wedding images or not, you can invite the couple in for a viewing session when the images are finished. As mentioned previously in this book, you can set up a viewing area where you and your clients sit to watch a show of the finished images once they're done and ready to be delivered. After the show, you have the option to go back and take print orders. Pro Studio Manager runs the slide show and then lets you scroll through the images to order prints. You can even make quick image adjustments right there while the client is watching. As the print order builds up, the client can see which images have been ordered, at what sizes, and how much the order will cost. After the order is finished, the software prints a customer receipt, which contains thumbnails of each image in the order, as well as sizes, quantities, prices, and other information. As you create the order, the software calculates the total charged and records everything where you can easily view it later. After

the client leaves, you can do final retouching and click Send. A few days later, the prints arrive in the mail. If you've been using a local lab for your prints, you might be surprised to find that using an online lab can drastically cut down on the amount of time you spend driving back and forth to the lab every day, without adding a significant delay in order processing time.

Figure 16-7: Pro Studio Manager helps you show images in your office, organize your online galleries, and place print orders directly from your computer.

Figure 16-8: Pro Studio Manager gives you a lot of flexibility in the look of your online storefront and in the type of products offered for sale to your online customers.

Pro Studio Manager also enables you to set up different image galleries for each job. You can also set different types of product and different prices for different types of clients. For example, you might have a portrait price list that you apply to all portrait galleries and a different wedding price list that you apply to all wedding galleries. Each of those can have completely different types of prints offered for sale.

Set an Expiration Date

No matter which company you choose to use for your online storefront, setting an expiration date for each online gallery is extremely important. A lot of psychology goes into pricing and selling wedding images, and one of the worst mistakes you can make is to give your clients a long time to order. This is true of all types of photography, but especially so with weddings. When a wedding is over, it's over! Everyone suddenly goes back to their normal lives where there are a million distractions, and they may soon forget all about the wedding. The guests may forget within a week or two, and the couple may follow a few weeks later. If you don't get any sales immediately, you might as well forget it too. If you leave the images online for only two weeks or a month, you create a sense of urgency, and your clients will have to act right away or not at all. If you give them a chance to procrastinate, they will.

Pro Studio Manager can do all of the tasks the average wedding photographer needs to accomplish. But if you want to start with a full-featured studio, the studio software packages offered by the companies listed as follows are far more complex than Pro Studio Manager, and they'll basically walk you through the process of organizing your entire business:

LumaPix (www.lumapix.com)

PhotoOne Software (www.photoonesoftware.com)

StudioPlus Software (www.studioplussoftware.com)

SuccessWare (www.successware.net)

Time Exposure (www.timeexposure.com)

Summary

The digital age is teeming with new and unusual products that you can offer your clients, and the list continues to grow every day. The only way to keep up is to read photo magazines where new products are constantly being reviewed by experienced photographers.

Whether you keep your images and sell prints in a traditional fashion or charge more up front and provide the images on CD, both business models can benefit by offering custom albums, custom prints, video slide shows, and other aftermarket products. Both business models can also tap into previously untouchable clients by selling prints to distant friends and relatives through an online storefront and both can benefit from advertising with online video slide shows. This chapter provides an overview of the possible products you can produce for your clients and includes a few lists of resources where you can find vendors to help you make each type of product.

✦ ✦ ✦

17

Cracking the Secret Code: Breaking into the Business

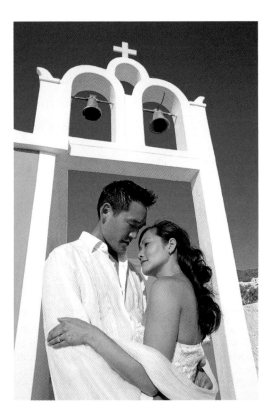

As a new photographer, there is no task that is more difficult or intimidating than taking those first few steps toward getting your business off the ground. Many good photographers simply can't manage to make things come together, so they eventually give up or find a permanent job working as an assistant or second shooter for someone else. What is it that separates these people from those who take the same skill set and make it fly? In some cases, some luck may be involved, such as stumbling into a first job or finding a mentor who lives next door. However, in most cases, the secret to success boils down to sheer determination. I've taught a

few young people how to do wedding photography, and one thing that has become apparent to me is that no matter what skills I teach them, they won't take that experience and turn it into a business unless they really want it deep down inside. If a person lacks determination and desire, no amount of skill, help, or encouragement will cause him to succeed. But if he possesses determination and desire, no lack of skill, help, or encouragement can stop him from succeeding.

For those of you who have the drive, all you need next is a little bit of information about where to direct all that energy. Reading this book is a big step forward, as it will give you a lot of ideas about how to actually do the job of wedding photography. In this chapter I outline the basic process of how to go about finding the jobs, because even if you're a great photographer and you know all about how to run a business, it won't do you much good if you can't get anyone to hire you. Finding clients and getting them to sign the check is the key to your survival in this business.

Networking

If you work in your own neighborhood, the majority of your business will come to you from two directions. First will be the clients you find through your own advertising efforts. And second will be the clients who come to you as referrals from friends, previous clients, and perhaps most important, from other local vendors — including photographers. Meeting other vendors and making friends with them is vital because it helps you maximize your advertising efforts. When you send your extra clients to your vendor friends, they might eventually feel inclined to return the favor. Keeping your extra clients within this circle of friends will bring a return on your original advertising dollars because your vendor friends will also be referring their extra clients to you.

Networking with the locals

If you want to succeed in this business, you need to make friends. Any effort you make to talk with other wedding vendors at each wedding will be well worth your time. Not only will these people take care of you by making sure you have food and drinks, but they will also clue you in on many little things that are happening around the wedding that you might miss without their help. Be sure to keep a stack of business cards in your pocket while you work, and make a point of trading cards with every wedding vendor you meet, whether at a wedding or otherwise. These people are the key to your survival; once they get back home they'll receive calls from brides who don't yet have a photographer. Who do you want them to recommend?

One way to keep your name at the front of other wedding vendors' minds is with pictures. All wedding vendors need images of themselves and their services for their own advertising, and I highly recommend that you shoot a few images specifically for this purpose when you have a few minutes to spare at a wedding. Make a mailing list (from those business cards you've collected) and provide each vendor with images that they can use provided your website address appears as a credit line. If they want large prints, by all means spend a few bucks and make the prints for them. And every time you make a client album, it will only cost you a couple hundred bucks to get an identical copy for the venue.

"Only a couple hundred bucks." Does that sound like a lot of money? Attending a wedding show can cost $1,000; a page advertisement in a local magazine typically costs $1,500; a *Yellow Pages* ad runs several hundred dollars a month. After your website, getting a beautiful album into the hands of the coordinator at a popular venue is the cheapest long-term

advertising you can purchase. And it only costs you $200 to $400. Every chance you get to help other wedding vendors, take it! You'll be helping yourself more than you can imagine. Figure 17-1 shows an image I shot for a local florist whom I've known for many years.

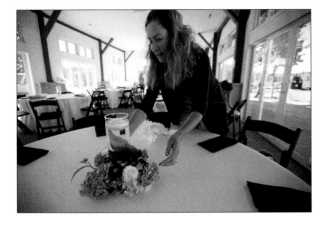

Figure 17-1: When you see vendors at work, shoot some images just for them and make sure they get a copy.

Networking with other photographers

One of the scariest things for a new photographer to do is to meet all the old-timers in the business. I remember how intimidated I was by these folks when I first started. Being hesitant to introduce myself and mix it up with other photographers was one of the biggest mistakes I ever made. When I did finally get to know these photographers, I found them to be friendly and extremely willing to share information. And after making friends with them, I discovered that they were one of my biggest sources of new business. I couldn't believe it — my competition gave me more jobs than I could find on my own.

Think about this: You're an established photographer and you get calls for weddings all the time. Every year there comes a time when your calendar gets pretty filled up, but the calls keep trickling in from last-minute brides. What do you do when you're booked for that day? Do you say, "Sorry, but I can't help you." No, you never want to send a bride away without getting anything out of it. Remember, your advertising efforts are what brought that bride to you in the first place — never waste that.

Instead, you say, "I'm booked for that day but why don't you call my friend, ____. He shoots in a style similar to my own and I know he's a really great guy who will take good care of you. Here's his website address, and please tell him I sent you." Then you send your buddy an e-mail message about the bride and maybe include her contact information. Of course your buddy is going to remember what you did and send referrals back your way on days when he's booked. You both benefit by keeping that bride in your circle of friends.

If there isn't already a social photography group in your area, think about starting a mailing list and hosting regular gatherings for local photographers. You can make it an opportunity for everyone to show off new work or just meet at a local dinner spot to socialize. For example, you could host a potluck dinner at someone's studio and invite each person to show a few images afterward. The party options are endless and the return will be in the form of new friends and new business contacts.

Networking with coordinators

A wedding coordinator is someone the bride hires to plan the details and run things on the wedding day. Most of these people really know their stuff and they tend to work on larger weddings where it would be almost impossible for the bride to do it all herself, or where there are very wealthy clients who tend to have more money than time. In either case, making friends with a wedding coordinator can be extremely valuable to you. Sometimes a wedding coordinator will just pass along your name to the bride; other times, the bride will hire the coordinator to do everything. In this case, the coordinator interviews you, signs the contract, and even pays your fee. Needless to say, wedding coordinators have a lot of influence over the brides they work with and can potentially get you a lot of work.

If you work mostly in your local area, you'll find that many of the popular wedding venues have a full-time coordinator who handles wedding paperwork and works with the bride on the day of the wedding. So will most large catering businesses, as well as some florists, cake makers, and party supply rental houses. Getting to know all of these people and keeping a supply of your advertising material in their hands will greatly increase your wedding business. Keeping them supplied with images like those shown in Figures 17-2 and 17-3 will also help ensure that your name is familiar to them.

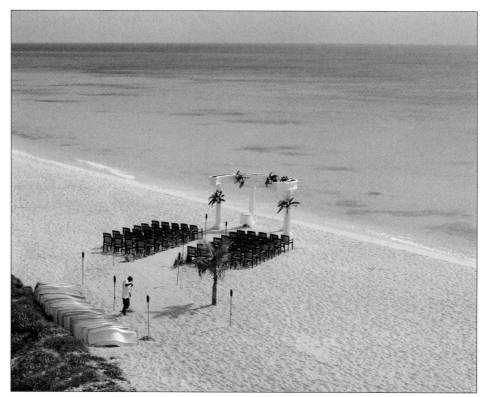

Figure 17-2: The coordinator for this location in Mexico was delighted to get a shot that showed off the secluded beach spot with no guests in the scene.

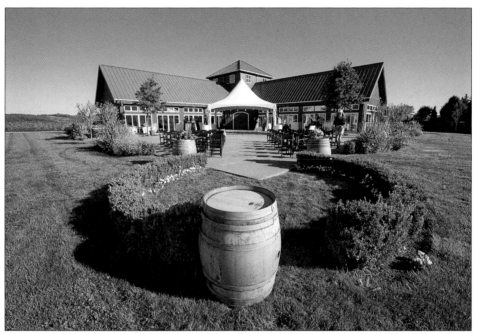

Figure 17-3: Wedding site coordinators need photos of the site with and without guests. They also like photos that show how the place can be decorated because they can use these images in bridal interviews to discuss the layout of tables and decorations.

Networking during interviews

Another great way to help land future bookings is to mention your favorite wedding vendors when you interview a new client. I collect advertising materials from all of my favorite vendors and at the end of each new client interview, I stop talking about myself and start asking about what other services the couple might still be looking for. I'll say, "Oh, if you need a florist, you should talk to my friend, Renee. She owns [business name] and she's an excellent florist. Here's her number and her e-mail address. When you talk to her, tell her Glen says 'Hi.'" Then I'll also e-mail a note to Renee letting her know to watch for these people. You can bet Renee will return the favor if she ever gets a chance.

Advertising

There are so many businesses hoping to get your advertising dollars that you won't have any difficulty finding places to spend your money. The hard part will be figuring out which advertisers will bring in the biggest return, and then after the ad run is over, assessing how effective the ad was. Every advertising effort you make is influenced by hundreds of outside factors that all combine to determine how many calls you get out of it. For example, is there a big economic downturn that might be causing people to spend less? That could be dynamite if your prices

are low, or disastrous if you're an established professional who charges a fairly high amount. Did one of your competitors pay more to get a larger ad with better graphic design? Was your ad buried in the middle of 25 ads from other photographers, leaving brides feeling overwhelmed and confused? Did you pay for a booth at a big wedding show only to find out on the first day that the show has 40 other photographers? All these factors determine whether your efforts totally bomb or make the phone ring nonstop.

Keep the following ideas in mind when you plan your advertising strategy:

✦ How many competitors will be at that particular wedding show?

✦ Do your prices fit the economic status of the bride who buys that magazine or attends that wedding show?

✦ Is the cost of the ad going to be more than 10 percent of the income generated from that ad?

Magazines

Almost every location on the planet has a magazine that is specifically dedicated to weddings. And even those areas with no magazine will almost surely have state or regional magazines that cover the area. Do some research on the Internet, at the local bookstores, florist shops, and bridal dress shops to find out what wedding magazines are available in your area. Contact the sales departments of those magazines and request an advertiser packet. These magazines often reach clients that you wouldn't find otherwise, and with a little help from a graphic designer, you can easily make a very good impression on future brides.

Testimonials from the Bride

Brides love to talk! Every bride you work for should have a handful of your business cards when she leaves. And if you present your images to her on a hard drive, why not also include some video slide shows from different weddings that she can show to her friends if she knows someone who's getting married soon?

Every happy bride should also be asked to write up a little review about your work. Sending this to you via e-mail is great, and from there you can transfer it to your website. Another beneficial way to get these reviews is to ask the brides to write them on a big wedding website like The Knot (www.knot.com), or some other website of your choice that focuses on a market you are interested in. Google also has a place to write up business reviews in the map that shows up on top of the page when you do a search. The more positive reviews you get, the higher you go on the list.

Another often overlooked way to maximize your business contact with each bride is to send out an occasional newsletter to all your old clients. This keeps your name in their minds and lets them know what else you are available to shoot. For example, are you willing to shoot baby portraits, commercial assignments, family groups, and so on? Why should your wedding clients get their baby portraits done by anyone but you? You already know they love your creative style. Many of them will be delighted to work with you again every time they need photos of anything. All they may need is a little reminder that you're out there.

If you want to break into destination weddings in a certain area, you'll find magazines like *Mexico Weddings and Honeymoons* (www.mexicoweddingsmagazine.com), *Destination Weddings & Honeymoons* (www.destinationweddingmag.com), and *Weddings Jamaica* (www.weddingsjm.com). All of these are great sources of new clients, but it won't be cheap. Small local magazines may charge as much as $1,500 per page. Regional magazines like *Mexico Weddings and Honeymoons* might charge $1,500 to $3,500 per page. International magazines and high-fashion magazines in the United States might start at $3,500 per page and go up from there. Whether or not that money is well spent depends on the quality of your work and the effectiveness of your ad. If your work fits that market, you'll have no shortage of payback from magazine advertising.

One way to get free advertising from magazines is to submit your photos for their "real weddings" section. This is a portion of the magazine where they do a small feature story (with photos) from one or two real weddings that took place recently. If you shoot a wedding that you're particularly proud of, you can find the submission information for different magazines and send in your images. If they like your work, you may find you've just gotten yourself several pages of free advertising.

Wedding websites

There is no shortage of websites dedicated to the business of weddings. Here are a few of the big names:

> Best Destination Wedding (www.bestdestinationwedding.com)
>
> Brides.com (www.brides.com)
>
> MyWedding (www.mywedding.com)
>
> The Knot (www.theknot.com)
>
> Wedding Channel (www.weddingchannel.com)
>
> WeddingWire (www.weddingwire.com)

These websites and thousands of others will all gladly take your advertising dollars and make you a little miniweb page on their site where you can tell all about yourself, show off a couple of photos, and get a link back to your own website. I don't recommend wasting your time with the large sites unless you become a big-name photographer. Instead, focus on smaller regional websites that won't have a thousand other photographers listed there. If you want to work in Oklahoma, for example, get an ad in TulsaCelebrations.com. If you want to work in Alabama, take out an ad in AlabamaBridal.com. You'll have a lot less competition in small regional websites like these, and when a bride has fewer choices, you're more likely to get called. Too many choices spells disaster for all the advertisers involved, and I really believe that when brides are presented with too much information and too many choices, they are more likely to just walk away in confusion without calling anyone. Any time your ad would be listed among more than 20 other photographers, I recommend looking elsewhere.

Wedding shows

Wedding shows typically take place once or twice a year in every region. Most shows have more than fifty vendors and some have hundreds. A single booth space is usually 10 × 10 feet and the price may range from $500 to $1,500 for a show that typically runs Friday, Saturday, and Sunday. These shows can bring in a tremendous amount of business if you take the time to really know the market and set your prices to fit the average bride who will attend that show.

I highly recommend that you attend a show or two as a guest before you get your own booth. Walk around and take notes on designs you like, but don't waste the vendor's time pretending to be a bride or groom if you're not. Keep in mind that the booth fee will only be the tip of the iceberg. You'll have to buy furniture and buy or build all of your props, and you'll need some big prints or big monitors to show off your images. It is not unrealistic to budget a minimum of $1,500 for each wedding show.

There is also a lot of psychology involved in the construction of your booth. You don't want a booth that keeps people out in a highly trafficked walkway, where they'll get trampled if they try to stay and talk to you. You want an open front that encourages visitors to walk inside and talk with you, and take a closer look at some albums. You should always stand up or sit on a high stool, because nobody wants to make you have to get up if you're sitting down in a low comfy chair, and they'll avoid talking to you for fear of making you have to get up. A lot of people will also try to walk by without talking, but if you stand near the opening of your booth handing out flyers to anyone who passes by, you'll be surprised at how many people will return to take another look after reading the flyer.

Whenever possible, I recommend that you find a chatty bride and get her to attend your booth with you. You can pay her, do a trade toward album credit, or do whatever it takes to get her in there. If the show runs multiple days, you might have to find a different person for each day, but whatever it takes — do it! The reasoning behind all this comes down to how we as a culture feel about bragging. Someone who brags about him or herself all day just comes off looking bad. But when someone else brags about you, suddenly you're the greatest thing there ever was! And if you're a guy, you really can't chat to a bride like another woman can. No matter how much you like weddings, women like weddings on a whole different level.

If you're a husband and wife photography team, you're really in luck because you can brag about your partner's photography skills without either of you ever having to say a word about yourself.

Another favorite trick of mine is to *not* hand out business cards at a wedding show — in fact, I don't even bring any. Instead, I bring a clipboard and when a couple seems interested in my work, I hand them the clipboard with a sign-up sheet for interviews and offer to call them later to talk about photography and to schedule a private interview. This is a no-obligation way to collect the contact information and wedding date of potential clients. When you get back home, the follow-up is in your hands instead of theirs. If you hand them a business card, you leave it up to them to make that first call, potential clients may procrastinate or feel overwhelmed after attending the show. It's much better to have the ball in your court. When you do call, it's not at all unusual for them to be unable to remember you because they talked to so many different photographers. When you remind them that they signed up on your contact list, you'll have their attention again. From there you can talk about their wedding and if they have a budget that fits your prices, you can schedule an hour for a private interview.

Printed materials

Whether you are already established, or just starting out, you should have a big file drawer or shoebox where you collect advertising materials you like. Look for cool business cards, envelopes, single page newsletters, booklets, magazine ads, and so on, and if the design really appeals to you, stash it away. Later on, when you sit down to brainstorm for your own advertising materials, you can scan through everything you've got in your collection and pick out the details that appeal to you the most from each piece.

Whatever you come up with, it has to be intriguing. It has to catch someone's attention just enough to make her curious. You don't want it to include every single detail about your business; you just want it to convey a "feeling" of romance and high-quality photography. That feeling makes potential clients curious to find out more and points them to your website. Don't ever put prices in your printed material for two reasons. One is that you might decide you want to change your prices before you've used up all the print pieces. The other is that a price can easily scare off a client if the client doesn't first get to know that you're worth it.

Make your ad pieces brief. You might use a couple beautiful pictures and then minimal text to reel potential clients in for a closer look. Price is a huge part of the equation for most couples and if you put your prices on the flyer, you might lose a lot of people right there. It might seem like you shouldn't waste your time talking to a bride who can't afford your services; however, you'd be surprised at the number of times I've had brides say they can't afford me, only to have them figure out a way to do it because they really like my work. If you chase them off by flashing a big price tag before they even know you, you'll never know if they might be able to make it happen. You need to hook these brides in and make them take a closer look. One way to do this is to offer a fairly useless, low-priced package — perhaps one that includes almost nothing and is only available in the off-season. Now you can say something like, "prices from $1,000." This low price brings them in for a closer look, and if they really do like your work, they'll find the money for the regular package. If the money is all they care about, they'll wander off.

Finder's fees

One successful way to get clients from people you don't even know is to offer to pay them a commission, or a "finder's fee." In either case, you offer to pay roughly 10 percent of your net income (after deducting expenses) for every couple they send who signs a contract with you. This is absolutely the best type of advertising dollar you can possibly spend. Think about it: you don't have to pay unless they get you a client. The normal advertising arrangement is to pay up front and you stand a fair chance of getting absolutely nothing in return. With a finder's fee, you've got a sure thing and that is definitely worth the money.

To get this ball rolling, write up a letter introducing yourself and put it in an envelope along with a few copies of your printed brochure. Explain the commission arrangement in the letter and make it very clear that you would be delighted to pay people for the time and energy they spend passing out your materials and chatting you up.

If you find a coordinator who is willing to work on commission, you can send copies of your contract and any other details because he or she might be working with a bride who wants the coordinator to take care of all the details. In that case, you'll be doing all the paperwork directly with the coordinator.

Travel agents, wedding coordinators who work for a particular resort, independent coordinators, florists, cake makers, videographers, limo owners, DJs, caterers, dress makers, and even other photographers all would love to make a little cash from a referral.

Interviewing Clients

Once you get a potential client's attention, you have to schedule a time when you can meet with him or her in private. Rarely will you find people willing to sign contracts at a wedding show. The vast majority will want to meet with you in a quiet place where they can ask questions and have your undivided attention. This is your chance to really impress them with your professionalism. I usually don't bring images to show at these meetings because I want them to check out my slide shows on the Internet before they meet with me. I do bring album samples and I plan on talking and just making friends with them over a cup of coffee.

Qualify the client

The most vital thing you must do before you agree to meet with a couple for an interview is first qualify them as potential clients. You must know that they can afford your prices, that they've looked at enough of your pictures to know your work, and that all the final decision makers will attend the interview. Your worst nightmare would be to get to a meeting and find out that they haven't even looked at your slide shows. Or they might say, "So, how much do you charge?" Or even worse, they could be vetting you for the couple and say, "We're here to decide if you're any good; then we'll tell the bride and you can interview again with her." You need to get all these concerns out in the open and tell the couple that they get one free interview, but the second one will cost $200. The couple needs to invite everybody who matters to that first interview, even if it has to happen at midnight on a Saturday.

Interview location

Deciding where to hold your interviews is also important. If you do other types of photography, you may have a studio that would make an excellent meeting place. If you only do weddings, and you don't want to meet in your home, then coffee shops and restaurants also make good locations. Just watch out for times when the restaurant might be crowded, and avoid sports bars that have distracting televisions all over the place. Normal background noises in a coffee shop, restaurant, or bar can be easily ignored.

You need to do your research in advance, so you can say, "Oh you live on the south side of town. How about meeting at Tom's Coffee shop on the corner of 7th and Madison?" Then you'll also need to know when Tom's is open so you don't come across as a fool when you arrive and find the sign that says, "Closed on Mondays."

Points to cover

Once you find a comfortable location and your clients arrive and get settled in with a cup of coffee, you'll need a list of general topics you want to cover. Of course you can let the potential clients ask questions and lead the conversation for as long as they can but don't count on them knowing even the first thing about what it is that they need to know. Remember, this

is likely their first time hiring a wedding photographer. They may have no idea what sort of questions they should be asking. This is your chance to look like a pro by providing them with some education about what to ask, and then providing the answers. You can also pre-educate your couples by sending them information (or links to information) via e-mail. I have several articles on my website that I use for this purpose. One is about scheduling the day for photos; another is about decorating the location for better photos; another is full of tips on choosing a photographer. All of that is good information to use when you do interviews. You can feel free to use my articles on your own website, or e-mail them to brides, as long as you follow the copyright instructions I provide on my site.

So what are the main points you should cover in an interview?

✦ Your photographic style

✦ Your personality and how you conduct yourself at a wedding

✦ Basics about the equipment you use – including backups

✦ Meals for the photographer and assistant (if you use one)

✦ The finished product they will receive

✦ Options for additional products you offer that are not included in the contract

✦ Payment schedule and other contractual details

At the end of the interview, I sign two copies of the contract and give both copies to the couple. If they want to make a decision right there, they can sign both copies, give one back to me, and we're all set. If they want to take it home and think about it, they can do that too. If you want to be the high pressure salesman type, you could proceed with questions like, "So what package do you like?" or "what are the objections standing in your way and keeping you from signing the contract right now?" Sometimes this question may bring up concerns that are actually mis-understandings about your service and you can proceed to clarify things. At other times this might bring up the fact that they have an interview scheduled with another photographer a few minutes after your interview is over.

I personally don't like this technique, but I know I've lost jobs to other photographers who posed this question at the end of the interview: "I really want to work with you, so tell me, what would it take for you to sign the contract right now?"

Once you do get a signed contract, agree to check in again two weeks before the wedding to go over final details.

Presenting the contract

I don't like to come across as the high pressure salesman. I prefer to present all the informa-tion possible and let the clients choose which photographer to hire. Of course they have the option of choosing me or someone else. As mentioned earlier, at the end of the interview, I sign two copies of the contract and ask the clients if they want to take the contract home or sign it now. More often than not, they take everything home and talk it over before signing.

Talking Badly

Under no circumstances should you ever bad-mouth another photographer in any way, unless you believe this person to be so bad as to be a detriment to the business. And especially don't talk badly about one photographer to another photographer. That sort of thing always gets around and creates bad feelings. It's fine to toot your own horn, but never try to get business by making someone else look bad. If a bride asks you about another photographer, its fine to say something like, "All the photographers in this area are really good people, but they have such different styles that you can't compare one against the other."

It is also important to avoid trying to get a sale by underbidding another photographer — do you really want to get business just because you're the cheapest? You might actually get a sale out of it, but word about that sort of practice gets around. I've had two clients tell me (right after hiring me) that a particular photographer was trying to get their business by insistently offering to lower his price so they would change their minds about me and hire him instead. The ironic part is that this other photographer only got that interview because he was on my list of favorite photographers. That list is a little shorter now. Never underestimate the amount of business you can get by having good relationships with other photographers in your area.

At the end of the interview, if the couple says they still want to shop around, I've found it helps to act confident and not come across as too needy. If you act like you want the business and you expect to get it, you can let go of trying to make the client choose you. And you can get away from trying to beg for their business by lowering your prices or some other seemingly desperate tactic. Instead, I say something like, "I'd love to work with you, but if you still want to check out other photographers, let me supply you with the names of all the other good photographers in the area." Then I actually supply them with a list of all the other established photographers in the county where I live. At first glance this may seem counterproductive, but what it really does is make the client think I'm confident. Let's face it: They can always find these names if they care to look around, but when I supply them, it says "I know I'm good and I don't have to hide anything or beg for your business." It says, "The more you know about my competition, the more likely you are to choose me" — and that just reeks of confidence. I've actually had clients who seemed hesitant, but when I presented them with a long list of other photographers, they signed the contract right there. Others went home and looked at all the websites, then came back with a check in hand.

Vendor recommendations

As you come down to what should be the end of your interview, you have an opportunity to win points with both the new bride and groom, as well as with all the other wedding vendors in your area by asking the bride if she's still searching for any vendors for her wedding. Because the photographer is almost always one of the very first things a bride shops for, you'll almost certainly have the opportunity to pass along some contact information.

As part of your wedding interview kit (which you should make) you can put together a collection of business cards, flyers from other vendors, and even vendor photos on your laptop like

the one shown in Figure 17-4. If you discover that your bride still needs a florist and a caterer, pull out your little vendor packet and start talking up your favorite florist and caterer. Pull out a little notepad (part of your kit) and write down the contact info for the bride. This gives the bride a further reinforcement that you are an established pro in your area with long-term good relationships with other wedding professionals. And at the same time, the other wedding professionals will certainly take notice and start returning the favor.

At some point along the way, you'll have to decide if you want to keep giving your referrals away for free, or if you want to make a more direct money exchange. If you have a favorite vendor who sends you about as much business as you send them, it may be fine to just trade back and forth and call it even. However, because you are often one of the first vendors a bride meets, you may find that you tend to give more referrals than you get. This will be especially true for vendors like cake makers and florists, who are often lower on the bride's list of things to do. If you do decide to work on a commission basis with other local vendors, it might be best to meet with them and talk about a deal that will be fair to all involved. Usually, this comes out being an agreement to pay 10 percent of net proceeds from the job, or a maximum of $500. This allows vendors to subtract expenses from the proceeds and then pay the 10 percent just from the profits.

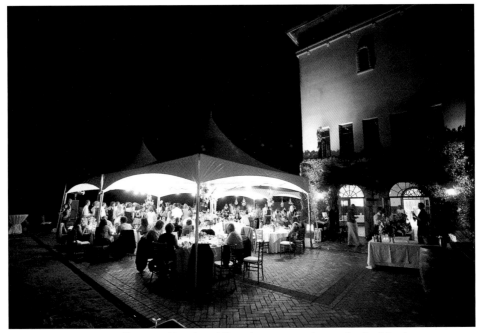

Figure 17-4: I have a collection of local wedding photos on my laptop that I might show at an interview if a bride is still looking for a wedding location.

Vendor clubs

As you grow your business in your local community, you'll most likely gravitate toward a group of wedding vendors who will become your good friends. Why not gather all these folks together and form a networking group? Not only can a group like this be a fun social gathering, but also you can share brides, you can share information about advertising opportunities, you can make a group website, and you can make a group brochure that you all pass out. You could even rent a small storefront where you all place advertising materials and have a shared office space or a really nice place to do interviews with a media center where you can play your own promo DVD.

In addition, with a club like this, you can track your referrals to see if they're one-way, or if they're going around evenly, then from that information, you might decide whether or not to set up a commission system for referrals.

Summary

Finding those first few clients can seem like an impossible task when you're just starting out. This chapter gives you a solid list of things to do that will jump-start your business and take you from crawling to flying high in a very short time. Now all you need is the inner drive to put these ideas into motion.

The three main aspects to getting a contract are networking, advertising, and interviewing potential clients. Networking and advertising could almost be placed in the same category, as networking is really nothing more than a person-to-person form of advertising that happens through forming friendships and trading favors with other people in the industry.

Traditional advertising is perhaps one of the most expensive and difficult of all the challenges you'll face as a business person. You have to sort through the millions of advertisers that want your money to decide which ones might bring in the best return for your money. And then you have to create an ad that will grab the bride's attention enough to make her check out your website or give you a call.

Once you do get a bride's attention, you have to know how to conduct a personal interview with the couple that leaves them feeling like you're not only a great photographer, but also a friendly person and a respected professional in the field.

This chapter puts all that together and leaves only one last major piece of the advertising puzzle — your website. In the next chapter I go into great depth about this most essential tool, which serves as free advertising as well as your personal secretary.

✦ ✦ ✦

18

Show Yourself:
A Website of
Your Own

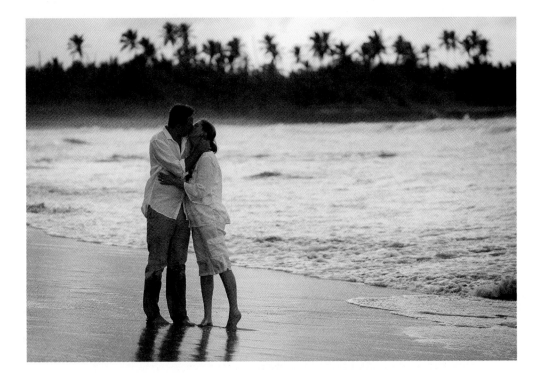

The digital age has created an advertising opportunity that was previously not possible —
no matter how much money you had. Before the web, major corporations spent billions
of dollars on advertising without reaching half the people you can now reach for free. Only
twenty short years ago, it would have been inconceivable to think that you could buy an ad
that could be found by anyone on the entire planet, viewable day or night on a large bright
screen, displaying all the photos and text you can possibly dream up, available for you to edit
whenever you want, and practically free!

You are lucky to live in a time when almost anyone can sit down at a computer to create a website and within hours the entire population of our planet can view it. However, not everyone knows how to do this. If you don't have the skills to create a website, or the money to pay someone else to do it for you, you're stuck in the pre-Internet world of adverting. This limits you to your local area and you must pay far more to advertise than your more knowledgeable competitors. Any competitor who creates a web presence before you, or one that is better than yours, will almost instantly vault over you in the business world.

Right now, the only thing standing between you and your potential clients is the knowledge of how to make your website happen. In this chapter I point you in the right direction and give you the tools to start moving, planning, gathering your thoughts, building your skills, and focusing your ideas to create the ultimate form of advertising.

Of course, building a website and making it easy to find with good search engine optimization (SEO) are both topics that fill rows and rows of books at the local bookstore. It is impossible to cover everything you need to know on these topics in this one chapter. What this chapter does provide is a bit of foundation, some helpful tips, and information on different ways to find out more.

Fundamental Concepts

Before you start to plan your website, it is important to understand a few fundamental concepts about the Internet and websites in general.

Internet service

Before you can log on to the Internet, you'll need to purchase an Internet service that connects your computer to the Internet. The companies that do this are called Internet Service Providers (or ISPs for short). Your local phone company, cable TV companies, as well as many independent companies offer Internet service for $15 to $20 per month. This service usually comes with free e-mail and a free space where you can create a small personal website.

If DSL or cable Internet is available, adding that to your normal Internet service will greatly speed up your connection and the added speed is practically vital if you intend to send your images to the print lab over the Internet.

If you do go with DSL, you must purchase a DSL modem that connects to the phone line in your office. DSL operates at a completely different frequency from phone conversations so you can use your DSL service to surf the net while talking on the phone at the same time.

DSL modems can be purchased with a wireless feature for only a few dollars more. If you have a laptop computer, or computers in distant parts of your office, using the wireless feature may be far easier that running wires, although the wire connections allow faster transmission times.

Domain name

A *domain name* is a website address. Your domain can be www.yourname.com or www.yourname.biz or pretty much anything you like with the .com or .biz endings — as long as that name is not already taken. You can check to see if your name is taken by simply

typing it in the address bar of your Internet browser (Firefox, Google Chrome, Internet Explorer, Safari). The domain registrar is a company that helps you register the domain name for your business. You can find a listing of domain registrars at www.internic.net.

Website host

The *website host* is the physical place (usually a company) where your website resides on a computer that is hooked directly to the Internet. This computer runs constantly so that your website can be accessed at any hour of the day or night. When you first start out, you may find it easier to have your website-hosting company also do the paperwork to register your domain name for you. Most website-hosting companies do this for free, or for a small fee, if you host your site with them.

As soon as you sign up for an account with a website hosting service, you get a password that allows you to log on and load your website onto the host's computers. Using this logon information, you can easily reconnect at any time to make changes to your website.

The website host often has a control panel like that shown in Figure 18-1, which enables you to manage many features of your website as well as look at statistics that tell details about how many people viewed your site, where each visitor comes from, what search terms they used to find you, what time they visited, how long they stayed, which pages they looked at, and so on. This feature is extremely valuable for assessing how your clients are finding you. These statistics tell you what aspects of your marketing plan are working and which ones you need to improve.

Figure 18-1: This screenshot shows the control panel supplied with my hosting service. From this page I can set up my own e-mail accounts, check my website visitors, set up a blog and pick from many other options.

Search engines

Search engines are software programs that look for web pages that match the words someone types into the search box. The two most popular search engines are Google (www.google.com), and Yahoo! (www.yahoo.com). Search engines are designed to follow from one link to the next around the Internet, gathering information about all the web pages they find, and sending that information to a database where it is stored. If your website has no links to it from other pages, the search engines will never find you unless you take the time to go to each search engine and fill out a form telling them where to find your site. Once a search engine finds your page, it will "crawl" your site. What that means is that it will read every page and follow all the links from one page to the next. As each page is found, the search engine reads the text and analyzes the page to see what it is about. That information is then sent back home to the Google or Yahoo! database where it is stored.

When someone types words into the Google search box, for example, the Google software analyzes all of the pages it has stored in its database to decide which ones are relevant to those words. Google then presents a list of all the pages it thinks fit the search terms in order of importance. The really interesting part is that the Google software has very complex (and secret) ways of analyzing each web page so that when a search is performed, the pages Google returns are listed in order of relevance, with the first page most closely matching those particular search terms. Getting yourself to the top of that list is what it's all about, because if your website shows up on page three of that list, you might as well be invisible. Human visitors have a notoriously short attention span, which means they rarely ever look past the first or second page of choices presented by the search engine.

Two Ways to Create Your Site

Once you decide to create a website for your business, you can get the ball rolling one of two ways: do the work yourself or hire someone to build your website for you. If you have never built a website before, the amount of time you have available to dedicate to teaching yourself how to build a site is usually the deciding factor. However, taking what seems to be the easy path — hiring someone to build the site for you — may not always turn out to be the best choice in the long run. I describe both options in the following sections.

Build your own site

You'll reap some huge benefits if you can learn to build your own website. First and foremost is the convenience factor — you can literally make a change to your website in 10 seconds, and if you learn about some new technique or you want to incorporate a new design, you can do it any time you like. The second benefit is the money. Over the whole of your own personal lifespan, you'll stand to save thousands of dollars, and maybe tens of thousands if you use your website a lot.

Can you do it? Building a website is definitely *not* rocket science. If you're a bit motivated to succeed, you should have no trouble. Of course, the beginning stage will be slow because you first need to read educational books and websites about how to do the various jobs you need to accomplish. But like anything, once you learn the basics, you'll be able to get started, and your website will evolve right along with your skills. I have personally deleted my website and rebuilt it from the bottom up six times now. Sometimes you might do something like that to

create a different style for the site, and sometimes it might be to redirect the site toward a different customer. Once you get the basic ideas about website construction it isn't that difficult to do it again, and every time it gets better.

Hire someone to build a site for you

Many photographers simply hire a website designer to create a site for them. The amount of time you have to spare will probably determine whether you try to build your own site or hire the job out to someone else. If someone else does the work for you, you'll almost certainly be online, looking good, and ready to go far quicker than what you could ever hope to do on your own, but the advantages of this method often end there.

If you hire out the job, you'll have the choice of spending tons of money to get a designer who will work one-on-one with you to customize your site, or spending much less to get a "template" site that will look pretty similar to other sites built with the same template. The template sites will certainly work, but companies sell so many of them that before long, your prospective bride might get the impression she's driving through "the 'burbs" of the Internet, where every house looks pretty much the same except for little touches here and there on the paint. If you hire a custom site builder, you'll get exactly what you want, but of course you'll pay a premium to get it.

The major drawback to both a custom site and one designed from a template is that you have to continue to pay the people who created the site an hourly rate every time you want to make a change — forever! That may not seem like a huge thing in the beginning, and it tempts many people to try the quick and easy route. But as with most things in life, the quick and easy path is not always as wonderful as it seemed at first glance. Imagine you read through your site and find a typo, or perhaps you want to change a price. You have to contact the designer who created the site for you, tell him or her exactly where you want to make a change and exactly how you want it to look, then wait for the designer to complete your request. Depending on how busy this person is, you might wait several hours or several days, but eventually the change is completed. If you're not totally satisfied, you start the process over with more specific instructions. When you are happy with the results, you send the okay and they bill you for the time — usually at a minimum rate of one half or a quarter of an hour, even if the change only actually took 10 seconds.

The Construction Phase

Building a website is a bit like building a house. You absolutely must start with a design, and then a foundation. You don't just throw a pile of 2×4s out on the ground and start hammering at them. You have to start with a plan. The best way to get ideas for your own website is to check out what your competition is doing. If nothing else, you may learn a lot about what you *don't* want to do with your own website. As you browse through your competitors' sites, make notes and sketches for features you like. Later, you can use the ideas you collect to rough out a design for your own site.

The design phase is by far the most difficult and also the part on which you should spend the most time. If you happen to be a great home decorator, you'll probably enjoy doing the design for your website as well, but if you happen to be the type who would hire a decorator for your home, then you could probably benefit from similar help with your website. This is where a graphic design artist can really make you look good. This person doesn't have to actually build

your site; he or she can handle details such as choosing colors, picking and making graphic elements such as buttons, choosing fonts, and creating background textures. You can then take these parts and put them together into a website.

Make it search engine friendly

You probably already know that you have to build your site in ways that allow and encourage the search engines to find you. The techniques used to do this are called *search engine optimization* (SEO), and I'll go into much greater depth about this later in the chapter. Before I get into all that, I must emphasize right up front that you basically have two visitors you cannot afford to neglect when you plan and build your website. Of course you have to please your human visitors, but you also have to please the search engines that bring those humans to your website. If you ignore either one when building your site, you'll be losing much of your potential. And building a website that is friendly to both can be quite a challenge.

The section in this chapter about SEO is vital to your success because it shows you ways to take the information you want to give your human visitors and present it in a way that helps your search engine visitors find you and analyze your site. SEO is a bit like trying to write something in two languages at the same time, with only one set of words. Both visitors actually speak the same language — they just understand the words in completely different ways.

Links and navigation

A link, or *hyperlink* as it is often called, is a word or phrase that contains the website address to some other page on the Internet. The standard style for a link is blue underlined text but that is often disregarded in an effort to make pages that have a certain visual style. But no matter what the color is, when your mouse moves over a link it automatically changes to a hand with a pointing finger. The pointing hand indicates a link that will take you to a different page if you click it. The text in the link is very important. For example, if I make a link like this, "Click here to see a web page about Glen Johnson" That link will have far less meaning to a search engine than a link made like this, "Check out this web page about Glen Johnson." The second one is made from the text that is very likely to be typed in the search box. Google will rate this link as being much more important than a link made from the words "click here." This text used in the link is called the *anchor text*.

The physical structure of the site has a lot to do with the way your clients move around in it. You have to balance your need to lead clients through all the information on your site without making them feel like they've gotten lost every time they view a new page. Each page should match the style of the others and provide clear ways to navigate to all the other parts of the site. For example, when clients click a link on your site, they are transported from one page to the next. If you've done your work correctly, they should still be able to find the menu (a collection of links for your site) that led them to the specific page and from each page, they should have no trouble using that menu again to go to any other page on your site.

Building a menu for your site is like building a flowchart. You make as few headings as possible; then from there you have subcategories, and each of those subcategories can have subcategories of their own. So let's say you make slide shows from every wedding you shoot. If someone wants to look at your shows, she certainly won't want to see a drop-down list with 30 shows all in a row. What you might do is put shows in subcategories by location. This way when a bride first clicks on the menu category for "Slide shows," she sees a list of locations where you've shot weddings. If she clicks on a location, a drop-down list of the slide shows

from that location appears. So the navigation would look like this: Slide shows ⇨ List of locations ⇨ Shows from each location. You can see an example of this in Figure 18-2. The most desirable effect of all this is to make your menu take up as little space as possible on the front page of your website. Study the menus you find on other websites and bookmark those you like the best. Before you start building anything, make sure to read all the SEO material in this chapter and other places to see what types of menus are visible to the search engines and which types aren't, because there are ways of making a menu that makes them invisible to the search engines. When you do that, you've got to come up with some other way for the search engines to find all the pages on your website.

Figure 18-2: This screenshot shows the navigation menu on my site. Every single page on my website has the same navigation menu at the top. This makes it easy to get from one page to the next without getting lost.

What to include

You can use your website for far more than a portfolio of your work. You can also use it to educate your clients by including information about how photographers work, how to schedule the time for photography, how to decorate the wedding site, and basically anything else you can think of that a bride may want to know about wedding photography. If you find yourself telling each bride the same thing over and over, why not take a few minutes to craft your answer into some well-written text and place it in a new page on your website? Many brides who are contemplating hiring you will read every single word on your website and the more you can educate them, the more professional you seem.

I see my website as my silent secretary — it takes calls, communicates with clients, shows them photos, discusses prices, and lets them know if I'm available on that date. By the time potential clients actually get ready to talk to me in person, my website has already confirmed they have the proper budget, an available date, and like my photographic style. By putting details such as prices, contracts, and other information on your site, you won't have to answer phone calls from people asking, "How much do you charge?" or "What kinds of things are in your packages?" When your website addresses all of these questions, it saves you a tremendous amount of time.

However, if you consider yourself to be a great salesperson and you enjoy talking to people and convincing them to buy your services, you may want to take the opposite approach and put just a phone number on your website so potential clients actually have to call and talk to you before they can get any details.

Software for creating your website

The most commonly used website creation programs are Coffee Cup from Visual Site Designer (www.coffeecup.com), and Adobe Dreamweaver (www.adobe.com). Of the two, Coffee Cup is far cheaper and easier to use for beginners. You can download this program and easily get started making web pages right away without having prior experience or understanding HTML (Hypertext Markup Language). Of course, Dreamweaver is much more powerful, and thus the obvious choice if you're going to take the time to really study website design and learn a lot about it. As you can see in Figure 18-3, the program seems a bit complicated at first glance. In either case, every minute you spend learning about website design will come back to you tenfold over your lifetime.

Every new technique you discover and incorporate into your website will push you that much farther ahead of your competition. However, in the beginning the temptation will be to fill your site with tons of cheesy little gimmicks just because you can. The challenge will be to develop a clean, uncluttered site design that is attractive enough to appeal to your market, while still maintaining all the basic function you need for it to work.

Figure 18-3: This screenshot shows a page from my website that is open and ready to edit in Dreamweaver.

Template websites: blessing or curse?

Unfortunately there are no programs that can create good graphic design ideas for you. And good graphic design artists are quite expensive. Those two problems have led to a whole new type of website: the template. You can go online and choose from hundreds of basic designs that are absolutely beautiful. If you purchase a template site you can customize it by adding your name and your photos, and some basic information to fill in the menu bar. This is what I mentioned earlier as "the 'burbs" of the Internet. When you purchase a template, not only will you have to worry about it looking very similar to the one your competitor just purchased, but you'll also have to pay a monthly fee to have it hosted, and more fees to put any custom touches on it. And if you stop paying the monthly hosting fee, it all goes back to the company because you don't actually own the thing; you're just renting it. And even if you do learn to work on website and you decide you want to work on your rented template, you must know how to work with Adobe Flash, as most template sites are built with this program. If all that isn't enough to turn you away from the templates, consider that almost all templates are created with Adobe Flash which is invisible to search engines, so all the text on your site will be invisible as well.

SEO and Construction Considerations

Before you start working on your website, take time to really study the major aspects of search engine optimization (SEO). Many of the early decisions you make in your website design will affect how your site performs in searches. How you name your files, the words you choose for titles, and whether or not to use frames or JavaScript or Flash or Java, probably sounds like Greek to you right now, but your answers to these questions will have a huge impact on how the search engines see your website, and it's much easier to design a site with these things in mind than it is to redesign a site after you've already made something that doesn't work very well.

In particular, you need to know that search engines don't read programming language. They can't see inside a Flash file, and they can't read JavaScript or Java. These items can look extremely cool to your human viewers, but the search engine sees a blank spot and nothing more. If you must use these types of technology, you have to know how to work around them and continue to create text and links the search engines can read.

For my own site, I wanted to use a JavaScript navigation menu that automatically unfolds when the mouse passes over it. I know the search engines can't see into this script so if I did use it, all my pages would be hidden from Google. To get around this, I made a formal Google "Sitemap," which is a text file that tells the search engines where to look to find all the pages on my website. There are ways to get around little problems like this; you just have to know how to do it. Or you have to know how to teach yourself, and the Internet is a wonderful teacher. Anything you ever wanted to know is right there.

As you might be able to guess by now, I'm no fan of this sort of website. I believe that photographers are where they are because they're creative and they're not afraid of technical things. If that doesn't describe you, you might as well quit reading this book. If that does describe you, then you can put some of that creative juice to work and make your own website.

Copying from other photographer's websites

I've had other photographers copy pretty much all of my website and just insert their own name where mine is. I've had them claim my pictures, claim to have written my articles, steal my calendar (with my jobs on it), steal testimonials from my clients, and even try to make websites with names almost identical to my own. They say, "Mimicry is the greatest form of flattery," but it's still annoying — not to mention illegal. If you ever find yourself being copied, the only consolation I can give is to remind you that those people are behind you! Don't spend too much time looking over your shoulder at someone who's trying to follow you. Think more about what's ahead of you and keep moving forward.

That's not to say you should simply take it. You can occasionally check to see if anyone is plagiarizing your pages at Copyscape (www.copyscape.com). If you find someone copying you, you may file a complaint with Google by following the directions found at www.google.com/dmca.html. This is in accordance with the Digital Millennium Copyright Act and if the legal folks at Google agree with your complaint, they'll remove the offending website from the search index. That should get someone's attention.

For those of you who are just starting out, which will be the majority of this book's readers, I would like to offer this advice. Not only is it illegal to copy the work of others, and as mentioned previously could get you removed from all Google listings, but also it is just plain wrong to build your business on something that you know will be harmful to someone else. While I strongly discourage direct copying, I don't discourage you from being inspired by new ideas and techniques that you find on other websites. In fact, my favorite way to get ideas for my own website is to scan the web looking at other photographer's sites. I might look at the code to see how they did something, and I might try to copy the "feel" of the site in some way, but I don't copy anything exactly, or in any recognizable form. One of the best possible sources of inspiration online is the Best of Wedding Photography website found at www.bestofwedding photography.com. The photographers featured on this site are the best on the planet, and the creativity found in their websites will constantly amaze you. Another source of inspiration is to do a Google search for "Graphic Designer" or "Website Design."

Slide-show options

Slide shows are a key element of all photography website and there are many different ways of producing them. Determining what you want the slide show to accomplish might be to first step in deciding which method you use. For example, if you want to put up a quick show with simple fades and no music, your best choice might be to use one of the Adobe Photoshop Lightroom or Photoshop slide show templates. If you want speed and ease of use, with a more dynamic show that has moving pictures and single music tracks, you can try Show It (www.showitfast.com). I use a Show It slide show on the front page of my website shown earlier in Figure 18-3. If you want extreme control and flexibility, I highly recommend ProShow Producer (www.photodex.com), which allows you to create amazing effects and have total control over both the sound and the images. The slide shows you make with ProShow Producer are rendered into just about any format you can imagine, but my favorite is HD video that can be uploaded to YouTube.

You can easily embed YouTube videos in your website, but the really amazing thing about them is that your viewers can choose a resolution when watching the show. If they have a slow Internet connection, they can use a low resolution. If they have a big monitor and are willing to wait for the download, they can watch it full screen and as high as 1920×1024, which is *big*! No other format can even begin to compete with a slide show like that. Playing one of these videos on a big monitor, with a good sound system, is an amazing experience.

SEO: How to Get Found

The Internet functions in a very different way from say, a *Yellow Pages* ad. The two are similar in that they both have information about you, but the phone book shows listings for anyone who can afford to pay for an ad, while the Internet shows listings based on how important other businesses think you are. This fundamental difference makes the Internet a very challenging and competitive place to market yourself, while at the same time making it a very effective tool when you're trying to find something amidst the millions and millions of pages out there on the web.

Factors that Affect PageRank

The following is a list of factors that will affect the PageRank of your website in the Google search engine:

✦ The age of the website and the age of the specific page

✦ The overall popularity of the website on the Internet

✦ The text in the Title tag (must include best keywords)

✦ The words used in links pointing to the page (anchor text)

✦ The number of inbound one-way links

✦ The number of two-way reciprocal links

✦ The text in the Description tag (again with keywords)

✦ The visible page text that repeats all keywords from Title and Description tags

✦ The words used in Alt tags

✦ The words used in Header tags

✦ The quantity of words on the page

✦ The frequency the page is updated or changed

The first concept you have to understand is called *PageRank*. This Google-copyrighted term is represented by a number between zero and ten that is given to a web page to indicate how important the Google search engine thinks that page is compared to other pages on the Internet. Pages that have a lot of links are considered important so they receive a higher PageRank and are more likely to appear at the top of Google's search results. Pages that have few links are either new, or not deemed to be very important by other website owners, so these pages are given a lower PageRank.

PageRank also considers the importance of the page that makes the link. Pages that have a lot of inbound links and a high PageRank have great value; thus when a highly valued page makes an outbound link, that link carries greater value than the same link would have if it came from a page with a low PageRank. This is basically a peer review system. On the web, you don't get to be important until other people think you're important, and if really important people think you're important, that's even better.

There are no "secrets" to SEO because everything you could ever possibly want to know about the topic is right there on the Internet waiting for you to read it — for free. Simply type SEO into Google and you'll have months and months' worth of homework at your fingertips.

That is exactly what I did when I decided that I wanted to be a destination photographer. I simply sat down and started reading for about two weeks straight. Then I deleted my entire website off the server and started building a new one based on the SEO concepts I had learned.

People sometimes ask, "How do you keep up with all the changes going on with the search engines?" And the answer is, "I don't." The reason I say that is because I've learned that the basic concepts of search engine marketing don't change much. It's the different methods of cheating that change so rapidly. Based on all the things I've tried over the years (mostly legal and some not so much), I've learning that following the basic rules and concentrating my efforts on the major methods will accomplish my goals with far less effort than trying to keep up with all the little ways to cheat and then dealing with getting caught and having to rebuild everything to get out of trouble.

I once got in trouble for using something called "doorway pages," which I had never even heard of before that date. Figure 18-4 shows my website statistics around that time. Can you tell when Google discovered that I was doing something against the rules? You can also see that even after I fixed the problem, they were in no hurry to get me back into the game.

Figure 18-4: This screenshot shows how my website visitors dropped off when Google found out I was using "doorway pages" on my site. Google completely dropped me from the index until I changed my site to meet their requirements.

What is cheating and what happens if you do it? It turns out that each search engine has various rules and regulations (listed on their websites) that spell out what you can and can't do. In reality, it's pretty much common sense. If you do something that is directly aimed at misleading the search engines, they will eventually figure it out. They won't call you on the phone or send you a nasty letter, but what they will do is rewrite their search engine to penalize people who cheat and place them lower (if at all) in the search listings. And they won't tell you they've done this because their efforts are not aimed at you alone. Their efforts are aimed at maximizing the ability of a searcher to find exactly what he wants without having to dig through pages and pages of junk. So if you cheat, one day you may be at the top of the world and the next day you don't exist. I don't know about you, but I've got more important things to worry about.

SEO Techniques

The following is a list of the most basic elements of good search engine optimization. If you concentrate on these few things, you won't have to worry about getting slapped down by the search engines.

Keywords

Keywords are the very first step to good SEO. Keywords are the terms your future clients will type into the search engine box when they need to find your service. For example, if you live in Atlanta and you want to show up when someone types "Atlanta Wedding Photographer" into Google, those are your main keywords. Your first page will need to be optimized for the keywords you want the most. However, you may have many pages on your site and each one of them can be optimized for a completely different set of keywords that are specific to that page.

What are your keywords? In most cases it will be obvious, but if not, you might have to do a bit of research. In either case, you absolutely must define the words you want to target for each page. If you have a lot of keywords, then you must make a lot of different pages. Don't make the mistake of trying to put a hundred keywords in one page. Doing that waters down the importance of each keyword and what you really want is for a page to concentrate on just a few keywords so those words are evaluated to be of high importance. Your home page will almost always be ranked the highest, so use your most essential keywords on that page. Other, less important keywords should get pages of their own.

The following websites can help you determine your keywords:

Good Keywords (www.goodkeywords.com)

Google Trends (www.google.com/trends)

Keyword Discovery (www.keyworddiscovery.com)

SEMRush (www.semrush.com)

Wordtracker (https://freekeywords.wordtracker.com)

YouTube Keyword Tool (https://ads.youtube.com/keyword_tool)

Do your research to find the best keyword phrases. The phrases you think your target market might be searching for may very well be incorrect. Compile a list of the most relevant phrases for your site, and don't use them all on one page. Avoid targeting general terms like "Weddings" because a million other people will be targeting that term, and because your site is not about weddings in general; it's about "wedding photography" in specific and people who want the photography part are the only ones you really want to catch. You should pay particular attention to the less often searched phrases and common misspellings because the competition for these people is low, which makes them much easier to draw in to your site.

Title tag

The *title tag* is the single most important piece of your SEO effort. This is the first place for your keywords to show up. You don't need to be repetitive — just one instance of each keyword needs to be in the title. Then make sure that every keyword in your title also shows up again in the text of that same page at least five to ten times depending on the total amount of text on the page.

For example, if I were to write a title tag to market myself in my hometown of Eugene, Oregon, I might use something like this:

```
<title>Eugene wedding photographer, Eugene Oregon wedding photos,
Eugene Photojournalistic journalistic style wedding photography by Glen
Johnson.</title>
```

Note that the most important keywords or phrases (terms the searcher might use when looking for your service) need to appear first in the title. Placing the same words farther along in the title will lower their importance to the search engines.

Also, it is not necessary to put your name or your business name in the title tag at all unless you're likely to get customers who search specifically for those words. In my case, due to this book and occasional magazine articles about me, people do searches on my name, so I would put that in the title, but not at the very beginning. The general rule is to place your keywords in the title in order of importance.

Notice that in the sample title I used the word "Eugene" three times, "wedding" three times, and for "photographer" I used three different versions of the word. You will get penalized if you blatantly repeat a single phrase over and over, but as long as you are honestly trying to use multiple versions of each keyword or phrase that human searchers might use to find you, you'll do fine. There doesn't seem to be any real enforcement to the length of a title tag, but if you try to use hundreds of words of random text, with your keyword appearing over and over, you will be penalized. Stuffing in extra keywords won't help past a certain point, after that it becomes a combination of all the other factors that determine the ranking of your page.

In my example title, I've used the keyword phrase, "Eugene wedding photographer," and I added other words that I think might also be used in searches. For example, I think some people might search for "Oregon wedding photographer," and others might search for "Eugene journalistic wedding photographer." If your keyword or phrase is something that might possibly be misspelled, by all means put in several differently spelled versions.

Your human searchers will only see the first few words of your title in the search results, so it doesn't hurt to use a nonsense phrase like,

```
"photojournalistic journalistic style wedding photography"
```

The search engines don't care about grammar; they just read (and count) the words. They also don't care about punctuation. However, when a client types "Eugene wedding photographer" she will be presented with a list of photographers and each listing will show only the first few words of your title, so you really should make that first line sound sensible to your human clients.

Links

When someone places a link in his website that points to your site, or to a page on your site, this is called a *return link*. Return links are often called "back links" because they only point from another website back to your website. Reciprocal links are where you trade links with another website and each of you has a link pointing to the other. Reciprocal links are valuable, but not nearly so much so as a nonreciprocal link from a website that is in your same subject area. Links in directories are the easiest to find, so look up every wedding photography directory there is and get your site listed there first.

Seek out only free links — never pay for links. One way to find link partners is to look at the links other photographers have and try to get the same ones. These sites are obviously receptive to linking to a wedding photographer so it won't be as difficult as other sites might be. You can find all the links to any website by going to www.yahoo.com and typing "link:www.yourwebsite.com." I just did this for my own website and found that I have 1,440 back links — most of which come from an old friend who is a very prolific blog writer, and many of the others from sources I've never even heard of. A large following like that takes a long time to build, but once you get into it, your efforts are magnified by the fact that, as your popularity builds, many people and directories will find you on their own and put up a link to you without you ever knowing it. Don't bother checking with Google for back links; they never list more than a handful even though there may be thousands. According to Google, I have 16 back links.

Perhaps the best way to get back links is to provide valuable content other people will want to link to. If your site is full of wonderful, useful information, other sites will naturally link to it without requests from you. For example, few photographers would normally care to link directly to my portfolio because they have no desire to show my work to their clients. However, I've written several articles for brides that other photographers like and want to share with their brides, so I allow them to copy the article and share it with their own clients in exchange for a link back to my website. This is a one-way link from someone in my field — the most valuable type of link there is.

Once you've constructed your page with proper SEO techniques, building your return links is the next most important thing you can do to go up in the search listings. However, you only want to trade with good quality sites, if you trade tons of links with low quality sites, Google downgrades the importance of all your links. One way to get link trades started is to schedule a regular time when you sit down and send out letters to solicit reciprocal links. Most people who understand SEO even a tiny bit will welcome your efforts at trading links. The easier you can make if for them, the more likely you are to be successful. Crafting a letter such as this will make it easy. Send the letter to people in the wedding industry and especially to other photographers who are not your direct competitors. For example, if you live on the East Coast, send a letter to photographers on the West Coast, or in other countries where you have no desire to work.

The following is a sample letter soliciting a reciprocal link exchange:

Hello,

My name is Glen Johnson and I'm a wedding photographer in Eugene, Oregon, USA.

I'm trying to boost the ranking of my website by trading links with sites like your own, which is in the same market, but not a direct competitor due to the geographic distance between us.

We can help each other by exchanging links. Increasing the number of links from members of your own industry is the single most influential thing you can do to boost your search engine rankings. A link trade between us will elevate both of our websites.

The details for my link are below. If you add it and send your details I will be happy get you up on my site as soon as possible.

Thank you for taking the time to work with me on this.

Your link will be added here: www.aperturephotographics.com/links

--------------------------My preferred link text -------------------------------

Eugene Wedding Photographer

-------------------HTML version of my link----------------------------

Eugene Wedding Photographer

--

Link to: http://www.aperturephotographics.com

Description: Storytelling Wedding Photography in Eugene Oregon.

Anchor text

As mentioned earlier in this chapter, the text a person uses when forming a link to your site is even more important than the link itself. For example, if I wanted someone to create a link to this page on my site: www.aperturephotographics.com/hawaii_wedding_photographer.htm, I might ask the person to make a link like this: "Check out the photos from Hawaii Wedding Photographer Glen Johnson." The words used in the link are the important part. If the person made a link to that same page with these words: "Click here to check out the photos from Hawaii Wedding Photographer Glen Johnson," nobody searches for the words "Click here" so that text doesn't carry the same level of importance as a link that uses the same words that might actually be typed into the search box. The words used for the link are officially called the *anchor text*.

Page text

When you sit down to write text for each of your pages, your primary concern should be to please your human viewers. The search engines will be equally pleased by almost anything that provides unique and valuable content. You can make your human visitors particularly happy if you can work in a few little things without compromising the readability of the page, or creating nonsensical sentences designed only for the search engines. This can take quite a bit of thought and creativity on your part, but you'll be in great shape if you can manage to write text that sounds good to a human and also uses keywords at every reasonable opportunity. Put page and paragraph titles (containing keywords) in the Header 1 style and use Alt tags (containing keywords) on all images, videos, and other media files.

Don't ever try cheating by stuffing in lots of text that is the same color as your page background. It may look invisible but the folks at Google will catch it. In fact, no method you might use for stuffing in a million keywords will help as much as getting more return links to your site. After you've used your keywords five to ten times on a page, any more will have diminishing returns, and then negative returns if you overdo it.

Make Your Site Search-Engine Friendly

Search engines are not real people. They are small computer programs that run through websites and gather information to use in cataloging that website and the Internet as a whole. When a search engine visits your website, it looks for information in the text to see what you do. If some of your pages have links to more pages on your site, the search engine will attempt

to follow them all to create a full map of your site. You may be making the search engine's job difficult or impossible if you build your site with Flash, or use Frames, or use JavaScript drop-down lists to create the links from one page to the next. Also, of course, many photographers like to use images, but a search engine can't see an image. It can only read text.

Images

Many website designers will want to use fancy fonts that must be made into an image in Adobe Photoshop because the web only supports the most basic fonts. These text images mean nothing to a search engine. When you do use images, be sure to take advantage of the ALT tag to add in the appropriate keywords for your site. These tags carry a fairly high level of importance with the search engines.

Flash

Adobe Flash is a complex program that makes animated objects and even whole websites that are contained in a single file with the .swf extension. These files can be as small as a moving bit of text, or they can be a whole website complete with photo galleries and music — all compressed into one file that contains everything. In the past, this type of file was completely invisible to the search engines. More recently, Google has been making big strides in being able to look inside these files and index the contents, but you will still be taking a risk if you make your entire site with Flash — or if you purchase a Flash template site.

Frames

A framed website starts out with one page that describes how to divide your view screen into two or more compartments. The first page contains nothing more than the instructions on how to arrange the other pages that fill each compartment, or *frame*. The first page is not visible to your human viewers. However, the first page is the *only* page that a search engine can find. This can be used to your advantage because you can put any keywords in there you like and it doesn't have to look good or make sense to human viewers. Just remember that the search engines can't see the other pages that show up in the frames, so you will need to put a sitemap on your index page that has links to any of your other pages that you want the search engines to find. Framed sites are no longer very common because of this problem.

JavaScript

JavaScript is a computer code language that is not readable by the search engines. If you make any of the text or links on your site with JavaScript, the search engines will completely ignore it. You can see in Figure 18-3 that the drop-down menus on my own site are made this way, and in fact, this is an extremely common way to make a navigation menu that folds up out of the way. If you use this technology, be aware that all the links inside the menu are invisible to the search engines so you'll have to provide some other way for the search engines to find all your pages.

Robots.txt and Sitemap.txt

If you use Flash, frames, or JavaScript in the creation of your website, you need to make arrangements to have text and links appear in other ways so that the search engines can read

them and follow the links to all of the other pages on your site. Usually, the search engines wander through your site by following one link to the next until they've made a catalog of the whole site. But what if you have pages that don't link together? Will the search engines find these pages? The easiest way to fix this is to use a sitemap file that contains links to all the other pages on your site. The *sitemap* is a text file titled simply "sitemap.txt." You can write this file with WordPad or your website editing software like Dreamweaver or Visual Site Designer.

You also need to put a reference to the new sitemap file in your robots.txt file or the search engines may never find the sitemap. The sitemap.txt and the robots.txt files are simple text files that you can easily create yourself. Find out exactly how, and why, to write these files by typing "create robots.txt" and "create sitemap.txt" into the Google search box and you'll have plenty of articles and current samples to learn from. Start off by reading all about these files on www.wikipedia.com.

Summary

Building a website and making it easy for customers to find is one of the most challenging and necessary parts of becoming a successful wedding photographer. Can you survive without a website? Maybe, but if you make (or buy) a really good website, suddenly it gets easier. Your clients find you — for free! And your market suddenly expands to encompass the entire planet. You're not limited to a tiny *Yellow Pages* ad, or a weekend ad in the Sunday paper; now you can post pages and pages of information, and you can put up all the images you want — at no additional cost!

In this chapter you'll find basic information about constructing a website from the ground up. This is not a detailed how-to article, but rather an overview of the process and concepts necessary to construct a quality website that will easily attract visitors.

The second half of this chapter concentrates on making your website findable. The concept of search engine optimization, which is an absolutely essential part of your website, is introduced. Living without it would be like printing a thousand beautiful business cards and then never passing them out. Nothing matters on the web unless your customers can find you.

✦ ✦ ✦

19
Destination Weddings

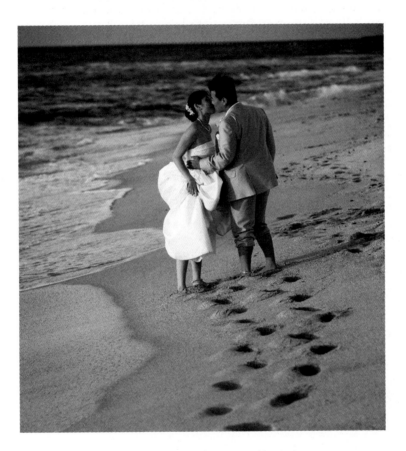

B y some estimates, as many as 10 percent of all weddings take place outside of the couple's home area, and many of those are even out of the couple's home country. This small but growing segment of the wedding population is not just made up of the wealthiest of clients as you might expect. Some couples actually choose a destination wedding to save money. Others plan a wedding abroad because they want a small wedding with perhaps only a few guests or none at all. In any case, they certainly don't want to miss out on the unique photo opportunities this sort of wedding presents. In fact, the extra work and money these couples

often put into making the event unique seems to make them that much more concerned with finding just the right photographer to preserve the event in a way they will enjoy sharing with all of their friends back home.

The very nature of a destination wedding requires travel to get to the event, so when a couple starts looking for a photographer, it really doesn't matter if that photographer lives just down the street from them or on another continent. This fact, combined with the worldwide shopping potential of the Internet, opens up the search for photographers to include a large portion of the globe.

Destination wedding couples are usually computer-savvy people who typically feel comfortable functioning in a high-tech world. It is not unusual for them to sit in front of their computers for hours at a time, seeking out and comparing the absolute best photographers. If they find someone whose style matches what they want and their budget, they won't hesitate to make all the arrangements over the phone and via e-mail without actually meeting the photographer in person.

In this chapter I discuss options for marketing yourself to these clients, pricing the job, choosing the right equipment for travel, and getting to the wedding and back in one piece.

Reality Check

For many wedding photographers, the dream of shooting a destination wedding ranks right up there with shooting a celebrity wedding. Shooting a destination celebrity wedding — well, that would just be *it!*

Is the reality as good as the dream? Having shot move than 50 destination weddings, I can say that I've experienced the dream and come out into reality on the other side. Some aspects of the fantasy are truly wonderful, but other aspects will weigh heavily against the idea of making destination weddings a large piece of your business. For example, walking on a deserted beach in Fiji is quite a treat. However, to get there you must spend a significant portion of your life in the world of modern transportation (see Figure 19-1), where you get to experience things like getting stranded in airports with overbooked flights; getting bumped from one standby flight to the next; eating terrible airport food because you have no choice; getting sent to a courtesy room at 2 a.m. only to find you're checked in at the Roach Motel with no running water and a highway right outside your window; getting the wake-up call two hours later and not being able to remember whether you're in Los Angeles or Miami but knowing that you have to get to the other side of the planet today or you'll miss the next wedding. During the flight, your muscles will cramp up from hours and hours of sitting in the same position without getting up except to use the restroom. And unless you're good at sleeping in an upright position with nothing to rest your head on but the stranger in the next seat, you'll arrive at your destination anywhere from five to forty hours later — in a state of extreme sleep deprivation. You'll get seasick, airsick, sick from creatures in the water, sick from creatures in the food, sick of being covered from head to toe with bug bites, sick of being the constant target of street hustlers, and if you ever manage to get really ill — as in high fever, vomiting, can't move, ill — you'll have to take care of yourself with no outside help and very sketchy medical resources, if you can find them at all.

Figure 19-1: Airline flight is quite the modern miracle, but don't count on getting a good night's sleep if you travel to a far-off destination wedding.

Have I scared you away yet? Okay, there's more…

You'll find yourself running a mile through a crowded airport dragging all your photography gear behind you — only to get there and have airline personnel tell you the gate changed at the last minute so you missed the flight anyway. You'll have to get used to repeating this routine over and over: Show the passport, unpack the backpack, pull out the laptop, take off the shoes, spread your arms and legs for the pat down, then put everything all back together again. You'll learn to dress to make it easier — nylon belt buckle, slip-on shoes, phone stays in the backpack, no change in pockets. Your luggage will get smashed, ripped, and melted; the wheels will get knocked off; and it will all get sent to the wrong country. Your luggage will also eventually get opened in the back room and anything interesting or valuable will disappear forever.

If the customs guys decide to search you, be prepared to hand over a substantial wad of cash to the nice man who seems to be saying something about a tax — and no, you don't get a receipt. You have to get used to the idea that bribery is an accepted form of negotiation in much of the world. So when someone at the Mexico City International Airport tells you there are no more seats available on your flight (for which you already have the ticket), don't freak out and start screaming at him, just put a $20 in your passport and very kindly ask him to please check again to see if maybe he missed your name — it's true, you're not in Kansas anymore.

You'll find a lot of cab drivers who imagine themselves to be practicing for the Indy 500. If you get tired of the death-defying cab rides, just rent a car and try it yourself. Now you have to deal with road signs that are in a different language; driving on the left side of the road; shifting gears with your left hand and hitting the windshield wipers instead of the turn signal every single time. In a rental car you'll have to deal with all of the above, plus managing to dodge the people and goats that always prefer to walk in the road, while also trying to read a map to find your way around. If you can read the road signs at all you've got it made — that is, if there are signs. Many third-world countries have vast areas of country roads, and even major highways in major cities, with no road signs. How good are you at using a map and compass? Do you even have a compass?

You'll learn to ask for a hotel room on the second floor or higher, and you'll check the locks on the doors and windows before you pay for it, because there are people in many countries who make less in a year than what your camera is worth, and sooner or later, they will try to get it away from you.

Eventually, though, you stumble out of the cab into paradise! The shimmering water, the warm sun, and the coral sand between your toes all slowly melt away the trials of the journey. Being there in a different country is the truly magical part. If you like new experiences, like the challenge of never knowing what's going to happen next, and are easygoing and quick to adapt, you just might fall in love with getting to explore the world as a destination wedding photographer.

However, if you want to be a destination wedding photographer, you must be the type who can relax and enjoy the ride. You must be able to appreciate the fact that life is about the journey and the best part is not the end — it's all the little adventures, and disasters, that happen along the way (see Figure 19-2).

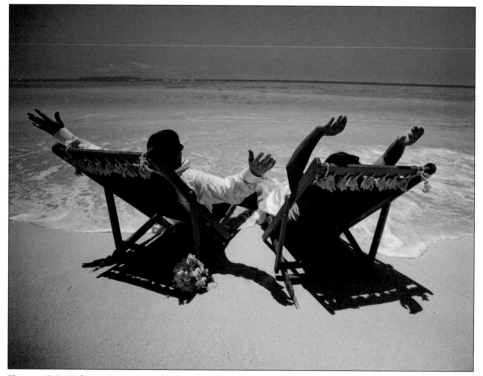

Figure 19-2: Taking pictures on the beach on a remote Fijian island is quite a shock to someone coming from Oregon in December. Total travel time from my house to Taveuni Island: 46 hours on the way out (had to wait for the Typhoon to pass), 32 hours coming back home.

How to Find the Jobs

Landing your first destination wedding job is not something you should be too concerned about when you first start off in the business of wedding photography. However, as your skills grow and you gain the experience and talent necessary to compete in the market, you will start to catch the attention of a few destination brides.

Basically there are four avenues for finding these jobs. The first is, of course, blind luck. Occasionally you will shoot a wedding for one person who absolutely loves your work and her sister remembers you when she plans her wedding. Of course, the second sister has to outdo the first, and before you know it, you're packing up for your first destination wedding.

The other three sources are: (1) your website, (2) wedding coordinators, and (3) paid advertising. These sources are much more reliable, and they have the potential to supply a steady flow of customers.

Your website

Building a website is only the first of many steps to being found by destination brides. As discussed earlier in this book, unless you know how to market that website, it won't get you very far, no matter how incredible it is. From the preceding chapter, you learned that if you want to work in New York City, you have to design a single page on your website that shows up when a bride goes to one of the big three search engines (Bing, Google, and Yahoo!) and types in a search phrase, such as "New York wedding photographer." If your website doesn't appear on either the first or second page of the search results, you don't exist!

If you want to work as a destination photographer, you have to create a single page that targets each geographic location where you wish to work. This is far more difficult than just targeting your home page for your home town, which is what most wedding photographers want to do. When you get into creating multiple pages for multiple locations, you still use the same search engine optimization (SEO) techniques on each page, but each page must be unique and different from the others by a large percent. That means each page has to have unique and valuable content about that location. You can't just make copies of your home page and change a few words here and there to fit that location. The search engines call that making "doorway pages," because each page is largely identical to the next, and its sole purpose is to redirect customers to the home page. (That's what I got in trouble for.) Each page has to stand on its own. So if you make a page that targets couples getting married in Aruba, you need that page to have a lot of information that is specific to Aruba and no more than a small percentage of that information can be identical to other pages on your site. If you try to have more than 50 percent of your content repeated on all of your destination pages, you run a high risk of having those pages downgraded by the search engines.

One way I discovered to get around this is to take any text that you want to have repeated on every page, set that text on the same colored background in Photoshop, and then output that text block as a JPEG image file. Remember, an image file, even if it has text on it, is invisible to the search engines. This little trick eliminates the repeated text and only leaves the unique text for the search engines to read. So now you may not have as much text, but all of it will be

unique to that location. The last step is to make sure your home page contains a text link to each of your destination pages so that the search engines will find them quickly.

If you concentrate on other types of advertising, such as working with wedding coordinators or purchasing advertising space in magazines, you can use your website as a portfolio without trying to make it show up in the search engines. In this case, a potential client finds out about you from some other source and then goes home to look your site up on the computer.

In any case, having a well-designed website with a lot of helpful information and great images is the key to convincing brides to spend the money to fly you to some faraway place. The couple shown in Figure 19-3 found me on my website and were already about to hire me when they looked at my address on the contract and realized that we both live in the same town!

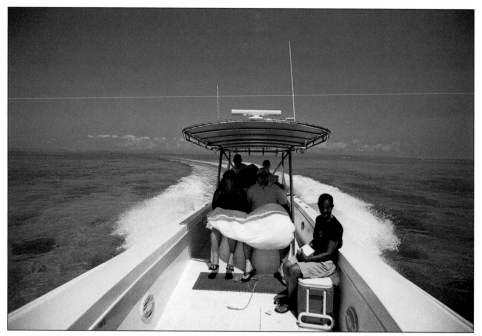

Figure 19-3: Be prepared to ride on a lot of small boats where the conditions can range from super deluxe, as in this shot, all the way down to tortuous rides where you need Dramamine and spend half the day getting pounded and drenched by big waves.

Wedding coordinators

Your website is only one aspect of a good Internet marketing plan. After you have a website, you have to start telling people how to find it by passing out information about yourself that can lead potential clients to your site. You can spread the word about your website in many places, but the source brides trust the most is a good wedding coordinator. These people

make it their job to know everything there is to know about planning a wedding, and they are hired to take over the job for brides who have more money than time. Many coordinators are responsible for finding and hiring all of the vendors that work at the wedding. If you are hired for one of these events, you may never even talk with the bride until the day of the wedding because all planning is done through the coordinator.

If you manage to get in good with a high-end wedding coordinator, you can count on a steady flow of new clients. Most of these relationships start by accident, when you happen to get hired by a bride who is also hiring a coordinator. As you work together with the coordinator on this first wedding, the coordinator gets a sense of your personality, and then after the wedding when you send him or her a slide show or a small album, the coordinator knows that you can be counted on to produce good work. Every time you impress a wedding coordinator, it can turn into multiple jobs in the future.

Many wedding coordinators can be contacted through their own websites. If you can manage to talk them into visiting your website and looking through your portfolio, you may be able to get jobs without meeting them first in person. However, there are thousands of good photographers in the world, and coordinators know very well that it is your personality and your professionalism that makes you stand out from the crowd. Wedding coordinators will be looking for an outstanding portfolio, but they also want to see a good business structure with a solid contract and a professional attitude. These are details a bride might not care so much about, but a coordinator is much more business-oriented than the average bride.

If a wedding coordinator finds a job for you, it is not at all unreasonable for you to voluntarily send him or her a "thank you" in the sum of roughly 10 percent of your profit. This money may or may not be required but, if you pay it voluntarily, as a gift of course, you can bet you will be on top of the list next time around.

With some coordinators, and particularly those who work for big hotels, the kickback is a required part of the partnership, and they may even stipulate it in a contract. I've always thought it mildly amusing that they want 10 percent of the photographer's $3,000 profit, but would they pay 10 percent of their $50,000 profit if you sent a wedding to them?

Paid advertising

Destination brides need information! These women must often do all of their planning through magazines and websites using only phone calls and e-mail to contact the vendors. They want to know about locations, coordinators, bands, photographers, catering, dresses, and all sorts of other details. Fortunately most of these magazines and websites will be happy to sell you ad space.

Web

The most prominent websites brides look to for general wedding information are The Knot (www.theknot.com), Wedding Channel (www.weddingchannel.com), and Best Destination Wedding (www.bestdestinationwedding.com). These sites sell ad space for photographers at a very reasonable rate, which you can easily recoup in your first job. My favorite feature of these websites is the "discussion board." This is where a bride goes to post a question to thousands of other brides. You can go to the discussion board yourself to look but don't dare make

comments or you'll be blackballed because vendors are generally not allowed. What you can do is ask your current brides to post a good reference about you on one of these boards. This can be an incredible source for new business. All it takes is one talkative bride to get new jobs flowing in from all over the world. This also works in reverse: if you make a bride angry she can put a huge long-term dent in your business by posting her story on a couple of discussion boards.

Magazine

There is no shortage of bridal magazines on the bookstore shelves today. Many brides go through five or six magazines a month as they plan their wedding. Magazines are a great place to spend your advertising dollars if you want to do destination weddings. Most of these magazines gladly sell you as much space as you can afford — which may not be much at the rates they charge. However, even at the outrageous rates, it would be hard for you to not make money with this sort of advertising. The thing to remember with magazine advertising is that it is a long-term endeavor. You won't land many new clients on the first few times around but if you can maintain a steady campaign of continual ads, you will eventually build up some name recognition. The best magazine that caters specifically to the destination bride is *Destination Weddings and Honeymoons* (www.destinationweddingmag.com).

As mentioned before, you can occasionally get free ad space by sending in a selection of pictures from one of your weddings for the "Real Weddings" section. This coverage may not feature your name very prominently but it gets you out there for free, and any bride who wants to find you after seeing the pictures can do so. The images shown in Figures 19-4, 19-5, and 19-6 were all taken from a wedding I shot after the bride found my advertisement in a magazine.

Figure 19-4: This Jamaican wedding came to me from a magazine ad. After the wedding, I traveled around with the couple for a day in the country south of Negril.

Figure 19-5: Rural Jamaica can be such a friendly place. The scenery is beautiful and the locals are fascinated by foreigners.

Figure 19-6: Waiting for the traffic to calm down near the little town of Roaring River, Jamaica.

Travel Arrangements

The physical act of getting there and back is sometimes the most adventure-filled part of a destination wedding. You will travel by airplanes, buses, taxis, and rental cars to get where you're going. You have to learn how to use them all and when to use each mode of travel. The following are some tips and techniques you might find helpful as you travel to your next destination wedding.

Airline travel tips

Working as a destination photographer also means working as a travel agent. If you get really busy, you may eventually decide you want to hire a travel agent to take care of the details, but even then you need to know how to arrange your own travel in case emergencies pop up. You need to develop the skills necessary to find tickets, order tickets, and change tickets. You can do much of this job through the Internet, but often the Internet is not the best method. The following is a collection of tips and techniques that I've gained while organizing my own travel.

The main websites for airline travel arrangements are Expedia (www.expedia.com), Orbitz (www.orbitz.com), and Travelocity (www.travelocity.com) . Travelocity tends to have the highest prices, so I rarely use it. Expedia works great for regular tickets within the United States, where you go straight out to one destination and then straight back home. Orbitz works much better than the others if you have complex travel plans that involve multiple countries or travels that require stopping overnight and then continuing on the next day. The online trip finder at Orbitz brings up hundreds of flight combinations to get you where you need to go. You can look through the selections and choose your favorite single flights, or you can choose a whole package of flights.

For a really complex flight, what seems to work best for me is to use one of the travel websites to see what flights are available at the times I want. As I find each flight segment that works, I copy the details from the site and paste them into a text document. When I get the whole potential itinerary together, I call an agent at my favorite airline and he or she puts it all together in a finished itinerary. After you purchase your ticket, make sure to get a receipt via e-mail and check it carefully. It is also good practice to get the name and direct phone number of the ticket agent so that you can get back in contact with this same person again if there is a mistake. If you said Aspen and the ticket agent thought you said Austin, this is the time to catch that mistake. If you happen to be purchasing a ticket for two or more different locations, it is much better to talk with an actual person at one of the airlines. This person can make sure your tickets work without any overlapping times, and he or she can find the best rates — often far better than what you can find on your own with the Internet.

When to purchase tickets

Wait until about three months before the date of the wedding before purchasing your tickets. There are two reasons for this. One is that if you make a reservation six months in advance, you may get another wedding that requires you to change your first ticket in order to accommodate the second wedding. Changing tickets costs you at least $100 and occasionally you have to forfeit the original ticket completely and start over. The second reason for booking three months in advance is that this is the best time for low prices. The airlines wait until the date gets close before they make the best ticket rates available. Two websites: FareCompare (www.farecompare.com) and Skyscanner (www.skyscanner.com) are good resources for finding price trends over time. This is helpful because you really should know what a good

price is before you start shopping; otherwise you run the risk of watching the price fall after you've already got your tickets. With FareCompare, you can set up a trip and they automatically check the price every day and e-mail you if the price changes significantly. FareCompare also has a star rating system on prices, which compares today's price to the historical low price for that time of year. One star is a good price and three stars is a super-good price. This is helpful when you would otherwise have absolutely no idea what a good price should be.

In general, prices start to drop about two to four months before the flight. Then they spike upward when almost all the seats are taken. Then if there are any seats left at all, the price will drop again very steeply about a week before the flight, when the airline become desperate to fill those last few remaining seats. I don't recommend that you ever try to wait for that last-minute low price because if the seats do actually fill up, the airline won't need to drop its prices in the final week before the flight and you'll be left without a seat at all.

To give you an example of how the prices fluctuate, I checked the fares for a flight from Eugene, Oregon, to Athens, Greece (see Figure 19-7). I actually do need to buy this ticket and am amazed at how accurate my prediction is. Here are the results:

Leaving tomorrow: $495 (last minute desperation)

Leaving in two weeks: $2,500 (seats are almost full)

Leaving in three months: $895 (normal price)

Leaving in six months: $1,200 (too far away)

Figure 19-7: Visiting ancient historical sites like this one can make you think that maybe the plane fare wasn't so bad after all.

What to do if you miss a flight

Usually smaller airlines are not as reliable as the major players when it comes to staying on schedule. The price may look better, but a half-hour delay could cause you to miss all of your connecting flights. This might not be a big deal if you're just headed home, but if you have another wedding to shoot the next day, you really don't want to get stuck in the airport. Stick with the major airlines when you have a tight schedule.

Missing one flight at the beginning of a long trip may cause you to miss all of the others as well. The airlines will generally accommodate you and keep you moving without making you buy new tickets (unless it was your fault that you missed it), but you will not get first priority on the next flight even if it was their fault. Instead, you get bumped into the world of "standby," which means that you can only get on the next flight if there is an empty seat. The airlines give you a list of each flight that goes to your destination that day and you walk from one gate to the next until eventually, hopefully, one of the flights has an empty seat. If the flights are all packed, they buy you a hotel room (if it was their fault), and you start your quest again the next day.

If your flight is overbooked, don't take an offer to give up your seat unless you have several days to spend in the airport. The airlines will offer you money and swear to you that there is another flight leaving in a few minutes, but what they don't say is that as soon as you get out of line, you go into standby status, so if the other flights are also overbooked, you don't get on. If this happens during a major holiday or spring break, you could be there for days, walking from plane to plane without finding an empty seat.

One technique I've used successfully is to put the phone numbers for Orbitz (if you use it) and your airline's ticket counter into your cell phone. When you encounter a cancelled flight, or even a delayed flight that you think might end up being cancelled, you can whip out your phone and immediately call to get a reservation on the very next flight to your destination. The importance of doing this immediately is that once the flight cancellation is officially announced, everyone else on that flight will want a seat on the next flight. Many will actually run to the next ticket counter because it is really a race to see who gets there first. If you're on the phone before they get there, you've got the next seat.

Taxi travel tips

Make sure to negotiate your taxi rate with the driver before you get into the taxi. The reason for this is that in many places tourists are frequent targets of inflated taxi prices. The drivers know that if there is a long line of taxis parked in a row, they have to give you a competitive price or you can just walk to the next one. However, if you get in and take off without talking price, you just lost your ability to negotiate. The driver can pretty much make up any rate he wants, and you can't say anything about it. What are you going to do, get out and walk?

Never pay your taxi driver until you get there. This gives you a bit of extra bargaining power with drivers who do things you might not like, such as driving crazy, blasting the radio, or stopping to buy groceries on the way to your hotel. If you threaten to not pay, you can usually get your trip to go the way you want. Be patient if your driver needs to buy gas on your ride and always be aware of the fact that many of these guys are extremely poor, so your fare might be the only gas money they've seen all day. If your driver is going too fast for your taste, offer a $5 tip to slow it down. You really have to remember that many drivers in developing countries

barely survive on the money they make, so the faster they can drop you off, the faster they can get back to pick someone else up and make another $10 before the day is over. Offering a good tip will usually be enough to take off the pressure and they'll slow down. Try to be understanding, and tip well if the driver treats you well.

Bus travel tips

In many developing countries, the bus is by far the cheapest and safest way to travel, although at first it may be difficult to find. As you arrive in a new place and begin to exit the airport, you will typically be accosted by a hungry mob of taxi drivers waiting to catch you before you explore alternative modes of transportation. You can certainly hire one of these helpful gentlemen to take you where you want to go, and if you happen to be in a hurry, they will definitely be your best bet. If you're not in a big hurry, the bus can save you a lot of money. For example, a cab from the Cancun airport in Mexico to Play del Carmen costs about $80 while the bus costs about $5.

Don't bother asking a taxi driver where the public bus terminal is located because he'll just swear there isn't one. If you can find a person who lives in the area, he or she will gladly direct you to the public bus, which is usually parked somewhere close by. Many countries in the Caribbean have a medium-sized bus called a Jitney that serves as the normal mode of transportation for all the locals.

I don't recommend taking a bus from your hotel to the wedding location on the actual wedding day simply because the bus may not be punctual or predictable. If you need to be there on time, call a cab and tell the cab to arrive thirty minutes before you actually need it because it is not unusual for cabs to be late too. I once had a cab driver show up so late that I missed my flight on St. Thomas and had to re-book my other flights all the way to Tahiti — at a cost of $400. So don't trust cab drivers to be on time, and if they're more than 10 minutes late, call another cab. Don't sit there waiting until it's too late.

Recording your travel expenses for tax purposes

Figuring the Federal tax for your travel expenses turns out to be far easier than you might expect. Instead of collecting every receipt for everything you do during your travels, the government allows you to claim a day rate called a *per diem rate*, which allows you to write off a pre-calculated amount that is different for each location. You simply look up the day rate for the country or area you are visiting and multiply that amount times the number of days you spent traveling (including those spent on the airplane), then add in your plane ticket cost, and that is the allowable expense for your trip. The two websites where you can find the official per diem rates are the Defense Travel Management Office (www.defensetravel.dod.mil/site/perdiemFiles.cfm) and the U.S. Department of State (http://aoprals.state.gov/web920/per_diem.asp).

Health Issues

Health concerns should be high on the priority list for the traveling wedding photographer. Not only do you have your health to worry about, but also you have an obligation to your clients to show up. If you catch any of the thousands of ailments out there that can endanger your health, missing a wedding might be the least of your worries.

Travelers' diarrhea

Travelers' diarrhea is a major concern for the wedding photographer. This common condition is rarely dangerous, but it makes you very uncomfortable for three to five days. There are roughly 20 different germs that can cause this ailment, and you can easily acquire most of them through food and drinks that are prepared with little or no hygiene. The best way to avoid these germs is to only drink bottled water and avoid the local water in any form. This includes not brushing your teeth with the local water, eating salads washed in it, drinking drinks with ice, and so on. Be particularly aware of this at least until after the wedding is over. Wash your hands and eat only well-cooked foods. If you think you might be in a really remote area, take along an iodine water purification kit. Polar Pure Water Disinfectant (www.polarequipment.com) is my favorite form of iodine water treatment.

Travelers' diarrhea is normally self-limiting, and if you get it you should be back to normal within a few days without any treatment other than drinking a lot of water to combat dehydration. However, as a wedding photographer you may not be able to wait that long. If you do find yourself with this condition, be prepared with an antimotility drug that slows the diarrhea, thus retaining water and allowing your body to function semi-normally for a while so that you can work — sort of. Imodium is one common brand name for this type of drug. However, this drug is not really good for you, so don't just take it to feel better. Take it only when you absolutely must feel better for a short time and then quit taking it as soon as possible to let your body work through the intestinal infection normally.

Some people are afflicted with Travelers' diarrhea every time they travel abroad, while others are very resistant and hardly ever get it even though they eat and drink the same things. If your system is fragile and easily affected by this sort of thing, you might want to consider sticking to weddings in the US, and if you do travel abroad, don't do it alone. Being really ill and alone in a strange country is the worst.

Dangerous critters

If you are the more adventurous type and you decide to go trekking around in the countryside (which I highly recommend doing after the wedding), you should also check with the locals to get a rundown on all the dangerous critters to watch out for. You should have some idea about local wildlife, such as snakes, spiders, scorpions, centipedes, ants, bees, packs of wild dogs, and plants that can hurt or even kill you. On my own travels, I've run into a brown spider as big as the palm of my hand in the jungle on the north shore of Kauai, an 11-inch centipede that didn't seem at all frightened of me on Crooked Island in the Bahamas, and a tree that causes severe skin rashes if you touch it or if rainwater even drips off of it onto you in Barbados.

Moray eels, crown-of-thorns starfish, stinging corals, box jellyfish, stingrays, and sea urchins can be found in all Caribbean snorkeling areas, and it is not at all unusual to look up from your snorkeling and see a six-foot barracuda or shark circling around to check you out. You should know that one of the critters in the list above kills more swimmers than all the others combined. Do you know which one it is? Read up on the hazardous types of marine life before you go snorkeling; even after doing your research, it's always best to avoid touching anything while snorkeling — although as you can see in Figure 19-8, that can be hard to resist for a youngster.

Figure 19-8: Snorkeling with your family members does have a certain element of risk, but if you know what to watch out for, there are few experiences more enjoyable than a day in the sea. And if you're lucky enough to run into a sea creature like this, you can bet your kids will remember it for the rest of their lives.

And in pretty much every warm place on the planet, you have to watch out for the ever-present mosquito. Malaria is still a concern in many destination wedding locations, and you need to know this before you go because you have to start taking the drugs before you get malaria — not after. Find specifics about your destination at the Centers for Disease Control and Prevention (www.cdc.gov) and in fact, it wouldn't hurt to check out this website before traveling to any unknown area for the first time.

Dangerous people

Of course the vast majority of people you meet on your worldwide travels will be kind, honest people who want nothing more than to live their lives in peace and happiness. However, there are those that prey on the gullible and the unwary, no matter what country you visit. If you happen to be a tourist with a different skin color from the locals, you might as well have a bull's-eye painted on your back.

I have a theory about these predator types. In my experience, they concentrate along the borders of the "touristy" zone. This is the border between where the locals live and the area that caters exclusively to the tourists. This is the danger zone! You won't find them in the big resorts, or in the suburbs where the regular folks are going about their business. But when you cross between the two zones, you'd best keep your eyes open.

Once while standing directly across the street from Margaritaville in Mobay (Montego Bay, Jamaica), I was buying a Red Stripe (Jamaican beer) from a sidewalk vendor when I realized very suddenly that four different guys (at least) bumped into me all at once, and none of them seemed to be paying me the slightest bit of attention. They all jostled into me for no apparent reason, and at that very same moment, I had a very slight feeling of something moving in my pocket. I jumped out of the crowd and walked across the street to where the cops were standing. I stood beside the cops debating. Hmmm, I could tell the cops about this, but I've got to live here for a month and I don't want to be on the bad side of all the local guys. In the end, I decided to chalk it up to a pretty cool experience. I lost nothing because I had all of my cash in a zippered pocket on the leg of my pants (a precaution I highly recommend). But I had to appreciate the art these guys used in the attempt they made. It was so slick! If I'd had money in that pocket, there was no possible way I would have been able to know which one of them took it.

Another time, in Barbados, I was lying in bed wide awake after shooting late into the night at a wedding. At about 3 a.m., while I was watching a movie about giant spiders that attack the town, I heard a loud rumbling that sounded like a bomb going off in the distance. I sat up, looked out the window, and then threw open the curtain that covered the sliding glass doors. I was expecting to look for the source of the booming noise, but instead, I found myself standing there, buck-naked, staring into the face of a local guy with long dreadlocks, shorts, and flip-flops. I didn't understand what was happening at all! He quickly said, "Sorry, I was looking for someone else mon." Then he vaulted over the side of the porch and disappeared around the corner. I called security and they looked all over for him, but of course they found no one. If I hadn't accidentally been awake at the time, that man would have probably walked off with every scrap of my camera gear — and the wedding images.

After that experience I started packing a small combination lock with an alarm and a three-foot cable. When someone tries to move my camera box or cut the cable, a 110-decibel alarm sounds. I leave it attached between my camera box and laptop whenever I'm out of the room or sleeping. The maid accidentally set it off once and she refused to come back into my room for the rest of my stay. (It's loud!)

First aid kit

If you know that you'll be going to areas where healthcare providers are few and far between, and the possibility of finding a good drugstore may be pretty low, it wouldn't hurt to talk with your doctor, or a doctor who specializes in travel issues, about getting some supplies to cover you in the event you encounter some of the more common ailments. I won't get into the specifics because I'm not a doctor, but I personally carry a general antibiotic that works for larger injuries like stepping on a nail or an infected tooth. And I also carry an antibiotic that is specific to intestinal parasites. And as I mentioned before, having a few Imodium tablets along is absolutely essential.

Some first-aid items are so essential to your work that it's important you keep them in your camera case. If you start to come down with the flu or a bad cold on the day of the wedding, you're in trouble. I carry a small vial of Tylenol because it will effectively mask all flu symptoms and allow me to function pretty much like normal even though I'm getting sick. Imodium also masks the symptoms of an illness. Both of these drugs can save you from missing the wedding, but they won't stop the problem; in fact, they will make it worse. The Tylenol will cut off the fever your body needs to produce in order to kill a bacterial infection, and Imodium will prevent the diarrhea your body needs to produce to flush out an intestinal infection. So it's important to understand that you're not doing your body any favors by taking these drugs, but they will get you through the day in an emergency.

Of course, your first-aid kit should also contain an assortment of sterile bandages and treatment for small- to medium-sized wounds. To treat these you can use the iodine from your water purification kit to sterilize the wound when it first happens, and then apply an antibacterial ointment like Bacitracin twice a day while the wound heals. These two things are absolute essentials for any first-aid kit.

Vaccinations

Before you travel to any other country, consult with a good travel doctor to see what sort of vaccinations you may need. You need to keep updated on tetanus but there are also many other strange diseases for which you may need shots, and the specific list of shots differs for each location. If malaria is a possibility, you need to be aware of that. Most wedding destinations don't have malaria, but if you travel into the countryside after the wedding, that's a whole different story. If you can't find a travel doctor in your area, the best website to check for diseases and other current dangers is the Centers for Disease Control and Prevention (www.cdc.gov). Don't wait to do this till the last minute, or even the last month before your trip. Some vaccinations must be taken well in advance of your departure date.

International Travel Paperwork

As a photographer traveling the world with a lot of expensive photo gear, dealing with border-crossing officials can be one of the most frustrating parts of the entire experience. Every country you visit has a different set of regulations for border crossings and for acquiring a legal work permit. Some countries may be very relaxed about enforcing these laws while other countries may be extremely rigid. The amount of enforcement you encounter also depends on the personality and the mood of the particular officer you happen to run into that day.

Obtaining foreign work permits

Every country has a legal requirement that you obtain a work permit (or business visa) before performing any professional services in that country. However, the fact that most third-world countries have websites that are minimal at best can make it difficult to find out how to comply with the legal work requirements or even to find out what the requirements are. Your best bet is to look at the website for the country you are interested in and find the phone number for the Customs and Immigration office in that country. It is doubtful the website will have a section dealing with traveling photographers because there simply aren't that many of us around. Call the country to ask about what paperwork you need. On my website (www.aperturephotographics.com) in the "For Photographers" section, I have information and tips about traveling to various countries and the documentation each one requires. I try to keep that section updated with the help of other photographers who also send in information they find.

Do you really need to do all that just to shoot a wedding? Legally, yes! If you try to slip around the laws and you get caught, you might end up in jail or sitting on an airplane after having all of your equipment confiscated. The possibilities are serious enough that you would do best to call the customs agent for the country you are visiting several months in advance and make sure you have all the necessary paperwork completed before you leave home. And I do mean months in advance because much like our own, the government offices of foreign countries don't always provide a quick turnaround.

The following countries are places I have worked as a destination photographer. The lists show which countries showed any resistance to me shooting a wedding there, or to bringing my equipment in and out through the airports.

Countries where no restrictions were found:

Aruba	Fiji	St. Lucia
Barbados	Greece	Tahiti
British Virgin Islands	Hong Kong	Mexico
	Italy	U.S. Virgin Islands

Countries with restrictions that are enforced:

Bahamas

Jamaica

Crossing U.S. borders

U.S. customs law says that if you carry commercial equipment across the border and you want to return with it, you need to register it before leaving; otherwise, it could be subjected to duty as "new" equipment upon reentry to the United States There are various options as to how it can be registered, but the easiest and least expensive method that will get you in and out of the United States is a simple form. The U.S. Customs and Border Protection website (www.cbp.gov) has two forms: Form 4457 and Form 4455. These two forms allow you to declare a list of equipment to the customs office before you exit the United States. Form 4457 is for personal effects and perhaps a small list of gear. Form 4455 is for a larger list of gear, and you are allowed to attach an inventory list to this document. Form 4455 also works for any associate photographers or assistants who travel with your company equipment. The main difference is that you can keep Form 4457 and use it over and over, while Form 4455 may be collected as you reenter the United States. If you save a copy of Form 4455 on your computer, you can print a copy every time you need to travel.

Form 4457 is the most appropriate for a traveling photographer and getting one completed and stamped will only take approximately 30 minutes. You should have your printed equipment list and form in hand when you go through customs upon departure for international travel. If you are attempting to comply with the laws, U.S. Customs officials are extremely helpful.

Specialized Equipment for Travel

If you do more than an occasional destination wedding, you need to travel light. I've whittled down my own gear box to just the essentials listed in this section. Depending on your style of shooting, you may require more camera gear, and you certainly don't have to travel with the laptop and all of the associated computer gear I mention unless you will be gone for extended lengths of time. If you are shooting a single destination wedding, you can easily get by without the laptop by just bringing your compact flash memory cards back home (on your person) before downloading them to your home computer.

Carry-on camera case

I personally don't like to trust the airlines with my camera gear, so to be able to take it all with me onto the airplane, it has to fit into a case that conforms to the regulation size dimensions for carry-on luggage. My favorite is the Pelican 1510, which I discuss in detail in Chapter 3. This rolling box is the exact maximum dimensions allowed for carry-on luggage. The fact that it rolls on its own wheels and is practically bombproof makes it perfect for protecting your delicate gear during long-distance travel.

As tough as these Pelican boxes are, I don't recommend that you check them with the regular checked baggage. The results you get with checking your bags simply depend on who is throwing it that day and how good of a shot he or she is because all baggage handlers throw all the bags and boxes that get checked on the plane. The box itself will almost always survive being thrown short distances, but the gear inside will be subjected to huge g-forces that may actually be so strong they cause the camera bodies and lenses to penetrate the foam padding inside the box and come in direct contact with each other. As you can see in Figure 19-9, the baggage handlers on land can sometimes be rough, too.

Figure 19-9: A Pelican rolling case is tough enough to withstand even these young baggage handlers having a tug-of-war to see who gets to carry it.

Another item I found to be an essential part of moving around over rough ground is a strap that allows you to attach your camera box to your rolling suitcase so that they both roll as one unit. This greatly increases your ability to move around over short distances as you go from hotel to cab to bus to plane, and so on. You can easily make your own strap for this use. When you do, try to make it just long enough that the two boxes are balanced over the wheels when you walk with them. If the weight is too far forward or back, moving over rough ground is difficult. If you get a system like this to work, it becomes much easier for you to travel through crowds of people and over rough ground than if you've got a rolling suitcase in one hand and your Pelican case in the other.

Carry-On Camera Box: List of Contents

My Pelican 1510 with padded dividers and lid organizer contains the following items:

✦ Camera bodies × 2

✦ Flash × 2

✦ 16-35mm f/2.8 lens

✦ 50mm f/1.4 lens

✦ 70-200mm f/2.8 lens with Image Stabilizer

✦ Lensbaby

✦ Extension tubes for extreme close-ups

✦ Air blower and other CCD (charge-coupled device) cleaning materials

✦ Padded metal case containing memory cards

✦ Batteries and battery chargers for camera and flash

✦ Radio slave set

✦ Small bottle of pills (see the "First aid kit" section in this chapter)

For those occasions when I do hire a second photographer, I also have an identical set of this gear in an identical Pelican box (without all the stickers).

Gear in the suitcase

In my suitcase I also carry a power plug adapter for the country I'm visiting, my Domke photo vest, a small reflector, a folding softbox, and my tripod. The aluminum tripod is fairly fragile so as you can see in Figure 19-10, it travels inside a protective tube I constructed out of PVC pipe just for this purpose.

Carry-on backpack

My backpack holds the most fragile items as well as those that I absolutely must keep with me at all times while traveling. In it I pack my laptop, snacks, something to read, passport, tickets, travel itinerary, hat, light jacket, sunglasses, and money. One item that has become trouble-some these days is a water bottle. I carry my own bottle because I can't stand the way we're filling our planet up with empty plastic bottles, and because once you're on the plane, if you ask for a drink they give you a tiny sip in a plastic cup and it becomes impossible to get enough to drink on a long flight. The only drawback to carrying your own bottle is that you have to dump it or drink it every time you go through a security gate and if you forget, airport security tends to get really surly about it. One time they even dropped it in the trash and told me that if I wanted to keep it I'd have to go back out around outside the security gate, get the bottle out of the trash, dump it in the restroom, and then come back and go through security again.

Bolt holds cap to body

Marks align holes in cap and body

Figure 19-10: My old Gitzo tripod travels in this PVC pipe carrier I made for about $5.

I also recommend that you purchase a semihard protective case for your laptop. This type of case typically zips open so that your laptop can lay flat while still inside the case. It is acceptable, even in the United States, for you to lay the open case (with the laptop still in it) on the security conveyor belt. As long as you have nothing else in that laptop case aside from the laptop, you don't have to completely unpack it. This makes your trips through the security line a little easier.

Gate-Checking Your Camera Box

When you travel on small- to medium-sized planes, there may not be enough space inside the airplane for you to keep your camera box with you. When this happens, you are required to part with your precious gear just outside the door of the plane. You are generally given a receipt ticket and then your gear is taken to the cargo hold where it is "placed" safely inside. Every time this happens to me, I open the box immediately afterward to make sure all the contents are still present. This is one of those times that you'd better hope you have a tough camera box because they will throw it. Tell the person who is taking the boxes that the contents are very fragile and worth about $15,000 — you'll be surprised at how often they ask the flight attendant to help you find a space for your box inside the plane.

How to Calculate a Fee

The following rates are based on arriving at the destination one extra day before the wedding. This extra day is a security against the times when you have to deal with getting stranded in the airport. Hopefully this won't happen, and you can spend the extra day scouting locations or just lounging on the beach. The total time necessary to complete a destination wedding includes one full day of traveling, the extra day, the wedding day, and a full day for the trip home. This makes each job a four-day affair at minimum. Although prices listed here are estimated, they are based on my experience and are typical for most locations. This should give you some basic guidelines for figuring out your own price.

The following are estimated costs of the travel expenses for a typical destination wedding:

- ✦ **Airline ticket and two hours to research and book the ticket.** Cost: $1,000. Ticket prices vary widely depending on the season and the location. This arbitrary price assumes a normal ticket price of $800–$900, which is common for most destinations.

- ✦ **Food at $40 per day for four days.** Cost: $160

- ✦ **Car rental at $35 per day for four days.** Cost: $140

- ✦ **Hotel at $80 per night for three nights.** Cost: $240

- ✦ **Fee for two travel days at $200 per day.** Cost: $400

- ✦ **Fee for extra layover day at $100 per day.** Cost: $100

This brings the travel fee to approximately $2,040 and in reality, it always comes out to be more than that. Add to that amount the normal fee you would charge for the same package if it were a wedding at home, and you have your total destination wedding fee. The national average price for wedding photography is roughly $2,500 and that is for "average" photography. In reality, very few "average" wedding photographers will be asked to travel at all, but for this discussion, let's use the average price, plus the $2,040 we calculated for travel. That tells us the real fee for a destination wedding should start at roughly $4,500 and go up from there — especially if you consider yourself to be above average.

Even if you want to travel so badly that you're willing to forego the payment for your travel days, that still leaves the travel fee at about $1,650. So basically, if you charge anything less than $1,500 to cover your travel expenses (in addition to your normal fee), you'll be going backward. At this point, you have to accept that it simply isn't a sound business decision to accept a job where you make less money from four days of intense work than what you'd make from shooting a single wedding in your own home town.

If you happen to be just starting out in the wedding industry, I can tell you that your predecessors have worked long and hard to create a tradition of high pay in the wedding industry. You have an obligation to all wedding photographers to charge competitive rates. If your work is good, you will get plenty of jobs at a competitive rate. If your work is not attracting clients at a competitive rate, then you should think about changing your work, not your rates.

If you want to find out what the local going rate is, call up a few of the more established photographers in your area and tell them that you are calling to find out rates so you don't run down prices. I'm sure they'll be glad to tell you what the price range is in your area.

Two Reasons to Do Destination Weddings

The first and most common reason to shoot destination weddings is the lure of getting out of your own town to see the world. Some people are content to be where they are while others are always curious to see what's on the other side of the hill, no matter how good it is where they are. If you happen to fall into the latter category, destination weddings will certainly be attractive to you.

The second reason to shoot a destination wedding is if you happen to live in a remote area or an economically depressed area that doesn't have many clients. For example, a good photographer in New York City could easily charge $6,000+ for a day of shooting and might gross $10,000 after the couple purchases albums and prints. If that same photographer were to move to a small town in rural America, the number of $6,000 jobs within driving distance would not be enough to survive on. At this point, the price difference has nothing at all to do with the quality of the photographer. Luckily, we live in the age of the Internet, so if you know how to market your website, a bride in New York can find your business right in the comfort of her own home. She can also use the Internet to pay you and communicate with you to make all of the necessary arrangements, even if you happen to be off shooting a destination wedding in some remote place halfway around the planet. Thanks to the Internet, photographers are no longer quite so limited by geography — photographers can live and work anywhere they want.

Is It a Job or a Vacation?

Every job you do as a wedding photographer has to make money. That is a very simple fact of our existence that seems to elude some people for an amazingly long time. Destination weddings may seem at first like they would be so much fun that you might even be tempted to do them for free. Heck, some are so cool it seems like maybe you should be paying the bride for the privilege of doing the job. Many photographers who are new to the destination wedding business undercharge to get what looks like a "free ride" to some exotic location. At first, going to Hawaii for a wedding sounds like the perfect excuse for a vacation in Hawaii. However, as photographers, we must collectively realize that destination weddings are a growing part of our market, and in the future they are certain to become much more common. With that in mind, the concept of undercharging to get the job has the same effect abroad that it does for wedding photography at home. For example, if you are an established wedding photographer and one of your competitors starts charging a fee so low she barely breaks even, you would be knocking on her door to inform her she is devaluing the whole business of wedding photography. Of course, beginners have to start with low fees, but decent photographers should always check the local market to see what everyone else is charging so as not to degrade the business by running prices down. Pricing for destination wedding photography works exactly the same way — or at least it should.

As you can see when you look at the figures in the section "How to Calculate a Fee," you are far better off skipping the working vacation and just taking a real vacation instead. Compare those prices to the fact that you will be gone for at least four days during which time you can't do any other work except answer e-mail from your laptop. How much money could you have made if you had stayed home and worked those four days at local weddings and portrait jobs? Assuming you're open to shooting more than one wedding per weekend, you could probably

shoot at least two on a prime weekend. This would make roughly $5,000 net, which you could spend on a real vacation to Hawaii.

Summary

Traveling to exotic destinations to photograph a wedding can be one of the most rewarding jobs you will ever encounter as a photographer. Of course, you frequently face transportation and health challenges, but with a little preparation, the rewards far outweigh the difficulties, and if you develop the right mental attitude, the little difficulties are some of the best parts of the experience.

Will you get rich doing destination weddings? Definitely not! In fact, you can easily make more money working right in your own home area.

If you're going to make destination weddings a large part of your business, you have to charge a realistic fee or you won't be able to pay your bills; but even with a decent fee, you're not doing these jobs for the money — it's all about the experience of traveling around the world, seeing new places, tasting new foods, meeting new people, and learning about other cultures. These are things you can't really put a price on, and these are the reasons photographers may find themselves lowering their prices down to outrageously low levels. Sometimes, even if you come home broke, you'll be a far richer person for having gone out to see the world.

✦　　✦　　✦

A How-To Gallery

Do It Again!

Taken at ISO 400, f/4, 1/250 second with a Canon 50mm f/1.4 USM lens set at f/4.

This image is one of my personal favorites. What I find most attractive about it is that it looks (to me) like a spontaneous natural moment, but I know that's not how it happened. It came about during the reception while I was standing in the food line. I was in the process of filling my plate when I noticed the groom and the best man laughing as they tried to take a photo of themselves with a little box camera. I put down my plate and walked over there, but of course they had already taken the photo before I arrived. I told them I was watching and that I thought it would make a cool picture to re-create what they were doing. They were game so I set up my camera to get a medium depth of field, which I hoped would blur out the background a bit. I tried to include a portion of the reception site in the background to give it some feeling of the location, but in hindsight, I think the background is too busy.

I shot perhaps ten images of this scene with slightly different angles, and in a few shots I placed the focus on the box camera instead of on the men's faces. I chose f/4 instead of using the wider apertures on this f1.4 lens because I know from past experience that it is almost impossible to get two faces in perfect alignment with your camera, so one of them will invariably be blurry if you shoot wide open (f/1.4) with a lens like this.

Anticipation

Taken at ISO 1000, f/3.5, 1/90 second with a Canon EF70-200mm f/2.8L IS USM lens.

This image is one of my favorite types of images that I create at a wedding. What may be surprising is that it is a spontaneous image that I caught without any staging. I used the 200mm lens because it lets me get back away from the action a bit while still creating the impression of being right in there.

One of the most difficult parts of being a wedding photographer is learning how to really watch people and use their behavior to set yourself up to catch a photo that tells a story or captures the feeling of what is going on. With this shot, I remember seeing the bride pick up the pearls and call for her mom to come help. I was sitting down in the other room at the time, but I jumped up and got myself ready. I had to move again as Mom came into the scene, but by the time she started to put the pearls on her daughter's wrist, I was already shooting. If I hadn't been paying attention, I would have missed this shot.

Experimentation

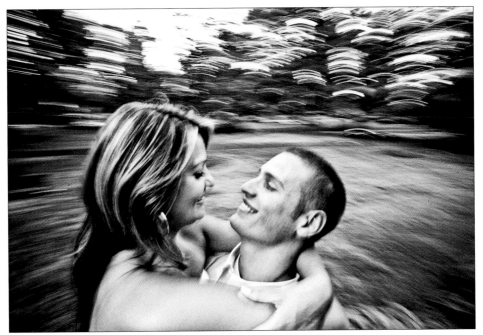

Taken at ISO 640, f/16, 1/15 second with a EF17-40mm f/4L USM lens.

This image came from an engagement session shot on a college campus. I'd gone through a lot of playful poses with the couple already and the light was getting pretty low so I decided to try to make something fun that showed a lot of motion. We played around with several ideas where I was moving with them and even running around them. Then I had the bright idea to hook elbows with the groom and hold the camera above my head while all three of us spun together as a unit. It worked really well so I shot perhaps 20 images as we twirled around and around. I varied the shutter speed to get differing amounts of blur in the background, stopping occasionally to check the effect I was getting. When this image showed up on the LCD, I knew we could quit.

Typical shutter speeds to get an effect like this would be something around 1/8 to 1/20 second. The quickest way to get a slow shutter speed is to run your aperture up to f/16 or f/22, then change your ISO if the shutter speed still isn't slow enough.

Awareness

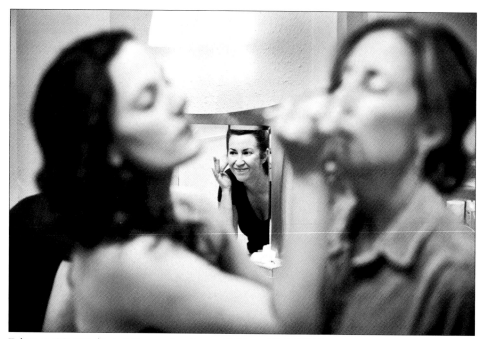

Taken at ISO 500, f/1.4, 2.5 seconds using an EF50mm f/1.4 USM lens.

I love the fact that there are two separate scenes nested together in this image. I was originally shooting the two closer women in the dressing room when I noticed the other woman moving in the background and decided to try shooting through the first couple while focusing on the scene at the mirror. I love trying to put two different stories together into one image, and in this case I think it works particularly well because I was able to get both scenes contained within the frame and both are still recognizable despite the way the foreground image is severely blurred.

For this shot there was no time for changing lenses or moving people around. In fact, I doubt I could have created a scene like this if I wanted to. As usual, being in the right place at the right time is partly skill, but sometimes having just the right lens in place to get a great effect does involve a certain amount of luck.

I shot perhaps five frames, looking for different hand positions on the woman in the background, before everyone eventually moved on to something else.

I usually shoot the 50mm f/1.4 lens at f/2.8 simply because of the increased risk in missing the focus if I use wider apertures. I find f/2.8 is a good balance between shallow depth and enough depth to catch your focus point almost every time.

Textures

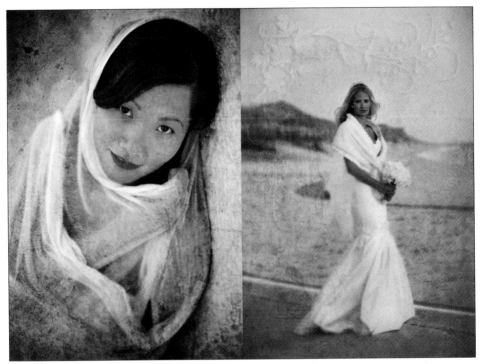

Left image: taken with a 50mm f/1.4 lens. Right image: taken at f/2.8 using a 70-200mm lens.

These two images are examples of an effect that has gained some popularity over the past few years, which is to open the photo in Photoshop and place a texture over the whole image. To do this, put the texture layer above the image layer and then apply different layer modes to the texture layer until you find something you like. I usually end up liking either Soft light or Overlay modes. To finish the image, I need to erase some of the texture over the face and hands. To do this, I place a layer mask on the texture layer and paint black on the mask in places where I want to remove or fade out the texture. To remove texture I set my brush to paint black at 100% opacity. To fade the texture, turn the opacity of your paintbrush down to about 20%. If you go too far with the black paint, simply switch the color to white and paint over your mistakes.

For these two images, I also created a blur in the background. To do this, I copied the image layer and then placed a layer mask on the topmost of the two image layers. On the top image I chose Filter ➪ Blur ➪ Gaussian Blur and adjusted the blur to the maximum that I thought might look good at any place on the image. Then I painted black on the mask as mentioned above to hide the blur and fade it out of the areas where I wanted the image to appear sharp. In the image on the right, you can see that I also placed a big scroll design over the image, which I blended into the image by changing the layer mode and adding a very small drop shadow.

Light

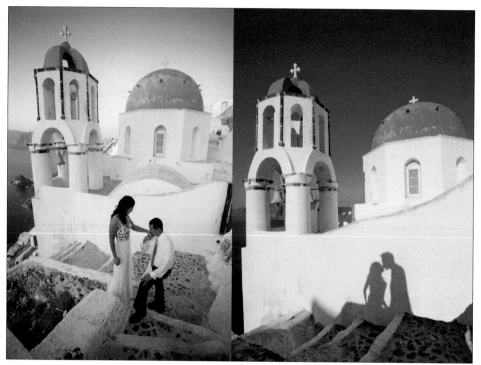

Both images taken using a Canon EF17-40mm f/4L USM lens at f/4.

These two images were shot in consecutive years (with different couples of course) in the town of Oia on Santorini Island. I love the colors and the shapes of these two buildings and the style of the architecture is so typical for this area that almost anyone who sees it can instantly recognize the location. I always try to use these two buildings in my wedding images because they have that distinctive Santorini signature look.

The left image was shot at sunrise. You can see a bright yellow light hitting the far wall of the canyon as the sun was coming up behind me. The even light made the exposure easy enough, so my main concern was trying to move myself and the couple around to get them into a place where they had a reasonably plain section of the building behind them that would make a good background. I tried several combinations in an effort to find something that showed the couple and the buildings in a composition that worked.

Sometimes something happens to throw a complete new twist on things, as shown in the image on the right. In this case, the bride was trying to get out of the way so I could get a shot of the groom, but when she did, she accidentally threw a big shadow on the wall. At first I asked her to move, but then it struck me that I might be able to use that shadow to my advantage. That little spark eventually evolved into the image shown here.

Predict the Light

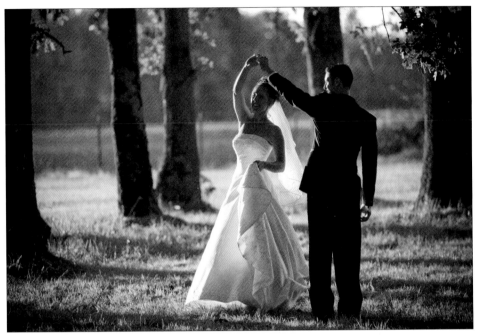

Taken at ISO 400, f/2.8, 1/800 second using a Canon EF 70-200mm f/2.8L IS USM lens.

This image was created during a wedding at a venue that had a very homey and farm-like feeling. The location didn't have much in the way of beautiful architecture, and there was a house and barn to the west of the actual wedding site that would block the sunset. This was something I noticed when I arrived in the morning and took a walk around before I started shooting. On that same walk, I noticed that about a hundred yards away, there was a beautiful grove of oak trees and tall grass that had the open view to the west I was looking for. I mentally logged this down as the place to watch at sunset. Sure enough, late in the evening, just before the sun went down, the sunset hit that grove and the light was spectacular. By then I'd already talked with the bride and groom about going out to this grove, so when the time came, they were mentally ready to go.

So much of wedding photography is about learning to anticipate how something might happen and get yourself ready to shoot *before* it happens. This is true for both people and the light at the location. A simple image like this one could have been caught by any beginner if he or she were lucky, but no beginner can catch 200 "simple" images at a single wedding. The point is to stop relying on luck. As a professional, you have to develop the skill to create great images every single time you work — no matter where the wedding takes place.

Warp Speed

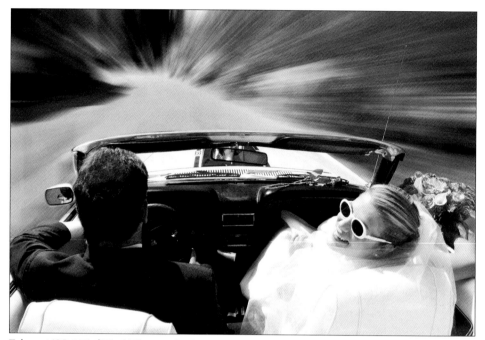

Taken at ISO 100, f/22, 1/45 second using a Canon EF17-40mm f/4L USM lens.

This image reminds me of the starship hitting warp speed. I took the shot while the bride and her father were waiting for the signal to drive up to the ceremony location. I asked if I could get in behind the seats of this convertible Mustang and shoot over their shoulders. Dad reluctantly agreed — *if* I agreed to take my shoes off first. So I got in behind them and shot several shots while the car was sitting still. We couldn't actually drive anywhere or the guests would have seen us, so I had to settle for the still shot.

Back at home, I created the motion in Photoshop. I copied the image layer, and on the uppermost of the two layers, I applied a motion blur that focused down the street. No problem so far. However, when I masked out the sharp image layer, I discovered that every piece of the car (such as the window frame and mirrors) created a blurred version of itself. This bothered me because if the motion were real, the blur would only be in the background. I wanted the effect to appear as realistic as possible, so I very painstakingly cloned out the blur artifacts around the window, the mirrors, and the antenna until the window appeared to separate completely from the background.

I used a wide lens for this shot and I leaned back as far as I could to get as much of the car as possible without including my own knees.

Index

Continued